ART+PARIS

IM

THE ~~ULTIMATE GUIDE~~
TO ARTISTS, PAINTINGS
AND PLACES IN PARIS
AND NORMANDY

PRES

SION

ISTS

& POST-IMPRESSIONISTS

Published in the United States by:
Museyon, Inc.
20 E. 46th St., Ste. 1400
New York, NY 10017

Museyon is a registered trademark.
Visit us online at www.museyon.com

ISBN 978-0-9822320-9-5

19590421

Cover image: Claude Monet, *Woman with a Parasol–Madame
Monet and Her Son*, 1875, National Gallery of Art, Washington, D.C.

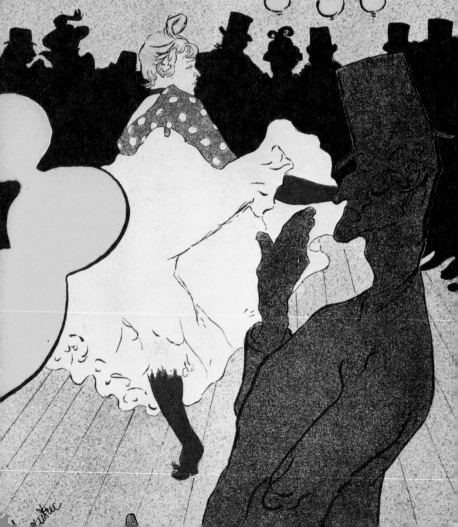

FOREWORD

In 19th-century Paris, a group of artists made the brazen move to stand up to the establishment. Inspired by Édouard Manet, young artists including Claude Monet, Pierre-Auguste Renoir, Édgar Degas and Paul Cézanne, set out to make art on their own terms. Spurning the Académie and foregoing the official Salon, these artists paved the way for modern art.

At a time when the average working man made between 1,500 to 2,000 francs a year and an artist favored by the official Salon could sell his a single painting for even more, the Impressionists struggled to get even a few hundred francs for their work. Many of these artists lived on the verge of poverty, surviving only on handouts from patrons and friends. Though they struggled in obscurity for decades, those who survived through the turn of the century were vindicated with international success.

This book will take you into the lives of the core Impressionists and the artists who followed them. Not only will you discover the dramatic true stories of their struggles and triumphs, this book will take you to the real-life places where they lived and worked in Paris and beyond.

See the world through the artists' eyes. Get inspired.

Henri de Toulouse-Lautrec, *Moulin Rouge–La Goulue*, 1891
Civica Raccolta di Stampe Bertarelli, Milan

ART+PARIS
IMPRESSIONISTS & POST–IMPRESSIONISTS

TABLE OF CONTENTS

MAP ICON KEY	
🏠 Address	€ Admission in Euros
☎ Phone Number	■ Existing Building or Reconstruction
🖥 Website	■ Building No Longer Exists
🕐 Hours of Operation	

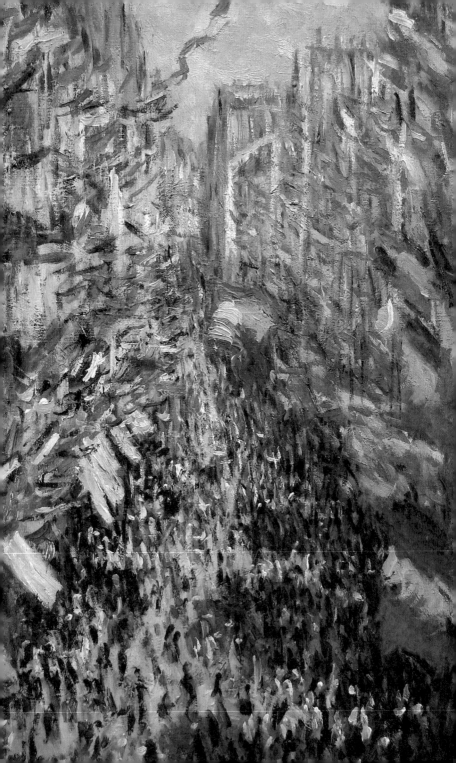

What Is Impressionism?

by Cindy Kang

On Thursday evenings, as the gas lamps were lit in Paris of the early 1870s, the smoky, dark-paneled Café Guerbois became the center of boisterous artistic debate. Over cigarettes, strong coffee and weak beer, Claude Monet, Pierre-Auguste Renoir, Edgar Degas, Camille Pissarro and other friends from different art studios discussed the possibility of forming their own exhibiting corporation. They had had enough of the conservative taste and nepotism of the French art academy, which had rejected their paintings from the annual exhibition in Paris known as the Salon.

When their first exhibition opened in 1874, the group was called the Corporation of Painters, Sculptors, Engravers, etc. Of the unmemorable name, Renoir explained: "I was afraid that … critics would immediately begin talking about a 'new school.'" Despite the artists' attempt to assert their individuality, the critics did indeed perceive a new movement, which they dubbed, derisively, Impressionism.

The *bête noir* and namesake of the exhibition was Monet's *Impression, Sunrise*. A morass of thick, choppy brushstrokes of unblended blues, violets and shocking orange, Monet's work was the opposite of academic paintings such as William Bouguereau's *Nymphs and Satyr*—the darling of the 1873 Salon. The latter's glossy, highly-finished surface, titillating mythological subject and seamlessly layered and blended tones made Monet's painting look like an insignificant, blurry sketch done in bright, vulgar colors.

The eight Impressionist exhibitions mounted between 1874 and 1886 showcased these artists' radical technique and subject matter. Although each artist worked in an individual style, their shared engagement with modern developments in science, urbanization and new cultural influences led to a revolution in Western painting.

Claude Monet
The Rue Montorgueil in Paris. Celebration of June 30, 1878 (Detail)
Musée d'Orsay

The Roots of Impressionism

Optical Theory

Drawing from new theories of optics derived from Hermann von Helmholtz, the Impressionists believed that the human eye encountered a scene as a field of pure colors. The brain then processed these colors to create an intelligible image. An Impressionist painting was therefore an attempt to recapture that primary sensation.

Thus, Monet instructed a student: "When you go out to paint, try to forget what objects you have before you … Merely think here is a little square of blue, here an oblong of pink, here a streak of yellow, and paint it just as it looks to you … until it gives your own naïve impression of the scene before you."

Paint in a Tube

Renoir once claimed, "Without colors in tubes, there would be … no Impressionism." Before the mid-19th century, artists either made their own paints for each work day or stored them in messy, smelly pig bladders. The invention of paint in metal tubes was a revelation for the Impressionists. They could now bring their easels outdoors and work on whole paintings for entire afternoons, instead of being tied to a studio to work on one section of a painting at a time. Tube paints allowed the Impressionists to seize their direct, fleeting sensations of light and atmosphere and completely dissolve form into touches of pure brilliant color.

Photography

The Impressionists reacted competitively to the development of photography in France in the middle of the 19th century. Photography's limited palette

pushed them to emphasize color as a distinguishing feature of painting. Their sketch-like technique, which looked spontaneous and dashed-off, even though it was meticulous and deliberate, attempted to compete with the immediacy of a photograph.

Nevertheless, the Impressionists also borrowed some of photography's tricks. In Degas's *Place de la Concorde*, the arbitrarily cropped man at the left and the blurry figures and horse in the background were all devices imported from photography to convey a sense of motion and the impression of a moment frozen in time.

Japonisme

The formal innovations of the Impressionists were as much indebted to Japanese woodblock prints as to photography. The craze for Japanese art, dubbed *japonisme*, was launched by the exhibition of the Japanese pavilion at the 1867 Paris Universal Exposition. Japan had been closed to the West for the past two centuries and the influx of art from the East astounded the avant-garde artists. Degas was one of the earliest collectors of Japanese prints and Pissarro called the Japanese printmaker Hiroshige "a marvelous Impressionist." The asymmetrical compositions, strong outlines, areas of flat color and aerial perspective found in works by Degas and Mary Cassatt were inspired by Japanese design principles.

Paris, City of Light

Wide, sparkling boulevards, lazy boats on the Seine, seedy cafés under lamplight—these everyday scenes painted by the Impressionists actually

reveal the total transformation Paris experienced in the 19th century. Before Paris became the City of Light, it was a haphazard accumulation of old neighborhoods with narrow, meandering, sewage-filled streets. Emperor Napoleon III appointed the Baron Georges-Eugène Haussmann to raze the city and build orderly *grands boulevards*, allowing light and air to circulate. The facelift included radiant glass-and-iron train stations to service a rising middle class. This *petite bourgeoisie* demanded new forms of leisure—day trips to the countryside, raunchy entertainment at *café-concerts*—all of which the Impressionists captured in their quest to express modern life through painting.

Haussmann's Renovation of Paris

In June of 1852, Napoléon III commissioned the Renovation of Paris, a visionary program to modernize and reshape the city of Paris. Led by Baron Georges-Eugène Haussmann, an able city administrator whose title was Prefect of the Seine, it had a far-reaching effect on not only how Parisians lived but on their aesthetic experience of Paris as well. Haussmann's plan cut through narrow medieval streets and alleyways and created grand avenues and boulevards, displacing many of Paris's poor. But the plan didn't stop at updating the streets;

it refashioned the look of the city as well. The elegant new buildings that were constructed to line the boulevards were rigorously planned to be the same height, with identical grey roofs, cut stone façades and balconies that aligned on the second and fifth floors. As a result, the streets had a unified aesthetic and each block seemed like one seamless palace.

The extensive urban planning project, with its primary goals of bringing safer and more sanitary living conditions to Paris, introduced clean water, modern sewers, and gas streetlights to Paris life, as well as train stations, schools, hospitals, city buildings, public monuments and a central market at Les Halles. Because urban Paris was a favorite subject of many of the Impressionists, Haussmann's innovations can be seen in such paintings as Renoir's *The Grand Boulevards*, Monet's paintings of the Gare Saint-Lazare, and Caillebotte's *Paris Street; Rainy Day* and *Boulevard Haussmann, Snow*.

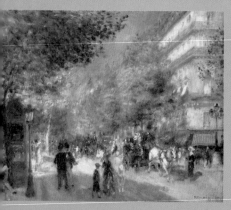

Auguste Renoir
Les Grands Boulevards, 1875
Philadelphia Museum of Art

Impressionists

The Impressionist revolution was led by a core group of artists.
Friends and colleagues, they developed their theories over cheap
wine in Parisian cafés and in trips to the countryside. They painted
together and suffered together, they fought authority and fought
amongst themselves; these are the artists who set the stage for
modern art.

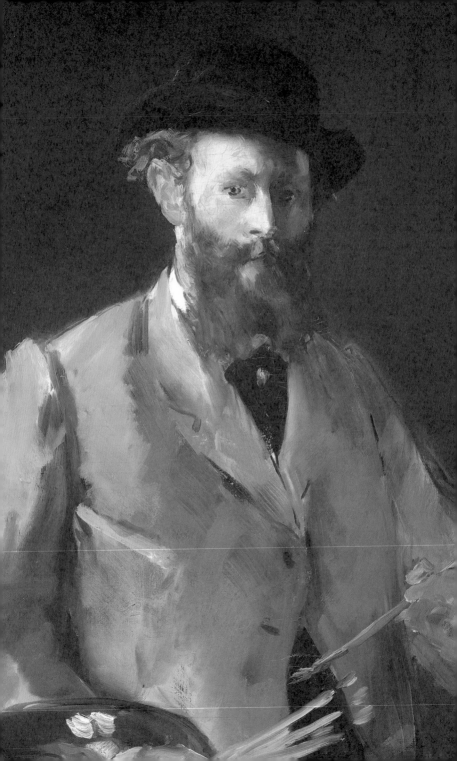

Édouard Manet

"If I'm lucky, when I paint, first my patrons leave the room, then my dealers, and if I'm really lucky I leave too."
—Édouard Manet

Self-Portrait with a Palette, 1879
Private Collection

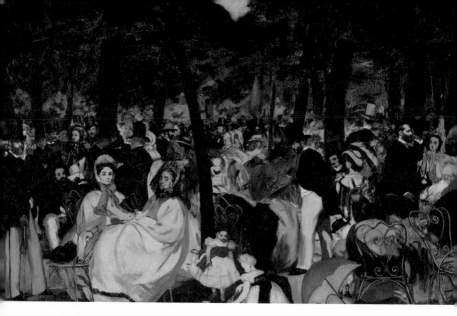

Concert in the Tuilleries Gardens, 1862, National Gallery, London. This painting features Manet's friends and family including his brother Eugène, the poets Baudelaire and Théophile Gautier, painter Fantin-Latour and composer Jacques Offenbach.

by Michael B. Dougherty

Édouard Manet never wanted to be seen as a radical figure in the world of painting, but his contribution to art history is nothing less than revolutionary. As the reluctant father of the Impressionist movement, his approach to technique and subject matter made their epoch, and Modernism itself, possible.

The son of a bourgeois mother who moved in royal circles (her godfather was the Crown Prince of Sweden) and a wealthy bureaucrat father, Manet enjoyed a privileged background unknown to many of his contemporaries. From the age of 7 he attended a day school in Vaugirard, a small village near the present day Porte de Versailles Métro station, studying French and classic literature. By the time he was 12, he was enrolled in Collège Rollin (known today as the Lycée Jacques-Decour) as a boarder.

Despite the financial and social advantages of his family, Manet performed poorly as a student, gravitating instead towards the arts. It was a source of great irritation for his father, who had hoped that Manet would follow his career in law, but after Édouard twice failed the entrance exam to the French navy, and following a brief stint as a merchant marine, Auguste Manet finally relented to his son's wishes.

left: *The Absinthe Drinker*, 1859
Ny Carlsberg Foundation, Copenhagen
right: *Spanish Singer*, 1860
Metropolitan Museum of Art, New York

In 1850, at the encouragement of his childhood friend and future Minister of Fine Arts, Antonin Proust (no relation to the novelist), Manet entered into the tutelage of Thomas Couture. He spent six years in the studio of the classical painter, refining his technique and moving away from Realism. Like the other artists of the Parisian avant-garde, he was drawn toward images of modern urban life, painting street scenes with a relaxed, sketch-like quality to them. It was also during this time that Manet's reputation as an urbane dandy, with his graceful mien and impeccable appearance, began to circulate, later captured by Henri Fantin-Latour's *Portrait of Édouard Manet*.

After opening his own studio, the blond-haired, bearded Manet began to mingle with other young, Parisian intelligentsia such as the poet Charles Baudelaire, studio-mate Albert de Balleroy and Fantin-Latour. He created work, like 1859's *The Absinthe Drinker*, that provided an unusual glimpse into everyday city life. Experimenting with the *plein air* technique of painting outdoors, Manet populated his *Concert in the Tuileries Gardens* canvas with the denizens of Café Tortoni and Café Guerbois in the Les Batignolles district, where he and many of the future Impressionists often gathered.

In 1861, Manet received his first taste of official recognition and early success when the Paris Salon recognized his *Spanish Singer* with an honorable mention. It wouldn't last. The Salon of 1863 was so brutally selective that Napoleon III, bowing to public pressure, formed an alternative, the Salon des Refusés. It was there that Manet first displayed *Déjeuner sur l'herbe*, and he was savaged for it. The attacks were two pronged: critics lambasted both his technique, which eschewed academism with its severe lighting and unnatural perspective, and subject matter, a clothed pair of young men with a naked—not an allegorically nude—woman. It was a critical disaster, one that set the stage for the Impressionist revolution.

Now married to his childhood piano teacher Suzanne Leenhoff, Manet faced an even greater fusillade when he submitted *Olympia*, arguably his greatest

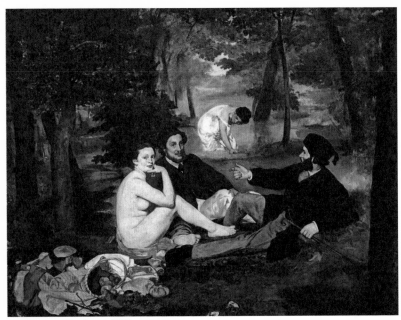

Luncheon on The Grass, 1863
Musée d'Orsay

work, to the Salon in 1865. Théophile Gautier, writing in *Le Moniteur Universel*, opined, "With some repugnance I come to the peculiar paintings by Manet … *Olympia* can be understood from no point of view, even if you take it for what it is, a puny model stretched out on a sheet." It was the most contentious piece in the Salon; *Olympia's* fourth-wall-breaking gaze scandalized viewers who recognized her as no mythologized nymph, but a prostitute awaiting her next client. The painting's style, too, was radical. Instead of a polished, academic painting, Manet's canvas had the raw, unfinished look of underpainting, his flat figure starkly outlined.

Manet instantly became known as the *enfant terrible* heir to Gustave Courbet, although he never aspired to be. But infamy had another side: Manet became an anti-establishment hero to a growing number of young artists. The novelist Émile Zola published the first public defense of Manet in 1867, declaring, "The future is his." By the early 1870s, Manet had become the *de facto* leader of the inchoate Impressionists, befriending Claude Monet and mingling with the group at the Café Guerbois and, later, at the Café Nouvelle-Athènes. It wasn't always a comfortable position for Manet, who continued to resist the avant-garde label. He declined to participate in the first Impressionist

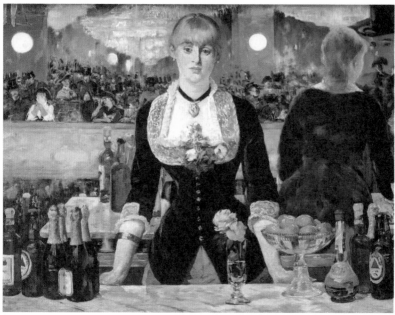

Bar at the Folies-Bergère, 1882
Courtauld Institute, London

exhibition, during the spring of 1874, as he did for the next seven.

During the later years of his life, Manet continued to seek the official approval that had always eluded him, submitting more pieces to the Salon. His last great act was *Bar at the Folies-Bergère*. With its visual inconsistencies, rapid brush strokes and worldly subject, it provided a final reminder of his contribution to Impressionism and the bridge it built to Modernism. In the fall of 1881, he received (at Proust's urging) the Chevalier of the Legion of Honour, but the approbation would be short-lived. Less than two years later, Manet died at age 51, most likely the victim of a tertiary syphilis infection.

MANET AND THE ESTABLISHMENT
After the disastrous Salon receptions of the mid-1860s, Manet learned that he was to be banned from the 1867 Exposition Universelle as well. Using money from an inheritance, Manet set up a display stand of his own, across the street from one of the Exposition's entrances, and filled it with 50 paintings.

DID YOU KNOW?

An Aristocratic Background

Manet's mother, Eugénie-Desirée Fournier, was the daughter of a diplomat and goddaughter of the Swedish crown prince, Charles Bernadotte, from whom the current Swedish monarchs are descended. She was named after Bernadotte's wife, Eugénie Bernhardine Désirée Clary, whom had once been engaged to Napoleon.

Manet and his Father's Lover

Manet married his Dutch piano teacher Suzanne Leenhoff in 1863, after the death of his father the previous year. Manet had been romantically involved with Leenhoff for 10 years and it is speculated that she was his father's mistress as well. In 1852, Leenhoff gave birth to a son, Léon-Édouard Leenhoff, out of wedlock. The boy was often the subject of Manet's work, such as in *Boy Carrying a Sword*, 1861.

Manet and his Teacher

Manet spent six years studying with Thomas Couture, an artist who favored the established method of copying antique sculpture in a studio space. Manet detested this academic approach. At the end of their relationship, Couture held little respect for Manet's work and likewise, Manet for his.

Titian's Influence

One of Manet's most famous works is *Olympia*. The painting pays homage to Titian's *Venus of Urbino*, which was made for the private use of a patron. While Titian's *Venus* is demure and sensual, Manet's *Olympia* is stark and confrontational. To greater emphasize the difference between the two women, Manet replaces Titian's dog, a symbol of fidelity, with a black cat, a symbol of prostitution. Manet visited Germany, Italy and the Netherlands from 1853-1856, studying the great masters; he likely saw Titian's work at the Uffizi in Florence.

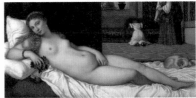

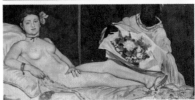

Titian's *Venus of Urbino* and Manet's *Olympia*

Manet and Poe

Manet created a series of lithographs to illustrate the French translation of one of Edgar Allan Poe's most famous poems, "The Raven." While the exact nature of the arrangement remains a mystery, Manet was most likely commissioned by the French poet Charles Baudelaire to produce the engraving for his collection of Poe's work.

Manet and His Art Dealer

Upon returning from the Franco-Prussian War, where he served as an artillery gunner in the National Guard, Manet sold almost the entire contents of his studio to the art dealer Paul Durand-Ruel, for around 50,000 francs. Durand-Ruel would later famously boast that Impressionist art he once purchased for 50 francs apiece were now selling at 50,000 each.

A Painted Mirror

The mirror in *A Bar at the Folies-Bergère* (1881-82) has been the cause of much debate as to the painting's meaning. To some historians (as well as some of Manet's own contemporaries), the barmaid may actually be a reflection of a woman gazing in the mirror, thus a reflection of the viewer. Other theories pose that the viewer is reflected as the customer seen in the mirror, or that the central female figure is actually pausing to think of past events seen in the background.

Manet and Monet

Despite a chilly first encounter (the older Manet believed the younger Monet imitated his style, poorly), the two became close friends. During the summer of 1874, Manet and Monet vacationed nearby one another in the suburbs outside Paris. Painting together often, they were joined on one particular day by Monet's friend, Auguste Renoir. As they all worked, Manet stole glances at Renoir's canvas, later remarking to Monet, "He has no talent, that boy! Since you're his friend, tell him to give up painting!"

Manet, *Monet's Family*
Renoir, *Camille Monet And Her Son Jean*

Manet's Last Days

Later in his career, Manet suffered neurological complications that developed because of gangrene, possibly related to syphilis. The gangrene resulted in his foot and much of his leg having to be amputated, which his friend Dr. Gachet advised against. The operation resulted in his death 10 days later.

Victorine Meurent

In the 1940s, Adolphe Tabarant wrote a biography of Manet. He acknowledged that Manet's model Victorine Meurent exhibited at the Salon, but condemed her as a wreck, saying that she sold her drawings to her "companions of the night," and had fallen into drunkenness and depravity before disappearing.

Meurent was born in Paris in 1844 to a working-class family and began modeling for Manet in 1862. It is unknown how they met, perhaps at Thomas Couture's studio (where she worked as a model) through Meurent's father, or on the street near the Palais de Justice. Her address, 17, rue Maître Albert, was recorded in one of Manet's notebooks.

In 1875, Meurent returned to Paris, from perhaps America, and began attending evening classes at the Académie Julian. Her self-portrait was shown at the Salon the following year and her work appeared there again in 1879, 1885 and 1904. In 1903 she was elected a member of the Société des Artistes Français. Meurent was a lover of Alfred Stevens, the Belgian painter, but she never lived with a man. For the final 20 years of her life she shared a house with Marie Dufour, a piano teacher, in Colombes, just outside Paris.

Meurent claimed that Manet had promised her a small gratuity, which she had refused, intending to remind him of his offer if she was ever in need. Four months after Manet's death in August of 1883, she found herself needing the money, so she wrote to Manet's widow, "That time has come sooner than I expected." Madame Manet ignored the letter.

A Retrospective for Manet

One year after Manet's death, a result of the amputation of his left leg below the knee, a retrospective of his works was held at the École des Beaux-Arts in the Salle Melponène on January 5-28, 1884, organized by Berthe Morisot and her husband, Eugène, Manet's brother. More than 13,000 people attended the exhibition of 179 paintings, watercolors and drawings, giving the painter more recognition than he ever received in life.

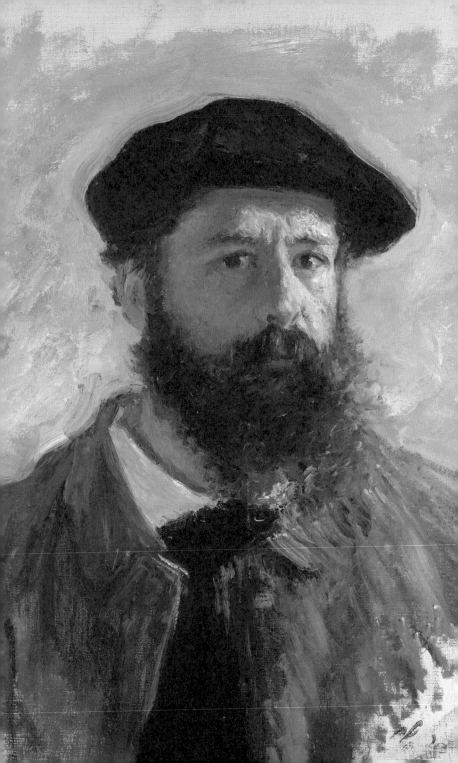

Claude Monet

"Color is my day-long obsession, joy and torment."
—Claude Monet

Claude Monet, *Self Portrait with a Beret*, 1886
Private Collection

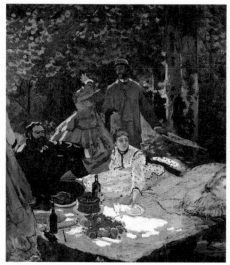

Luncheon on the Grass, 1865-1866
Musée d'Orsay

Woman with the Green Dress, 1866
Kunsthalle Bremen

by Heather Corcoran

On June 21 1869, Claude Monet threw himself into the Seine. The painter had just been evicted from the hotel where he was staying with his wife and young son. With no money, no patrons and no critical support, the moody Monet had lost all hope. He intended to die that day, but the early-summer Seine was no match for the strong swimmer.

Monet was 28 years old when he survived his suicide attempt, but it was not the end of his problems. He struggled throughout much of his life: with depression, with money and with the artistic establishment. He relied on friends and family for financial support and was often unable to pay his own rent. But over the next six decades, he would become one of the most controversial and, ultimately, one of the most revered artists of his generation.

Oscar-Claude Monet was born on November 14, 1840, in Paris. As a young boy, his family moved to the Norman port of Le Havre, where he first studied drawing. By 1859, he had dropped out of school, returned to Paris and joined the Academie Suisse, where he met Camille Pissarro. But he was soon called for military service in Algeria—a seven-year stint cut short by a case of typhoid fever and the help of his aunt. He was sent back to Le Havre as an invalid and convinced his family to finance a return to Paris.

In the capital, Monet immersed himself in the art world. He joined the studio of academic painter Charles Gleyre, where he met Auguste Renoir, Frédéric Bazille and Alfred Sisley. At the opening of the Salon in 1865, Monet encountered the older artist Édouard Manet. Manet's *Olympia* was a scandal, while Monet—who had frantically painted versions of works from the previous year's Salon in order to make the deadline—was prominently displayed. Unlike other members of Gleyre's studio (including Renoir), Monet was not listed as a student, further infuriating Manet.

Following the Salon, Monet left the city, where he was joined by his friend Bazille. Monet began working on the multi-figure composition *Déjeuner sur l'herbe*, named after the infamous work that Manet exhibited at the Salon des Refusés in 1863. He intended for the work to be his *magnum opus*, a massive testament to the method of painting *en plein air* that he had learned from Eugène Boudin as a teenager. Monet planned to submit the painting to the Salon, but was discouraged by the artist Gustave Courbet (the bearded figure in the painting). He never finished the work and gave the canvas to his landlord in exchange for rent.

Discouraged, Monet returned to Paris, settling in the bohemian hub of Batginolles. There, he joined in lively discussions at the Café Guerbois, where Manet, Bazille, Renoir and writer Émile Zola met on Thursday nights. That spring, he completed two paintings in time for the May 20 submission deadline for the 1866 Salon. *The Woman with the Green Dress*, a stunning, full-length portrait of Monet's new muse, 19-year-old Camille Doncieux, was completed in the studio in only four days. It was the talk of the exhibition, establishing Monet as art's newest sensation.

During this time, Monet continued to venture to the suburbs, determined to work outdoors. He set up his easel in a garden, digging a trench into which he lowered his canvas, allowing him to reach the top without a ladder. The result was *Women in the Garden*, a painting of four fashionable women, modeled by Camille. But the real subject of Monet's work was light, which he painted filtered through the leaves of the tree. To create the illusion of shadow, he deepened his hues rather than adding black, a technique that would become one of the hallmarks of Impressionism. The jury of the Salon considered

"Impressionism"
Art critic Louis Leroy coined the term "Impressionism" to characterize Monet's *Impression, Sunrise (Impression, soleil levant)*, 1872, in a review of the 1874 Impressionist exhibition for the magazine *Le Charivari*. Though the word was intended by Leroy as a criticism, the Impressionists appropriated the term for themselves.

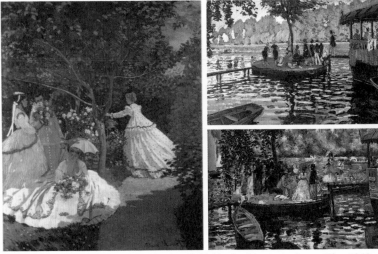

Clockwise from left: *Women in the Garden*, 1866, Musée d'Orsay; *Le Grenouillère*, 1869, Metropolitan Museum of Art, New York; Auguste Renoir, *Le Grenouillère*, 1869, Nationalmuseum, Stockholm

the work unfinished and rejected it. To others, including Zola, the painting set Monet apart as a leader in the avant-garde. Without official approval, however, Monet was unable to find a buyer. To help his friend, Bazille bought the painting for the exaggerated price of 2,500 francs.

By the summer of 1867, Camille was pregnant and Monet, with few prospects, returned to his family in Le Havre. While there, he traveled along the seaside to Sainte-Adresse, Honfleur and Trouville, painting landscapes and boats and vacationing couples—his commitment to *plein air* painting evidenced by the sand embedded in his paint.

Over the next two years, Monet continued to find inspiration in Normandy and the suburban towns along the Seine. With his friend Renoir, he traveled to the popular meeting place La Grenouillère, where they painted small pictures in hopes of selling them to tourists. Life remained difficult and, in 1869, Monet attempted suicide by jumping into the Seine. In 1970, he married Camille, but rejection from the Salon was another blow to his pride; he would not submit work again for 10 years.

With the onset of the Franco-Prussian War, Monet fled to London, where he discovered the work of the British landscape painters and met the influential dealer Paul Durand-Ruel, who became one of the Impressionists' biggest

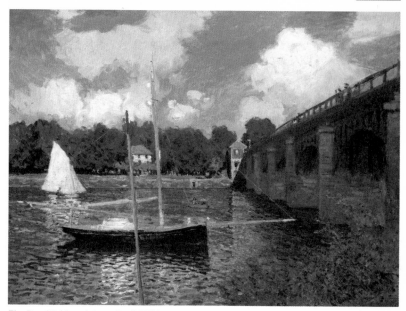

The Road Bridge at Argenteuil, 1874
National Gallery of Art, Washington, D.C.

supporters. Monet stayed abroad throughout the war and the Paris Commune, traveling from London to Zaandam in the Netherlands. In the fall of 1871, he returned to France, settling in suburban Argenteuil with his family. The town was easily accessible by train, and Monet continued to travel throughout Normandy. In 1972, he set up his easel along the harbor in Le Havre and captured his impression of a sunrise over the sea: the sun a fiery ball reflected in the murky water. He called the work *Impression, soleil levant*. The painting was a landmark moment in Monet's career, though he didn't know it yet.

Monet also made trips into Paris, where he painted views from the studio of photographer Félix Nadar. Around this time, the members of the avant-garde had grown tired of the Salon's rejection. Together with Renoir, Pissarro and Sisley, he decided to launch an independent exhibition, an idea Monet had had for some time. Paul Cézanne, Berthe Morisot and Edgar Degas agreed to join; Manet and Monet's friend Johan Jongkind declined to participate. Though each artist had their own style, Zola and the writer Paul Alexis dubbed them the Naturalists for their frank depictions of modern life.

On April 15 — just before the Salon — the exhibition opened at Nadar's former studio at 35, rue des Capucines. Monet's contributions included *Impression,*

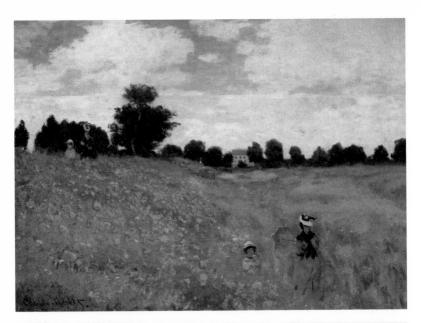

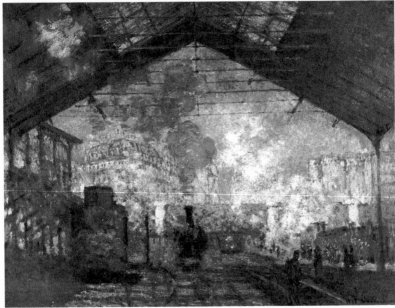

Top: *Les Coquelicots*, 1873, Musée d'Orsay
Bottom: *La Gare Saint-Lazare*, 1877, Musée d'Orsay

soleil levant, *Les Coquelicots* and *The Boulevard des Capucines*, which he had painted from Nadar's window. The response was mixed. The most lasting critique came from Louis Leroy, who satirized the exhibition in *Le Charivari*. In a swipe at Monet's painting, Leroy called his article "The Exhibition of the Impressionists."

Monet had yet to achieve financial success by 1876, when he found a patron in the department store magnate Ernest Hoschedé. Hoschedé hired the artist to paint murals at his luxurious château in Montgeron. There, Monet became close with Hoschedé's wife Alice, whom he would later marry.

In early 1877, Monet returned to Paris and found a small room near the Gare Saint-Lazare, which was easy to access from Argenteuil and a convenient place for rendezvous with Alice. The railway station itself was a dramatic symbol of the new, modern Paris, and the railroad was a popular subject for painters. Though Hoschedé bought some of the Gare Saint-Lazare paintings, times were still hard for Monet and he relied on the young artist Gustave Caillebotte to pay his rent and buy his work.

Hoschedé's largess did not last long either; his extravagant lifestyle quickly left him bankrupt. By 1878, Hoschedé, his wife Alice and their six children were living with the Monets in Vétheuil. Camille, weakend by the birth of her second son, became ill and died the following year.

In 1880, Monet was disqualified from the Impressionist Exhibition for submitting work to the Salon. Two landscapes of Seine ice floes were accepted. Some colleagues felt betrayed and others wondered if he was saving work for a solo exhibition with Durand-Reul. His exhibition with Durand-Ruel in France and abroad would come later; in 1880, Monet had a solo exhibition at the offices of the journal *La Vie Moderne*.

In 1883, Monet settled in Giverny, where he spent the rest of his life with Alice and each of their children. There, he finally found the financial security that had eluded him for so long thanks, in part, to the support of Durand-Reul and the increasing acceptance of the Impressionists. Monet died in Giverny at the age of 86, surrounded by his garden, which he considered his true masterpiece.

Monet at the Gare Saint-Lazare
Setting out to paint at Saint-Lazare station, Monet donned a smart suit and gold-tipped cane, and presented his card to the stationmaster. The impressed official not only granted the artist permission to work, but also instructed his engineers to load the engines with enough coal to make them generate the artist's preferred amount of smoke.

Camille Doncieux
Monet's existence in Paris was one rife with poverty. In 1866, he rented a small studio on the 4th floor of 1, place Pigalle. It is there where he met his future wife, when she came in to model. Camille Doncieux spent several years as Monet's mistress but became his wife in 1870 and together they endured depressing financial woes. Until the moment of her death, Camille continued to model for Monet. She can often be seen in the painter's rural landscapes.

Love of the Land
Even in Paris, Monet preferred landscape to academic painting. When he went to the Louvre with friends, he preferred to look out the windows than at the works on display.

The Studio Boat
In 1873, Monet bought a boat but it wasn't to make jaunty day trips. Instead, the outdoorsy painter turned it into his studio. Monet, ever

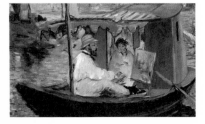

the advocate of *plein air* painting, would use the boat to make trips up and down the Seine, changing his scenery and thus his subject matter. In 1874, Manet wanted to record the way in which Monet worked, thereby paying homage to his friend's achievements.

Monet and the Hoschedé Family
Ernest Hoschedé was one of Monet's closest friends and most important patrons until he was bankrupted by a lavish lifestyle, at which point it was the artist's turn to offer assistance. But Monet's relationship with Hoschedé and his wife was not always viewed as selfless: In January 1880, Parisian newspaper *Le Gaulois* reported that Monet had left for Vétheuil with his "charming wife" Alice Hoschedé. He went on to marry Alice in 1892, the year after Ernest Hoschedé's death.

Alice Hoschedé
"This young woman has wit, intelligence in plenty and, I believe, strength of will. Her conversation is easy, though I find her voice rather loud. She seemed to me more delicate and prettier than in her photograph," wrote the mother of Ernest Hoschedé in her journal upon meeting Alice for the first time in 1863.

right: Carolus-Duran, *Madame Alice Hoschedé* (detail), 1878

Camille's Fatal Illness
In 1877, Monet wrote to his friends Manet and de Bellio regarding the illness of his wife Camille. Monet thought that she might have been suffering from an "ulceration of the womb," from which it has been inferred that Camille attempted an abortion, as the family was far too poor to support another child. However, ulcerations of the womb can also be

caused by tubercular or cancerous lesions. Many historians consider uterine cancer to be the true cause of her death.

Painting Camille's Death

Monet paints Camille on her deathbed, more fascinated by color than the reality of what was happening. Monet did not have a strong emotional connection to Camille and at the time, may have already been having an affair with Alice Hoschéde. Of painting Camille in her last moments Monet writes, "I caught myself watching her tragic forehead, almost mechanically observing the sequence of changing colors which death was imposing on her rigid face. Blue, yellow, grey, and so on."

Monet's Success Arrives

Monet had his first solo show at the gallery of the publication *La Vie Moderne* in June 1880. The exhibition catalogue described how Monet "despite the season... leaves his studio and works under the open sky." After this exhibition, his paintings slowly began to sell and painting *en plein air* became his preferred way of working.

Monet in Venice

Prompted by a period of creative frustration, in 1908 Monet decided to travel to Venice. He had originally intended to make just a short visit but fell in love with the city and stayed for three months. While there, Monet embarked on one of his signature series

works, painting six views of Santa Maria della Salute, none of which he finished while in Venice. Instead, he brought the paintings back to Giverny where they were completed, revisiting Venice once more in 1909 to again look at the light. The paintings were not publicaly displayed until 1912.

Monet's Vision

Monet was diagnosed with cataracts in 1912, and in 1923 had two operations to remove them. The condition's effects are discernible in his later paintings, which are darker and less distinct, with broader strokes and a reddish tone. He attempted to counter this by keeping an orderly palette, but was eventually forced to abandon his work despite otherwise respectable health.

Stolen Monet

Monet's *Falaises près de Dieppe (Cliffs near Dieppe)* has been stolen twice. On the first occasion, in 1998, it was taken from the Musée des Beaux-Arts and recovered a few days later on a boat in the port of Saint-Laurent-du-Var. Beaux-Arts curator Jean Forneris was ultimately convicted of masterminding the theft and jailed along with two accomplices. The second time around was in August 2007, when the painting was taken from the Musée des Beaux-Arts, Nice, by a gang of five masked robbers. It was found almost a year later in a vehicle in the port city of Marseilles.

Monet's Record Sale

The current auction record for a Monet was set on June 24, 2008, when *Le bassin aux nymphéas* (from the "Water Lilies" series) sold at Christie's in London for £40,921,250 ($80,451,178) with fees, making it the 19th most expensive painting ever sold at auction. The previous record for his painting was the $41.4 million paid for *Le Pont du chemin de fer à Argenteuil*, 1873, also at Christie's, on May 6 of the same year.

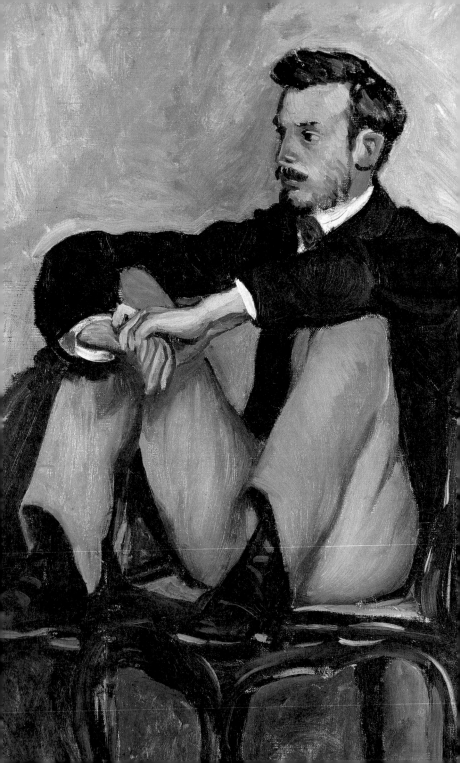

Pierre-Auguste Renoir

"I never think I have finished a nude until I think
I could pinch it."

–Pierre-Auguste Renoir

TIMELINE

February 25, 1841
Pierre-Auguste Renoir is born in Limoges.

1844 The Renoir family moves to Paris.

1854 Haussmann's redesign of Paris razes
the Renoirs' house in the courtyard of the
Louvre. They move to the rue de Rivoli,
nearby. Renoir leaves school and becomes
apprentice to the Lévy porcelain workshop.

1856 Renoir becomes a full-fledged
porcelain painter by age 15.

1860 Renoir granted official permission to
copy works at the Louvre.

1861 Begins studying at the Paris studio
of Charles Gleyre, where he meets Sisley,
Bazille and Monet.

1864 Exhibits in the Paris Salon for the first
time, showing *Esmeralda Dancing*, a canvas
that he later destroys.

1871 Narrowly escapes murder at the hands
of members of the National Guard, who take
him for a spy.

1874 Six of his paintings are included in the
first Impressionist exhibition.

1881 Travels to Algeria, Spain and Italy.

1883 Meets the young Ambroise Vollard,
who will later become an important patron.

1885 Birth of his first son, Pierre.

1890 Marries Aline Charigot.

1892 Exhibition organized by dealer
Durand-Ruel marks the beginning of broad
acclaim for his work.

1894 Second son, Jean, is born.

1901 Birth of third son, Claude, also known
as Coco.

1907 Moves to a farm at Cagnes-sur-Mer,
near Nice, hoping the warmer climate will
help his arthritis.

December 3, 1919
Renoir dies of a heart attack in
Cagnes-sur-Mer.

Frédéric Bazille, *Portrait of Pierre-Auguste Renoir*, 1867
Musée d'Orsay

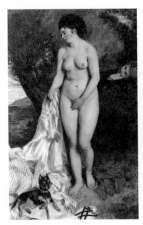

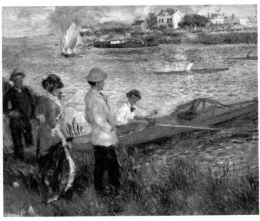

Bather (La Baigneuse au griffon), 1870, Museu de Arte de São Paolo

Oarsmen at Chatou, 1879
National Gallery of Art, Washington, D.C.

by Heather Corcoran

In 1854, Baron Georges-Eugène Haussmann's workers were busy razing Paris, clearing the way for new boulevards and blocks of elegant new buildings. They tore through the city, demolishing entire neighborhoods evicting residents along the way. One of Haussmann's targets was the courtyard of the Louvre, crowded at the time with the homes and shops of working-class artisans. Among the families displaced were the Renoirs—father Leonard, a tailor, mother Marguritte, a dressmaker, and their six children. The family was forced to leave, but the Louvre would continue to play an important role for the youngest Renoir son.

Pierre-Auguste Renoir was born in Limoges in 1841. His family moved to Paris in 1844, at a time when the city was shaking off the last of its 18th-century traditions in favor of the coming wave of modernization. Renoir's childhood was idyllic—he would reminisce on the lost Paris of his youth throughout his life—and he took immediately to the arts, sketching on the floor of his father's tailor shop and singing in the church choir. By age 13, his artistic talent was evident and he apprenticed at a local porcelain workshop. The boy was charming, and easily befriended the wife of the factory-owner. With her help and the encouragement of his sister, Renoir quickly worked his way up, from painting borders on plates to painting profiles of Marie-Antoinette for three *sous* apiece. He was making quite a bit of money—even being recognized on the street for his work—but industrialization soon threatened to make his craft obsolete. He decided to strike out on his own.

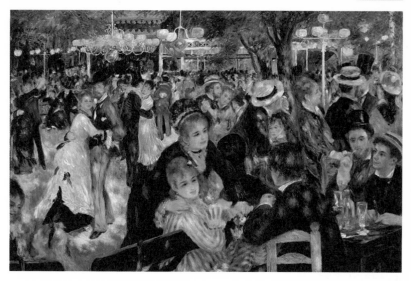

La Moulin de la Galette, 1876, Musée d'Orsay
The girl in the striped dress in the middle foreground was said to be Estelle, the sister of Renoir's model, Jeanne. Another of Renoir's models, Margot, can be seen dancing to the left. At the foreground table at the right are the artist's friends Frank Lamy, Norbert Goeneutte and Georges Rivière, editor of the short-lived publication *L'Impressionniste.*

By the age of 20, Renoir had joined the atelier of the Swiss artist Charles Gleyre, where he met fellow painter Frédéric Bazille. Gleyre was a conservative teacher, and his students spent much of their time practicing drawing and sketching live models. "The discipline of having to copy the same anatomical model 10 times is excellent," he later told his son Jean, who recorded it in the book *Renoir, My Father.* "It's boring, and if you weren't paying for it you wouldn't bother to do it. But the Louvre is the only place to learn, really."

Renoir spent hours copying at the museum with Bazille and others from the Gleyre studio—Claude Monet, Alfred Sisley, Camille Pissarro and Paul Cézanne. Inspired by Camille Corot and painters of the Barbizon school, these young artists also headed to the Fontainebleau Forest and set up their canvases outdoors. In those early years, Renoir had very little money, and sometimes could not even afford to buy paint. His work was met with some acceptance, however, and he exhibited at the Salon for the first time in 1864 with *Dancing Esmeralda.*

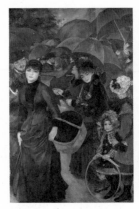

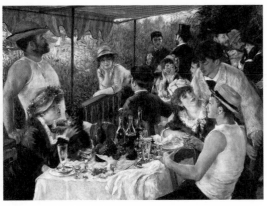

The Umbrella, 1881
National Gallery, London

Luncheon of the Boating Party, 1880-81
Phillips Collection, Washington, D.C.

Yet Renoir and his contemporaries remained wary of the establishment. "It's all very well to be accepted by the Salon, but it only happened by a fluke. I already felt that the officials were going to turn against us sooner or later," he said.

Together, Renoir and Monet explored the emerging towns along the Seine, places like La Grenouillère, a popular riverside resort for all classes. They explored new techniques, loosening up their brushstrokes and experimenting with color. They painted playful pictures of modern life—boaters, couples dancing under ribbons of sunlight—on small canvases with the hope of selling their work to tourists. Renoir and his friends frequented the Maison Fournaise, a lively scene he captured in *Luncheon of the Boating Party*.

Renoir painted constantly, often working outdoors. During the Commune of 1871, he set up an easel on the banks of the Seine near Versailles. He began painting and, when approached by members of the National Guard, Renoir was too immersed in his work to even notice. The Guardsmen took one look at the canvas and could not believe that Renoir was a real painter. He must be a spy, they surmised. They arrested him and the crowd that had gathered suggested throwing the artist into the river. Renoir was dragged to the town hall, where, if not for a fateful run-in with an acquaintance that helped plead his case, he would have been executed.

Renoir and his contemporaries continued to face resistance, but they found hope with the art dealer Paul Durand-Ruel, who helped the Impressionists (a term Renoir despised) put on their independent exhibitions. "Without him

Madame Charpentier with Her Children, 1878
Metropolitan Museum of Art, New York

we wouldn't have survived," Renoir told his son. While his colleagues were lambasted and reviled, Renoir suffered an even worse fate—his work was ignored.

Unlike some of the other Impressionists, who favored landscape and city scenes, Renoir, found a more classical subject—the human form—to be the ultimate inspiration. The artist loved women— "I can't stand having anybody around me but women," he once said—and he became very close with many of his models. In 1880, he met the model Aline Charigot, a feline beauty with unruly hair who posed for a number of works, including *Luncheon of the Boating Party*; the pair would marry 10 years later and have three sons together.

Jean Renoir
Renoir's son Jean (1894-1979) became an admired and influential film director who made more the 40 films, including the 1939 classic *La Règle du jeu* (*The Rules of the Game*). In 1962, Jean published *Renoir, My Father*, a biography of the artist that is still considered definitive.

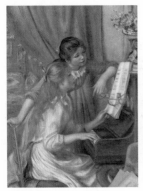

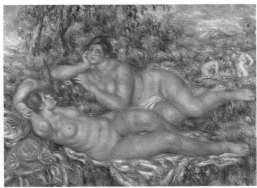

Girls at the Piano, 1892
Musée d'Orsay

The Bathers, c. 1918-1919
Musée d'Orsay

To create the luminous flesh tones for which he was known, Renoir limited his palette to just a handful of neatly arranged colors, which he applied in light washes. But the technique was not embraced by others. A critic at the second Impressionist exhibition wrote: "Try to explain to M. Renoir that woman's torso is not a mass of rotting flesh, with violet-toned green spots all over it, indicating a corpse in the last stages of decay."

After those disastrous independent exhibitions, Renoir turned his attention back to the Old Masters. He spent even more time visiting museums and traveled to Italy, Algeria and Spain, studying the works of Raphael, Delacroix and Velázquez, and sinking even further into his classical tendencies. He painted *The Girls at the Piano* and other highly polished scenes of bourgeoisie life in the style of Ingres, while his nudes took on fleshy proportions and traditional poses. Thanks to the continued support of Durand-Ruel and changing tastes, Renoir finally began to find financial security.

He continued to paint deep into old age, surrounded by his family and his dear servant Grand' Louise, his hands twisted by arthritis. Shortly before his death in 1919, Renoir returned to the Louvre to see his works hanging alongside the masters that inspired him. As he later laid in his deathbed, finally vindicated, the artist asked his maid to bring his paints and brush. He toiled for a few hours on his last painting, a picture of anemones, before putting down his brush. Satisfied, he said, "I think I am beginning to understand something about it."

DID YOU KNOW?

Renoir on Women

As an artist, Renoir loved the female form, but he had nothing but disdain for the woman-izers he encountered: "I feel sorry for men who don't stop running after women," he said. "What work! On the go day and night, without a minute's rest! I knew painters who never completed a piece of work because, instead of painting their models, they were seducing them."

Renoir in Venice

Renoir wrote to his friend Charles Deudon of having trouble finding models to paint in Ven-ice. He saw one girl "beautiful as a Madonna. My gondolier tells me he knows her, I hug him for joy." But the resultant canvas was unsuc-cessful, and the artist decided that "to get someone to pose, you have to be very good friends and, above all, speak the language."

Arthritis

In 1887 Renoir broke his arm falling off a bicycle, and suffered his first attack of rheumatoid arthritis shortly thereafter. By the time he finished painting *The Farm at Les Collettes* in 1914, the artist suffered from the condition so acutely that he was confined to a wheelchair. But contrary to popular belief, he did not attach brushes to the backs of his hands; the bandages shown wrapped around them in late photographs were to prevent skin irritation. "The pain passes," he wrote, "but the beauty remains."

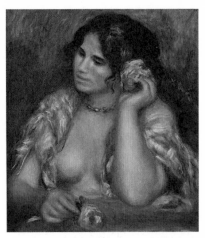

Gabrielle Renard

Later in life, Renoir's muse was Gabrielle Renard, a young cousin of his wife who entered into service with the family in 1894, and remained with them until 1914. Gabrielle was in charge of looking after Jean, and plays an integral part of many of Renoir's paintings of his children. In addition to inspiring several odalisques, she also posed as the male figure of Paris in the 1908 painting *Judgment of Paris*, so uneasy was Renoir with his male model's physique.

Renoir's Record Sale

In 1990, a smaller version of Renoir's *Bal du moulin de la Galette* fetched $78.1 million at Sotheby's in New York, shattering the artist's previous record of $17.7 million to become the fifth most expensive work of art ever sold at auction. Its owner, Ryoei Saito, threatened to cremate the painting, along with Vincent van Gogh's *Portrait of Dr. Gachet* (which he bought for $82.5 million) with his body upon his death. However, when Saito's business failed and Saito died, the bank sold the painting privately, reportedly to a Swiss collector for approximately $50 million.

Renoir's Grave

Renoir asked his son Jean for a modest grave: "Do not place too heavy a stone on me," he joked, "I want to have the strength to go for a walk in the coun-tryside." He is buried with his family in the cemetery at Essoyes, a village in the Aube department.

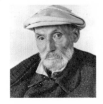

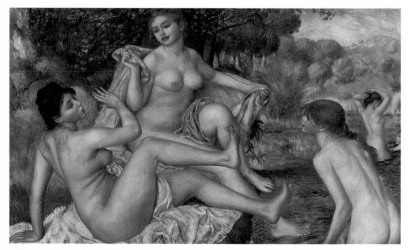

The Artist Who Loved Women

With their luminous skin, rosy cheeks and cascades of shimmering hair, it's almost impossible to resist the fresh-faced women in Renoir's color-drenched canvases. Renoir, who is perhaps the most beloved of the Impressionists, was a figure painter, not a landscapist, at heart; most of his most important paintings feature women. While Monet was painting the interplay of light on haystacks, poplars and cathedrals, and Alfred Sisley and Camille Pissarro were dappling color on Norman landscapes and Parisian vistas, Renoir was painting the beautiful women he loved, both as models and in real life as well.

Some art historians suggest that Renoir veered away from "true" Impressionism because his paintings were figurative, and not pure explorations of light. In fact, a close look at his paintings reveals that, while the backgrounds are dancing with the vibrant color and loose brushwork the Impressionists developed, the women's faces he painted are elegantly—and fairly classically—rendered. Renoir developed close relationships with his models that often lasted for years and, in at least one case, a lifetime. One model, Jeanne Samary, once said "Renoir ... marries all the women he paints ... but with his brush."

Lise Trehot

Renoir's first important model, muse and lover, was Lise Trehot, who met Renoir when she was 16 and he was 24. With her large, dark eyes and thick, cascading dark hair, she modeled for him from 1865 until 1872 and he painted her nearly two dozen times, including

such masterpieces as *Portrait of Lise* with an *Umbrella* and *Diana the Huntress*, both from 1867.

Marguerite Legrand

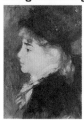

The enchanting girl dancing in *Bal du moulin de la Galette* (1876) is Marguerite Legrand. Marguerite, who was known as Margot, was one of Renoir's favorite models from 1875 until 1879, when she died tragically of typhoid

fever, leaving him distraught and temporarily unable to paint. Painted between 1876 and 1877, *Woman Reading*, *Couple Reading* and *Nude in the Sunlight* all capture Le Grand's youthful beauty.

Nini Lopez

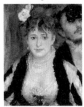

Nini Lopez was an actress from Montmartre who Renoir painted frequently between 1876 and 1879. Known as "fish face," she is the fashionable woman in *La Loge* (posing with Renoir's brother). Renoir met her when he moved to Montmartre for the summer to paint *Bal du moulin de la Galette*, using real women from the neighborhood instead of expensive models. Unlike some of the other more flamboyant and unreliable models and actresses of the day, Titian-haired Nini was dependable, discreet and serious about her work.

Jeanne Samary

Jeanne Samary, a prominent actress from a theatrical family, met Renoir in 1877 and for several years she was both his model and his lover. Though she wasn't classically beautiful, with her wide chin, broad, open face, and stout figure, Renoir found her enchanting and painted three portraits of her between 1877 and 1878, each called *Portrait of Jeanne Samary*. Jeanne eventually married and had children but she too died of typhoid when she was only 33.

Aline Charigot

Perhaps Renoir's most iconic face is that of Aline Charigot, a young seamstress and milliner who began modeling for Renoir in 1879, when she was just 20. It was soon after posing for *Luncheon of the Boating Party* (she is the fresh-faced young woman playing with the little dog on the left) that Charigot became

Renoir's lover. They had an on-again, off-again relationship for many years but eventually married in 1890 and had three sons (including French cinema great Jean Renoir). Renoir painted Charigot many times over the years, perhaps no more rapturously than in *The Large Bathers* (1884-1887, opposite page), in which she is the majestic, rosy-cheeked "goddess" with dark hair.

Suzanne Valadon

Passionate, creative Suzanne Valadon was another model with whom Renoir was reputed to have been romantically involved. Valadon also modeled for Puvis de Chavannes and Toulouse-Lautrec and eventually became a painter herself. Valadon, who embodied the spirit of Parisian bohemian life, never married and there was some speculation that Renoir was the father of her illegitimate son, the painter Maurice Utrillo. Valadon, whose strong, angular face stands out among Renoir's portraits, can be seen in *Dance at Bougival* (1882-1883), as well as in the foreground of *The Large Bathers*.

Julie Manet

While there were several other models who figure prominently in Renoir's work, and life, perhaps the most enchanting is Julie Manet, the beautiful dark-haired girl in *Two Young Girls at the Piano* (1892). Julie, who was the daughter of Impressionist painter Berthe Morisot and Manet's brother, Eugène, posed frequently for her mother and other Impressionists as well. Julie's diary, which she kept from the ages of 14 to 20, which has been published as *Growing up with the Impressionists*, is an extraordinary snapshot of the period and reveals her deep affection for Monsieur Renoir, an affection that most of his models seemed to share.

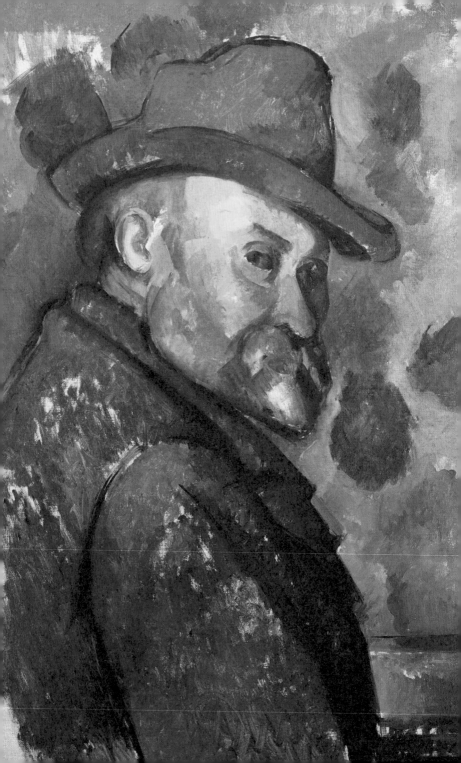

Paul Cézanne

"Treat nature by the cylinder, the sphere, the cone, everything in proper perspective so that each side of an object or a plane is directed towards a central point."
—Paul Cézanne

TIMELINE

January 19, 1839
Paul Cézanne is born to Louis-Auguste Cézanne and Anne Élisabeth Honorine Aubert in Aix-en-Provence.

1852 Enrolls in the College Bourbon; befriends Émile Zola.

1857 Begins to study painting and drawing at the École Gratuite de Dessin in Aix.

1858 At his father's insistence, registers for law school.

1861 Moves to Paris to pursue painting; meets Camille Pissarro.

1863 Exhibits for the first time in the Salon des Refusés.

1864-1869 Travels back-and-forth between Paris and Aix.

1872 Son Paul is born; Cézanne paints with Pissarro in Pontoise.

1874 Submits work to the first Impressionist exhibition.

1877 Exhibits in his second, and last, Impressionist show.

1883 Monet and Renoir visit Cézanne in L'Estaque, near Aix.

1886 Cézanne ends his friendship with Zola; marries longtime mistress, and mother of his son, Hortense Fiquet.

1890 Begins to suffer from diabetes.

1895 Art dealer Ambroise Vollard hosts a solo exhibition of Cézanne's work.

1902 Builds a new studio at Les Lauves.

1905 Exhibits work in the Salon d'Automne.

October 23, 1906
Cézanne dies (likely from pneumonia) in Aix-en-Provence.

Paul Cézanne, *Self-Portrait in a Felt Hat, c.* 1890-94
Bridgestone Museum of Art, Tokyo

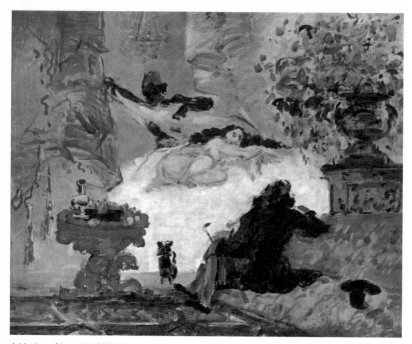

A Modern Olympia, 1873-74
Musée d'Orsay

by Michael B. Dougherty

The urban haunts of Paris may have provided the grounds for Impressionism's rise, but Paul Cézanne's life began (and ended) in the southern, Roman city of Aix-en-Provence. Born the illegitimate son of a hat merchant, Cézanne formed an early bond with the Provençal landscape. At the age of 13 he entered the College Bourbon, where he met Émile Zola, the future writer and champion of the Impressionists, and Jean-Baptiste Baille, who went on to become an astronomer and professor at the École Polytechnique. Collectively they became known as *les trois inseparables* (the three inseparables).

Cézanne was a promising student, and his father's career switch to banking provided a comfortable financial existence for the family. Early on, Louis-Auguste Cézanne encouraged his son to seek a career in law, but the boy had other aspirations. In 1857, Cézanne enrolled in free drawing classes offered by the city's art school, gaining exposure to life drawing and classical sculptures in the local museum. To appease his father's wishes, Cézanne also registered for law school the following winter, even as he was writing his

The Bay of Marseilles seen from L'Estaque, 1878-1879
Musée d'Orsay

friend Zola, now living in Paris, for information about the École des Beaux-Arts there.

By 1861, Cézanne finally won his father's approval through attrition, and he journeyed to Paris to join Zola. The victory would be short-lived though, as Cézanne failed his art school entrance examination and was forced to return to Aix soon after. Deterred but still resolute, Cézanne continued at the drawing school, returning to Paris in time to exhibit in the Salon des Refusés, the alternative exhibition established by Napoleon III in response to the prohibitive Salon of 1863. Cézanne suddenly found himself exhibiting with the likes of Édouard Manet and Camille Pissarro.

At the time, Cézanne's work was mainly dealing with classical and Romantic themes, comprised of

Cézanne and Zola
In 1886, Cézanne's lifelong friendship with Zola came to an end with the publication of *L'Œuvre*. The tale of a talented but ultimately unsuccessful artist—"She felt surprised that an intelligent young fellow should paint in such an unreasonable manner, so ugly and so untruth-ful besides. For she not only thought Claude's realism monstrously ugly, but considered it beyond every permissible truth. In fact, she thought at times that he must be mad"—seemed a thinly veiled reference to his own life, and Cézanne was incensed. The two would never speak again.

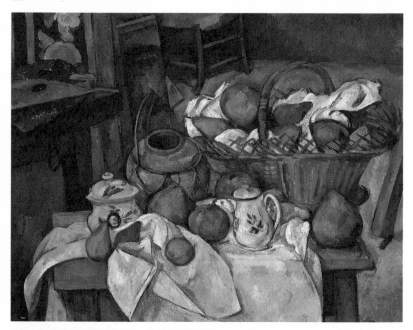

Still Life With a Basket (Kitchen Table), 1888-90
Musée d'Orsay

dark tones and executed with dramatic brushwork. He associated with Claude Monet and Edgar Degas, meeting with them and other members of the avantgarde at the popular Café Guerbois, but Cézanne's style of painting barely resembled that of the ascending Impressionists. He never fully assimilated into Paris's *beau monde*, and often retreated to Aix, his beloved hometown. There he found more inspiration in landscapes than in Paris's café scenes.

For the remainder of the decade, Cézanne faced rejection from the Salon time and time again. He was also in conflict with his family, whom he described as, "the nastiest people in the world and irritating beyond measure." But despite the personal hardships, Cézanne was physically in good shape and healthy, with long hair, handsome features and a manner of dress known to draw attention on the avenues of Aix. Just as the decade was waning he also met his future wife—model Hortense Fiquet.

In 1872, Cézanne began an intense, two-year period of painting with Pissarro in the Parisian suburb of Pontoise. There, Cézanne established his commitment to painting *en plein air* and dispensed with his somber palette for more vibrant colors. The experience also convinced him to participate

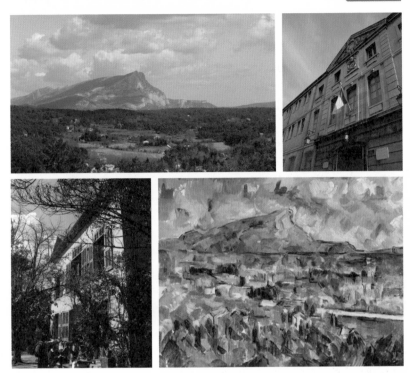

Clockwise from top right: Mont Sainte-Victoire; the Bourbon school where Cézanne met Zola; *Mont Sainte-Victoire Seen from Les Lauves*, 1902-6, Private Collection; the studio at Les Lauves in Aix-en-Provence

in the Société Anonyme exhibition of 1874, known colloquially as the first Impressionist show. Art critic Louis Leroy, writing in the satirical magazine *Le Charivari*, summed up popular reaction to the work when he wrote of Cézanne's *A Modern Olympia*: "Do you remember the *Olympia* of M. Manet? Well, that was a masterpiece of drawing, accuracy [and] finish, compared with the one by M. Cézanne." Cézanne would only appear alongside the Impressionists one more time, in 1877, as he was slowly retreating to the psychological and physical comforts of southern France.

Cézanne lived in relative isolation in Aix, often painting water scenes of L'Estaque. Here he continued to develop his style, dissecting the visual language of form and color with the precision of a scientist. He experimented with watershed techniques of tonal modeling (using shades of the same color side-by-side, instead of dark paint, to create dimension) and multiple perspectives (giving each object, rather than the total scene, independence).

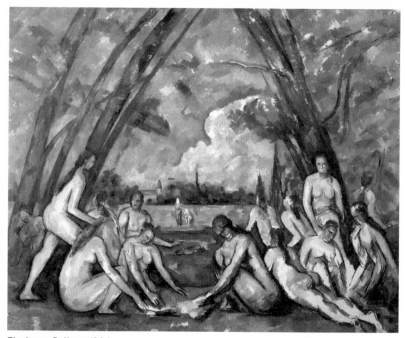

The Large Bathers, 1906
Philadelphia Museum of Art

Personally, his life began to show signs of stress— his wife and son were living apart from him in Paris, and he began to suffer from diabetes, which left him irritable. He returned to Paris, somewhat vindicated, for a solo show in 1895 organized by the influential art dealer Ambroise Vollard. The exhibition revitalized his reputation and earned him new converts, like the painter Mary Cassatt and the critic Bernard Berenson. Back in Aix, Cézanne broke ground on a new studio located just outside the city at Les Lauves, painting during the day and visiting with friends at the café in the evening.

By the turn of the century, Cézanne was living alone and had cut his wife out of his will. His work was shown at the 1905 Salon d'Automne, but it proved to be his last exhibition. Cézanne collapsed while working outside one rainy day and his condition deteriorated over the course of a week. His estranged wife and son rushed from Paris, but it was too late. On October 23, 1906 the "Master of Aix" died.

DID YOU KNOW?

Cézanne and his Father

On January 19, 1839, Paul Cézanne was born in Aix-en-Provence to a successful retailer and his mistress. Cézanne's father, Louis-Auguste Cézanne, was a domineering man, not at all interested in art. The artist's father and mother, Anne-Élisabeth-Honorine Auburt, did not marry until he was five, causing him discomfort as an illegitimate child.

Cézanne in Paris

Cézanne's 1861 stay in Paris lasted only six months, during which he destroyed many canvases in bouts of deep depression. He returned home to Aix and, for a year, worked with his father. His time back in Provence convinced Cézanne to try an artistic life again.

Cézanne and the Salon

Suffering constant rejection from the Salon in the mid-to-late 1860s, Cézanne wrote a letter to its organizer, the Count of Nieuwerkerke, asking that the Salon des Refusés be reinstated so that his work could find a sympathetic venue. Dated April 19, 1866, it reads in part: "Therefore, let the Salon des Refusés be reestablished. Even were I to be there alone, I should still ardently wish that people should at least know that I no more want to be mixed up with those gentlemen of the Jury than they seem to want to be mixed up with me." The request was denied.

Cézanne and the Military

During the Franco-Prussian War of 1870, Cézanne was declared a draft dodger after he fled to a home his mother owned in L'Estaque. Cézanne was unwilling to die in the conflict for his country and only returned to Paris after the cessation of hostilities.

Cézanne's Marriage

At 30, Cézanne met Hortense Fiquet, who became his mistress. Cézanne kept this relationship from his father for many years, though not from his mother, even after the birth of his son, which was also kept a secret. In 1878, Cézanne's father found out about his son's family and threatened to cut him off, but he soon relented and gave Cézanne an additional 300 francs on top of his 100-franc monthly allowance. In October of 1886, Cézanne's father died, leaving the artist a large inheritance.

Cézanne and Van Gogh

In the early summer of 1888, Vincent van Gogh had been staying in Arles, in western Provence. Recalling landscapes by Cézanne he'd encountered, Van Gogh remarked, "Involuntarily the Cézannes I saw come back into my memory, because he has so captured the harsh side of Provence."

Cézanne and Modern Art

Cézanne is often described as the father of modern art. Pablo Picasso said of Cézanne: "My one and only master . . . Cézanne was like the father of us all." Art historian Sir Lawrence Gowing once remarked that Cézanne was "reaching out for a kind of modernity which does not exist, and still does not."

Maurice Denis, *Homage to Cézanne*, 1900
Musée d'Orsay

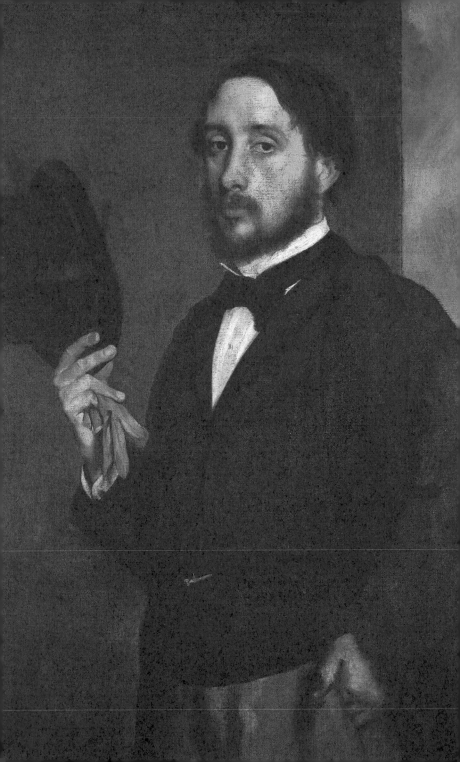

Edgar Degas

"I frequently lock myself in my studio. I do not often see the people I love, and in the end I shall suffer for it... painting is one's private life."

—Edgar Degas

TIMELINE

July 19, 1834
Hilaire-Germain-Edgar de Gas born in Paris.

1853
Graduates from Lycée Louis-le-Grand; begins copying famous works at the Louvre.

1856
Studies in Italy for three years.

1859
Returns to Paris, paints realist paintings of historical scenes.

1865
First exhibit at the Salon.

1870
Briefly serves in the Garde Nationale during the Franco-Prussian War.

1872
Visits family in New Orleans and paints several portraits.

1874
Exhibits at the first Impressionist exhibition.

1875
Palais Garner opens; Degas is inspired to create many paintings. Financial trouble in the family forces him to sell most of his art collection.

1881
La Petite Danseuse de Quatroze Ans is exhibited at the sixth Impressionist Exhibition and garners widespread criticism and praise.

1898
The Dreyfus Affair brings to light issues with Anti-Semitism in France. Degas's own anti-Semitism surfaces and many of his friendships are lost.

September 27, 1917
Degas dies and is buried in Montmarte Cemetery.

Self-Portrait, c. 1863
Lisbon Calouste Gulbenkian Museum

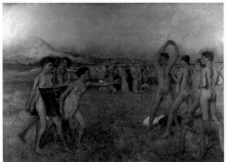

Young Spartans Exercising, c1860,
National Gallery, London

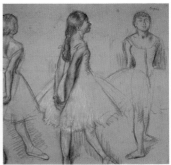

Three Studies of a Dancer (Detail),
c. 1880, Morgan Library & Museum

by April Isaacs

Marie is girlish and delicate, but her arrogant upturned face and outwardly thrust chest speak of womanly ambition, hunger. She isn't frozen in a pirouette or a stretch at the barre, but firmly, defiantly planted to her wooden platform, staking her claim, conscious that people are looking at her. Once she was made of wax, but now she is eternally frozen in bronze, a creation of the artist Edgar Degas.

Marie was a *petit rat*, one of the little rats of the Palais Garnier, who were no more than 14 years old and sometimes as young as 8. Girls like Marie lurked backstage, scavenging for scraps left by the established ballerinas, ever on the hunt for directors and older men worth seducing. Edgar Degas, a middle-aged and well-known painter in Paris had also been loitering around at rehearsals and in the orchestra pit during shows with his easel and pastels. All the *petits rats* knew who he was: a stuffy old bachelor who was at turns funny and even charming, but usually serious. Most pertinently, he paid them to model.

Something about this particular *petit rat*, Marie, caught Degas's eye. Would she be interested? It was for a sculpture and he promised he would pay her well for it. He wanted several nude sketches and then a few with her ballet attire on. She, a step above street urchin, was thrilled. She might not be getting top billing at the Palais, but her likeness would be front and center at the Impressionist Exhibition.

As a young painter, Degas didn't have to scavenge like the *petits rats*. Though he lived in Montmarte for his entire life, the starving-artist lifestyle was unknown to him. From early on, he knew he wanted to paint, and there was little to get in his way financially or otherwise (his father had hopes that

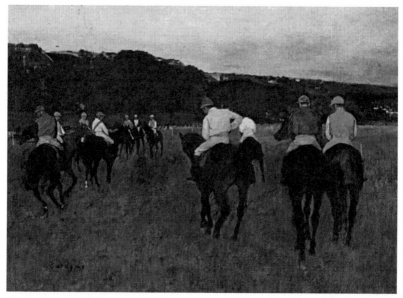

Racehorses at Longchamp, 1871-74
Museum of Fine Arts, Boston

Edgar would become a lawyer, but soon gave up the idea). Degas painted historical subjects, trying desperately to get his work shown at the Salon. An academic at heart, he took immense pleasure in copying the work of the masters—Delacroix and Ingres were among his most revered. Even well into middle age he copied like a student, ever the diligent scholar. But the Salon didn't care for his work. With persistence, he was successful at getting some of his work exhibited, but the effort exerted and the stuffy competition left a bitter taste in his mouth.

Degas reveled in color and line, assiduously cultivating his style with delicate pastels and high-spirited hues that evoked the jubilance of Paris. Hard lines are a trademark of his work. "Art is not what you see, but what you make others see," became his personal motto. From his regular trips to the Louvre to copy, he fell in with the likes of Édouard Manet, Paul Cézanne and Claude Monet, who admired his ability to experiment in different media beyond oils and pastels: photography, lithography, sculpture, etching.

Degas was a non-conformist, but not a sensationalist. He holed up in his studio, while the other Impressionists painted the countryside. His conservative political opinions were better suited to a stodgy banker than an

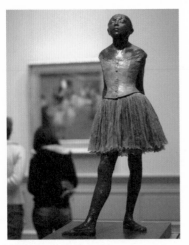

La Petite Danseuse de Quatroze Ans,
c. 1879-81, Metropolitan Museum,
New York

avant-garde artist living in a bohemian slum. While these young Impressionists had different sensibilities, there was one thing they could agree on: the old way of doing things at the Paris Salon had to go. As the Impressionists gained press and held exhibitions, Degas began experimenting with new subject matter—horse races, bathing women, dancers—and built a name for himself. He became synonymous with the ballet.

His penchant for pastel led him to the Paris Opéra, particularly toward the pink and white costumes of the ballet. When the Palais Garnier opened in 1875, he couldn't stay away. He was an ever-present audience, poking his head into dressing rooms and hanging out at every dance class. The ballerinas were flattered by the attention, and even the famous ones gladly posed.

In 1881, Degas unveiled his masterpiece, *La Petite Danseuse de Quatorze Ans*, at the Sixth Impressionist Exhibition. There she stood, no bigger than a walking stick at 38 inches, the opportunistic little ham, immortalized in wax for all to see. Degas made a wig of human hair for the sculpture and dressed it in real ballet attire with tights, shoes and corset. Marie, like most of the audience at the exhibition, thought this was strange. No one had ever put clothes on a sculpture, nor a wig of real hair. But she didn't question his artistic choices—she was a dancer, not a sculptor—and as a token of her gratitude she gave him two finishing touches for the sculpture: her tutu and a big, green, floppy bow which he affixed to the end of the braided wig. Later, after Degas' death, his *Petit Danseur* sculptures were all cast in bronze.

Some of the critics were horrified: "Perhaps [Degas] knows things about the *danseuses* of the future that we do not know. He has plucked from the *espalier* of the theater a flower of precocious depravity." Others, like the novelist J.K. Huysmans, thought it was something altogether new and daring: "This little statue is the only truly modern attempt I know of in sculpture." Everyone had an opinion; perhaps the only thing that could be agreed upon was that it was so *unlike* Degas to be controversial. In this little *petit rat* Degas must have seen something of himself: the malcontent, the rebel.

L'Etoile, 1878, Musée d'Orsay

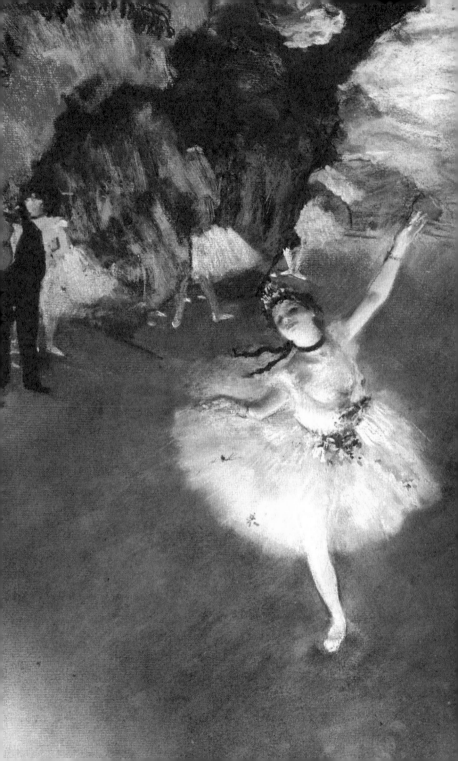

DID YOU KNOW?

Monsieur and Madame Édouard Manet

In the 1860s, Degas painted a double portrait of his friend Manet and his wife, Suzanne. Dissatisfied with the outcome of her portrait, Manet had it cut from the painting along with the entire right-hand side of the work. When Degas discovered this, he was furious and stormed off with the work, returning a still life with plums that Manet had given him. Degas meant to restore the work but never did; it is now at the Kitakyushu Municipal Museum of Art in Japan.

Degas in New Orleans

In 1872, Degas lived with relatives in New Orleans, Louisiana for a year. It is here that he painted *A Cotton Office in New Orleans*, a scene depicting the very moment his uncle Michel Musson's cotton brokerage business went bankrupt in an economic crash. Degas's brothers are portrayed in the work, René is the figure reading *The Daily Picayune* and Achille is leaning against the windowsill.

Degas brought the painting back to France and it was the first work to be purchased by a museum (Musée des Beaux-Arts de Pau) during his lifetime.

Marie van Goethem

Degas's sculpture *Little Dancer* features Marie van Goethem, a scrawny 14-year-old ballerina-in-training and a neighbor of the artist. Though Marie was a rising star in the ballet world, at age 17 she was dismissed from the *corps de ballet* for tardiness and too many days absent. Degas soon learned that Marie's mother, a widow, had been prostituting the girl and her two sisters at night to help make ends meet. In an 1882 newspaper article titled "Paris at Night," Marie was outed as being a regular at all-night cafés the Rat Mort and the Brasserie des Martyrs. The author continued, "Her mother ... But no: I don't want to say any more. I'd say things that would make one blush, or make one cry." This is the last recorded instance of Marie.

Abonnés

During the time of Degas, the ballet in Paris was a fashionable pastime. Wealthy men would be able to pay for a subscription pass to go backstage, a privilege that titled them *abonnés*. A lover of the ballet, Degas initially could not afford such a subscription and instead had his well-connected friends usher him behind the scenes. In a letter circa 1882 to Albert Hecht, a prominent collector and friend, he wrote, "My dear Hecht, Have you the power to get the Opéra to give me a pass for the day of the dance examination, which, so I have been told, is to be on Thursday? I have done so many of these dance examinations without having seen them that I am a little ashamed of it." He was later able to afford to become an *abonné* himself.

The Dreyfus Affair: Anti-Semitism

In the 1890s, Alfred Dreyfus, an officer in the French Army, was convicted of treason. In 1896, he was absolved and it was widely believed that he was convicted only for being Jewish. It caused a huge controversy in France and brought to light many anti-Semitic sentiments throughout the country. Already known for his anti-Semitic prejudices, the

incident spurred Degas to cut ties with several colleagues and even close friends for being Jewish.

Photography

During the late 19th century, as more advances were made in photography, Degas took a keen interest in this medium. In many of his paintings, such as *View from the Orchestra* and *The Singer with a Glove*, critics have noted how photography inspired Degas's compositions. Rather than posing models or working from sketches, he often painted from photographs.

Apotheosis of Degas, 1885, Musée d'Orsay

Dogs

Degas was famous for his hatred of dogs. If Degas was expected at a home, the dog had to be locked away lest the painter batter it on the head when it went to meet him at the door. Invited to dinner by the dealer Ambrose Vollard, Degas replied "With pleasure but no flowers on the table...I know you won't have your cat around and please don't allow anyone to bring a dog."

Myopia: Degas's Failing Eyesight

The artist's brother René de Gas wrote to family about Edgar's arrival in New Orleans: "Unfortunately his eyes are very weak and he's forced to use them with the greatest caution." Degas's failing eyesight was a health issue he dealt with for most of his life. Into his 70s and 80s he was nearly blind and was said to wander around Paris stumbling into

things. He painted less and less frequently, but continued to take photographs. As his vision waned, his fame rose, though this didn't give him much comfort.

Mary Cassatt and Degas

Cassatt recalls seeing Degas's work in the window of the Durand-Ruel gallery when she was young girl, after her and her family had just moved from Pittsburg to Paris: "I used to go and flatten my nose against that window and absorb all I could of his art. It changed my life. I saw art then as I wanted to see it." Cassatt was both a society woman with a vast education and an accomplished artist. She was constantly entertaining friends from America, France and England, including Louise Elder from Philadelphia whom Cassatt convinced to buy a Degas pastel print. Elder later went on to amass the largest collection of Degas paintings outside the artist's own stores.

Julie Manet and Degas

Morisot's daughter Julie Manet kept a diary for six years, from the time she was 14 until when she was 20 and became engaged to the artist Ernest Rouart. The diary spans the years from 1893 to 1899, shedding light and perspective on the painters that populated her life, like Édouard Manet, her uncle, Renoir, Degas, Monet and Mallarmé. She talks about visiting the artists in their studios, going to their exhibitions and conversing with them while she herself was copying art at the Louvre. Julie also gives anecdotes about the artists such as "Monsieur Degas can think of nothing but photography. He has invited us all to have dinner with him next week and he'll take our photograph by artificial light: the only thing is you have to pose for three minutes." When Julie went back to visit Degas after he photographed her, he greeted her with " I'm sorry, the photographs were all failures, I haven't dared to get in touch with you."

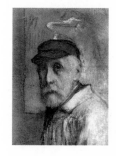

Berthe Morisot

"In love, there's sentiment and passion; I know only sentiment through myself, passion through others. I hear certain voices I know say: sentiment equals love of the intellect; I can answer: passion equals the love of the body."
—Berthe Morisot

TIMELINE

January 14, 1841
Berthe Marie Pauline Morisot is born in Bourges, France.

1862 Morisot and her sister Edma begin studying under Camille Corot and learn *plein air* painting.

1864 The Salon accepts two Morisot paintings; she continues to exhibit at the Salon until 1873.

1868 Morisot is introduced to Édouard Manet by Henri Fantin-Latour. Manet paints Morisot for the first time in *The Balcony*; he produces 10 more portraits of her before 1874.

1869 Edma Morisot abandons serious pursuit of art in favor of marriage and family life.

1873 Manet's *Repose*, a portrait of Morisot, exhibits at the Salon.

1874 Morisot exhibits at the first Impressionist Exhibition.

1874 Marries Eugène Manet, Édouard Manet's brother.

1878 Julie Manet is born in Paris.

1879 Following Julie's birth, Morisot does not exhibit with the Impressionists.

1884 Morisot helps organize a posthumous exhibit for Édouard Manet along with his brothers, wife and Claude Monet.

1886 Exhibits at the final Impressionist Exhibition.

1892 Eugène Manet dies.

1892 Morisot has her first solo exhibition.

1894 The Musée du Luxembourg acquires *Young Woman in a Ball Dress* for 4,500 francs at the urging of Stéphane Mallarmé.

March 2, 1895
Morisot dies at home in Passy after catching pneumonia from her daughter.

Édouard Manet, *Berthe Morisot With a Bouquet of Violets*, 1872
Musée d'Orsay

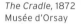

The Cradle, 1872
Musée d'Orsay

Chasing Butterflies, 1874
Musée d'Orsay

by Charlie Fish

Passy, with views of the Seine and the Eiffel Tower, its quiet streets
and luscious greenery, is home to the city's upper crust. Parisians here
value the tranquil and the idyll; bike rides along the Bois de Boulogne
and a Sunday stroll through the Jardins du Trocadéro bring a sense of
quaint village life to modern-day city dwellers. Passy is home to Paris's
wealthiest, and has been so for generations.

The painter Berthe Morisot, who lived in Passy for most her life and is buried
in its famous Cimetière, found in it a beautiful, serene respite from neighboring
city life. Given the constraints placed upon women during 19th-century France,
Passy served as a safe haven where the painter could feel free to explore her
surroundings. By contrast, a respectable woman of her status could not, for
example, visit the Gare Saint-Lazare by herself (as Édouard Manet and Claude
Monet did), or gather at cafés to discuss politics, art and literature.

Her works, in turn, often depicted the everyday lives of her lush environment:
picturesque landscapes of the countryside (*Chasing Butterflies*) and portraits of
those closest to her (*The Artist's Sister at a Window*). Her models were mainly
family and almost entirely women: sister Edma, with whom Berthe studied
painting with while growing up; the matriarch, with her bourgeois sensibilities
and caustic tongue; later, Julie, Morisot's only child and beloved muse.

Morisot was determined to become a painter, an unconventional and
unacceptable profession for a female at the time. Her early years as an artist
were marked by great tutelage under Camille Corot and precocious skill; by

Woman at Her Toilette, 1875-80
The Art Institute of Chicago

1864, two of her works were accepted by the prestigious Salon. Despite a teacher's admonition that Berthe's dedication would prove catastrophic, her parents encouraged and supported their daughter's choice. When Edma relinquished her art world pursuits in 1869 in favor of marriage, Berthe was left to develop her artistry on her own.

Morisot was described as a graceful and distinguished woman, attractive in features and temperament and possessing great charm and intelligence. Because of her wealthy status, her chosen profession was more readily tolerated amongst the family's progressive social circle. But Morisot wasn't entirely free from controversy.

Although she had enjoyed the proverbial pat-on-the-back from the Salon and the brief renown such feats brought, a long-hoped-for meeting with a brilliant painter altered the course of her career. While studying and copying the Old Masters in the Louvre, the Morisot sisters took notice of Édouard Manet, who was but a novice at the time. The Morisot sisters continued to see him during their studies at the Louvre, but never dared to introduce themselves, as proper young girls had to be introduced. That meeting finally came via potential suitor and mutual friend Henri Fantin-Latour.

From the onset, Manet and Morisot were close friends, exchanging letters and discussing art. She visited him in his studio, where she sat for several portraits and benefited from his teachings. But she was no pupil; a more apt description of their relationship would be mutual muses. Not only did Manet paint 11 portraits of Morisot (depicting various facets of her personality: seductive, melancholy, bewitching or grief stricken), he also had a liberating effect on her technique. In turn, Morisot encouraged Manet to paint *en plein air*, which she had learned from Corot.

Theirs was a bond that lasted many years. Manet's take on art was so influential that Morisot parted with the Salon in 1873 in order to join the Independents for their first exhibit of 1874. Called a madwoman for joining the group of intransigents and mistaken for a whore in one of Manet's paintings, Morisot's professional reputation and acclaim were challenged when she embraced Impressionism. Although Morisot took criticisms to heart—becoming withdrawn at times and suffering from self-doubt and depressive bouts—the painter remained loyal to her dedication, producing a reported 800-plus paintings in her lifetime.

Despite the critiques she faced, there were also good reviews and glowing commentaries on her brush strokes and command of color; her work was appreciated because of the softness and simplicity she imbued onto her canvas and palette. But, unmarried and in her 30s, that she continued to pose for Manet—considered to be one of the most reviled Impressionists of the time by the art establishment—threatening her upper-class status.

Whether Manet and Morisot had a romance is a debatable topic. Art critic George Moore, close to both wrote: "There can be little doubt that she would have married Manet if Manet had not been married already." After Manet's posthumous exhibit she wrote her sister and declared that her "days of trysts" were long over. However, Impressionist biographer Jeffrey Meyers implies that not only were Manet and Morisot romantically involved, but that Manet insisted that Morisot marry his brother, Eugène, to silence the rumors surrounding their relationship (fueled by his glorious portraits of her), and prevent permanent damage to Morisot's social standing. It also ensured the Manet and Morisot families would be bound together for eternity, leaving room for vicarious intimacy. Morisot was reluctant to marry Eugène at first, but then agreed. "They burned each other's letters when she married," wrote Meyers of Édouard and Berthe. "Manet did not paint Morisot [again] after her marriage in 1874."

Young Girl in a Ball Gown, 1874, Musée d'Orsay

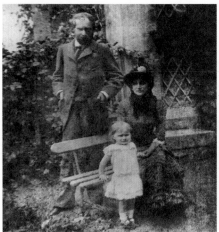

Eugène Manet, Berthe Morisot and their daughter, Julie, at Bougival, 1880

Auguste Renoir, *Berthe Morisot and daughter Julie*, 1894, Private Collection

By all accounts, Eugène supported Morisot's decision to continue painting and seemed nonplussed that she kept her maiden name. After a miscarriage, Berthe gave birth to their only child, Julie, in 1878. Julie Manet inherited her mother's eyes and her father's auburn hair; she was beautiful, and was a constant muse for her mother in such paintings as *The Artist's Daughter Julie, with her Nanny* and *Julie Daydreaming*.

Although Morisot exhibited in all but one of the Impressionist exhibits, her paintings were not among the Caillebotte Collection that was bequeathed to France. Morisot, like the rest of the Impressionists, was given more credit as the years and the establishment grew kinder to the painters and their techniques. Unlike some of her contemporaries, however, Morisot had little commercial success while alive. Her biggest sale came in 1894 when a devotee and longtime friend, the poet Stéphane Mallarmé, orchestrated a viewing of her *Young Woman in an Evening Dress* by the Musée du Luxembourg. Flustered at having to take in 40 of Caillebotte's Impressionist paintings, the Luxembourg was more than hesitant to admit another Impressionist work, let alone one by a female painter. In the end, Morisot sold it to them for 4,500 francs, giving her great pleasure and a sense of accomplishment. But it would be short lived. A year later, while tending to her sick daughter, Morisot caught pneumonia and died on March 2, 1895. She was 54 years old. Despite her exhibitions and critical success, her death certificate was marked "no profession."

DID YOU KNOW?

Joseph Guichard's Letters to Mme. Morisot:

...On her Daughters' Aspirations:

"With characters like your daughters' my teaching will make them painters, not minor amateur talents. Do you really understand what that means? In the world of the *grande bourgeoisie* in which you move, it would be a revolution, I would even say a catastrophe."

...Upon Seeing Morisot's Work in an Impressionist Exhibit:

"When I...saw your daughter's works in this pernicious milieu, my heart sank, I said to myself, 'One does not associate with madmen except at some peril.' To negate all the efforts, all the aspirations, all the past dreams that have filled one's life, is madness. Worse, it is almost a sacrilege."

Morisot on Men

"I don't think there has ever been a man who treated a woman as an equal and that's all I would have asked, for I know I'm worth as much as they."

"Men incline to believe that they fill all of one's life, but as for me, I think that no matter how much affection a woman has for her husband, it is not easy for her to break with a life of work."

Behind the Portrait

One of Manet's most striking portraits of Morisot is *Berthe Morisot Holding a Bouquet of Violets*, where Morisot's expression shows, as a critic noted, "rapt attention to the artist portraying her; a profound complicity." Upon Morisot's death, her daughter Julie revealed in her diary what happened the day of the sitting: "On that day my Uncle Édouard told Mama that she ought to marry Papa."

A Rival

Eva Gonzalès became Manet's pupil in 1869, much to Morisot's chagrin. "He has forgotten all about you for the time being," her mother is quoted as telling Berthe. Later, Morisot wrote her sister and complained: "Manet lectures me, and holds up that eternal Mademoiselle Gonzalès as an example; she has poise, perseverance, she is able to carry an undertaking to a successful issue, whereas I'm not capable of anything." But, when given to a good mood, Manet would set the record straight: "To my great surprise and satisfaction," she wrote Edma after a visit from Manet, "I received the highest praise; it seems that what I do is decidedly better than Eva Gonzalès."

The Morisot Salon

Though respectable women couldn't mingle in cafés in 19th-century Paris, there was nothing stopping them from hosting dinners and salons in their own home. Eugène Manet built a home for his family at 40, rue de Villejust (now rue Valery), where Berthe held dinners for their friends Degas, Cézanne, Renoir and other prominent artists, writers and composers of the time. On the menu: exotic foods like Moroccan chicken and dates.

In Her Own Words: On her Marriage

In a correspondence with her brother Tiburce, Morisot writes: "I have found an honest and excellent man, who I think loves me sincerely. I am facing the realities of life after living for quite a long time in chimeras that did not give me much happiness."

Farewell to a Daughter

As Morisot was dying, she penned a heartfelt, poignant letter to her daughter, which read: "My little Julie, I love you as I die; I shall still love you even when I am dead; I beg you not to cry, this parting was inevitable. I hoped to live until you were married. Work and be good as you have always been; you have not caused me one sorrow in your little life."

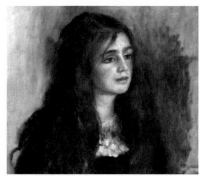

Julie Manet

Gustave Caillebotte

"I leave to the State the paintings in my possession; however, as I want this gift to be accepted ... a certain lapse of time will be necessary before the execution of this clause, until the public may, I do not say understand, but admit this painting."

—Gustave Caillebotte

TIMELINE

August 19, 1848
Gustave Caillebotte is born at home on rue du Faubourg-Saint-Denis in Paris.

1860 The Caillebottes begin spending their summers in Yerres; young Gustave is introduced to painting and rowing.

1866 The Caillebottes move to a newly erected house on rue de Miromesnil; Caillebotte will later have a studio built on one of the upper floors.

1870 After earning a law degree, Caillebotte is drafted to serve in the Franco-Prussian War.

1872 Begins to seriously study painting under Léon Bonnat.

1873 Accepted to École des Beaux-Arts.

1874 Meets Degas, Pisarro and Sisley

1874 Patriarch Martial Caillebotte dies, leaving 26-year-old Gustave a considerable fortune.

1875 *The Floor Scrapers* is rejected by the Salon; Caillebotte leaves the École des Beaux-Arts.

1876 Takes part in the second Impressionist exhibition; purchases his first Monet canvas. Predicting an imminent death, he makes his will, leaving his entire art collection to the state.

1878 His mother's death further enriches the Caillebotte siblings, who sell the Miromesnil house and split the remaining fortune.

1879-1886 Funds, coordinates, participates in and organizes most of the remaining Impressionists exhibitions.

1881 Acquires property at Petit Gennevilliers.

1882 Caillebotte turns focus to sailing, stamp collecting, gardening and engineering.

1888 *Man at His Bath* exhibits in Brussels; because of its shocking nature, the work is relegated to a side room, where very few viewers, if any, see the piece.

February 21, 1894
Gustave Caillebotte dies while gardening. In his will, he leaves his collection of Impressionist works to France.

Self-Portrait, c. 1889
Musée d'Orsay

Portraits à la campagne, 1876
Musée Baron Gérard, Bayeux

The Canoes, 1878
Musée des Beaux-Arts de Rennes

by Charlie Fish

The rue de Miromesnil and its surrounding area offer ample opportunity for leisurely walks through Paris's stylish and well-to-do 8th arrondissement. Aromas from brasseries waft in the air while the chic and well-shod pop in and out of boutiques. In the 19th century, the area would have been filled with *flâneurs*, grand gentlemen who strolled for leisure, making keen observations on society for artistic purposes.

One such gentleman, Gustave Caillebotte, lived and worked at 77, rue de Miromesnil for many years. Just a short walking distance from the Gare Saint-Lazare and the Place de l'Europe, the Caillebotte mansion allowed the young painter to find inspiration in the newly paved, modern *grands boulevards*. Here he would witness the increasingly crossed paths (but noted lack of interaction) between the working class and the *haute bourgeoisie*.

Born to privilege and wealth, Caillebotte was passionate and energetic; by many accounts, he was also an attractive and stylish man. Paintings (and a few surviving photographs) depict the artist with short-cropped hair and a goatee, his wardrobe befitting his social status. He was financially independent by age 26, having inherited his father's fortune. Caillebotte, determined to receive artistic acclaim as a painter, studied under academic painter Léon Bonnat for a few years before setting his sights on the École des Beaux-Arts and the Salon. However, by 1874 the young painter had seen

the first Impressionist exhibit and met Edgar Degas, Claude Monet, Auguste Renoir, Alfred Sisley and Camille Pissarro. The exhibit left an indelible mark on the painter and he subsequently established long-standing friendships with Monet and Renoir.

When Caillebotte submitted *The Floor Scrapers* to the Salon in 1875, it was deemed vulgar and was rejected. This snub severed any remaining ties Caillebotte had to the art establishment; the painter withdrew from the École des Beaux-Arts and used his wealth to paint freely and to champion his artistic *raison d'être*: the Independents and their work.

Caillebotte was brought into the group by the cunning Degas—who was seemingly more interested in Caillebotte's wallet than his palette—and exhibited for the first time during the second Impressionist exhibition in 1876. When he exhibited *The Floor Scrapers*, the piece caused such a stir that critics were divided. Émile Zola described it as too realistic, "neat as glass," and added, "Photography of reality which is not stamped with the original seal of the painter's talent—that's a pitiful thing." Its subject matter—shirtless workers preparing what is believed to be Caillebotte's studio floors—challenged outmoded ideals that the working class was not a proper subject.

The Gare Saint-Lazare
Caillebotte's earlier work *Paris Street; Rainy Day* and *Le Pont De l'Europe* were painted mere blocks from the artist's palatial home and steps away from many an Impressionist's industrial muse, the Gare Saint-Lazare. Symbolic of modernity and urban renewal, the train station was subject to various interpretations by Monet, Manet and Béraud. While other artists painted the station and its underbelly, Caillebotte chose to present a socio-cultural slant with his *Le Pont de l'Europe*, depicting himself as a flâneur on the newly erected bridge as he glances at a member of the working class.

Many of Caillebotte's earlier, better known works differ from the other Impressionists' in their heavy brush strokes and academic leanings. As the painter matured over time, his brush loosened and his style reflected that of his peers. His most renowned paintings, however, have Caillebotte trademarks: forced perspectives, reflective surfaces and a balance between Realism and Impressionism.

At the third Impressionist exhibition, Caillebotte debuted *Paris Street; Rainy Day* to great fanfare, with most critics claiming that it was both his masterpiece and the best of the exhibited bunch. Even Zola changed his tune, claiming that Caillebotte could well be remembered as the boldest of the group, provided he loosen his brush a tad.

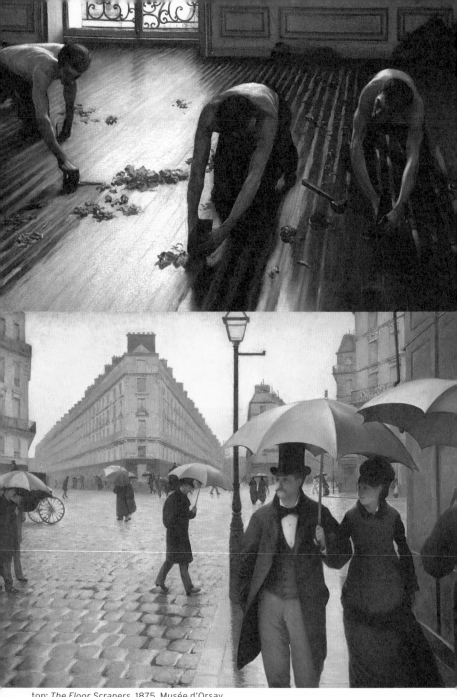

top: *The Floor Scrapers*, 1875, Musée d'Orsay
bottom: *Paris Street; Rainy Day*, 1877, Art Institute of Chicago

Because he was the youngest and wealthiest member of the Impressionists, it is unknown whether Caillebotte was truly accepted as a peer or whether he was tolerated for his substantial financial contributions. Caillebotte was as serious about supporting his peers' artistic contributions as he was about enriching his own style. He used his inheritance to purchase his colleagues' works (his first Monet was bought in 1876) and fund their paintings, as well as to organize and produce most of the remaining Impressionist exhibits. Not only did he pay for the venues and advertising, he also bought frames and even hung pictures. His generosity extended beyond the studio. When Monet was down on his luck, the younger artist would frequently come to his rescue, assuming full responsibility on Monet's 17, rue Moncey *pied-à-terre* (near the Gare Saint-Lazare), and consistently doling out cash advances to keep the financially struggling artist afloat. In 1879 alone, Caillebotte gave Monet 5,000 francs; his largesse toward the painter continued until around 1881.

Regarded as an anomaly within the Impressionists, Caillebotte was dogmatic in his beliefs about the movement. This led to clashes with Degas, the *de facto* recruiter of the group, who often suggested new painters, much to Caillebotte's chagrin. The pair even fought over the advertising designs. On several occasions, they even tried to exclude

Financial Support to Monet		
from Monet's Accounting Book		
1876	July	480 francs
	Aug	330 francs
	Dec	700 francs
1877	Jan	Twice 100 francs
	Jan 17	Monet moves in new studio. Caillebotte pays Monet's rent until July 1878.
	Mar	430 francs
	Apr	250 francs
	Jun	140 francs
	Aug	50 francs
	Sep	200 francs
	Oct	110 francs Plus 60 francs for Monet's frame.
	Dec	20 francs
1878	Jan	255 francs
	Apr	40 francs
	May	60 francs
	Jul	100 francs Pays for Monet's moving cost from rue Monceau. Monet's rent is paid by Caillebotte from Oct 1878 to the autumn of 1881.
	Dec	Caillebotte pays 15 francs for Monet's debt by court decision on Jan. 1876
	Apr	2,900 francs
	Jul	1,000 francs
	Aug	200 francs
	Sep	500 francs
	Oct	700 francs
	Dec	100 francs
1880	Feb	100 francs
	Aug	200 francs
	Oct	240 francs
	Nov	300 franc (after 200 franc repayment from Monet)
	Dec	100 francs
1881	Jan	500 francs
	Feb	100 francs

A Balcony, 1880
Private Collection

Thatched Cottage at Trouville , 1882
Art Institute of Chicago

the other from upcoming exhibitions. Degas once complained that, "All the good reasons and the good taste in the world can achieve nothing against the inertia of some and the obstinacy of Caillebotte."

New modes in painting, namely Seurat's Pointillism and the rise of Neo-Impressionism, further divided the group. These fractious, heated debates—coupled with the increasing commissions his beneficiaries now enjoyed, rendering Caillebotte's influence minimal, at best—resulted in the dismantling of the group after the final Impressionist Exhibit of 1886, 12 years after the initial exhibit forever changed the artist's life.

Shortly afterward, Caillebotte ceased (for the most part) to exhibit; the whims of the art world and the group's dissipation scarred him. The remainder of his life was spent at his home in Petit Gennevilliers, where he focused on his other passions: he excelled in the design, engineering and sailing of yachts; he reveled in orchid horticulture and gardening; he took up stamp collecting and textile design. Though he withdrew from the art world, he nevertheless remained close with Monet and Renoir, the latter of whom he named executor of his will.

Upon his death in 1894 at the age of 45, Caillebotte was remembered more as a patron than a skilled artist worthy of renown. Because he never had to sell any of his paintings, Caillebotte's work became largely forgotten over time. In a prescient move at 26, Caillebotte included in his will the exact instructions with which to handle his collection, which now forms the bulk of the Impressionist paintings currently on exhibit at the Musée d'Orsay. Through his donation, Caillebotte ensured Impressionism a place in history.

DID YOU KNOW?

Martial Caillebotte, Sr.

Gustave Caillebotte was born to privilege and wealth. His father, Martial, was a shrewd businessman with triumphs in real estate and textile design; a great majority of the Caillebotte family fortune (and an aid to their social status) came from providing bedding to the Imperial Army of Napoleon III.

Caillebotte: The Lawyer?

As was expected of a member of the upper class, Caillebotte originally studied law, earning a license to practice in 1870. Before he could start practicing, however, he was called to serve in the Franco-Prussian War.

Brother, Martial (left)

The Park On The Property At Yerres, 1875

The Caillebotte Estate in Yerres

With their solid financial standing, the Caillebottes were able to purchase an estate on a riverbank in the suburban town Yerres. Gustave spent many summers here, enjoying leisurely rowing and sailing, which would become a prominent pastime in his later years. While at the Caillebotte Estate in Yerres, which is now owned by the city and open to visitors, it is presumed that young Gustave took an interest in painting.

Caillebotte vs. Morisot?

Notably absent in the collection Caillebotte bequeathed to France are any paintings by fellow Impressionist Berthe Morisot. Both painters were financially independent, and both shared a history of being overlooked in favor of other members of the group. Morisot was known as the mollifying force that often held the group together. Yet, neither would frequent the other's dinners and hosted evenings. In *The Private Lives of the Impressionists*, biographer Sue Roe writes that, "For reasons best known to herself...[Morisot] never really hit it off [with Caillebotte]."

See For Yourself: Caillebotte's Paris

Take the Métro to the Gare Saint-Lazare for a brief walk around one of the neighborhoods that inspired the Impressionists and Caillebotte's old stomping grounds. Head to place de Dublin, just north of the train station. When you reach the intersection between rue de Turin and rue de Saint-Pétersbourg, turn around: this is the site Caillebotte captured in paint *Paris Street; Rainy Day*. Now walk down rue de Saint-Pétersbourg until it becomes rue de Vienne. Stop on the station side of the street and turn around to face the place de Europe for a view of the pont de l'Europe site.

Caillebotte's Mistress

Though Caillebotte was a wealthy heir, an accomplished painter, sailor, and, by all accounts, rather handsome, he never married. The only serious relationship ever to be alluded to the account of his life was with Charlotte Bertheir, a woman of substantial lower class who was 11 years younger than he. In his will, Caillebotte left Charlotte and sizable annuity. The woman whose face is turned away from the viewer in Caillebotte's *Roses in the Garden*, 1886, has been identified as Charlotte.

Vincent van Gogh

"I can't change the fact that my paintings don't sell. But the time will come when people will recognize that they are worth more than the value of the paints used in the picture."

–Vincent van Gogh

TIMELINE

March 30, 1853
Vincent van Gogh is born in Groot-Zundert, Netherlands.

1869 Works as an art dealer for Goupil & Cie and is transferred between London and Paris.

1879 Does mission work in Borinage, a mining village in Belgium.

1880 Devotes himself to art full-time. Enrolls in the Academie Royale des Beaux-Arts in Brussels.

1882 Moves to the Hague and sets up a studio.

1885 Completes *The Potato Eaters*, considered his first major work.

1886 Enrolls at Academy of Art in Antwerp.

1886-1888 Moves to Paris, shares an apartment with brother Theo, attends Fernand Cormon's atelier, and befriends Toulouse-Lautrec, Pissarro, Gauguin and Bernard.

1888 Moves to Arles and has artistic breakthrough, painting several of his major works.

October–December 1888 Gauguin visits him in Arles and the two have a falling out wherein Van Gogh infamously cuts off part of his own ear.

1889 Admits himself to the St-Paul-de-Mausole asylum in Saint-Rémy.

1890 Sells *The Red Vineyard*, the only painting he sold during his lifetime.

May 1890 Moves to Auvers-sur-Oise, meets Dr. Gatchet and is taken into his care.

July 29, 1890
Vincent van Gogh commits suicide and is buried in Auvers.

Self-Portrait, 1889
Musée d'Orsay

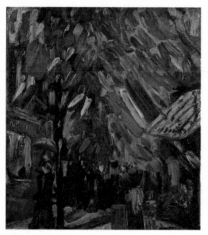

Fourteenth of *July Celebration in Paris*
1886, Villa Flora, Winterthur

Henri de Toulouse-Lautrec, *Portrait of*
Vincent van Gogh, 1887, Van Gogh Museum

by April Isaacs

The sun had barely risen on that brisk Parisian morning in early 1886, when a skeletal man with wine-stained teeth strode purposefully into the Louvre, easel and a box of paints tucked under his arm. He would have been a sight to behold, with wild orange hair and a crazed look in his eye, sketching the masters as though Hell had put him up to it. He had just left behind the overcast skies and provincial stagnation of Holland and Belgium for the lights of Paris. He sent a note to his brother Theo informing him of his arrival: "Don't be cross with me that I've come all of a sudden ... I've thought about it so much ... Will be at the Louvre from midday ... We'll sort things out, you'll see. Yours Truly, Vincent." Theo no doubt was rattled—he now had an untidy, querulous and emotionally demanding roommate on his hands—but unsurprised, for Vincent was an unstoppable force.

Once Vincent van Gogh had felt quite differently about Paris, railing against it as a corrupt city where dealers had turned art into merchandise. Life was too superficial in Paris to do serious work; it was a marketplace, not a studio. As an art dealer himself, and in an obvious moral conundrum, he was miserable. He projected his own desires onto Theo, urging him in a letter to leave Paris and become a painter, to take up the motto: "I don't want the city any longer, I want the country. I don't want an office, I want to paint." Years later, while studying art in Antwerp, Vincent heard tales of the new

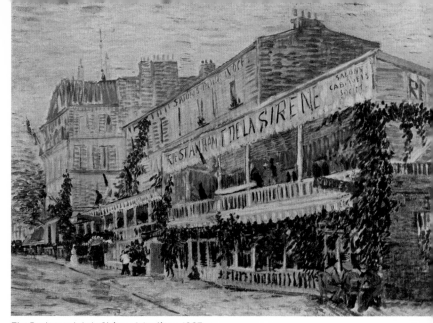

The Restaurant de la Sirène at Asnières, 1887
Musée d'Orsay

scene erupting in Paris, brimming with creative geniuses, new ideas and good drinkers. He had hit a plateau with his own work—mimicking the outdated realist style. In Paris, he would evolve.

Van Gogh quickly joined the atelier of the French academic painter Fernand Cormon, the beginning of a completely new direction. In Paris, Van Gogh created more work than ever before. He felt as though his whole life, not just his artwork, had burst from black-and-white to color. He used short brushstrokes to place colors next to each other, letting the eye blend them instead of the brush. "In Antwerp I hadn't even heard of Impressionism," he wrote artist Émile Bernard. At Cormon's studio Van Gogh made friends with a few of his other emerging contemporaries—Henri de Toulouse-Lautrec, Paul Gauguin, Paul Signac—but most of the students kept their distance. At 36, Vincent was much older and even less fun; he hated buffoonery and frequently lost his temper.

Apart from the constant absinthe and cigarettes, Vincent prefered the singular and ascetic life of a monk, rarely eating full meals and taking nary a break from his painting. There had been women once, but Vincent's worsening psychological ailments, fanatical work habits and inability to earn money quickly extinguished any romance that came his way. Days were spent at the Louvre copying Eugène Delacroix and the Old Masters. Afternoons,

were spent rambling around Paris sketching its street life. In the evening, he terrorized Theo. The two lived in Montmartre, a neighborhood of nefarious characters, opium dens, street musicians and cheap rent: a modern artist's Shangri-La.

Père Tanguy's paint shop was a frequent stop, patronized by living legends and rising stars of the avant-garde. Some, like Van Gogh, hung out all day criticizing exhibitions, discussing news and comparing work. Tanguy displayed Van Gogh's work in the window and let him run up a line of credit. It was one of the few places, along with Restaurant la Fourche, the Cabaret du Tambourine and some seedy little cafés, where Van Gogh's work was exhibited. He painted three portraits of his kind-hearted patron, employing the techniques he'd picked up from some Japanese woodcut prints.

Theo Van Gogh
Vincent was completely dependant on his younger brother as a friend, father figure and benefactor. As an art dealer, Theo championed the works of the Impressionists, but was unable to sell his brother's paintings. The two exchanged hundreds of letters, which are the main source of insight into Vincent's life. Vincent's death destroyed Theo, resulting in angry outbursts and mental breakdowns of his own. Six months later, he was checked into a hospital and died shortly thereafter. The two are buried side by side in Auvers-sur-Oise.

The lifestyle exacerbated his poverty, drinking and depression. After two years, the city life was killing him. If he'd been a merry bohemian like Toulouse-Lautrec, a native son like Degas or born rich like Seurat, a Parisian destiny would have made more sense. What business did an angry recluse like himself have in *gay Paris*? He hadn't "made it," could not get his work shown, could not get even his brother to sell his paintings. He wanted the country again, not the city. He tried to rally his friends to join him in Arles to start an artist commune. "It is in the South that we must build the studio of the future." None, save for Gauguin, would make it.

In the country, Vincent's mental health deteriorated, but his painting flourished. The light in Arles was like a sunburst of inspiration, his new teacher and atelier. "I just had to get away from Paris," he wrote passionately to his friend Émile Bernard. He only felt sad to leave Theo. As a parting gift, Vincent arranged for Bernard to break into Theo's Montmartre apartment and place Vincent's things as if he were still living there. "At least we can be together in spirit," Vincent wrote.

DID YOU KNOW?

Failings in Love

Vincent never had much luck in the love department. In Antwerp he fell madly in love with a prostitute named Clasina Hoornik (called "Sien") who didn't return his feelings. Many considered her hideous, and it's rumored that she gave him both gonorrhea and a child. Then came Margot Begemann, more volatile and unstable than even Van Gogh himself. When Begemann's father robustly condemned her marriage to Vincent, she drank strychnine in a show of opposition. In Arles he wrote to Theo of his new philosophy: "eat well, live well, see few women."

Van Gogh and the Ministry

Van Gogh's lack of interest in creature comforts and general fervor made him an excellent candidate for mission work. After his termination at Goupil et Cie, he attended a Methodist mission school in Amsterdam. He was sent to a poor mining village in Belgium on a temporary assignment. He slept on the ground and ate almost nothing in order to better understand the plight of his flock. The director felt this was over-the-top and Vincent was dismissed.

Van Gogh and Agostina

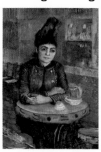

While living in Paris, Van Gogh began an affair with Agostina Segatori, the owner of the Café du Tambourin on the boulevard de Clichy. Segatori would use her café as a casual gallery space for artists including Van Gogh. At the café he showed his flower still-lifes as well as his collection of Japanese prints, which can be seen in the background of his portrait of Segatori, *Agostina Segatori in Le tambourin*, 1887. The subject of a woman sitting alone at a table was a popular one with the Impressionists; the portrait is Van Gogh's attempt at that theme. Van Gogh and Segatori's affair lasted six months and in a letter to his sister, Van Gogh tells her it did not end well.

The Ear Incident

There's a lot of speculation about the ear incident. According to Gauguin, who was visiting Van Gogh in Arles, Vincent attacked him. In a dramatic and psychotic flourish, Van Gogh turned on himself, slicing off part of his own ear lobe. Shortly after losing his ear, Van Gogh wandered into a nearby brothel and presented the ear to a prostitute who alerted the police. A new study in 2009 suggests that it wasn't Gauguin who instigated the self-mutilation, but Theo, whose recent engagement announcement undoubtedly upset his jealous brother. Other researchers speculate that Gauguin, a skilled fencer, lobbed it off during their fight.

Mental Illness

"I always knew he would either surpass us all or end up a madman. I never thought he would do both," Pissarro said of Van Gogh after his death. Some psychiatrists suspect Vincent's madness was aggravated—if not caused—by a combination of syphilis and absinthe. The artist suffered from a debilitating depression and Theo's depictions of his violent mood swings suggest that Vincent was also bipolar. In Saint-Rémy he checked into an asylum. Later, in Auvers, he was treated by Dr. Gatchet, a man who was also unstable. "I don't think we should rely on Gatchet at all," he wrote Theo. "He is sicker than I am. When one blind man leads another, don't they both fall in the ditch?"

Van Gogh Respects Monet

Van Gogh greatly appreciated the work of Monet and mentioned him in several of his letters to his brother Theo. May 4, 1888, "I'll work, and here and there some of my work will last – but what Claude Monet is in landscape, the same thing in figure painting – who's going to do that?" From May 7, 1888, "You'll see beautiful things at Claude Monet's. And you'll think what I send you is pretty poor, in comparison." On June 16, 1888, ". I congratulate you on having the Monet exhibition at your premises, and I much regret not seeing it." And on May 3, 1889, "Ah, to paint figures like Claude Monet paints landscapes. That's what remains to be done despite everything, and before, of necessity, one sees only Monet among the Impressionists."

Camille Pissarro (1830-1903)

Considerably older than his colleagues, Camille Pissarro was the patriarch of the Impressionists. He served as an artistic father to many, including Cézanne, Seurat, Gauguin and Guillaumin. Born on the island of St. Thomas to French-Portuguese Jewish parents, he arrived in Paris via Venezuela as a largely self-taught artist. His international upbringing gave him a unique perspective of the world, and he was more politically active than many of his Impressionist colleagues. He was an anarchist sympathizer in the 1870s and by the 1890s, he was a full-blown anarchist. The subject matter of his paintings also shifted. In 1885, he met Seurat and adopted the Neo-Impressionist style of Pointillism, along with a new attention to peasants and rural labor, as evident in *The Gleaners*. Pissarro's particular brand of anarchism promoted individual freedom within a communal, agrarian setting in which man could feel in harmony with nature and his fellow men. His integrity in art and in life was admired by generations of avant-garde artists.

Alfred Sisley (1839-1899)

Despite being part of the core group of Impressionists, Alfred Sisley tends to fly under the radar. He was born into a family of British expats in Paris who sent him to study business in London. Instead of learning about the silk trade, he spent his time studying the Turners and Constables in the National Gallery. He enrolled in the studio of academic painter Charles Gleyre in 1862, where he fell in with Monet, Renoir and Bazille. When Gleyre's studio closed in 1863, the foursome continued their painting education in the forests of Fontainebleau. Sisley never swerved from this genre and remained dedicated to capturing the effects of light and atmosphere in nature in works such as *Snow at Louveciennes* (1878). Although he was represented by the same dealers as his peers, Sisley never gained a firm foothold in the art market. He didn't socialize at the Café Guerbois or circulate amongst the art crowd. He left Paris in 1871, settling in small villages in the countryside. He experienced financial troubles until the end of his life, when he succumbed to throat cancer.

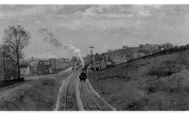

Lordship Lane Station, Dulwich, 1871 Courtauld Gallery, *London; Red roofs, corner of a village, winter*, 1877, Musée d'Orsay

View of Montmartre from the cité des Fleurs 1869, Musée des Beaux-Arts, Grenoble; *Flood at Pont-Marley*, 1876, Private Collection

Frédéric Bazille (1841-1870)

Frédéric Bazille came from a very wealthy family in Montpellier who sent him to Paris to study medicine. He was always enamored of painting, however, and in 1862 he entered the studio of Charles Gleyre, an academic painter who was fairly lenient with his students. There he met Monet, Renoir and Sisley, and quickly abandoned medical school. His painting *Studio on the rue La Condamine* attests to the close friendship among these artists; Bazille is the central figure with the palette and Manet is the figure with the hat. Bazille was a generous friend, especially to the perpetually impoverished Monet. During a period when Monet was especially hard up for money, Bazille bought his painting *Women in a Garden* for the exhorbitatnt sum of 25000 francs and paid Monet in monthly installments. Renoir and Sisley also knew that if they ever needed a meal or more studio space, they could count on Bazille. Bazille died before he was 30 years old. During the Franco-Prussian War, he joined the elite Zouave regiment and was killed in combat in 1870.

Armand Guillaumin (1841-1927)

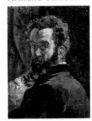

Armand Guillaumin moved to Paris at 16 to work in his uncle's shop. After selling linens for 12 hours a day, he made his bed under the store's counter and drew by candlelight. He enrolled in the Académie Suisse in 1862 where he met Cézanne and Pissarro, with whom he would paint landscapes at Pontoise, Auvers-sur-Oise or Issy-les-Moulineaux. In order to go on these countryside jaunts, Guillaumin worked the night shift at the Department of Bridges and Roads, digging ditches three nights a week for nearly 20 years. Guillaumin often painted laborers and industrial scenes, an even more progressive subject than the suburban leisure favored by his Impressionist colleagues. Guillaumin participated in Impressionist group exhibitions and would inspire the Neo-Impressionists. His landscapes, such as *Sunset at Ivry*, attracted the attention of Van Gogh, whose brother Theo began selling his work in the mid 1880s. Guillaumin was eventually rewarded—he won the lottery in 1891, after which he retired and devoted himself to his art.

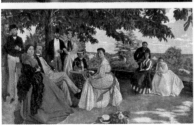

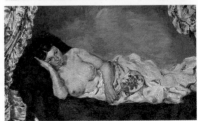

The Improvised Field Hospital, 1865, Musée d'Orsay; *Family Reunion, 1867*, Musée d'Orsay

Sunset at Ivry, 1874, Musée d'Orsay
Reclining Nude, c. 1876, Musée d'Orsay

Mary Cassatt (1844-1926)

The daughter of a Pittsburgh banker, Mary Cassatt rejected the life of high society and instead lived as an expatriate artist in Paris. Cassatt studied academic painting in the late 1860s and had work accepted to the Salon, a formidable achievement for an American woman. She hated conventional art, however, and was looking for a new direction. In 1874, she noticed a Degas pastel of ballerinas in an art dealer's shop in Paris. "It changed my life," she said. "I saw art then as I wanted to see it. I began to live." That year Degas noticed Cassatt's work at the Salon, and it was the start of a 40-year friendship. Degas invited Cassatt to join the Impressionists in 1877 and she made her debut in 1879 with works like *At the Opera* exploring the complexities of upper-class female life. Cassatt was instrumental in spreading Impressionism to the United States; thanks to Cassatt, American museums such as the Metropolitan Museum of Art and the Philadelphia Museum of Art have some of the best collections of Impressionist painting in the world.

Paul Gauguin (1848-1903)

Paul Gauguin described himself as "a wolf in the woods without a collar." He spent his childhood as an aristocrat in Peru and was handed a job in 1871 as a stockbroker in Paris. After the market crashed in 1882, Gauguin fled civilization to try out the role of impoverished artist. His first stop was Brittany where, he thought, the religious peasants would get him closer to the state of primitive man. Gauguin experimented with ceramics, believing that fired clay was an earthy, pre-modern medium. After a tragic detour to Arles in 1888 (where Van Gogh's ear was sliced off) he settled in Tahiti where he spent most of the 1890s and painted his masterpiece as manifesto, *Where do we come from? What are we? Where are we going?* (1897-98). Gauguin's escape from Paris was a bid to become the new leader of the avant-garde; he painted with an eye on the Parisian art market and crafted his image to promote his work. Gauguin possessed the talent to back up his egomania—his astonishing work launched the Symbolist art movement in France and set the stage for Fauvism and Expressionism.

The Bath, 1891-92
The Art Institute of Chicago

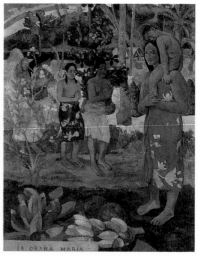

We Hail Thee Mary, 1891
Metropolitan Museum of Art, New York

Eva Gonzalès (1849-1883)

Tall, slim and beautiful, Eva Gonzalès was Manet's student and one of the few female Impressionist artists. One writer from the period described that she had been burning with desire to receive Manet's counsel. Her informal training with Manet and natural talent made her an accomplished painter, sensitive to the subtleties of color and light. Many of her subjects, such her beautiful *Milliner* (1877), were women, painted in bourgeois interiors or gardens. She exhibited at the Salon several times where she received positive critiques from Zola and Mallarmé, the same men who admired her teacher. Even though she painted in the Impressionist style, Gonzalès never fully allied herself with this group and never exhibited with them. Her friendship with Manet continued after she finished her training because her husband, Henri Guérard, was Manet's printmaker and good friend. Gonzalès died suddenly six days after Manet's death. Legend has it that she died while braiding flowers for the tomb of her teacher. She left behind a baby that was only 16 days old.

Jean Béraud (1849-1935)

The novelist Marcel Proust characterized Jean Béraud as a "young and celebrated master," "a charming creature sought, in vain, by every social circle." Béraud was extremely successful in his own day for his honest and beautifully painted canvases, which captured Paris's Belle Époque. Béraud extended the subjects depicted by the Impressionists to include all aspects of daily life. He painted the city's streets, its pedestrians, and the interiors of cafés, opera houses and theaters. Many of Béraud's paintings are snapshots of daily life: people going about their business on the streets, battling the wind, enjoying a cup of coffee. Influenced by the newly emergent art of photography, Béraud would drive around in a cab and stop when he saw something interesting that he wanted to sketch; all the city's cab drivers knew him. Béraud painted in the Impressionist style and hailed Manet as his hero. In paintings like the *Bal Élysée-Ménilmontant* (1880) he was concerned, like Renoir before him, with how to depict several figures in movement lit by gas and natural light.

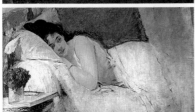

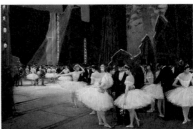

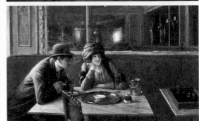

A Box in the Théâtre des Italiens, 1874, Musée d'Orsay; *Morning Awakening*, 1876, Kunsthalle Bremen

In the Wings at the Opera House, 1889, Musée Carnavalet Paris; *At the Café*, Private Collection

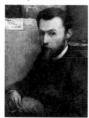

Georges Seurat (1859-1891)

Despite his conservative academic training at the École des Beaux-Arts, Georges Seurat became one of the most innovative and influential painters of modern times. He developed a technique based on his studies of optics and color theory, and his masterpiece, *A Sunday on La Grande Jatte* (1884), is a visual manifesto of his discoveries. To achieve harmony—the most important quality for the artist—Seurat used primary colors applied side by side with their complements. He believed that the small dots of color would mix directly in the eye, eliminating the need to mix colors on a palette. By breaking down the paint surface into dabs of color, Seurat drew attention to the building blocks of painting itself and to the viewer's ability to "take in" painting with the eye. This structured, time consuming method, a departure from the Impressionist's rapid and spontaneous manner of painting, would become known as Pointillism. The contemporary art critic Félix Fénéon hailed Seurat for his discovery, calling him a "Neo-Impressionist." Seurat died suddenly at age 32.

Paul Signac (1863-1935)

Once Paul Signac came across Seurat's proto-Pointillist manner of painting at the first Salon des Indépendants in 1884, he never looked back to the Impressionists he had followed up to that point. A self-taught artist, Signac became the most important proponent of Neo-Impressionism—or Divisionism, as he preferred to call it—after Seurat's early death. Signac was an anarchist who wanted to eliminate social divisions and all government, and working-class people and the industrial outskirts of cities and towns were among his favorite subjects. He also often depicted idealized views of people living in a state of anarchy, in works such as *In Times of Harmony* (1894). Signac was the first to put the ideas of Seurat and the Neo-Impressionists into formal writing. His 1889 treatise, *From Eugène Delacroix to Neo-Impressionism* argued that the group was the locial successor of the Impressionists. He persuaded several artists to experiment with Pointillism, including Pissarro and Van Gogh.

Bathers at Asnières, 1884, National Gallery, London; *A Sunday on La Grande Jatte*, 1884-86, Art Institute of Chicago

Breakfast (The Dining Room), c. 1886-87 Kröller-Müller Museum, Otterlo; *The Papal Palace, Avignon*, 1900, Musée d'Orsay

Émile Bernard (1868-1941)

Émile Bernard rejected both Impressionism and Pointillism, in search of a new artistic vocabulary that was not about accurately representing the world, even in the form of a simple impression. He developed a method of painting that he called "Cloisonnism," in which he filled dark contours with bright areas of color. In paintings like *Breton Women in the Meadow* (1888), Bernard was interested in using line and color to express ideas about the world, rather than in rendering illusions of objects in three dimensions. When Gauguin met Bernard at Pont-Aven in 1888, the older artist was intrigued by this method of painting and adopted it in his own works. To Bernard's dismay, Gauguin received most of the credit for the development of his new technique. Aside from Gauguin, Bernard knew a number of other Post-Impressionist artists. He frequented the Paris nightclubs with Toulouse-Lautrec and was friends with Vincent van Gogh. Theo, Van Gogh's brother, even asked Bernard to organize a retrospective exhibition the year of Vincent's death.

Henri de Toulouse-Lautrec (1864-1901)

A gifted artist from a young age, Henri de Toulouse-Lautrec developed an original painting style that distinguished him from any other artist of his day. Two leg injuries during his adolescence combined with a genetic disorder (possibly attributed to inbreeding among his aristocratic family) left him deformed and feeling like an outcast. He found refuge in brothels, and became a regular in the bars of Montmartre and the red-light district of Pigalle; there he found inspiration for his art, painting prostitutes in a manner both frank and compassionate. He sketched figures in bright blue or green chalk, then applied thin layers of paint that left the drawing visible. Nightclub owners comissioned advertising posters and, inspired by Japanese prints, Toulouse-Lautrec used simplified forms with flat contours and blocks of color. Unlike other poster artists, he often focused on the patrons in the clubs rather than the performers, as seen in *Moulin Rouge: La Goule*, a 1891 poster promoting a popular *can-can* star. He suffered from alcoholism and syphilis and died of a stroke at age 37.

Madeleine in the Bois d'Amour, 1888, Musée d'Orsay; *Breton Women in the Meadow*, 1888, Private Collection

Les Ambassadeurs: Aristide Bruant, 1892 Musée Toulouse-Lautrec

Impressionist Influencers

Eugène Delacroix (1798-1863)
Romantic master Eugène Delacroix was known for his daring use of lush colors—applied in small strokes—that "came together" when viewed from a distance. In the opulent *Death of Sardanapalus* he forgoes perspective, instead creating rich patches of sensuous color and shimmering light. The influence of his color techniques can be felt in the works of Degas but also in works by Renoir, whose *Odalisque* was clearly inspired by Delacroix's *Women of Algiers*.

Gustave Courbet (1819-1877)
Courbet, an important figure in the Realist movement in French painting, applied richly colored paint with broad brushstrokes or a palette knife to create his evocative canvases. His liberal use of thick impasted whites and blacks in paintings like *A Burial at Ornans* (1849-50) was innovative and inspired later painters like Manet (although Courbet refused to go to an exhibition of Manet's paintings, professing not to understand them). His influence can be clearly seen in the early and later works of Cézanne, with their sculptural solidity and liberal use of the palette knife.

Eugène Boudin (1824-1898)
The world owes a debt of gratitude to Eugène Boudin for convincing his protégé Claude Monet to renounce caricatures and instead try his hand at landscapes. A celebrated painter of seascapes and skies, Boudin was one of the first French *plein air* painters. In *Trouville* (1864) he anticipates the Impressionists with loose, feathery brushwork, dabs of pure color, and an interest in the immediacy of light.

Camille Corot (1796-1875)
One of the leading figures of the French Barbizon School and a champion of outdoor (*plein air*) painting, Corot strove to capture the fleeting effects of light and color, creating shapes through contrasting light and tone. In *The Bridge at Narni* (1826), he uses a loose spontaneous style, concentrating on the evanescence of the atmosphere and the water. Morisot studied for several years with Corot, whose treatment of light had a strong affect on all the future Impressionists.

John Constable (1776-1837)
Constable studied light and nature's shifting majesty with a scientific precision, capturing each moment with activated brushwork that often combined several shades of each color to make a vibrant, natural whole. That vigorous brushwork is evident in *Weymouth Bay with Approaching Storm* (1818-1819), where he captured the dark blue of the changing sky and sea and the lively whiteness of the foam. Monet, Pissarro—and later Van Gogh—all benefited from Constable's color studies and used the same technique of juxtaposed hues to create their own "impressionistic" colors.

Joseph Mallord William Turner (1775-1851)
Known as the "painter of light," Turner more than anyone before him made color itself the subject of his shimmering landscapes. In *Landscape with a River and a Bay in the Background*, 1845, Turner uses bright patches of color and atmospheric washes to capture the evanescence of the light. Monet saw Turner's work when he traveled to England in 1870 and some art historians have suggested that Monet's *Impression, Sunrise*—the work that gave rise to the term "Impressionism"—owes much to Turner's dazzling use of color to create shifting values of light.

Henri Fantin-Latour, *Homage to Delacroix*, 1864
Musée d'Orsay

Gathered around a portrait of Eugène Delacroix are Henri Fantin-Latour (in the white shirt), James Whistler (standing in the foreground), Édouard Manet (standing with his hands in his pockets) and the writer Charles Baudelaire, seated on the right.

People Around Impressionism

■ ARTISTS

Zacharie Astruc (1833-1907)

Zacharie Astruc was a painter, poet and art critic who exhibited in the first Impressionist exhibition. Astruc associated with Manet, and has even been credited with titling *Olympia*. Astruc was also incredibly well versed with Spain and Spanish literature; it's likely he played a role in organizing Manet's only trip to Madrid.

Charles Gleyre (1806-1874)

Charles Gleyre was a painter-turned-teacher, whose studio was an early meeting place for Impressionists. His pupils included Sisley, Renoir and Monet, who disliked Gleyre's academic leanings and teaching methods.

Constantin Guys (1802-1892)

With his acute observations and "precious records" of day-to-day civilized society, Constantin Guys was the basis for the eponymous "painter of modern life" in Charles Baudelaire's landmark essay. Guys's illustrations and cartoons, which ran in numerous publications throughout his career, were remarked upon for their ability to distill the essence of a scene.

Félix Nadar (1820-1910)

Born Gaspard-Félix Tournachon, Félix Nadar was a photographer, caricaturist, aeronaut and leftist. The colorful figure had a studio on 35, boulevard des Capucines, which he loaned to a group of artists, who would later be known as the Impressionists, for their first exhibition.

■ CRITICS & WRITERS

Paul Alexis (1847-1901)

Paul Alexis was a critic and novelist, and was Cézanne's friend. He called the Salon des Refuses a "powerful" idea to revive "anemic" institutions. He is depicted in Cézanne's painting *Paul Alexis Reading to Zola*, and was Zola's biographer.

Charles Baudelaire (1821-1867)

Renowned poet and writer, Charles Baude-laire helped define the role of the artist and introduced Paris to the *flâneur*, the urbane social observer. His collection of poems, *Les Fleurs du Mal*, was highly controversial and considered profane by some; Victor Hugo, Marcel Proust and Stéphane Mallarmé were devout fans of the poet's work. Baudelaire posed for portraits by Gustave Courbet and Émile Deroy.

Jules-Antoine Castagnary (1830-1888)

Although Louis Leroy is credited for coining the phrase "Impressionists," another critic that year also called the group of independent artists by the same name. Writing a review for *Le Siecle* on April 29, 1874, Jules-Antoine Castagnary said, "If one wishes to character-ize and explain them with a single word, then one would have to coin the word impression-ists. They are impressionists in that they do not render a landscape, but the sensation produced by the landscape."

Edmond Duranty (1833-1880)

Edmond Duranty was a Realist author and art critic who published "The New Painting" in 1876. The piece served to analyze the Impres-sionist movement, offering contextualization and critical analysis. Duranty was close with Degas and was a frequent patron of the Café Guerbois. After giving Manet short shrift in a review, Manet challenged Duranty to a duel. Duranty was wounded, but the two patched up their differences and remained close for years to come. Legend has it a song was written at the Café Guerbois to commemorate the sword-fighting duo.

Théodore Duret (1838-1927)

A journalist and art critic, Théodore Duret first met Manet in Madrid in 1865. The two struck a friendship and, through Manet, Duret became acquainted with the Impressionists. Duret remained a staunch advocate for Im-pressionism, often defending it in his writings. He also wrote a biography about Manet after the artist's death.

Louis Leroy (1812 - 1885)

Despite having been an engraver and painter in his own right, Louis Leroy is widely remem-bered for having coined the phrase Impres-

sionism. After seeing the debut exhibition of the so-called Intransigents—particularly Monet's *Impression, Sunrise*—Leroy wrote a scathing, satirical review for *Le Charivari*, wherein he remarked, "A preliminary drawing for a wallpaper pattern is more highly finished than this seascape." The term went on to become the official name for the group.

Edmond Maître (1840-1898)
A writer and a musician, Edmond Maître was close friends with Bazille and Renoir. Both painters made portraits of the musician, and Maître can be seen in the painting *Bazille's Studio* playing the piano under a Monet still-life.

Stéphane Mallarmé (1842-1898)
Stéphane Mallarmé was a leading Symbolist writer and friend to Manet, Morisot, Renoir and Degas. His weekly salons, known simply as Mardis (Tuesdays) were a breeding ground for innovative ideas and discussions on art, poetry and philosophy; notable guests included Oscar Wilde, Paul Valéry and Rainer Maria Rilke. The writer and art enthusiast sat for portraits done by Renoir, Manet and Gauguin.

Georges Rivière (1855-1943)
In 1877, Georges Rivière published *L'Impressionniste* to accompany the third Impressionist exhibition. Originally planned during the first exhibition as a means for the artists to articulate their views, the publication was a short-lived affair. In the third edition of the journal, the artists explained they were embracing the term "Impressionists."

Hippolyte Taine (1828-1893)
A noted historian, philosopher and critic, Hippolyte Taine's theories influenced writers like Émile Zola. Taine proposed that the perception of reality was a biological process unique to each individual artist; thus, each artist would represent reality through his or her personal "screen." Taine made acceptable within the scientific community the claim that art combines the objective and the subjective. He also posited that artistic and literary output could be scientifically evaluated from the artist's race (nation), *milieu* (environment) and historical moment (time).

Émile Zola (1840-1902)
A novelist, journalist and an art critic, Émile Zola was also an early proponent of the Impressionists. He is most remembered for three key works: *Les Rougon-Macquart*, a 20-novel series following the lives of a fictionalized family throughout the Second Empire. *L'œuvre*, his *roman à clef*, depicting the tragic life of a painter loosely based on Manet, Monet and childhood friend Cézanne (who severed the friendship on account of the book). Lastly, his open-letter "J'accuse," published in the liberal daily newspaper *L'Aurore*, accusing the French military and government of anti-Semitism after Alfred Dreyfus was wrongfully sentenced to life imprisonment for treason. Zola was convicted of libel and sentenced to prison, but he fled to London until matters calmed down. He died four years after this letter was published from carbon monoxide poisoning resulting from a blocked chimney. He was portrayed in paintings like *Portrait of Émile Zola* (1868) by Manet and Cézanne's *Paul Alexis Reading to Émile Zola* (1869-70).

■ PATRONS & DEALERS

Victor Chocquet (1821-1891)
Victor Chocquet was one of the loudest supporters of the Impressionists, particularly during the time when they had little support. A customs official with very little earnings, he frequented auctions and used his income to purchase works by the likes of Delacroix and Monet, often bowing out after the prices fetched more than 300 francs. He was a Cézanne aficionado and purchased 32 of his works; the artist, in turn, painted several portraits of the polite collector.

Paul Durand-Ruel (1831-1922)
Paul Durand-Ruel was born into a family of art dealers. As a teen, he traveled with his father to sell pictures and source talent. After his father's death, Durand-Ruel continued to expand his profession, establishing a network of international galleries and perfecting his business practices, which included guaranteeing an artist income in exchange for a percentage of their output. A proponent of the Barbizon School, Durand-Ruel was also the most prominent art dealer to support the Impressionists, buying a total of more than 4,000 Impres-

sionist works. Durand-Ruel helped bring Impressionism to the United States, opening a gallery in New York in 1888. Pierre-Auguste Renoir made a portrait of his friend in 1910.

Henri Guérard (1846-1897)

An engraver and graphic artist, Henri Guérard was a friend of Édouard Manet. Guérard was a respected engraver who worked in the *japonisme* style, and often assisted Manet with his etchings. Guérard is portrayed in Manet's *Au Café* alongside actress Ellen Andrée. In 1879, Guérard married Eva Gonzalès, Manet's pupil.

Ernest Hoschedé (1837-1891)

A wealthy businessman and department store owner, Ernest Hoschedé was also an avid art collector. He purchased many Impressionist paintings, mainly from Monet. Bankruptcy in 1877 forced him to move to the suburban home of Monet, his wife Camille and their children. Monet and Hoschedé's families would grow closer and closer over time: Alice, Hoschedé's first wife, became Monet's companion (and second wife, upon Ernest's death) and adopted Monet's children when Camille died.

Ludovic Lepic (1839-1889)

Vicomte Ludovic Napoléon Lepic was a watercolor artist and printmaker who trained in Charles Gleyre's studio with Monet and Bazille. Lepic's work has been largely forgotten, but it is important to note that he introduced Degas to printmaking and the monotype technique. *The Ballet Master*, Degas's first attempt at the process, was done with help from Lepic. Degas brought him into the Impressionist group, where Lepic exhibited at the first two shows. Lepic's wealth allowed him to support his fellow artists, although he was adamant about excluding Cézanne. After he was banned from exhibiting at the Salon, Lepic parted ways with the group.

Julien "Père" Tanguy (1825-1894)

Known to many artists as Père (Papa), Julien Tanguy sold art supplies from his shop on rue Clauzel, a popular meeting space for artists. He would often exchange works from his patrons (including Cézanne, Van Gogh and Seurat) for painting materials, then he would exhibit the paintings in the back room. Well-

liked by many, he was the subject of several portraits, including three by Van Gogh.

Ambroise Vollard (1866-1939)

Born in the French island of Réunion in the Indian Ocean, Ambroise Vollard was a very powerful art dealer. A shrewd businessman and patron, he made a name for himself by launching solo shows for Manet, Cézanne and Van Gogh. Vollard was not a particularly charming man, and he was described as being boorish, grim and mysterious. He apparently suffered from narcolepsy, as there are many accounts of the dealer falling asleep in unusual times and places. Vollard asked many of the artists he knew to paint him, including Cézanne, Renoir and Picasso.

■ SCIENTISTS

Louis Daguerre (1787-1851)

Louis Daguerre introduced the daguerreotype—his photographic process using metal plates and light-sensitive chemicals—to France in January of 1839. By December, a caricaturist in Paris would depict a world overrun with daguerreotypes. So popular was the invention that, in little more than a decade and a half, millions of daguerreotypes had been produced—portraits, mostly, were the preferred subjects. Painters, in particular, noted the importance of the process, as it pushed them to accurately record the natural world; Impressionist painters like Caillebotte used photography as an aid for their work.

Hermann von Helmholtz (1821-1894)

Hermann von Helmholtz was a German physician and physicist whose optical theory influenced the Impressionists and Neo-Impressionists. He deduced the difference between color as rays of light and color as solid pigment, which went on to influence Seurat's application of color.

Impressionist Connections

Berthe Morisot

Morisot married Manet's brother Eugène

Édouard Manet

Friendship

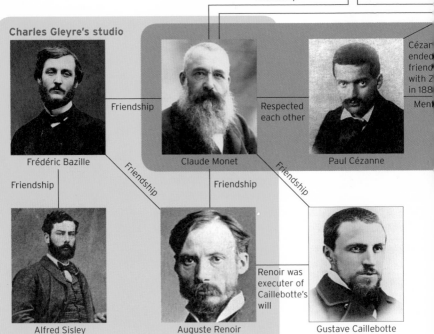

Charles Gleyre's studio

Frédéric Bazille — Friendship — Claude Monet — Respected each other — Paul Cézanne

Cézar ended friend with Z in 188

Men

Friendship

Friendship

Friendship

Friendship

Friendship

Alfred Sisley

Auguste Renoir

Renoir was executer of Caillebotte's will

Gustave Caillebotte

When they became acquainted:

1858: Pissarro attends the Academie Suisse and meets Monet

1861: Pissarro meets Cézanne at Academie Suisse

1862: Manet meets Degas at the Louvre

1862: Monet meets Renoir, Sisley and Bazille at the studio of Gleyre

1868: Morisot is introduced to Manet by Fantin-Latour while copying a Rubens at the Louvre

1874: Pissarro meets Gauguin at a collector's home

1877: Degas asks Cassatt to join the Impressionists

1882: Van Gogh meets Toulouse-Lautrec and Bernard in Cormon's studio

1885: Through Guillaumin, Pissarro meets Seurat and Signac

1886: Gauguin first meets Van Gogh after returning to Paris from Pont-Aven

Impressionist Supporters

Émile Zola

Charles Baudelaire

Stéphane Mallarmé

Friendship Friendship

Academie Suisse

Camille Pissarro

Edgar Degas

Mary Cassatt

Mentorship

Pissarro was
influenced by
Seurat

Mentorship

Fernand Cormon's studio

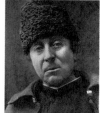

Paul Gauguin

Lived and
worked
together in
Arles.

Vincent van Gogh

Friendship

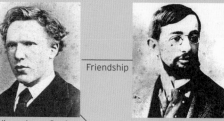

Henri de
Toulouse-Lautrec

Friendship

Émile Bernard

Neo-Impressionists

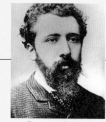

Georges Seurat

Paul Signac

Mentorship

IMPRESSIONISM **91**

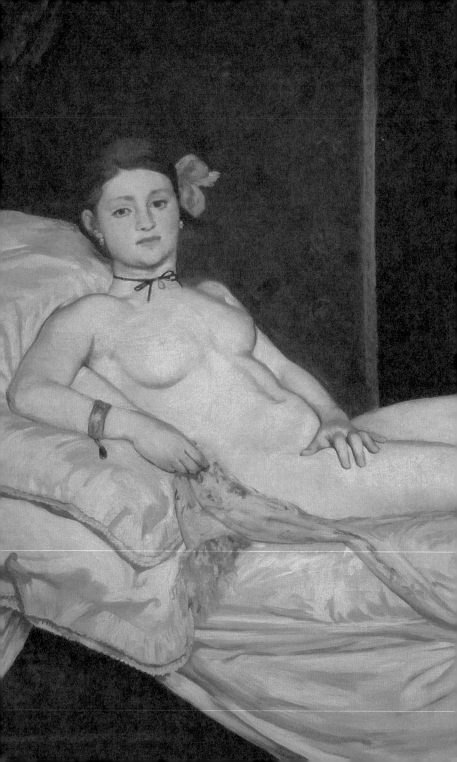

How the Impressionists Broke from the Salon

by Lelia Packer

In 1865, the Salon was buzzing with gossip. Rules for admission to the exhibition had relaxed somewhat, and Édouard Manet's *Olympia* was among works accepted. It created a complete scandal. With its shockingly unidealized portrayal of a prostitute and its flat areas of unpolished brushstrokes, the painting reveled in its own artificiality while simultaneously celebrating a modern naturalism. It was a landmark moment in art history, the moment modern art was born.

Throughout the 18th century, the Salon was the only public venue for Parisians to view the art of the day. Juries selected by the French Académie des Beaux-Arts decided which artists to include and which to exclude from the art establishment. The writer Émile Zola, the first outspoken critic against the Salon, lamented in 1866 that the Salon was not about the work of artists, but was instead a showcase for the jury, who handpicked art that it considered suitable for French official taste.

The Salon of 1863 was called the "Salon of the Venuses" as the goddess of love made an appearance in several of the works on display. Of particular note was the *Birth of Venus* by Alexandre Cabanel. Émile Zola mockingly wrote: "the goddess, drowned in a river of milk, resembles a delicious courtesan, not made of flesh and bone-that would be indecent-but of a sort of pink and white marzipan." Napoleon III purchased the painting for his private collection. In contrast, Édouard Manet's *Olympia* was painted with a frank style and contemporary details not seen before in paintings of the female nude, causing a major scandal.

Fed up with the scrutiny of the conservative Salon juries, artists began to look for alternative ways to show their art. Manet and Gustave Courbet each erected a pavilion near the entrance to the 1867 Universal Exhibition to showcase their works to the crowds heading to the fair. Critics largely ignored the shows. For the rest of his life, Manet continued to seek acceptance from the Salon, which he considered the true battleground for the avant-garde. At the same time, a group of artists (motivated by financial and commercial distress) decided to form their own independent exhibition. Though they varied stylistically, each shared the Realist impulse to portray modern life as they experienced it. In December 1873, the Société Anonyme des

François-Joseph Heim
Charles X Distributing Awards to Artists Exhibiting at the Salon of 1824 at the Louvre, 1827, Musée du Louvre

The Salon

For a 19th-century French artist, there was no faster ticket to success than having work shown in the Paris Salon, the official exhibition of the French Academy of Fine Arts in Paris.

The Salon was first held in 1667 when the Royal Academy of Painting and Sculpture put on an exhibition of works by recent graduates of the École des Beaux-Arts. The show took its name from in the Salon Carré, an elegant large hall in the Louvre, and was staged with the blessing of Louis XIV, the French "Sun King." The Academy changed its policy in 1737 to allow the public to submit work and, in 1748, a jury was created to judge which entries should be accepted, adding even more cachet to the already illustrious event.

For almost 150 years the Paris Salon, as it came to be known, was the most prestigious event in the art world. Thousands of artists submitted paintings and sculpture which covered every square inch of the exhibition rooms' walls. The juries were notorious for their conservative, academic taste and were not receptive to the new styles and techniques that were captivating the Parisian art scene. In 1863 they turned down a record number of submissions and the outcry led to the staging of the Salon des Refusés, a show of rejected work, which included paintings by several leading Impressionists.

Eventually, artists began organizing their own shows and, in 1881, the French government withdrew its support of the Salon. It was taken over by the Société des Artistes Français, which still organizes it today. Today the Paris Salon is just one of many annual art shows and salons—including the Salon des Independants, the Autumn Salon, and the May Salon—and no longer holds the power it once held over French artists' careers.

Henri Fantin-Latour, *A Studio in Les Batignolles*, 1870, Musée d'Orsay.
From left to right: Otto Scholderer, Édouard Manet, Pierre-Auguste Renoir, Zacharie Astruc,
Émile Zola, Edmond Maître, Fédéric Bazille and Claude Monet.

Artistes, Peintres, Sculpteurs, Graveurs, etc. (Corporation of Artists, Painters, Sculptors, Engravers, Etc.) was founded. Between 1874 and 1886, they organized eight group shows, known today as the Impressionist Exhibitions.

Though inspired by Courbet and Manet's ad hoc shows, the Impressionist Exhibitions were the first time a group of artists collectively protested against the Salon's authority and provided an alternative space for viewing contemporary art. The Salon had held a monopoly on public taste for much too long. This avant-garde group was determined to break free of the Académie's authority and to make a name for themselves.

The first Impressionist exhibition was held from April 15–May 15, 1874, in a centrally located studio (formerly the workspace of the photographer Nadar) at 35, boulevard des Capucines. The Impressionists transformed Nadar's studio into a modern art gallery: they covered the walls in black and made sure there was enough natural light. The organizers advertized the show in newspapers, journals and through word of mouth, and set the opening date — two weeks before the Salon opened its doors.

The Salon des Refusés

In 19th-century France, an artist's reputation could be made or broken by whether or not his work was accepted by the prestigious Paris Salon. In 1863, a record number of artists were shocked to receive the dreaded rejection notice. The sheer volume of rejections created a mini-scandal, prompting Emperor Napoleon III to request the creation of a Salon des Refusés, an exhibition of works that had been rejected (refusé) by the official Paris Salon.

The Paris Salon was one of the most important events of the French art world and established academic artists and brash newcomers alike submitted their work, hoping for recognition, prizes and coveted royal commissions. The Salon jury had always been fairly picky, favoring more traditional artists over newer ones, but the 1863 jury proved particularly hard to please. Of the more than 5,000 pieces that had been submitted, only 2,217 were accepted, leading to howls of protest and cries of foul from the Parisian art community. The long list of rejected painters and sculptors included not only controversial newcomers like Renoir, but also well-known academic painters who had been included in previous years, such as Johan Barthold Jongkind, whose paintings had received gold medals in previous Salons.

Alarmed by the discontent the decisions had created, Napoleon visited the Palais des Champs-Élysées to see for himself. There, he was shocked to see series of paintings representing the four seasons that he himself had commissioned hanging among the rejected works, stamped on the back with the dreaded red "R" for refusé.

To placate the protesting artists, Napoleon declared that a second exhibition would be held in another part of the Palais des Champs-Elysees so that the public could decide for itself if the jury had been fair or too harsh. While all 2,000 of the rejected

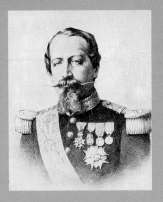

Emperor Napoleon III

artists were invited to participate, many declined, not wanting to incur either the Salon judges' wrath or the public's ridicule. In the end, fewer than 500 artists agreed to participate, but among them were such masters as Paul Cézanne, Camille Pissarro, Henri Fantin-Latour, James Whistler, with his majestic *Symphony in White*, and Édouard Manet, with three paintings displayed prominently in the last of the 12 rooms, including his controversial *Déjeuner sur l'Herbe*, *(Luncheon on the Grass)*, one of the most scandalous paintings of the day.

The public and critics were unsure what to make of the Salon des Refusés. Many of the paintings were met with laughter and derision, particularly Manet's groundbreaking *Luncheon on the Grass*, which portrayed two classical nudes and two men who were fully dressed, sitting together, inexplicably, on the grass.

In spite of the ridicule, the Salon des Refusés paved the way for a growing acceptance of the emerging Impressionist movement and several more Salons des Refusés were held over the next two decades as the influence of the official Salon gradually declined.

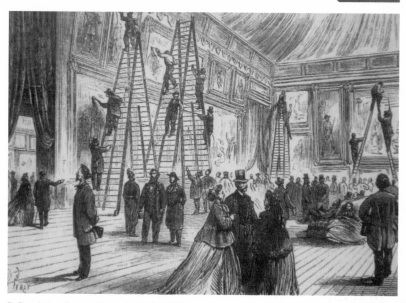

B. Perat, *Vernissage, Salon de Paris*, 1866
The vernissage, or exhibition preview, with workers still hanging art in the background.

Among the 30 artists who showed over 200 works were Edgar Degas, Claude Monet, Berthe Morisot, Camille Pissarro and Auguste Renoir. All were relatively unknown to the public. The show ran daily from morning to night, and artists offered discounts to those who bought directly from the venue.

Participants were prohibited from also submitting work to the Salon. This was not a concern for most of them; the jury had repeatedly rejected their submissions. Some, like Pissarro and Morisot, had shown with the Salon before, but their paintings were poorly exhibited in back rooms known as

"Impressionist painting: a revolution in painting that begins by causing terror."

"*le dépotoir*" ("the dump"). Others, like Renoir, exhibited at both venues over the years, realizing that many collectors needed "the backing of the Salon" to like a painting.

Only about half of the artists who exhibited in these alternative shows were Impressionists. The others were academically inclined painters that have since been forgotten. Monet had objected to including them, but Degas

L'affaire Caillebotte
How Impressionist Paintings Finally Made it to a Museum

Caillebotte and Gérôme

The painter and patron Gustave Caillebotte was one of the first to collect works by his contemporaries, including Monet, Renoir, Degas, Cézanne and Sisley. In a prescient move at 28, Caillebotte drafted a will bequeathing 69 works of art to France. His bequest became a drawn-out scandal.

Caillebotte stipulated the entire collection was to be accepted and exhibited at the Musée du Luxembourg and, eventually, the Louvre. Of utmost importance was the "attic or provinces" provision: the paintings could neither be relegated to an attic nor sent to a provincial museum.

When Caillebotte died in 1894, his brother Martial and friend Renoir—named executor of his will—set about to honor the bequest. Opposing them were Henry Roujon, the Director of the Académie des Beaux-Arts, and Léonce Bénédite, the Director of the Musée du Luxembourg, who maintained that the Luxembourg was too overcrowded to admit all 69 works and that policy dictated no artist should have more than four works on display.

The Academy was also adamantly against the bequest, fearing it would sully and undermine the establishment. The painter Jean-Léon Gérôme invited the press to protests at his studio, proclaiming: "For the state to accept such filth would be a blot on morality." Meanwhile, progressive-minded supporters published articles decrying the museum's willful exclusion of the works. It was an *affaire delicate*; Renoir and Martial were labeled uncooperative, while Roujon and Bénédite were lambasted for not honoring the will.

Caillebotte's longtime friend, the lawyer Albert Courtier, proposed a solution: the Luxembourg would accept that portion which it could hang, and the rest would become Martial Caillebotte's property. Thirty-eight paintings and pastels were selected (two Millet drawings had initially been admitted), leaving Martial in possession of 29 Impressionist works. American art collector Albert C. Barnes later purchased the majority of these remaining paintings, now housed at the Barnes Foundation in Philadelphia.

In early 1897, the Caillebotte collection went on view in the Musée du Luxembourg, in an annex built to accommodate the paintings. For the first time ever, the Impressionists, as a group, had a museum exhibition in France. This time around, no one laughed or mocked.

and Pissarro thought they would help the Impressionist cause. And they did. The Impressionist paintings stood out as something new and innovative against the more traditional offerings.

The exhibit garnered immediate—and mixed—reactions. One critic said that he left feeling angry, wishing that he had instead given the entry fee (one franc) to a beggar. Another famously compared Monet's painting, *Impression, Sunrise*, to wallpaper. Critic Louis Leroy scathingly reviewed the show in his critique "Exhibition of Impressionists," the name alluding to Monet's piece. One man even wrote of wiping his spectacles when looking at the hazy paintings because he thought his glasses were dirty. Despite the backlash, others had more positive things to say. Many were impressed by the efforts of mounting such exhibitions and praised the Impressionists' freedom from authority. The paintings were described as "fresh" and "gripping," in comparison to the banalities being produced by the Académie.

Fewer artists participated in the second 1876 show (which brought in even less money), most likely because the first exhibition yielded meager profits and numerous negative reviews. The show inspired the critic Edmond Duranty to write "The New Painting," a leaflet in which he praised the Impressionists for their groundbreaking ability to translate the subtleties of light to paint. Public ridicule and harsh critiques aside, there was still a growing sense that a new and revolutionary art was being produced in France.

From the core group of Impressionists, Pissarro was the only one who was represented at all eight shows, while Degas and Morisot exhibited in all but one of them. The wealthy Gustave Caillebotte, a member and patron of the Impressionists, was responsible for funding many of the shows, as they continued to bring in little profit. Beginning in 1879, some of the Impressionists mounted individual shows as well, in an effort to sell their art and increase their popularity. Between 1879 and 1880, Monet, Manet

Paul Durand-Ruel

and Renoir all had one-man shows at the offices of *La Vie Moderne*, a weekly magazine. In 1883, the art dealer Paul Durand-Ruel—a faithful patron of the Impressionists who almost went bankrupt because of it—mounted several individual shows at his gallery for Monet, Renoir, Pissarro and Sisley. At the urging of American-born Mary Cassatt, he also marketed the Impressionists in America—culminating with a show in New York in 1886.

Official acceptance proved more difficult to find in France. When Caillebotte died in 1894, he stipulated his collection of Impressionist art go to the Musée du Luxembourg (dedicated to living artists) and later, to the Louvre. Under the aegis of Renoir, it took two years of intense debate for the museum to accept 38 works from the 61-piece collection, including such masterpieces as Renoir's *Bal du moulin de la Galette*, Manet's *Le balcon* and Caillebotte's own *Floor Scrapers*. The exhibition went on display in February of 1897, marking the recognition of a new chapter in the history of art. Today these works can be found at the Musée d'Orsay.

Art After Impressionism

After fighting to make names for themselves in industrialized and urban Paris, many Impressionists moved away to be closer to nature in the 1870s and '80s. Monet went to Giverny, Pissarro to Éragny, Sisley to Saint-Mammès, and Cézanne to Aix-en-Provence, in the south of France. Their individual initiatives mounting one-man shows and their geographical separation caused the common will of the Impressionists to gradually dissipate and the Société Anonyme to disintegrate, as each artist pursued his or her own course. Some, like Monet, delved deeper into their own practices, revisiting themes and obsessively working to perfect their style. Others began to experiment with new modes, further breaking down the creation of art to its most essential parts: color and form.

These Post- or Neo-Impressionists extended the aims of their predecessors by making their brushstrokes thicker, their colors brighter and their forms even further removed from the natural world—a forward thrust that would continue for most of the 20th century.

As early as 1886, Pissarro began to experiment with new techniques, using the dappled brushstrokes favored by Georges Seurat and Paul Signac since 1884 (though the older Pissarro later renounced this style). New advances in color theory and the understanding of optics were at the core of Seurat's Divisionism and Signac's Pointillism, two styles that utilized carefully arranged dots of pure color to create luminosity and harmony.

By 1888, Vincent van Gogh—inspired by the light in the South of France—was experimenting with pure color, applying daubs of paint directly from the tube in sets of complimentary hues. His friend Paul Gauguin was also experimenting with color, though in a more emotional, less methodical way. Working in rural Brittany with the young painter Émile Bernard, Gauguin worked in a style combining subject matter, emotion and pure aesthetics, often in a symbolic way. It was dubbed Cloisonnism in 1888, after the way it broke objects down into simple pieces of flat color, like a stained glass window. At the same time, Cézanne was extending his studies of geometric form. From the 1890s onward, his work reveled in his desire to break objects down to simple shapes—the cylinder, sphere and cone. His still-lifes and landscape studies often show a single object from a number of vantage points.

Such explorations of style, color and form paint a direct line to the important developments in 20th century art. Cézanne's unusual angles inspired Pablo Picasso and Georges Braque, who would go on to create Cubism; the bright planes of color used by Van Gogh, Gauguin, Seurat and Signac inspired the abstraction of the Fauves, or "wild ones," led by Henri Matisse and André Derain. With each new movement came differing ways of creating, observing and appreciating art. What began with an outrage over *Olympia* became the revolutionary forward march of modern art.

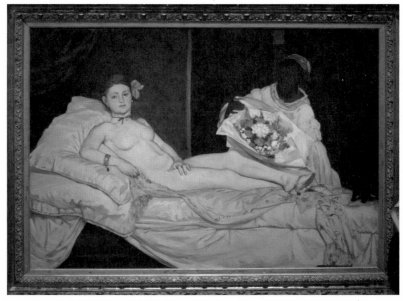

Paris and Impressionism Timeline

	Paris Events	Impressionism Events
1850s	1852: Second Empire 1853: Haussmannization 1855: Universal Exposition	1855: Courbet sets up a pavilion near the Universal Exposition.
1860s	1867: Universal Exposition	1863: Manet shows at Martinet's gallery; The Salon des Refusés. 1865: Shocking debuet of Monet's *Olympia* at the Salon. 1867: Manet and Courbet set up their own exhibition pavilions. 1868: Impressionists gathering at the Café Guerbois.
1870s	1870: Franco-Prussian War 1871: Paris Commune and Third Republic 1875: Palais Garnier 1878: Universal Exposition	1874: The 1st Impressionist exhibition 1876: The 2nd Impressionist exhibition 1877: The 3rd Impressionist exhibition 1879: The 4th Impressionist exhibition. Renoir's one-man show at the offices of *La Vie Moderne*.
1880s	1889: Eiffel Tower and Universal Exposition.	1880: The 5th Impressionist exhibition. Manet and Monet's one-man shows at *La Vie Moderne* 1881: The 6th Impressionist exhibition 1882: The 7th Impressionist exhibition 1883: A series of one-man exhibitions at Durand-Ruel gallery: Monet, Renoir, Pissarro, Sisley Impressionists exhibition in London. 1886: The 8th Impressionist exhibition American exhibition of Impressionist.
1890s & After	1900: Universal Exposition	1895: Cézanne's first one-man show at Ambroise Vollard gallery. 1926: Monet's death.

Opposite: *Édouard Manet "French Impressionist painter getting the better of the art establishment,"* cartoon by André Gill in *L'Eclipse*, May 14, 1876.

NEUVIÈME ANNÉE. — N° 394.　　PARIS ET DÉPARTEMENTS : 10 CENTIMES　　DIMANCHE 14 MAI 1876

FONDATEUR
F. POLO

ABONNEMENTS
PARIS
méros...... 6 fr.
méros...... 3 —

s abonnements partent du
1er de chaque mois

BUREAUX
6, rue du Croissant, 16

FONDATEUR
F. POLO

ABONNEMENTS
DÉPARTEMENTS
52 numéros................. 8 fr.
26 numéros................. 5 —

ANNONCES
Fermage exclusif de la publicité
ADOLPHE EWIG
10, rue Taitbout, 10

ADRESSER LES ABONNEMENTS ET RÉCLAMATIONS A L'ADMINISTRATEUR DU JOURNAL

LES TRIOMPHATEURS DU SALON, PAR GILL.

Detaille : *La Réconnaissance*, ou le triomphe de Meissonier. — **Firmin-Girard** : *Le Marché aux Fleurs*, ou le triomphe de l'adresse et de la photographie. — Caro
n & Vibert : *La Marquise et la Banquière*, ou le triomphe des escaliers chics. — **Clairin** : *Sarah-Bernhardt*, ou le triomphe de la levrette. — **Feyen-Perrin** : Les C
er, ou le triomphe de la grâce. — **Jean Béraud** : (141) *La Sortie du cimetière*, ou le triomphe de l'esprit. — **G. Doré** : *L'Entrée à Jérusalem*, ou le triomphe de la dimen
la tapisserie. — **Bastien Lepage** : *M. Wallon*, ou le triomphe de la sincérité. — **EDOUARD MANET**, ou le triomphe de l'absence.

1st Exhibition

April 15 – May 15, 1874

—

35, boulevard des Capucines
2nd arrondissement

—

165 Works

30 artists including Monet, Degas, Pissarro,
Renoir, Cézanne, Sisley, Morisot

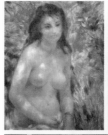

Monet, *Impression, Sunrise;* Cézanne, *The House of the Hanged Man, Auvers-sur-Oise;* Renoir, *La Loge*

The Société Anonyme des Artistes

Though this first exhibition organized by the Impressionists was well attended, it was by a public more curious than admiring. Most of the critics at the show took the artists anything but seriously; only a handful recognized the break from traditional painting the Impressionists were trying to make. It is at this show where the group became the Impressionists, a name they appropriated from a satirical review that lambasted Claude Monet's painting, *Impression, Sunrise*. The exhibition did not earn enough to cover its costs so an auction was held at the Hôtel Drouot on March 24, 1875, to make up the difference. The average price of a painting was little more than 100 francs. At this exhibition the painters found some of their longest lasting supports, Victor Chocquet, Ernest Hoschedé and Georges de Bellio.

2nd Exhibition

March 30 – April 30, 1876

—

11, rue Le Peletier
9th arrondissement

—

252 Works

20 artists including Monet, Degas, Pissarro,
Renoir, Sisley, Morisot, Caillebotte

Renoir, *Nude in the Sunlight;* Monet, *La Japonaise;* Caillebotte, *The Floor Scrapers*

Arrival of Caillebotte

The Impressionist's second exhibition took place at the Durand-Ruel Gallery, 11 rue Le Peletier. New additions to the show were Gustave Caillebotte, Marcellin Desboutin and Alphonse Legros, while Paul Cézanne opted not to participate. Beginning with this show, Caillebotte played an important role in organizing and financing the exhibitions. Unfortunately, this exhibition faired no better with the critics and the crowds, having already snickered at the first show, stayed away. Albert Wolf wrote in *Figaro magazine*, "Rue Le Peletier is unlucky. After the fire at the Opera, here is a new disaster befalling the district..." Wolf described Auguste Renoir's nude from the exhibition as a "mass of flesh in the process of decomposition, with green and violet spots which denote the state of complete putrefaction of a corpse."

April 1 – April 30, 1877

6, rue Le Peletier
9th arrondissement

230 Works

18 artists includng Monet, Degas, Pissarro, Renoir, Cézanne, Sisley, Morisot, Caillebotte

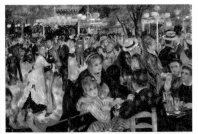

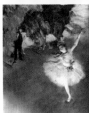

Renoir, *Dance at Moulin de la Galette*; Cézanne, *Portrait of Mr. Chocquet;* Degas, *L' Etoile*

Impressionism Masterpieces

This show marked the first time that the artists called themselves "Impressionists," titling the carefully planned show the "Exhibition of Impressionists," despite opposition from Degas. Caillebotte played an even bigger role, producing the event, paying for the five-room apartment where it took place and mounting a major advertising campaign. The show included some of Impressionism's greatest masterpieces, including Monet's *Gare Saint-Lazare*, Renoir's *Dance at the Moulin de la Galette*, Degas's *L'etoile* and Caillebotte's *Paris Street, Rainy Day*, which all received favorable reviews. Cézanne's offerings, including *Portrait of Mr. Chocquet*, received vitriolic attacks by critics; he never exhibited with the Impressionists again. Despite the breadth of work exhibited, the show was a financial failure once more.

April 10 – May 11, 1879

28, avenue de l'Opéra
1st arrondissement

165 Works

15 artists including Monet, Degas, Pissarro, Caillebote, Cassatt, Gauguin

Degas, *La La at the Cirque Fernando, Paris* Caillebotte, *Rooftops under Snow;* Monet, *Church at Vétheuil with Snow*

Artists Return to the Salon

This exhibition saw the absence of Renoir, Cézanne and Alfred Sisley. Facing financial difficulty, they had submitted work to the Salon, which was prohibited by Degas. Berthe Morisot was also absent, as she had recently had a baby. Monet ultimately refused to attend the exhibition, but allowed Caillebotte to pick up his paintings for the show and to display some of his paintings from Caillebotte's private collection. For the show, Degas chose a more neutral title, calling it the "Exhibition of a Group of Independent Artists." This exhibition also marked the first appearances by Paul Gauguin and Mary Cassatt. It was also the first time an Impressionist exhibition made any money. Caillebotte reported 15,400 admissions, which covered all expenses and paid each artist 440 francs.

5th Exhibition

April 1 – April 30, 1880

10, rue des Pyramides
1st arrondissement

232 Works

19 artists including Degas, Pissarro, Morisot, Caillebotte, Cassatt, Gauguin

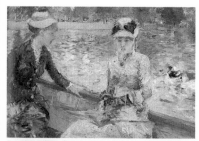

 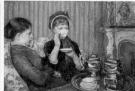

Morisot, *Summer's Day*; Cassatt, *Tea*; Degas, *At the Stock Exchange*

Separation of the Group

This exhibition was plagued with trouble from the very start, with Degas and Caillebotte arguing over the title, and the continued absence of Cézanne, Renoir and Sisley, as well as Monet, who had opted to show in the Salon. In addition, the venue chosen was undergoing renovations that caused such a distracting noise–vibrations shook the room–that critics noted it in their reviews. They also mentioned that the paintings were poorly lit and inadequately hung. Attendance at the show reverted to dismal levels. Since 1879, Monet and Renoir (as well as Manet, who never exhibited with the Impressionists) had held solo exhibitions at the offices of *La Vie Moderne*, ending their need to participate in poorly organized, poorly received group exhibitions.

6th Exhibition

April 2 – May 1, 1881

35, boulevard des Capucines
2nd arrondissement

170 Works

13 artists including Degas, Pissarro, Morisot, Cassatt, Gauguin

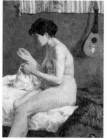 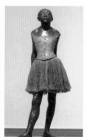

Gauguin, *Study of a Nude* or *Suzanne Sewing*; Degas, *Little Dancer of 14 Years*; Cassatt, *Holding a Big Dog*

Degas's Exhibition

This exhibition saw the breaking point between Degas and Caillebotte. After Caillebotte was unsuccessful in gaining Pissarro's support in ridding the group of Degas, he himself withdrew from the show. This exhibition had the classic signs of a show organized by Degas, with an emphasis on Realism. The show was held in the same studio as the first Impressionist exhibition, this time crammed into five smaller rooms at the back of the building that were poorly lit and cluttered with furniture. Once again, attendance was low and critics were harsh, though works by Mary Cassatt and Morisot were well-received. Degas's realistic wax figure of dancer Marie van Goethem–featuring a wig, hair ribbon and tutu–caused a scandal.

7th Exhibition

March 1 – March 31 , 1882

251, rue Saint-Honoré
1st arrondissement

203 Works

9 artists including Monet, Pissarro, Renoir,
Sisley, Morisot, Caillebotte, Gauguin

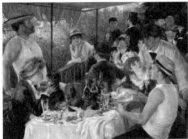

Renoir, *Luncheon of the Boating Party;*
Morisot, *The Harbor at Nice;* Sisley, *Overcast Day at Saint Mammes*

Original Impressionists Return

Not to be deterred by Degas, Caillebotte
once more attempted to gather his friends
together for an exhibition starting at the end
of 1881, with gallerist Durand-Ruel offering to
help with the business side. This new exhibition spurred Degas and saw the departure of
him and his group, leaving only nine artists
to show their work. The display at the "Exposition de Artistes Indépedants" included 35
paintings by Monet, 34 from Pissarro, 25 by
Renoir and 12 by Morisot, with prices ranging
from 500 to 2,500 francs. The show took
place in a building that held a panorama of
the battle of Reichenshoffen, commemorating the French defeat during the Franco-Prussian War of 1870-71, which had many
critics remarking on the strange juxtaposition of nationalism and avant-garde art.

8th Exhibition

May 15 – June 15, 1886

1, rue Laffitte
9th arrondissement

249 Works

17 artists includng Degas, Pissarro, Morisot,
Cassatt, Gauguin

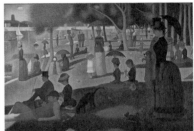

Seurat, *A Sunday on La Grande Jatte;*
Degas, *The Tub;* Signac, *Gas Tanks at
Clichy*

Birth of Neo-Impressionism

This final Impressionist exhibition was held
at the Maison Dorée, a popular, upscale
restaurant. Once more, production credit
returned to the hands of Degas and Pissarro,
who included the work of Neo-Impressionist
painters Georges Seurat and Paul Signac,
including the debut of Seurat's famed *A Sunday on La Grande Jatte*. Their method, called
both Pointillism and Divisionism, implemented the use of tiny dots of pure pigment
in complementary hues. This development,
based on optical science, signaled the beginning of the Post-Impressionist era. Critics
took particular offense at Degas's pastels,
which showed women in states of disrobe,
washing and dressing; Degas was labeled "a
ferocious misogynist" who took pleasure in
debasing women.

Museum Tours

The museums of Paris are home to some of the most exquisite works of art on the planet. Among them are these 150 Impressionist masterpieces that no visitor should miss. From idyllic images of the countryside to bawdy café scenes, these images paint a picture of life in Paris at the end of the 19th century.

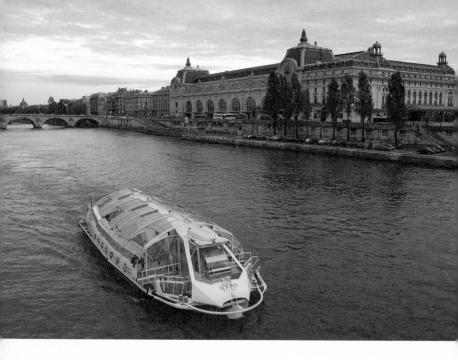

Musée d'Orsay

Musée d'Orsay
- 🏠 1, rue de la Légion d'Honneur
 7th arrondissement
- ☎ +33 (0)1 40 49 48 14
- 🖥 musee-orsay.fr
- 🕙 Tue-Sun 9:30AM-6PM, Thu 9:30AM-9:45PM
- € Museum ticket: €8
 Exhibition ticket: €10

Access: Located on the Left Bank in Paris, accessible by the Assemblée Nationale or Solférino Métro stops, 12 line.

One of the largest museums in Paris, the Orsay was originally built in the Beaux-Arts style as the railway station Gare d'Orsay in 1898. In 1939, the building became unsuitable for train use and in 1977 was turned into the museum, opening its doors in 1986.

The primary focus of the Orsay's collection is French art from the mid 19th to the early 20th century, but it is best known for its expansive collection of Impressionist and Post-Impressionist masterpieces, the largest in the world. The Orsay owes much of its extensive collection to the Musée du Luxembourg, founded by Louis XVIII in 1818 as a venue for the work of living artists, with the promise that the works would be transferred to the Louvre 10 years after their death, if their "glory had been confirmed by universal opinion."

Initially, the Luxembourg's works were purchased almost exclusively from the Salon, with a focus on history paintings, portraiture and classical

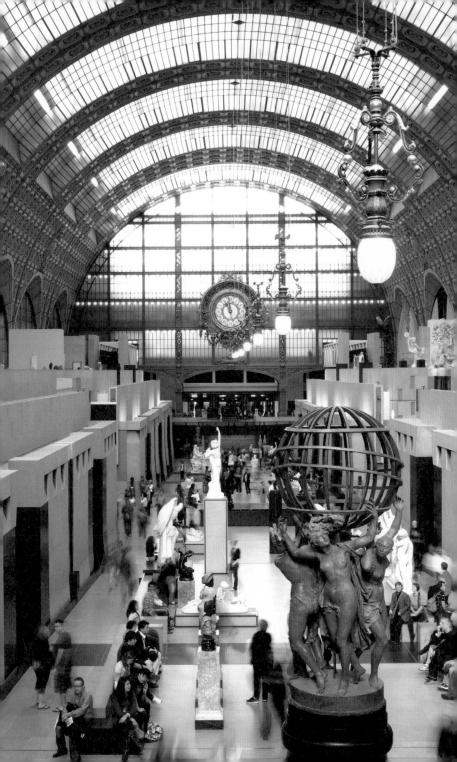

landscape. The museum's doors were closed to the more experimental work of the time such as Impressionism. But in 1890, a group of subscribers led by Claude Monet managed to open the doors of the Luxembourg Museum to Édouard Manet's *Olympia*. Then, in 1894, Gustave Caillebotte, an artist and patron of the Impressionists, died, bequeating his collection to France with the stipulation that it be displayed. After initial resistance and drawn out debate, the museum was forced to exhibit the works. Caillebotte's collection numbered more than 60 paintings by Degas, Manet, Cézanne, Monet, Renoir, Sisley, Pissarro and Millet, which in one swoop brought the Impressionists into not only the Luxembourg, but also the various institutions in Paris that shared the collection.

The Impressionist collection continued to grow at the Luxembourg with further bequests, including that of Van Gogh's friend Dr. Gachet. In the late 1800s, the museum opened its doors to foreign painters. This collection of foreign works eventually grew so large that, in 1922, the separate Musée du Jeu de Paume was created to house the works. In 1929, the Luxembourg transferred all the work from the Impressionists to the Louvre.

The Louvre reorganized its collection in 1947 and sent all their Impressionist works to the Musée du Jeu de Paume, located in a former tennis court. The new works proved so popular with the public that crowding became a safety concern. It was decided to convert the disused Gare d'Orsay into the museum we see today to house all of the work. Some of the collection's masterpieces include Manet's *Olympia*; Monet's *Poppies Blooming* and Van Gogh's *L'Arlésienne*.

The Orsay holds regular movie screenings and concerts and has a glittering restaurant that first opened in 1900 and serves traditional French cuisine, with dishes that often correspond to the museum's events.

ÉDOUARD MANET

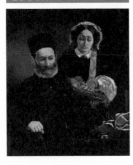

**Portrait of M. et Mme.
Auguste Manet**
1860, oil on canvas
111.5 × 91 cm (43.9 × 35.8 in)

The first painting Manet submitted to the Salon—*The Absinthe Drinker*—was rejected in 1859. In 1861, he submitted two works: *The Spanish Singer* and this portrait of his parents. The former garnered praise, while viewers commented that this canvas was overly realistic, that Manet's father—who would die two years later—looked old and his mother seemed agitated. The painting gives a glimpse into upper-middle-class life during the Second Empire.

Lola de Valence
1862, oil on canvas
123 × 92 cm (48.4 × 36.2 in)

Lola de Valence (real name Lola Melea) was the star of the Mariano Camprubi dance troupe from Madrid. Spanish fashion had influenced Paris since the 1840s; the French Empress Eugénie De Montijo, originally from Spain, was even considered a style icon in the country. Manet's earlier work, *The Spanish Singer*, received praise at the Salon of 1861, but this depiction of a modern Spanish figure was rejected from the 1862 Salon.

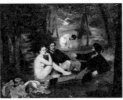

**Le déjeuner sur l'herbe
(Luncheon on the Grass)**
1863, oil on canvas
208 × 264.5 cm
(81.9 × 104.1 in)

The jury of the 1863 Salon rejected this controversial painting, which depicts two clothed men in a park in company of two women, one naked and one partially clothed. However, when it did exhibit at the Salon des Refusés, it elicited both praise and condemnation. Some viewers saw the piece as obscene. Worlds apart from a classical nude, *Luncheon on the Grass* caused scandal because there was no artistic reason, other than the obvious interpretation, for depicting a nude woman among clothed men. Although the nude woman was only one aspect of the painting, it became the focal point of the piece. Several viewers commented on its indecency, adding that such scandalous work would never hang in the Louvre.

However, it seems Manet found the controversy amusing, even nicknaming the painting *"la partie carrée,"* or "the foursome." He also delighted in the irony of the debate: Manet had borrowed the subject from the *Concert champêtre*—a painting by Titian that was, indeed, hanging in the Louvre.

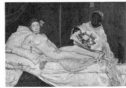

Olympia
1863, oil on canvas
130 × 190 cm (51.2 × 74.8 in)

This painting caused quite the uproar in the 1865 Salon. Once again, as with *Luncheon on the Grass*, Manet seems to have been testing his audience and critics with his re-interpretation of the female nude. He represented Venus as a prostitute (her black cat was a symbol of the trade) and her brazenly direct gaze at the viewer unnerved and upset many. Although the scene is contemporary, Manet did borrow inspiration from works of praised artists, including themes employed by Jean Auguste Dominique Ingres, as well as works like Titian's *Venus of Urbino* and Francisco Goya's *Naked Maja*. Critics attacked the painting, calling the figure a "yellow-bellied odalisque." The piece was, however, defended by a small group of artists, as well as Émile Zola. Paul Cézanne later painted two versions of the piece. In an ironic twist, this painting ended up right next to Ingres's *Grande odalisque* in the Louvre in 1907.

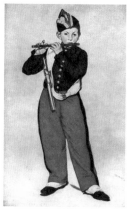

Le fifre (The Fife Player)
1866, oil on canvas
160 × 97 cm (63 × 38.2 in)

Manet was already influenced by Spanish art when he visited Madrid's Prado Museum in 1865. He based *Le fifre* on the 17th-century painting *Pablo de Valladolid* by Diego Velázquez. This painting applied a similar principle—an absent, airy background embracing a singular figure—to a contemporary subject, a member of the Imperial Guard's band. It was rejected by the jury of the 1866 Salon, but Zola applauded its modernity.

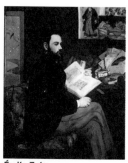

Émile Zola
1868, oil on canvas
146.5 × 114 cm
(57.7 × 44.9 in)

Zola's work was controversial throughout his career—he wrote about corruption in politics, as well as the Dreyfus Affair. Zola was a champion of Manet's work and the artist offered to paint him as a thank you for his ongoing support. Several elements from their relationship are depicted, including the cover of a brochure in which an article by Zola, defending Manet, appeared.

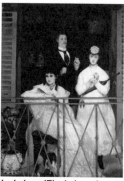

Le balcon (The balcony)
1868 – 1869, oil on canvas
170 × 124.5 cm
(66.9 × 49 in)

The figures in this painting are all Manet's friends, including the painter Berthe Morisot. This marked Morisot's first appearance in Manet's paintings; she is seen sitting down, hands elegantly clasped, with one arm resting on the balustrade. The other models are the concert violinist Fanny Claus and the landscape painter Antoine Guillemet. The child in the background could possibly be the boy Manet raised, Leon Leenhoff. The paternity of the boy was not certain; either Manet or Manet's father, Auguste, may have fathered him. The painter again turned to a Spanish

source: Francisco Goya's *Majas on a Balcony*. Critics at the 1869 Salon took issue with the use of color, as well as the contrast between light and dark. Yet the piece went on to inspire later artists; the Belgian Surrealist painter René Magritte offered his own version in 1950.

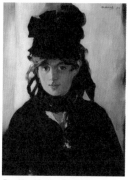

Berthe Morisot au bouquet de violettes (Berthe Morisot with a Bouquet of Violets)
1872, oil on canvas
55 × 40 cm
(21.65 × 14.96 in)

This is one of the first works that Manet completed following the Franco-Prussian War and the Paris Commune—he had served in the *garde nationale* and was unable to paint. The portrait depicts fellow Impressionist Berthe Morisot, a model and friend. Manet and Morisot were introduced by Frédéric Bazille in 1868. In this image she is seen dressed in black mourning veil following the death of her father. Morisot herself was an accomplished painter, her work had been accepted to the Salon and she and Manet often shared ideas about art. Manet would go on to paint Morisot numerous times, ceasing only when she married his brother Eugène.

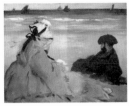

Sur la plage (On the beach)
1873, oil on canvas
95.9 × 73 cm
(37.8 × 28.7 in)

In July of 1873, Manet stayed with his family in coastal Berck-sur-Mer. He was enjoying financial and professional success—he had sold several works to art dealer Paul Durand-Ruel in 1872. He had also had his first major success since 1861 at the Salon of 1873 with the painting *Le bon bock (The Good Glass of Beer)*, a portrait of the art dealer Émile Bellot. The models for this painting are Manet's wife Suzanne and brother Eugène, who was featured 10 years earlier, almost in an identical position, in *Luncheon on the Grass*.

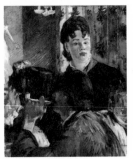

La serveuse de bocks
(The Waitress)
1879, oil on canvas
77.5 × 65 cm
(30.5 × 25.6 in)

Manet painted several café scenes beginning in the 1870s. This piece, derived from real-life sketches and painted in the studio, depicts the Reichshoffen *café-concert*. This painting seems to be a close-up version of *Coin de café-concert (Corner of a Café-concert)*. Manet began the painting in 1878, but cropped it into two parts. The version depicted here is missing both the dancer on stage and the orchestra.

CLAUDE MONET

Le déjeuner sur l'herbe
(Luncheon on the Grass)
c. 1865-1866, oil on canvas
Left panel 418 × 150 cm
(164.6 × 59.1 in)
Right panel 248 × 217 cm
(97.6 × 85.4 in)

Monet's failed attempt at a magnum opus bears the same name as Manet's infamous painting. It was as much an homage as it was a direct challenge. He planned to submit it to the Salon of 1866. It is rumored that Gustave Courbet (the seated male figure) became critical of the piece, leading Monet to abandon the work. In 1920, Monet gave his account: "I had to pay my rent. I gave it to the landlord as security and he rolled it up and put in the cellar. When I finally had enough money to get it back, as you can see, it had gone moldy." He cut the painting up and kept only three fragments; that third fragment has since disappeared.

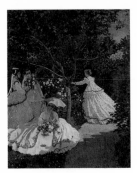

Femmes au jardin
(Women in the Garden)
c. 1866, oil on canvas
255 × 205 cm
(100.4 × 80.7 in)

After Monet abandoned his ambitious *Luncheon on the Grass*, he began work on this large piece. The painting was an attempt to show figures as they appeared in the open air. Abandoning black, Monet recreated the play of light and shadow through varying values of a single hues. Monet worked primarily outdoors on this piece, lowering the canvas into a trench (by pulley) when working on the top part. Camille Doncieux, Monet's companion, served as the model for the women on the left side of the painting. In 1867, the Salon rejected the piece. Some critics negatively commented on the visible brushstrokes and found the work incomplete. Zola, later a champion for the Impressionists, gave the painting a vivid, favorable review, marveling that Monet's treatment of light and shadow created "the strangest effect imaginable." Monet was, by now, in dire need of money; when the piece wouldn't sell for a reasonable price, Frédéric Bazille purchased it for a whopping 2,500 francs.

La pie (The Magpie)
1868 - 1869, oil on canvas
89 × 130 cm (35 × 51.2 in)

Monet often placed himself in the elements, working outdoors even in the chill of winter. This piece was completed in the winter of 1868-69, in Étretat. It depicts the effects of sunlight and shadows on the snow-covered countryside. A journalist from Le Havre, Monet's hometown, remarked on the artist's dedication, stating that he wore three overcoats, gloves and that his face appeared half frozen. Despite his perseverance, the Salon jury refused the work in 1869.

Hôtel des roches noires, Trouville (The Roches Noires Hotel at Trouville)
1870, oil on canvas
81 × 58.5 cm (31.9 × 23 in)

Before fleeing to London, Monet headed to Normandy with Camille to avoid the Franco-Prussian War—stopping to marry along the way.

This work depicts the seaside resort of Trouville; Monet's quick brushstrokes create the illusion of scattered clouds and flags fluttering in the wind. At this point, Monet's was repeatedly rejected by the Salon and he couldn't sell work. Camille's dowry kept the newlyweds afloat.

Coquelicots (Poppy Field)
1873, oil on canvas
50 × 65 cm (19.7 × 25.6 in)

The early 1870s in Argenteuil marked a prosperous, fulfilling time for Monet. This painting depicts wild poppies in a field, with Camille and their son Jean. The painting was shown at the first Impressionist exhibition in 1874. It likely hung near his controversial *Impression, Sunrise*, and likewise suggests a moment—a sunny summer's day—rather than directly reproducing an image.

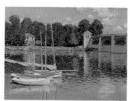

Le Pont d'Argenteuil (The Argenteuil Bridge)
1874, oil on canvas
60.5 × 80 cm (23.8 × 31.5 in)

Monet executed this painting during his productive time spent living in Argenteuil, a suburb on the basin of the Seine. While in Argenteuil, a lively center for boating, Monet painted several works depicting the river and bridge. He even converted a small boat into a floating studio.

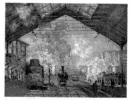

La gare Saint-Lazare (The Saint-Lazare Station)
1877, oil on canvas
75 × 104 cm (29.5 × 40.9 in)

In 1877, Monet returned to Paris. He had fallen into debt, his wife was sick and he felt the town, in the throws of industrialization, had lost its charm. Monet now turned to the more daring theme of modern urban landscapes. In January, Monet dressed in his finest clothes, and convinced the stationmaster to grant him permission to paint inside the Saint-Lazare station. He would have been familiar with the modern setting, as it was the Paris terminal for the Argenteuil line. Eight of Monet's Saint-Lazare paintings were shown at the third Impressionist exhibition; this painting greeted attendees, many of whom remarked on the painter's ability to convey the sounds of the trains and the sight of the billowing smoke stacks. "That is where painting is today," commented Zola, "Our artists have to find the poetry in train stations, the way their fathers found the poetry in forests and rivers."

La rue Montorgueil à Paris,
Fête du 30 juin 1878
1878. oil on canvas
81 × 50 cm (31.9 × 19.7 in)

This painting depicts the excitement after the World's Fair opened. It is often misinterpreted as a celebration of Bastille Day, the French national holiday on July 14, which only became a national holiday two years after this celebration took place. This event, celebrating "peace and work" was held to commemorate France's recovery after the tumultuous years of the Franco-Prussian War and its aftermath.

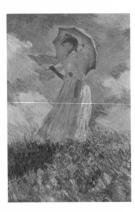

Femme a l'ombrelle tournee
vers la gauche
(Woman with a Parasol)
1886, oil on canvas
131 × 88 cm (51.6 × 34.6 in)

In 1885, Monet again turned to figure painting, a subject that marked the early part of his career. He approached the subject of the relationship between figures and landscape with the focus of a landscape painter, concentrating on how the light influenced his characters. The model for the painting is Suzanne Hoschedé, who later became his stepdaughter. In the way Monet painted the girl, there are several similarities to that of his late wife, Camille, whom he captured in a similar position in 1875. The work was exhibited at Paul Durand-Ruel's gallery in 1891.

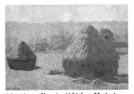

Meules, fin de l'été, effet du
matin (Grainstacks at the
End of Summer, Morning
Effect)
1891, oil on canvas
60 × 100 cm (23.6 × 39.4 in)

Monet produced a series devoted to grain stacks, viewed in different conditions. Where other artists might have used the subject matter as a visual comment on the socio-economic climate of the times and the debate between rural versus industrial ways of life, Monet instead sought to capture his sensations of the motif. From this point on, Monet would continue to focus on series, working quickly and on multiple canvases at a time. Such works were popular and helped Monet find financial security while inspiring younger generations of artists, including the Fauves.

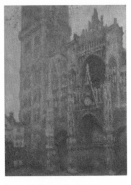

La cathédrale de Rouen.
Le portail, temps gris,
(Rouen Cathedral, the West
Portal, Dull Weather)
1892, oil on canvas
100 × 65.4 cm
(39.4 × 25.7 in)

Although this painting and the one that follows are dated 1894, Monet completed these works from February to mid-April of 1892 and 1893, respectively. In this series of paintings depicting the Rouen Cathedral's western façade–of which there are 30 different versions–Monet set out to capture varying effects on the same structure. The consuming nature of the endeavor is evident in a letter Monet wrote to his second wife, Alice, where he describes nightmares of the Cathedral crumbling on top of him in a mixture of colors. Monet painted these works while renting a studio across the street from the cathedral and completed the works in his Giverny studio. He showed 20 of the paintings at an exhibition at Durand-Ruel Gallery in 1895. The paintings were a sensational hit, although debate was sparked concerning the role of theology in the painting.

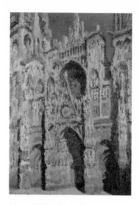

**La cathédrale de Rouen.
Le portail et la tour Saint-
Romain, plein soleil, harmo-
nie bleue et or
(Rouen Cathedral, the West
Portal and Saint-Romain
Tower, Full Sunlight,
Harmony in Blue and Gold)
1893, oil on canvas
107 × 73.5 cm
(42.1 × 28.9 in)**

Monet painted this work
in 1893, at a time when
religion and superstition
were once again popular
topics in French culture. In
painting the series, Monet
was producing relevant works
of art while satisfying his
continuing need to faithfully
represent subjects as seen
through varying effects.
The fact that the painting
depicts a Gothic cathedral
only further served to make
critics relish the works (and
the painter) as a testament
to France's cultural great-
ness. The writer Georges
Clemenceau took France's
president to task for not
having seen the series, ask-
ing: "Why has it not occurred
to you to go and look at the
work of one of your country-
men on whose account
France will be celebrated
throughout the world long
after your name will have
fallen into oblivion?"

**Londres, le Parlement.
Trouée de soleil dans le
brouillard
(London, Houses of Parlia-
ment. The Sun Shining
through the Fog)
1904, oil on canvas
81 × 92 cm (31.9 × 36.2 in)**

Monet most likely observed
the grounds of London's
Parliament from the terrace
of St. Thomas Hospital, on
the opposite bank of the
Thames near Westminster
Bridge. In the latter part of
his career, Monet distanced
himself from the French
scenes that had made him
famous, possibly after
becoming irritated with
French politics. France had
been divided for four years
concerning the Dreyfus
Affair—Alfred Dreyfus, a
Jewish captain in the French
army, was convicted of pass-
ing French military secrets to
the Germans. The nation was
split into those who thought
him innocent (including
Monet and Pissarro) and
those who believed he was
guilty (including Degas and
Renoir). Dreyfus was later
found innocent. Although the
Parliament was a newly built
structure when Monet paint-
ed it in this piece, fog masks
the details of the structure
so it does not appear as
such. Monet was particularly
interested in the London fog;
he had experimented with
the effects of smoke and fog
since his images of the Gare
Saint-Lazare.

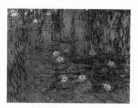

**Nymphéas bleus
(Blue Water Lilies)
c. 1916 - 1919, oil on canvas
200 × 200 cm
(78.7 × 78.7 in)**

Monet moved to Giverny in
1883 and lived there for the
rest of his life. While there, he
painted numerous large-scale
works depicting the serene,
kaleidoscopic water lily
pond he had built, his main
source of inspiration. Monet's
eyesight had been failing
for years, and in 1912 he was
diagnosed with cataracts.
Some have attributed the
purplish blue hues dominant
in this painting to cyanopsia,
a condition wherein the eye
perceives with a blue tint.
The series reflects the art-
ist's faltering vision, as lilies
become less defined and the
brushstrokes more blurred.

AUGUSTE RENOIR

**Chemin montant dans les
hautes herbes (Path Leading
Through Tall Grass)
c. 1875, oil on canvas
60 × 74 cm (23.6 × 29.1 in)**

Although he was mainly
a figure painter, Renoir
was interested in land-
scapes—early examples were

influenced by the Barbizon painter Narcisse Virgilio Diaz and depicted the Fontaine-bleau forest. The exact whereabouts depicted in this painting are not known, but it is possibly a depiction of an area near Paris similar to that seen in Monet's *Coqueli-cots* (1873).

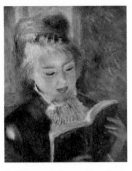

La Liseuse (Woman Reading)
c. 1874-76, oil on canvas
46.5 × 38.5 cm
(18.3 × 15.2 in)

Renoir often painted tender images of women in their everyday lives–engaged in tasks such as sewing, reading and embroidering. Renoir was particularly fond of the model for this work, Margot Legrand, his muse and lover. She can be seen in several of his pieces; she was also the dancing girl in his most famous work, *Bal du Moulin De La Galette* (1876). Described as having curly auburn hair, a wide nose and plump cheeks, she was said to be noisy and vulgar, with a heavy suburban accent. Renoir, however, seemed to transcend her average appearance with his paintings. When she died of typhoid fever in 1881, Renoir paid for her burial.

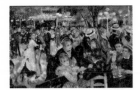

Bal du Moulin de la Galette (Dance at the Moulin de la Galette)
1876, oil on canvas
131 × 175 cm (51.6 × 68.9 in)

Renoir reminisced that this painting celebrated the simplicity of life before machinery, when leisure time was meant for enjoyment. Shown at the Impressionist exhibition in 1877, it depicts a Sunday afternoon at an open-air café, the Moulin de la Galette, in Montmartre. Several of Renoir's friends are depicted in the painting, including painter Norbert Goeneutte and Renoir's future biographer Georges Rivière.

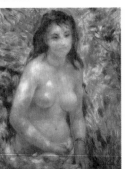

Etude. Torse, effet de soleil (Study. Nude In The Sunlight)
1876, oil on canvas
81 × 65 cm (31.9 × 25.6 in)

Renoir celebrated the classical subject of the female nude with this painting, in which the coloring and texture of the body suggest a seashell. The simplicity of the figure is only offset by the

appearance of a bracelet and ring, references to feminine vanity.

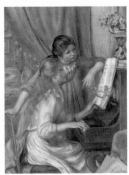

Jeunes filles au piano (Young Girls at the Piano)
1892, oil on Canvas
116 × 90 cm (45.7 × 35.4 in)

The painting gives a detailed account of bourgeois French family life at the end of the 19th century, from the bouquet of flowers on the piano to the "organized chaos" in the next room.

Les baigneuses (Bathers)
c. 1918-1919, oil on canvas
110 × 160 cm (43.3 × 63 in)

This work was executed toward the end of Renoir's life, when he suffered from crippling arthritis. Here, he returns to one of his favorite subjects–the nude figure, outdoors. All references to the modern world are excluded; he refers instead to the classical traditions of Italy and Greece, depicting the earth as "the paradise of the gods."

PAUL CÉZANNE

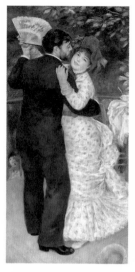

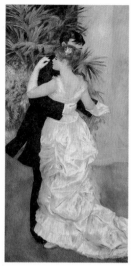

RENOIR'S TWO DANCES

Danse à la campagne (Country Dance)
Danse à la ville (City Dance)
1883, oil on canvas
180 × 90 cm (70.9 × 35.4 in)

These companion paintings—showing, respectively, a celebration in a rustic country and glamorous city setting—were shown at Durand-Ruel Gallery for Renoir's first one-man show in April 1883. Although there has been a debate over the identities of the models in the *Country Dance*, the man is said to be Paul Lhôte (a friend of Renoir's) and the woman is Renoir's future wife, Aline Charigot. The woman in the painting on the right is the painter Suzanne Valadon, the mother of future painter Maurice Utrillo. At this point in his career, Renoir had seen Raphael's work in Italy and was paying more attention to draftsmanship, carefully modeling the figures, especially in *City Dance*, the more refined of the two paintings.

Achille Emperaire
c. 1867 - 1868, oil on canvas
200 × 120 cm
(78.7 × 47.2 in)

Cézanne's portrait of the artist and fellow Aix native Achille Emperaire references Ingres's *Napoleon I on His Imperial Throne*. By portraying his friend's disfigured body—he suffered from dwarfism and a hunchback—on the throne, Cézanne straddles the line between homage (to Emperaire's lofty ambitions) and ridicule (of both Napoleon and Ingres, a leader of the French School).

La maison du pendu, Auvers-sur-Oise (The Hanged Man's House, Auvers-sur-Oise)
1873, oil on canvas
55 × 66 cm (21.7 × 26 in)

This was one of three paintings that Cézanne presented

at the first Impressionist exhibition. In it, Cézanne is employing the Impressionist techniques of pale colors and broken brushstrokes, while focusing on a simple subject—a home belonging to a Monsieur Penn'du. Despite the macabre title, there never was a hanged man; Cézanne's title is a witty play on words (Penn'du sounds like the French word for "hanged man"). Although the work received less-than-flattering reviews, Cézanne sold it to collector Count Armand Doria for 300 francs. Cézanne borrowed this painting back three times to hang it in exhibitions, including the 1889 Universal Exposition in Paris. This is one of few works that the artist signed.

**Une moderne Olympia
(A Modern Olympia)
c. 1873 - 1874, oil on canvas
46 × 55 cm (18.1 × 21.7 in)**

Cézanne reinterpreted Manet's scandalous *Olympia* in two versions. The first, *A Modern Olympia (Pasha)*, featured dark colors and rigid brushstrokes. This version features a lighter palette, executed with a quick, almost slapdash hand. The three pieces all share key elements: the black maid, the cat and the reclining female nude. However, Cézanne also includes a figure (in his own likeness) gazing at the woman. The artist executed this sketch while in the midst of a

heated discussion when staying with Dr. Paul Gachet—the psychiatrist who would later treat Van Gogh—at Auvers-sur-Oise. Dr. Gachet later owned the painting. A biting review of the first Impressionist exhibition by Marc de Montifaud, which appeared in *L'artiste*, commented that Cézanne must have painted this scene while in a state of *delirium tremens*.

**Le golfe de Marseille vu de
L'Estaque (Bay of Marseille
seen from L'Estaque)
c. 1878 - 1879, oil on canvas
58 × 72 cm (22.8 × 28.3 in)**

Cézanne took refuge at his mother's home in L'Estaque, west of Marseille, during the Franco-Prussian War. During this time, several members of his inner circle also fled: Monet and Pissarro escaped to London. Meanwhile, Renoir was drafted, Manet and Degas volunteered in the National Guard as gunners, and Bazille was killed in battle. After the war, Cézanne returned to L'Estaque several times, and the few seascapes the artist executed were painted here. In 1876, he wrote a letter to Pissarro describing the landscape and the area's unique light, which silhouetted objects "not only in black and white, but also in blue, red, brown and violet." At the beginning of the 20th century, the Fauves and Cubists also painted on the banks of L'Estaque.

**Portrait de Madame Cézanne
c. 1885-1890, oil on canvas
47 × 39 cm (18.5 × 15.4 in)**

This is one of 27 oil paintings Cézanne made depicting his mistress (later his wife) Hortense Fiquet. The two were married in 1886, although they had known each other since 1869 and had a son, Paul, in 1872. Cézanne, being from a wealthy family and fearful of compromising his inheritance, kept their relationship secret. By the time the two were married, he no longer had feelings for her and they later separated. For his portraits, Cézanne often enlisted relatives or those close to him due to the lengthy sitting sessions required for the models and the artist's timid nature.

**Le vase bleu (The Blue Vase)
c. 1889 - 1890, oil on canvas
61 × 50 cm (24 × 19.69 in)**

Cézanne often studied the varying effects of light upon objects. Originally titled *Flowers and Fruit*, Cézanne introduced apples into this piece because, as he reportedly told writer (and Cézanne biographer) Joachim Gasquet, he was "giving up flowers. They wither too quickly. Fruits are more reliable."

Baigneurs (Bathers)
c. 1890, oil on canvas
60 × 82 cm (23.6 × 32.3 in)

Cézanne reproduced numerous paintings of bathers, combining figures and landscape. Elements of the painting suggest he found inspiration in the drawings of the Italian Renaissance painter Luca Signorelli. The work was shown at the Salon d'Automne in 1904; several young artists, including Matisse and Picasso, owned versions of the painting.

La femme à la cafetière
(Woman with a Coffeepot)
c. 1890 - 1895, oil on canvas
130 × 96.5 cm (51.2 × 38 in)

Although not identified, the model for this painting could possibly be an employee of the Jas de Bouffan, Cézanne's family estate near Aix. Cézanne often painted working-class people in a very stoic manner. This painting also reflects the artist's inclination to "treat nature through cylinders, spheres and cones," a sharp contrast to his early Impressionist works.

Les joueurs de cartes
(The Card Players)
c. 1890 - 1895, oil on canvas
47.5 × 57 cm (18.7 × 22.4 in)

Cézanne completed five different versions of *The Card Players*. In this painting—divided into halves by the bottle—the painter depicts the concentration and inner tension of the players. By focusing on the competitive nature of the game, it is believed that *The Card Players* series was a retort not only to Zola, who had by this point declared Cézanne a failure in his thinly veiled novel, *L'Œuvre*, but also to his father, from whom he sought recognition for his work. The man with the pipe has been identified as Alexander, the gardener for Jas de Bouffan, the Cézanne family estate near Aix-en-Provence. The artist might have taken inspiration from the works by 17th-century French painters the Le Nain brothers.

Gustave Geffroy
c. 1895 - 1896, oil on canvas
110 × 89 cm (43.3 × 35 in)

Art critic Gustave Geffroy, possibly prompted by Claude Monet, wrote an article praising Cézanne in 1894. Cézanne, having endured harsh criticism, was moved by the flattering words and agreed, upon Monet's insistence, to meet the writer. To show his gratitude, he began painting Geffroy's portrait in the spring of 1895. As the timid and devoutly Catholic Cézanne got to know the liberal anarchist Geffroy, the painter's disdain for the writer grew. Cézanne asked to be relieved of his artistic duty—claiming the task was larger than his skill could accommodate—before completing the writer's hands and face. Geffroy insisted that he continue and, for a short while, Cézanne obliged. Then, without notice, he stopped communicating with Geffroy, sending a letter a year later asking that his utensils and materials be returned at once. The two men never spoke again, despite Geffroy's continued admiration. Cubists Braque and Picasso admired the painting for the geometric and unusual perspective of the bookcase.

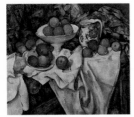

**Pommes et oranges
(Apples and Oranges)
c. 1899, oil on canvas
74 × 93 cm (29.1 × 36.6 in)**

This piece is part of a series of six still-life paintings executed in 1899 in Cézanne's Paris studio. Considered one of his most important still lifes, the piece was widely studied for its unique spatial construction and perspective. During this time, Cézanne's still-life paintings were garnering praise. At gallery owner Ambroise Vollard's seminal 1895 exhibition, one critic even commented that in French painting, Cézanne had already assumed the role of master of the still life.

EDGAR DEGAS

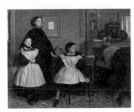

**La Famille Bellelli
(The Bellelli Family)
c. 1858 - 1867, oil on canvas
200 × 250 cm
(78.7 × 98.4 in)**

This painting was begun in 1858 (when Degas was in his mid-20s and living in Florence) but was not found until after he died. It depicts his aunt, Laure Bellelli, her husband, Gennaro, and their two daughters, Giovanna and Giulia. Gennaro, a supporter of Camillo Cavour (a leader in the Italian unification movement and the nation's first Prime Minister), was in exile from Naples and living in Florence with his family. The painting shows Degas's ability to emulate Flemish painters, namely Antoon Van Dyck. The painting also tells a story: Laure Bellelli was estranged from her husband, who appears distant from her in the painting. Her grandfather had recently died (his picture can be seen framed to her right), which explains why the family is dressed in mourning attire.

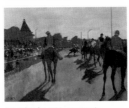

**Le défilé or Chevaux de courses devant les tribunes
(The Parade of Race Horses in front of the Tribunes)
c. 1866 - 1868, oil painting on paper mounted on canvas
46 × 61 cm (18.1 × 24 in)**

In the second half of the 19th century, horse racing became a recurring theme in Degas's work. A pastime of British aristocrats, racecourses became very fashionable places for the Paris bourgeoisie. Degas first encountered the activity in Normandy while visiting his friends the Valpinçons. This is one of Degas's first paintings using the subject matter and it might possibly have been the painting listed as no. 63 in the fourth Impressionist exhibition of 1879.

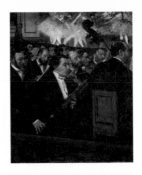

**L'orchestre de l'Opéra
(The Orchestra at the Opera)
c. 1870, oil on canvas
56.5 × 45 cm (22.2 × 17.7 in)**

Degas was an admirer of French and Italian music and befriended Désiré Dihau, a bassoonist at the Paris Opéra, in 1868. He was also friends with Dihau's sister, Marie, a singer. Through them he met several members of the orchestra, who would often meet at a restaurant near the opera house called Chez la Mère Lefebvre, on the rue de la Tour d'Auvergne. Dihau asked Degas to paint his portrait but the artist, instead of painting a straightforward portrait, incorporated the musician into a portrayal of the orchestra pit. Degas wrote that he wanted to create a series on instrumentalists. In addition to Dihau, Degas also knew several of the other musicians depicted in the painting; the composer Emmanuel Chabrier can be seen in the box, nearest to the stage and high up to the right. Some of Degas's friends who were not musicians are depicted as orchestra members in the piece. The dancers, which became an overriding theme in Degas's later work, are shown here with cropped heads and feet.

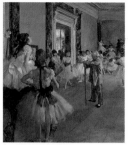

**La classe de danse
(The Ballet Class)
c. 1871 - 1874, oil on canvas
85 × 75 cm (33.5 × 29.5 in)**

From 1870 until his death, Degas immersed himself in ballet. This painting captures Opéra ballerinas after a lesson led by ballet master Jules Perrot. X-rays have shown that Degas made several changes from the initial sketch, moving Perrot and two ballerinas in the foreground. The ballerina sitting on the piano scratching her back was added later. The work was shown in London in 1876 and sold. It was brought back to France by way of Theo van Gogh, who was working for leading art dealer Goupil and purchased the piece at Christie's.

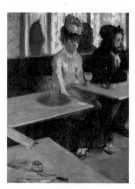

**Dans un café or L'absinthe
(In a Café or Absinthe)
1876, oil on canvas
92 × 68 cm (36.2 × 26.8 in)**

This painting depicts drinkers in the café La Nouvelle Athènes in Pigalle—a hub for artists and bohemians. Although the image represents an actual setting, the artist completed the work in his studio and used models—the actress Ellen Andrée and the engraver and artist Marcellin Desboutin—to portray the forlorn-looking patrons. Zola even described this work in his novel L'Assommoir, which was a study on alcoholism. Although Andrée and Desboutin were merely models for the painting, due to the subject matter, it cast them in a negative light. Degas had to publicly state that the two were not actually alcoholics.

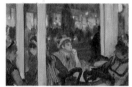

**Femmes a la terrasse d'un café, le soir (Women on a Cafe Terrace, Evening)
1877, pastel over monotype
41 × 60 cm (16.1 × 23.6 in)**

Between 1874 and 1875, Degas began experimenting with the monotype method of making unique prints. Degas loved the spontaneity of the technique and created hundreds of monoprints throughout his career. To create images like this, Degas worked in the "dark field" method, covering a plate with ink and use paintbrushes and rags to wipe away ink, revealing an image that was then printed onto paper. Often, as seen here, Degas would then add washes of color over the print with pastel or paint.

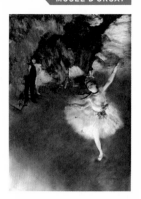

**L'étoile or La danseuse sur la scène (The Star or Dancer on Stage)
1878, pastel on paper
60 × 44 cm (23.6 × 17.3 in)**

Degas often focused on the painstaking preparation the Opéra ballerinas endured—he captured them in rehearsals, taking breaks, tired and completely worn out. This painting, however, shows the graceful reward of their hard work and dedication. In this piece, Degas has focused on one dancer—showing the delicate detail of her costume through the use of pastel, while the other performers (and possibly the stage manager) blend into the background.

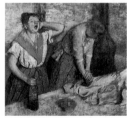

**Les Repasseuses
(Women Ironing)
c. 1884 - 1886, oil on canvas
76 × 81.5 cm (29.9 × 32.1 in)**

Washerwomen were one of Degas's favorite subjects between 1869 and 1895. This

is the third of four variations of an almost identical composition. The picture shows the daily life of the working-class.

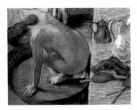

Le tub
1886, pastel on cardboard
60 × 83 cm (23.6 × 32.7 in)

This is one of seven pictures Degas made in the mid 1880s on the theme of women bathing. Degas's nudes were not meant to display women to an audience. Instead, the viewer becomes a voyeur witnessing women undertaking the simple ritual of bathing. "It's as if you were looking at her through the keyhole," Degas explained. Those in attendance at the last Impressionist exhibit were shocked by Degas's images of the female form.

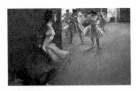

Danseuses montant un escalier (Dancers Climbing the Stairs)
c. 1886 - 1888, oil on canvas
39 × 90 cm (35.2 × 15.3 in)

Nearly half of Degas's paintings were about ballet. In this frieze-like work, Degas focuses on the ballerina in the foreground as she reaches the top of the stairs, about to join a lesson. It is full of movement, which Degas cleverly depicted. Durand-Ruel bought the work in 1888.

BERTHE MORISOT

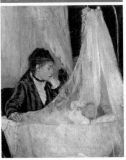

Le Berceau (The Cradle)
1872, oil on canvas
56 × 46 cm (22 × 18 in)

In 1872, Morisot painted one of her sisters, Edma (also a painter), as she watched over her daughter, Blanche. Such scenes of bourgeois domestic life, especially motherhood, would become the artist's signature. Morisot, who had shown her work at the Salon from a young age, submitted this painting to the Impressionist exhibition of 1874 and became the first woman to exhibit with the group. Though well respected within the group, Morisot's career choice was controversial for a woman. At one exhibition a man called her a *gourgandine* (street walker); Pissarro promptly punched him in the face. In 1868, she had met and befriended Manet through their mutual friend, Bazillle. The two formed a lasting friendship, with Morisot serving as a model for Manet and the two sharing ideas about art. She later married Manet's brother, Eugène. Unlike her reluctant brother-in-law, Morisot participated in seven of the eight Impressionist exhibits—only missing one in 1879 due to the birth of her own daughter, Julie.

GUSTAVE CAILLEBOTTE

Les Raboteurs de parquet
(The Floor Scrapers)
1875, oil on canvas
102 × 146.5 cm
(40.15 × 57.67 in)

Although he began working in a realistic, academic style, Caillebotte was heavily influenced by Impressionism. This is one of the first paintings in which he depicted urban workers—until this point, images of peasants and farmers were the only acceptable depictions of workers. It was presented to the 1875 Salon and rejected; some were offended by its realism and others commented that the subject matter was vulgar. Caillebotte decided to join the Impressionists and this painting was shown at their second exhibition in 1876. Zola condemned the painting, saying that its style was so accurate that it made the painting bourgeois.

Voiliers à Argenteuil
(Sailing Boats at Argenteuil)
c. 1888, oil on canvas
65 × 55.5 cm
(25.59 × 21.85 in)

By 1881, Caillebotte bought a house in Petit-Gennevilliers on the banks of the Seine. He began painting sailboats and boaters, often working *en plein air*. Caillebotte was influenced by Monet, who had settled in Argenteuil (just across the river) in 1871, though his own technique was less developed than Monet's. In this canvas, the riverbank and dock near his house are painted with heavy brushstrokes. On the horizon, behind the wooden bridge at Argenteuil, are the supports of the railway bridge and the hills of Sannois and Orgemont.

HENRI DE TOULOUSE-LAUTREC

Le lit (The Bed)
circa 1892, oil on cardboard
mounted on wood parquet
54 × 70.5 cm (21.3 × 27.8 in

From 1891, Toulouse-Lautrec was interested in showing the intimate lives of women who worked in brothels—he even lived in *maisons closes*, or licensed brothels, to get a better sense of his subjects. He used studies, such as this painting, for the composition *Au Salon* (*In the Salon*), 1894, and in the album of lithographs *Elles*, which was published by the erotic book dealer Gustave Pellet. The series of lithographs was on exhibition at the Galeries de la Plume's 20th Salon des Cent in 1896. Norwegian

artist Edvard Munch bought a set of 10 prints.

Jane Avril dansant
(Jane Avril Dancing)
c. 1892, oil on cardboard
85.5 × 45 cm (33.7 × 17.7 in)

Jane Avril was one of several stars of the Moulin Rouge, a hub of Parisian nightlife. She knew Toulouse-Lautrec's posters (including this piece) helped drive her publicity and, in 1893, she commissioned him to produce a publicity poster to sell to her fans. He made 20 impressions for the dancer; when she successfully opened a show at the Jardin de Paris, the club ordered two more editions of the piece.

Rousse, or La Toilette
1889, oil on cardboard
67 × 54 cm (26.4 × 21.3 in)

The wicker chairs in this piece suggests that the scene

is inside Toulouse-Lautrec's studio on rue Caulaincourt. Unlike most of his work, the features of the model are not shown here. Toulouse-Lautrec admired Degas and might have been influenced by the artist, who presented a similar series of bathing women at the last Impressionist exhibition. When Toulouse-Lautrec exhibited this piece in Brussels, at the Exhibition of Les XX, the title was *Rousse*, likely a reference to the artist's preference for red-haired models.

La clownesse Cha-U-Kao
(The Clown Cha-U-Kao)
1895, oil on card
64 × 49 cm
(25.19 × 19.29 in)

Cha-U-Kao was a dancer and clown at the Nouveau Cirque and Moulin Rouge. Her name was a phonetic combination of the French slang "*chahut*," a form of *can-can*, and "chaos," referring to the crowd's response whenever she hit the stage. Unlike his more theatrical depictions of the performer, this piece shows Cha-U-Kao in an intimate setting trying to fasten a yellow ruffle to the bodice of her stage costume. The reflection in the mirror shows an elderly man who could be an admirer, friend or, more likely, a customer.

Panneaux pour la baroque de la Goulue, a la Foire du Trône a Paris (Panels for La Goulue's booth at the Foire du Trône in Paris)
1895, oil on canvas
Left Panel 298 × 316 cm (117.3 × 124.4 in)
Right Panel 285 × 307 cm (112.2 × 120.9 in)

After years of success at the Moulin Rouge, dancer La Goulue (The Glutton) decided to start her own traveling show. She commissioned Toulouse-Lautrec to execute this massive painting–two panels designed to flank the entrance for her booth at the fairground Foire du Trône. On the left panel (La danse au Moulin-Rouge ou La Goulue et Valentin le désossé) she is shown performing the chahut during her heyday at the Moulin Rouge. The right panel (La danse mauresque ou Les Almées) shows her new dance direction: belly dancing, as befitting her ever-expanding figure. The piece was cut into eight pieces before an art critic stepped in and launched a campaign to restore it. In the right panel, La Goulue is surrounded by friends: the always-controversial Oscar Wilde (who was arrested that year on gross indecency and sodomy charges) and art critic Félix Fénéon, a former civil servant turned anarchist, and Toulouse-Lautrec (in back view), just to the right of the hat-wearing Jane Avril. La Goulue never found the same success that she once had at the Moulin Rouge.

Gelée blanche (White Frost)
1873, oil on canvas
65 × 93 cm (25.6 × 36.6 in)

This wintry landscape was painted near Pontoise, where the artist lived from 1873 to 1882. It was one of the five works he presented at the first Impressionist exhibition. One critic compared it to the work of Jean-François Millet, known for his paintings of peasant farmers. Pissarro showed empathy for peasants in his work, possibly a result of his anarchist political views.

Les toits rouges, coin de village, effet d'hiver (Red roofs, corner of a village, winter)
1877, oil on canvas
54.5 × 65.6 cm (21.5 × 25.8 in)

This piece, which depicts a charming village outside of Paris near the Côte Saint-Denis, was done while Pissarro and Cézanne–who had been working together since 1865–were painting in Pontoise. This painting was shown at the third Impressionist exhibition, although Cézanne did not show his version of the same scene.

Jeune paysanne faisant du feu. Gelée blanche (Peasant Girl Lighting a Fire. Frost)
1888, oil on canvas
92.8 × 92.5 cm (36.5 × 36.4 in)

Pissarro often used peasant workers as a subject, though from 1886, he was influenced by the experiments of younger artists, namely the scientifically derived Pointillism explored by Seurat. This painting appeared in the 1889 exhibition of Les XX in Brussels; Pissarro would later distance himself from the Neo-Impressionists.

Port de Rouen, Saint-Sever
1896, oil on canvas
65.5 × 92 cm (25.8 × 36.2 in)

Pissarro's first prolonged visit to Rouen took place in 1883. Attracted to both the industrial and historic parts of the city, he returned twice in 1896. He wrote to his son that Rouen was as beautiful as Venice, and painted mainly from the window of his hotel room, overlooking the Seine, port and bridges. He hesitated to show his Rouen paintings at the Impressionist exhibit for fear of comparisons to Monet's Cathedrals, which had shown in 1895.

La Seine et le Louvre
(The Seine and the Louvre),
1903, oil on canvas
46 × 55 cm (18.1 × 21.7 in)

Between 1900 and 1903 (the year he died), Pissarro produced around 30 paintings of views from his second-floor window on 28, place Dauphine. Having left behind the countryside as subject, Pissarro focused on urban cityscapes after 1893. In this painting, the tip of the Square du Vert-Galant is in the foreground, with a view of the Louvre and the Pont des Arts bridge spanning the Seine.

FRÉDÉRIC BAZILLE

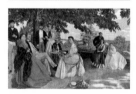

Réunion de famille
(Family Reunion)
1867, oil on canvas
152 × 230 cm
(59.84 × 90.55 in)

Bazille worked on this family portrait while on holiday in the family home at Méric, near Montpellier. It depicts 10 of his relatives on a terrace; Bazille is the figure on the far left. The painter made compromises to the composition and retouched the painting the following winter, resulting in a work that combines a study of the

light of the South of France with a rather conventional group portrait. It was accepted at the Salon of 1868, while bolder works by Monet were rejected. In a letter, he downplayed his acceptance: "I don't know how, probably by mistake."

L'atelier de Bazille
(Bazille's Studio)
1870, oil on canvas
98 × 128.5 cm
(38.58 × 50.59 in)

Bazille was born into a prominent family in Montpellier and moved to Paris in 1862. Originally intending to pursue medicine, he instead opted for a career in painting. The artist befriended Monet, Renoir and Sisley at Charles Gleyre's studio, and they all shared a great admiration for Manet. This scene shows the studio Bazille shared with Renoir for two years on the rue de la Condamine. Bazille is the tall figure in the center of the painting (added by Manet in his vigorous style) and Manet is in the hat, observing the canvas on the easel. Several of Bazille's works are depicted in the painting, including an unfinished version of *La Toilette*, which was rejected by the Salon of 1870, above the sofa; and *Fisherman with a Net*, which was rejected by the Salon the year before. Above the piano hangs a still life by Monet, whom Bazille helped financially by purchasing the work.

ARMAND GUILLAUMIN

Soleil couchant a Ivry
(Sunset at Ivry)
1873, oil on canvas
65 × 81 cm (25.6 × 31.9 in)

Though lesser-known in comparison to his friends Cézanne and Pissarro, Guillaumin influenced their work–Cézanne based his first etching on Guillaumin's *Barges on the Seine at Bercy*. Known for his vibrant use of color, Guillaumin shows the smoke from chimney stacks mingling with the sunset– possibly a comment on nature versus industrialization.

MARY CASSATT

Jeune fille au jardin
(Girl in the Garden)
c. 1880-1882, oil on canvas
92 × 65 cm. (36.2 × 25.6 in)

Mary Cassatt was the daughter of a wealthy Pittsburgh banker. Degas championed her work and invited her to exhibit at the fourth Impressionist exhibition. She went

on to show at the fifth and sixth exhibits, as well as the final show in 1886 (where this painting was shown). Cassatt should be credited with bringing Impressionism to an American audience; she was influential in urging art dealer Durand-Ruel to show the Impressionists' works in the United States.

VINCENT VAN GOGH

La guinguette à Montmartre (Terrace of a Café on Montmartre)
1886, oil on canvas
49 × 64 cm (19.3 × 25.2 in

Van Gogh lived in Paris, from 1886 to 1888 with his brother Theo. It depicts a café in an area in the northern part of the city called Montmartre, a haven to many artists. In Paris, Van Gogh was introduced to Impressionist techniques as well as the city's avant-garde artists: Pissarro, Toulouse-Lautrec, Bernard and Gauguin.

Le restaurant de la Sirène à Asnières
1887, oil on canvas
54.5 × 65.5 cm
(21.46 × 25.79 in)

Settling into an apartment with his brother on rue Lepic, Van Gogh explored his surroundings, painting areas in close proximity to where he lived, including Asnières, a nearby town along the banks of the Seine. There he drew inspiration from the bridges, often depicting several different views, as well as the restaurant de la Sirène.

La nuit étoilée (Starry Night)
1888, oil on canvas
72.5 × 92 cm
(28.54 × 36.22 in)

Van Gogh arrived in Arles on February 8, 1888, and became obsessed with the idea of capturing the night sky in a painting. His letters at the time expressed this desire: To fellow painter Bernard, Van Gogh said that such a painting kept haunting his dreams, while he shared with his sister the belief that the night sky had more beautiful colors than the day. He started experimenting with "night effects" in September of that same year, first with a sliver of sky in the painting *Café Terrace on the Place du Forum, Arles*. In this version of *Starry Night*, Van Gogh depicts the Rhône with the city gaslights reflecting in the water. While this version is tranquil and even romantic, a few months later he painted a more violent version of the starry night sky while confined to a mental institution.

L'Arlésienne
1888, oil on canvas
92.3 × 73.5 cm
(36.34 × 28.94 in)

Madame Ginoux and her husband, Joseph, ran the Café de la Gare on the Place Lamartine in Arles, an ancient Roman city in the South of France. Open all night, the café was often filled with artists, including Van Gogh, who rented a room from the proprietors from May to September 1888. Dressed in her traditional regional attire, Madame Ginoux appeared to Van Gogh to be the epitome of an Arlésienne, or "woman from Arles." He described the painting to his brother in a letter in November 1888, commenting that he executed it in an hour. Van Gogh's quick, thick and expressive brustrokes can be seen on the canvas. He would go on to paint Madame Ginoux a total of six times. Gauguin also painted Madame Ginoux, even creating a charcoal sketch during the same sitting when Van Gogh painted this canvas. It seems Van Gogh had an especially close relationship with his landlady. She too suffered from "nervous attacks" and when Van Gogh was hospitalized in December 1888, she looked after him.

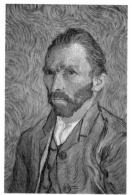

Portrait de l'artiste
1889, oil on canvas
65 × 54.5 cm
(25.59 × 21.46 in)

Van Gogh produced more than 43 self-portrait drawings and paintings in 10 years. He would study himself in the mirror and commented to his sister that he was looking for a more realistic likeness than a photograph could capture. He wrote to his brother: "People say, and I am willing to believe it, that it is hard to know yourself. But it is not easy to paint yourself, either." The letter also describes his admiration for Rembrandt's portraits. Here, Van Gogh shows himself dressed formally, in a suit and not the pea coat in which he normally worked.

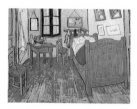

La chambre de Van Gogh à Arles (Van Gogh's Bedroom in Arles)
1889, oil on canvas
57.5 × 74 cm
(22.64 × 29.13 in)

This painting depicts Van Gogh's room in the yellow house, next to his former residence at Café de la Gare. This is one of the last two paintings the artist produced of this room. The first was made in October 1888 and was damaged in a flood while Van Gogh was hospitalized in Arles. This is the smaller of two copies he produced a year later, made for his family in Holland. In Arles, Van Gogh had sought to create an artist community. He requested Gauguin stay in the yellow house with him, with goals to create a Studio of the South. The two had a stormy relationship and, in this room, Van Gogh, in a fit of madness, attacked Gauguin and later cut off his own ear.

La méridienne dit aussi La sieste (d'après Millet) [The Siesta (after Millet)]
Dec 1889-Jan 1890
oil on canvas
73 × 91 cm
(28.74 × 35.83 in)

This was painted while Van Gogh was interned in an asylum in Saint-Rémy. Van Gogh admired Millet's images of rural France and this piece was modeled after one of his drawings for *Four Moments in the Day*. In a letter to his brother, Van Gogh explained the influence of Millet's work, stating it was a "translation into another language." Van Gogh added his own bold colors, chiaroscuro and texture to the theme.

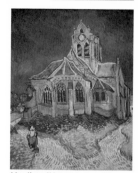

L'eglise d'Auvers-sur-Oise, vue du chevet (The Church in Auvers-sur-Oise, View from the Chevet)
June 1890, oil on canvas
94 × 74 cm (37 × 29.13 in.)

Van Gogh finally settled in Auvers-sur-Oise, a village in the outskirts of Paris, after his stay in Arles and his institutionalization at Saint-Rémy. Between May 21, 1890 (when he arrived in Auvers) and his death on July 29, Van Gogh made about 70 paintings and a large number of drawings, averaging more than one per day. This is his only completed painting of the 13th-century, early Gothic-style church, and is seen as a harbinger of the Fauvist and Expressionist styles that would soon become popular.

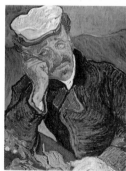

Le docteur Paul Gachet
1890, oil on canvas
68 × 57 cm

(26.77 × 22.44 in)

Doctor Paul Gachet was a homeopathic physician who specialized in psychiatry. He was also a skilled engraver and champion of the arts, which brought him into contact with the likes of Manet, Monet, Renoir and Cézanne. Theo Van Gogh encouraged his brother Vincent to go see the doctor after he was discharged from the hospital in Saint-Rémy. Van Gogh painted this during an intense periond in his work, and the subject's melancholy face was supposed to reflect his own feeling of desolation. Although Dr. Gachet tried to help Van Gogh with his troubles, the artist committed suicide not long after completing this painting.

PAUL GAUGUIN

La Seine au Pont d'Iéna.
Temps de neige
(The Seine at the Pont
d'Iéna, Snowy Weather)
1875, oil on canvas
63 × 92.5 cm
(24.8 × 36.4 in)

When Gauguin made this piece, painting was a hobby for the burgeoning artist, a stockbroker at the time. Gauguin was greatly influenced by the Impressionists, namely Guillaumin and Dutch landscape painter Jongkind. He often bought their works and followed their exhibitions. The dark colors and painstaking construction of this work is a far cry from the vibrant melding of cultures that defines his later art.

Les Alyscamps
1888, oil on canvas
91.5 × 72.5 cm
(36 × 28.5 in)

Gauguin visited Arles at the behest of Van Gogh. This painting shows the Roman necropolis, which was consecrated in the third century by Saint Trophime as a burial ground for Christians. By the 19th century, little remained; Gauguin leaves a few historical relics in the background, including the tower and part of the building of the Romanesque church. Three figures are shown, though Gauguin did not find the Arlésiennes attractive. When he sent the painting to his art dealer (Van Gogh's brother, Theo) he nicknamed the painting *Landscape* or *Three Graces with the Temple of Venus*.

Les meules jaunes (La moisson blonde)
[Yellow haystacks (The golden harvest)]
1889, oil on canvas
73.5 × 92.5 cm
(28.9 × 36.4 in)

After the infamous episode with Van Gogh in Arles, which resulted in the painter cutting off his own ear, Gauguin went back to Brittany (for the third time) in 1889. During the Universal Exhibition in the first part of the year, Gauguin exhibited his earlier works in an Impressionist and Synthetist exhibit at the Café Volpini in Paris. Depressed about how his work was received, and returning to find Pont-Aven overrun with artists, he settled in the village of Le Pouldu. He stayed at an inn kept by Marie Henry, where he sought quiet, peace and an "archaic," cheap lifestyle. Haystacks were a popular theme with the Pont-Aven School, and Gauguin painted them several times.

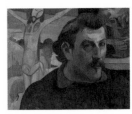

Portrait de l'artiste au Christ
jaune (Portrait of the Artist
with the Yellow Christ)
1890-1891, oil on canvas
30 × 46 cm (11.8 × 18.1 in)

Gauguin painted this portrait the night before his first trip to Tahiti. The melancholic expression could be attributed to the events in his life at the time: His wife, having recently left him, moved to her homeland Denmark with their five children. This painting can be seen as a triple portrait of sorts, with each component of the piece representative of the various forces at work in the artist's life: suffering, savage impulses and self-importance.

Gauguin was struggling to be understood on both a personal and artistic level, symbolized by the portrait of Jesus (painted in the artist's likeness) suffering on the cross. The image on the right is *Pot in the form of a Grotesque Head*, which Gauguin described as the "head of Gauguin the savage." Religious debates were common during the time and Gauguin may have used French philosopher Ernest Renan's *The Life of Jesus*, which showed Christ's suffering as that of a mortal man, as the basis for his work. Bernard even accused Gauguin of copying the theme of that book for his religious paintings.

**Femmes de Tahiti
(Tahitian Women)
1891, oil on canvas
69 × 91.5 cm (27.2 × 36 in)**

Gauguin first went to Tahiti in 1891, seeking what he imagined to be a primitive oasis from the money-driven European way of life. His early paintings while in Tahiti depicted native women in their everyday lives.

**Paysannes bretonnes
(Breton Peasant Women)
1894, Oil on canvas
66 × 92.5 cm (26 × 36.4 in)**

In Pont-Aven, between his two trips to Tahiti, Gauguin returned to using rural subjects as a theme for his work. However, Polynesian influences were evident in his paintings, from the fullness of the figures to the lively colors. This painting depicts two Breton women in a field of harvested wheat. Gauguin told his friend Georges-Daniel de Monfreid, who helped sell his work while he was abroad, that he would soon sell all of his paintings to finance his permanent move to the Pacific.

**Vairumati
1897, oil on canvas
73 × 94 cm (28.7 × 37 in)**

From Tahiti, Gauguin sent this picture to the Parisian art dealer Ambroise Vollard in 1898. Gauguin moved back to the island in 1895 and was disenchanted with Tahiti at the time; he felt it had lost the magic that had attracted him to it in the first place. Gauguin might have attempted to regain some of that magic with this painting, which depicts Vairaumati–Gauguin misspelled her name in the title–who was, according to Tahitian mythology, the Tahitian Eve: mother of the Ariois race, the native masters of the island. The sculptures of the Javanese temple of Borobudur might have served as inspiration for the two figures in the background of this painting.

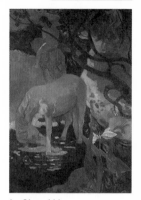

**Le Cheval blanc
(The White Horse)
1898, oil on canvas
140 × 91.5 cm (55.1 × 36 in)**

During his second trip to Tahiti, Gauguin was commissioned by the pharmacist Ambroise Millaud. Gauguin was drawn to the island's vegetation and wildlife, as reflected in the rich green hues throughout the painting. Gauguin had collotype photographs of the Parthenon, and the horse's stance is similar to that of one from the western frieze of the Greek structure. The pharmacist did not like the painting (chiefly because of the horse's green tint) and refused to accept it. Gauguin defended the piece, arguing that if he were to squint his eyes, everything in Tahiti is green, to which Millaud responded that he did not want to have to squint whenever he looked at the painting. Gauguin sent the piece to Monfreid in Paris, with the hopes that he could sell it and send the money to the financially downtrodden artist. Monfreid dubbed the painting *Le Cheval Blanc* and offered the piece to the French national collection. It became part of the Musée du Luxembourg.

ÉMILE BERNARD

Madeleine au Bois d'Amour
1888, oil on canvas
138 × 163 cm
(54.3 × 64.2 in)

Bernard was 20 when he painted this life-sized portrait of his 17-year-old sister Madeleine lying in the Bois d'Amour in Pont-Aven. Gauguin, who was living in Pont-Aven, had fallen in love with Madeleine and also produced a portrait of the girl. The two artists remained close until 1891, when the older Gauguin was described as the founder of the Pont-Aven movement. Bernard considered himself the rightful owner of such a title. When Gauguin, before leaving to Tahiti, exhibited without Bernard (to whom he had promised a joint show), Madeline angrily wrote to him, "You are a traitor. You have broken your pledge and done the greatest harm to my brother, who is the real initiator of the art that you claim as being your own."

Les Bretonnes aux ombrelles
(Breton Women with Umbrellas)
1892, oil on canvas
85 × 105 cm (33.5 × 41.3 in)

After Gauguin left for Tahiti in 1891, Bernard remained in Brittany and continued his research into Synthetism, a form of Neo-Impressionism that sought harmony between the appearance of objects, the artist's feelings about the subject and a pure exploration of color and form. Here, the artist separates flat, two-dimensional forms with dark outlines, a technique known as Cloisonnism. Bernard grew to admire the Breton women, depicting them as figures of devotion.

EVA GONZALÈS

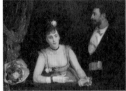

Une loge aux Italiens (A Box
at the Théâtre des Italiens)
1874, oil on canvas
98 × 130 cm (38.6 × 51.2 in)

Eva Gonzalès was a promising artist, having studied under Manet. Though refused by the Salon in 1874, this piece (after alterations) went on to receive rapturous acclaim at the 1879 Salon. Manet's influence can be seen in the work, whether in the bouquet resting on the edge of the box (recalling the bouquet in *Olympia*), or inherent in the dark backgrounds against bright flesh and fabrics. Like Manet, Gonzalès never exhibited with the Impressionists, though she was considered a member of the group. She died six days after her mentor, from childbirth complications; legend says she was braiding a floral wreath for Manet's grave before her passing.

GEORGES SEURAT

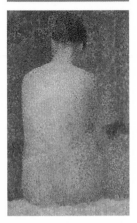

Poseuse de dos
(Model, Back View)
1887, oil on wood
24.5 × 15.5 cm (9.6 × 6.1 in)

This piece was a study for Seurat's larger composition *The Models*, which includes three models posing nude. Each of the nudes in *Models* is shown in the artist's studio seated in front of his groundbreaking painting *A Sunday on La Grande Jatte*. This piece served as the study of the model from rear view and recalls *The Valpinçon Bather* by the Neoclassical painter Ingres, a painter Seurat admired and whose nude figures caused a controversy when shown in the Louvre in 1879.

Port-en-Bessin, avant-port,
marée haute (Harbour at
Port-en-Bessin at High Tide)
1888, oil on canvas
67 × 82 cm (26.4 × 32.3 in)

This painting depicts the Norman fishing village Port-en-Bessin, a town Seurat visited during summers to "cleanse the eye." During the summer of 1883, Seurat made six paintings of the seaport. The image has a painted border of small dots for a transition between the painting and the frame, which he also painted.

Le cirque (The Circus)
1891, oil on canvas
186 × 152 cm
(73.2 × 59.8 in)

This unfinished piece was Seurat's last painting. He exhibited it in the seventh annual exhibition for the Société des Artistes Indépendants in the spring of 1891, just a few days before he died from a still-debated illness. The Cirque Fernando served as inspiration to both Seurat and Toulouse-Lautrec. Fellow artist and friend Signac bought the painting in 1900 and later persuaded the American collector John Quinn (who bought the painting from him) to leave it to the Louvre.

PAUL SIGNAC

Femmes au puits
(Women at the Well)
1892, oil on canvas
195 × 131 cm
(76.77 × 51.57 in)

Along with Seurat, Signac helped to develop the Pointillist style of Neo-Impressionism. After Seurat died in 1891, Signac left Paris and went to Saint-Tropez, where he stayed until 1913. While there, he worked on the composition *In the Time of Harmony*, highlighting the ideal society. In his preparation for that work he devoted a canvas to two women drawing water from a well. This scene shows real elements of the landscape merged together to the painter's liking: a hill with a citadel, the sea and the jetty, the Maures hills and foothills of the Estérel Massif. The painting was exhibited at the Salon des Indépendants in 1893–Signac would serve as its president from 1908

until his death—under the title *Provencal Women at the Well, Decorative Panel to be Seen in Half-light*. Although Paul Gauguin poked fun at the work, calling its execution "systematic" it was an inspiration for the young artists that would become the Fauves, most notably Henri Matisse, who stayed with Signac in 1904.

La bouée rouge (Red Buoy)
1895, oil on canvas
81 × 65 cm
(31.88 × 25.59 in)

Paul Signac was an avid sailor and discovered the port of Saint-Tropez in 1892 while aboard his yacht *Olympia*. At the time, Saint-Tropez was a small fishing port, soon to become frequented by painters including Henri-Edmond Cross, Henri Matisse, Albert Marquet and André Derain. Signac submitted the work to La Libre Esthétique in Brussles in 1896 and the Salon des Indépendants the following spring. Thadée Natanson, editor of *La Revue Blanche*, praised the painting, which is Divisionist in technique but a departure from strict Neo-Impressionism.

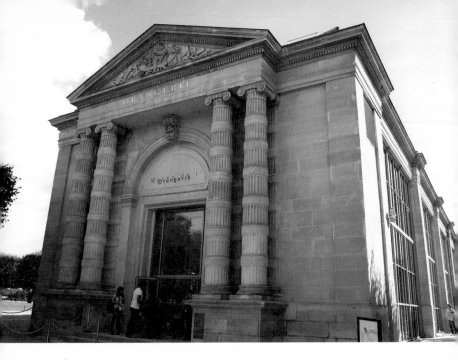

Musée de l'Orangerie

Musée de l'Orangerie
- Jardin des Tuileries
 1st arrondissement
- +33 (0) 1 44 77 80 07
- musee-orangerie.fr
- Wed-Mon, 9 AM-6 PM
 Closed Tue
- 7.50

Access: Accessible from the Métro lines 1, 8, 12 at the Concorde station or the bus lines 24, 42, 52, 72, 73, 84, 94, Concorde stop.

In 1914, Georges Clemenceau, the French statesman, convinced Claude Monet to paint a large-scale cycle of water lilies and from this year on, the painter devoted himself to the works, building a new studio at his home in Giverny just to house them. In 1918, Clemenceau visited Monet to choose 19 panels, which the painter had agreed to donate to the state with the stipulation that they were to be arranged in a circle and permanently installed in two specially constructed rooms in the Orangerie, the construction of which Monet himself helped oversee.

As the Orangerie was being renovated, and the years passed, Monet grew depressed and tried to withdraw his paintings from the museum multiple times, angering his old friend Clemenceau. In December 1926, Monet passed away and the following May, the works were installed and dedicated at the Orangerie in celebration of the end of World War I.

Monet's *Water Lilies* at the Musée de l'Orangerie

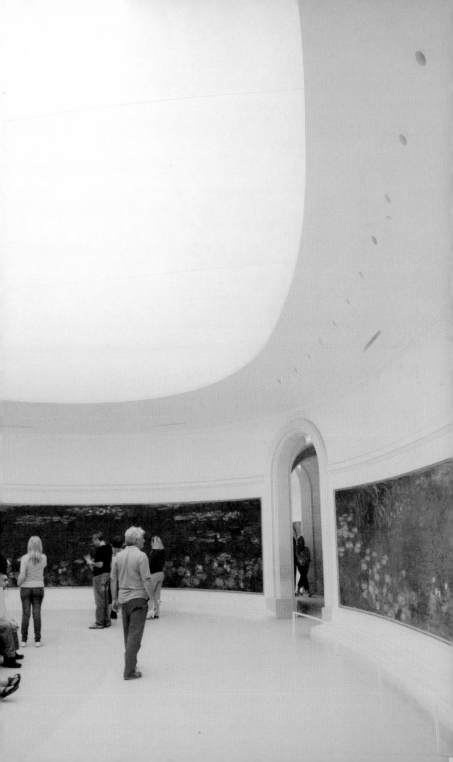

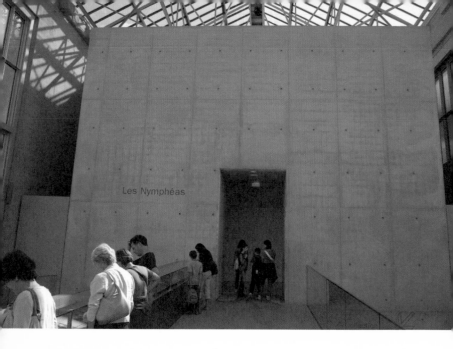

Built in 1852, the Orangerie was originally used to house oranges in winter but eventually saw use as everything from a sports arena to a music hall. Today, the Orangerie houses the Jean Walter and Paul Guillaume Collection in addition to the *Water Lilies* series by Monet.

The Walter-Guillaume Collection, donated in 1965, was the passion project of the art dealer Paul Guillaume, who wished his works would one day form their own modern art gallery. Unfortunately, Guillaume died before that dream could be realized. His widow kept building the collection and eventually bequeathed it to France.

The collection features a wide range of important works from Cézanne's geometric still-life study *Pommes et biscuits* to Renoir's lyrical double portrait *Young Girls at the Piano*. Other important works in the collection include Matisse's *Les Trois Soeurs*, Picasso's *Grande Baigneuse*, Rousseau's *La carriole du père Junier* and Sisley's *Le Chemin de Montbuisson à Louveciennes*. Monet's *Water Lily* paintings are now on display on curved walls in the basement of the museum, showcased under diffused light as per the artist's direct wishes.

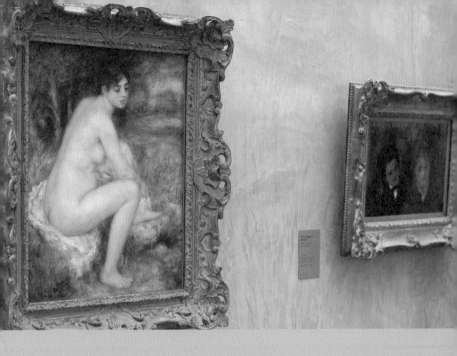

Paul Guillaume

The short life of Paul Guillaume is one etched with fame and intrigue. Born to very humble beginnings, Guillaume skyrocketed into the Paris art scene at a young age, as both a forward-thinking collector and friend and confidant to some of the greatest painters of his time. Guillaume earned the respect of his contempraries and Modigliani's portrait of Guillaume identifies him as *Novo Pilota*, the "new helmsman."

Far from being simply an art dealer, Guillaume promoted artistic life in Paris, supporting artists both morally and with materials. Unlike other art dealers, he sought not to just provide art for his clients, but to cultivate a vast collection of extreme avant-garde and African art. Guillaume died at the age of 42, before his grand collection could be realized. Before his death, Guillaume decided to donate his collection to the state but his widow Domenica prevented this, wishing to continue to build the collection and combine it with her own.

Guillaume's death was considered suspicious at the time, with reports saying he died of an ulcer that evidently went ill treated by his wife. After his death, hell bent on keeping the collection herself, Domenica hired a hit man to kill Guillaume's adopted son. The plan was thwarted by the hit man, who discovered that like himself, Guillaume's son was a paratrooper. The Minister of Culture, André Malraux proposed a deal with Domenica: bequeth the entirety of Guillaume's art collection to the State in place of prison. Domencia conceded and donated the collection in two batches, in 1959 and 1963.

In the end, the collection was much altered from Guillaume's original plan. Domenica edited out the more contemporary art and sold off the African pieces, acquiring more conservative works, like Monet's *Argenteuil*. The collection today bears the name of both Guillaume and Domenica's second husband, the architect Jean Walter, who also died under mysterious circumstances, in a car wreck.

Nymphéas (Water Lilies) [1914–1926]

Monet's *Water Lilies*, or *Nymphéas*, are a series of more than 200 oil paintings of Monet's flower garden at Giverny. Monet painted his lush water garden at various points throughout the day, paying close attention to the effects light had on the water lilies, willow branches and the reflections of the trees and clouds in the pond. This was a recurring motif for Monet during the final 30 years of his life. Many of the canvases were completed while the painter suffered from cataracts, as seen in the paintings' fuzzy washes of vibrant colors. Although he had begun painting the Japanese footbridge and other elements of his water garden in 1895, these paintings were completed between 1914 and 1926.

At the Musée de l'Orangerie, two large, oval-shaped rooms are dedicated to the massive canvases, which hang more than two meters tall on gently curving walls illuminated with natural light. Designed with help from Monet himself, the galleries completely envelop the viewer with images of the garden seen at different times of day.

Monet, a close friend of French Prime Minister Georges Clemenceau, offered these works to France in November 1918. *Nymphéas* was installed and dedicated at l'Orangerie in 1927, mere months after the artist's death.

Above: *Les Deux saules, The Two Willows*, at the Musée de l'Orangerie

A Closer Look
Details of Monet's *Water Lilies*

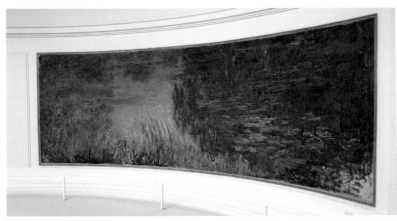

Soleil couchant (Sunset)

Le Matin clair aux saules
(Clear Morning with Willows)

Le Matin aux saules
(Morning with Willows)

Matin
(Morning)

Les Nuages
(Clouds)

Reflets verts
(Green Reflections)

CLAUDE MONET

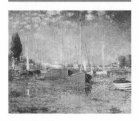

Argenteuil
1875, oil on canvas
56 × 67 cm (22.05 × 26.38 in)

Argenteuil was a picturesque town on the Seine known for its boating. Monet moved here with his family in 1871 and lived there until 1876. He was often joined by Renoir, Sisley and Manet, making the town a veritable artistic hub. The painting depicts sailboats at anchor in the basin of Argenteuil, and was one in a series of similar scenes. In this version, all signs of the modern world are notably absent, including factory chimneys that would have been visible from the port.

AUGUSTE RENOIR

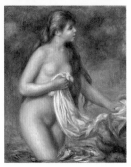

Baigneuse aux cheveux longs
(Bather with Long Hair)
1895-1896, oil on canvas
82 × 65 cm (32.28 × 25.59 in)

After a trip to Italy, Renoir abandoned the style with which he achieved early success and began painting voluptuous nudes. This piece was inspired by the work of classical 18th-century French painter François Boucher.

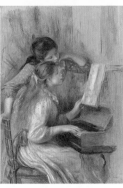

Jeunes Filles au piano
(Young Girls at the Piano)
1892, oil on canvas
116 × 90 cm (45.7 × 35.4 in)

This work remains unfinished. It depicts a typical bourgeois home, but as unlike the other works in the series, the bouquet of flowers on the piano is gone, the padded chair in the lower right corner was cleared and the candles set on the piano are only slightly visible.

of his son. This painting was most likely completed when Cézanne's wife and son stayed with him during his time in Gardanne, not far from Aix-en-Provence in Southern France.

**Le Rocher Rouge
(The Red Rock)
1895, oil on canvas
91 × 66 cm (35.8 × 26 in)**

This painting depicts Bibémus, a deserted ancient quarry in the Provençal mountains between Aix-en-Provence and Mont Sainte-Victoire, just above the village of Le Tholonet. Parts of the quarry dated back to Roman times and some of its yellow stone graced the façades of 18th-century mansions in Aix. From 1895 to 1899, Cézanne rented a hut at the quarry where he stored his painting materials; most of the 60 Bibémus paintings were completed during this period.

PAUL GAUGUIN

**Paysage (Landscape)
1901, oil on canvas
76 x 65 cm
(29.92 x 25.59 in)**

Painted shortly after Gauguin left Tahiti, bound for the Marquesas Islands, this picture likely depicts the second largest of the Marquesas, Gauguin's final resting place, Hiva Oa. The man dressed in black could be Catholic missionary Bishop Joseph Martin, who Gauguin sought out when he first arrived on the island. He requested land near the Catholic mission in Atuona to build his house. To earn the bishop's favor, Gauguin regularly attended mass. He finally received half a hectare in the village where he began building his infamous "house of pleasure."

PAUL CÉZANNE

**Pommes et biscuits
(Apples and Biscuits)
1879-1880, oil on canvas
46 × 55 cm (18.1 × 21.7 in)**

This composition consists of a group of apples seen from different angles. Deeply interested in geometry, Cézanne stated that in art everything can be modeled by the sphere, cone or cylinder.

**Portrait du fils de l'artiste
(Portrait of the Artist's Son)
1880, oil on canvas
35 × 38 cm (13.8 × 15 in)**

This picture depicts Cézanne's son, also named Paul. Cézanne enjoyed fatherhood and drew several sketches

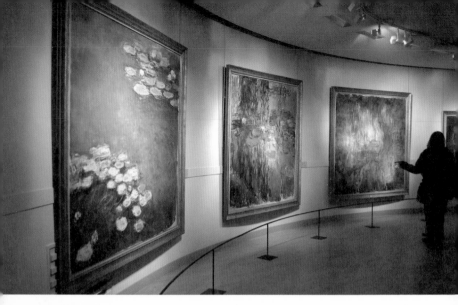

Musée Marmottan Monet

Musée Marmottan Monet
🏠 2, rue Louis Boilly
 16th arrondissement
☎ +33 (0) 1 44 96 50 33
🖥 marmottan.com
🕐 Tue-Sun 10AM-6PM
 Closed Mon
€ 10

Access: The nearest Métro
stop to the museum is La
Muette on the 9 line.

The Marmottan Monet Museum, housed in the former hunting lodge of the Duke of Valmy, has the largest collection of Monet paintings in the world, with over 300 works. Once a relatively obscure museum, in 1966 Monet's son Michel bequeathed his entire collection to the museum—130 works ranging from paintings to pastels, it is one of the greatest bequests in French history. This donation made Marmottan one of the most visited museums in Paris.

A highlight of the museum is *Impression, Sunrise*, the work that named the artistic movement. This painting was victim of a heist orchestrated by two French art thieves and a Japanese gangster in 1985. The work wasn't recovered until five years later and is now on permanent display along with the other works stolen and recovered: *Camille Monet on the Beach at Trouville*, *Portrait of Jean Monet*, and *Field of Tulips in Holland*.

In addition to pieces by Monet, the museum also has a huge collection of other Impressionist and Post-Impressionist works by artists such as Morisot, Renoir, Manet, Degas, Sisley, Pissarro, Gauguin and Signac.

Camille sur la plage de Trouville (Camille on the Beach at Trouville)
1870-71, oil on canvas
48 × 74 cm (18.9 × 29.13 in)

Due to growing political tension in Europe, Monet married his companion Camille in 1870–possibly because married men were the last to be called up for duty. The two, along with their son Jean, left Paris and settled in Trouville, a resort town close enough to London that they could flee at the onset of war. They were met by fellow painter Boudin and his wife.

Promenade près Argenteuil (Promenade near Argenteuil)
1873, oil on canvas
60 cm × 81 cm
(23.6 in × 31.9 in)

Monet settled in Argenteuil in 1871, when the town was on the cusp of a burgeoning industry. Its prime location on the Seine facilitated the transport of goods and It was also on the Paris-Le Havre train line, an ideal location for those who wanted to remain close to Paris without actually to living there. Manet and Caillebotte both had property nearby and Renoir and Sisley visited on a regular basis to paint.

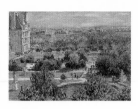

Vue du jardin des Tuileries, Paris
1876, oil on canvas
21.25 × 28.75 in
(53.97 × 73.02 cm)

Monet painted the Tuileries, the formal garden in the center of Paris, in 1876. He depicts the garden from a vantage point high in a building on the rue de Rivoli. The art collector, Victor Chocquet, an early champion of Impressionism, had a residence there.

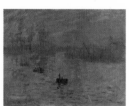

Impression, soleil levant (Impression, Sunrise)
1872, oil on canvas
48 × 63 cm
(18.86 × 24.86 in

This painting of the port of Le Havre gave its name to Impressionism. It was exhibited at the first Impressionist exhibit in 1874, and when Renoir's brother, Edmond, was editing the exhibition catalogue, he criticized the boring nature of Monet's straightforward titles. "Why don't you just call them impression?" Monet responded.

Entraîner dans la Neige or la Locomotive (Train in the Snow or The Locomotive)
1875, oil on canvas
59.05 × 78.10 cm
(23.25 × 30.75 in)

Monet was attracted to the way an object's appearance can change through light or the elements. He was interested in the train, which through its speed and smoke produced the qualities of ever-present visual change. This painting depicts the railway station in Argenteuil, opposite Monet's house.

Le Bateau
(The Rowing Boat)
1887 (or 1890), oil on canvas
146 × 133 cm
(57.5 × 52.37 in.)

Monet depicted boats at various points in his career, and was nicknamed "the Raphael of Water" by Manet. Monet may have been attracted to Giverny for its location near two rivers. Monet produced a number of boating scenes, including pictures of the Hoschedé girls floating, sculling, fishing or simply drifting along in the family boats.

Nymphéas (Waterlilies)
1907, oil on canvas
100 × 73 cm
(39.37 × 28.75 in)

Although Monet explored all aspects of his garden in Giverny, a few places became obsessions for the artist, including the Japanese Bridge.

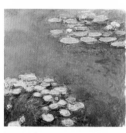

Nymphéas, harmonie en bleu (Waterlilies, Harmony in Blue)
1914-17, oil on canvas
200 × 201 cm (78.6 × 79 in)

Monet was direct in his approach, but was known to embellish stories for effect. Once when asked if the water lilies he was working on could be photographed, he abruptly replied that, because they were being worked on, they were in no state to be photographed.

Glycines (Wisteria)
1917-20, oil on canvas
100 × 300 cm
(39.37 × 118.11 in)

Most of Monet's later work depicts his garden, which he painted at various times of day and throughout the year.

Saule pleureur (Weeping Willow)
1918-19, oil on canvas
100 × 100 cm
(39.37 × 39.37 in)

By 1917, Monet's eyesight was failing and he had to rely on paint tube labels to choose the colors for his work.

Le pont japonais à Giverny (Japanese Bridge at Giverny)
1918-24, oil on canvas
100 × 89 cm (39.3 × 35.0 in)

Monet claimed most of the money he made from his work went into the property.

GUSTAVE CAILLEBOTTE

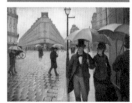

La Place de l'Europe, temps de pluie (Paris, Rainy Day)
1877, oil on canvas
221 × 276 cm
(87 × 108.66 in)

Caillebotte's modern street scene was praised at the Impressionist exhibition in 1877. Some critics even said it would not be out of place at the Salon. Caillebotte was considered academic in his approach, leading some to state that he was an Impressionist in name only.

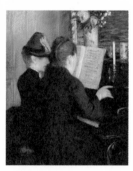

La leçon de pian (The Piano Lesson)
1881, oil on canvas
81 × 65 cm
(31.89 × 25.59 in)

Caillebotte was more financially secure than his Impressionist colleagues. His work often focused on indoor life.

AUGUSTE RENOIR

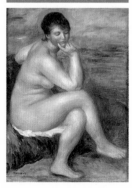

Baigneuse assise sur un rocher (Bather Seated on a Rock)
1882, oil on canvas
92 × 73 cm
(36.22 × 28.74 in)

Inspired by Classical nudes on a trip to Italy, Renoir's voluptuous figures of his later career were not readily accepted. Pissarro wrote to his son in 1887 that Renoir told him that his former fans, including dealer Durand-Ruel, were angry that he had left his Romantic period behind.

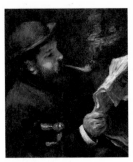

Claude Monet (Le Reader)
1873-1874, oil on canvas
65.1 × 49.4 cm
(21.63 × 19.45 in)

Renoir was known for his portrait paintings—a profitable genre—and often depicted friends and colleagues. He executed several portraits of Monet, who he met at Charles Gleyre's atelier.

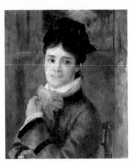

Portrait de Madame Monet
c. 1873, oil on canvas
61 × 50 cm (24 × 19.69 in)

Renoir often painted his colleagues as well as their spouses, including this image of Monet's first wife, Camille.

BERTHE MORISOT

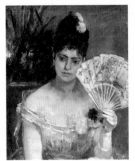

Au bal (At the Ball)
1875, oil on canvas
62 × 52 cm (24.38 × 20 in)

Morisot received criticism for her participation in the first Impressionist exhibition. Her work, considered delicate, was displayed side-by-side with more provocative paintings. On March 24, 1875 she publicly declared her belief in Impressionism. She showed At the Ball at the second Impressionist exhibition. This was one of 17 works she showed, outnumbered only by Degas, who showed 24.

Eugéne Manet and his Daughter at Bougival
1881, oil on canvas
73 × 92 cm
(28.74 × 36.22 in)

Although Eugéne Manet supported his wife's career, Morisot often jokingly complained that he was a difficult model. Their daughter, Julie, is included in most of her depictions of him—often showing Manet in a fatherly light, playing games with Julie or reading to her.

**La nacelle
(The Cherry Pickers)**
1893, oil on canvas
152 × 85 cm (59 × 33 in)

Morisot created several preliminary studies for this painting. She began sketching her daughter, Julie, standing on a ladder picking fruit while her cousin Jeannie Gobillard handed her a basket. A watercolor version also exists and Morisot produced pastel studies of both individual figures. The original studies were made in the garden of her family's rented house in Mézy, where they spent the summer of 1891. She picked up the theme again the following winter in her studio, using professional models. She regretted selling the final work and bought the painting back from the art dealer so that she could bequeath it to her daughter.

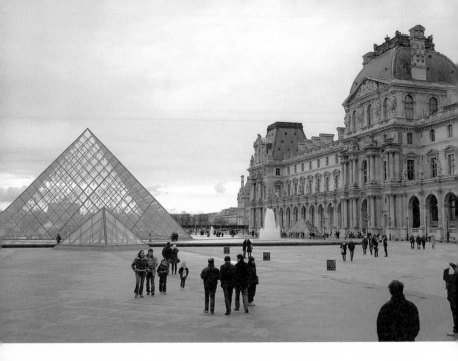

Musée du Louvre

The Louvre Museum
- 🏠 1st arrondissement
- 🖥 louvre.fr
- 🕙 Mon, Thu, Sat-Sun
 9AM–6PM
 Wed, Fri 9AM–10PM
 Closed Tue
- 💶 10

ACCESS: Métro stop
Palais-Royal–Musée
du Louvre on Métro
lines 1 and 7 and bus
lines 21, 24, 27, 39,
48, 68, 69, 72, 81
and 95, which stop in
front of the Pyramid
at the museum.

The Louvre is one of the world's largest and best-known museums. Although not a museum dedicated to modern art, the Louvre has in its collection a number of Impressionists paintings bequeathed by Carlos de Beistegui, and by Hélène and Victor Lyon (rooms A, B and C, 2nd floor Sully wing). The Impressionist collections of Beistegui and the Lyons have been kept intact at the Louvre in keeping with their wishes; which is why these works were not moved to the Orsay upon its opening.

In addition, the museum has a number of paintings that influenced the Impressionists (rooms 50-70, second-floor Sully wing, and rooms 75-77 first-floor Denon wing), including Titian's *Concert Champetre* (Room 7, first-floor Denon), which was the direct inspiration for Manet's *Le déjeuner sur l'herbe*. At different times, the official Salon was held at the Louvre in room 3, and in the

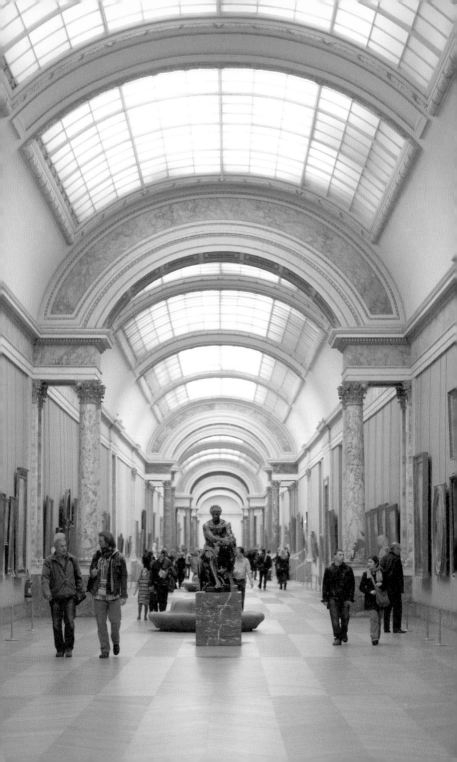

A view from the window next to the balcony where Monet painted *Saint Germain l'Auxerrois*, *Jardin de l'Infante* and *Quai du Louvre* (right page).

Apollo Gallery, both 1st floor Denon wing. In 1674, the Académie royale de peinture et de sculpture (part of the Académie des Beaux-Arts), held its first exhibition at the Salon Carré at the Louvre—this is the origin of the word Salon. Beginning in 1725, the Salon became the official art exhibition of the Académie des Beaux-Arts in Paris and its first show was held at the Louvre as well. The exhibition was originally private, but in 1737 opened to the public.

The Louvre was also an important meeting place for artists: a number first met there, either while visiting the museum (Morisot and Manet) or when making copies for famous works of art (Pissarro and Renoir). Napoleon III's renovations of Paris, and the establishment of the Salon des Refusés, set the stage for Impressionism. For a glimpse into his luxurious life, visit his apartments, which feature period rooms from the era and decorative arts.

In the spring of 1866, Monet petitioned the Superintendent of Fine Arts of the Louvre for permission to "paint views of Paris from the windows of the Louvre, and notably from the outside colonnade." From the east end of the Louvre he painted three paintings, which are his earliest images of Paris, and his first attempts to handle the panoramic aspect of modern society.

left to right: Edgar Degas, *Mary Cassatt at the Louvre: The Etruscan Gallery, 1879-80*, Metropolitan Museum of Art, New York; Salon Carré at the Musée du Louvre, where the Salon was originally held.

Monet's Visions from the Louvre

Saint Germain l'Auxerrois
2, place du Louvre, 1st arrondissement
Monet's painting of *Saint-Germain l'Auxerrois*, now at the Staatliche Museen in Berlin, shows this Roman Catholic Church, founded in the 7th century, with its delightful mixture of Romanesque, Gothic and Renaissance architectural styles.

Jardin de l'Infante
Southern end of the Louvre, below Cour Carrée, next to Quai Francois Mitterrand 1st arrondissement
Monet's painting *Jardin de l'Infante* (Allen Memorial Art Museum, Oberlin College, Ohio) portrays the Garden of the Princess, while the cupola of the Pantheon is visible in the distance.

Quai du Louvre
A continuation of Quai François Mitterrand, before Place de l'Ecole.
1st arrondissement
The third view of Paris that Monet painted from the Louvre balcony is now at the Haags Gemeentemuseum in The Hague, Netherlands. The picture shows a similar panorama to the artist's *Jardin de l'Infante* of 1865.

**Environs de Honfleur: Neige
(Environs of Honfleur: Snow)**
c. 1867, oil on canvas
81.5 × 102 cm
(32.1 × 40.2 in)

Known as France's "Northern Riviera," the coastal town of Honfleur was a popular destination for marine painters, who came to capture its booming port. Monet traveled here with Bazille in May 1864, and together they set up their easels along the coast, capturing the sea cliffs and countryside; he returned to Honfleur in 1866. Honfluer was also the birthplace of Boudin, one of Monet's early influences.

**Glaçons sur la Seine à
Bougival
(Ice on the Seine at Bougival)**
c. 1867 - 1868, oil on canvas
65 × 81 cm (25.6 × 31.9 in)

Bougival is a commune in the western suburbs of Paris that attracted a number of painters—including Monet, Sisley and Renoir—with its natural charms. Bougival was also the birthplace and family home of Monet's wife Camille. Monet painted this wintry scene during a visit in 1867.

**La Débâcle près de Vétheuil
(Ice Breaking up near
Vétheuil)**
c. 1880, oil on canvas
65 × 93 cm (25.6 × 36.6 in)

Fed up with the growing industrialization of Argenteuil and searching for a more isolated area in which to work, Monet moved to the small town of Vétheuil in 1878. While there, he suffered not only the death of his wife, Camille, but also financial hardships and unfavorable critical response to his work. In Vétheuil, Monet and his family set up a joint household with the Hoschedé family. Ernest Hoschedé, a department store magnate and art collector, suffered financial ruin and his wife, Alice, sought refuge in the hamlet. Although the exact nature of their relationship at the time is unknown, there are claims that Monet fathered Alice's last child, Jean-Pierre. They would later marry, after Ernest's death.

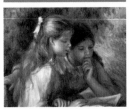

La Lecture (Reading)
c. 1890-95, oil on canvas
55 × 65 cm (21.7 × 25.6 in)

Renoir's soft, domestic scenes, such as this painting and *Young Girls at the Piano*, give a glimpse into upper-class French life at the end of the 19th century. Following his early experiments with Impressionism, Renoir traveled to Italy and Spain where he studied the portraits of Raphael and Velázquez.

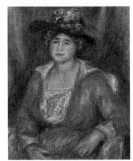

**Portrait de femme assise
(Portrait of a Seated Woman)**
c. 1916 - 1918, oil on canvas
35 × 27 cm (13.8 × 10.6 in)

Renoir was best known for his portraits, which often depicted friends, colleagues and other members of French society. But his most beloved subject was women. He had close relationships with many of his models, though, as the actress Jeanne Smary once remarked: "Renoir is not the marrying kind. He marries all the women he paints—but with his brush." Although Renoir was a careful observer of the the characteristics of each individual sitter, he was more interested in the types of women rather than the specific individuals he was depicting. These paintings often represented different ideals of femininity. At this later point in his career, Renoir was suffering from debilitating arthritis, which made it difficult to paint.

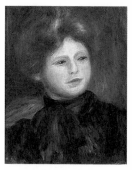

***Portrait de femme
(Portrait of a Woman)***
**oil on canvas
35 × 27 cm (13.8 × 10.6 in)**

Renoir drew upon several different themes related to women in his portraits, often depicting society women, women in the home, little girls, maternity and even costume pieces inspired by his trips to North Africa. His depictions of beauty changed later in his career, following a trip to Italy where he discovered the Renaissance painters, as evidenced by the voluptuous classical nudes and softer style that dominated his later work.

HENRI DE TOULOUSE-LAUTREC

Gustave Lucien Dennery
**c. 1883, oil on canvas
55 × 47 cm (21.7 × 18.5 in)**

Although Toulouse-Lautrec is widely known for his paintings of Parisian nightlife and entertainers, he did depict colleagues in his work. This work shows Gustave Lucien Dennery, a fellow painter and friend of the artist.

ALFRED SISLEY

Le Bois des Roches, Veneux-Nadon (The Roches Forest, Veneux-Nadon)
**c. 1880, oil on canvas
73 × 55 cm (28.7 × 21.7 in)**

Claude Monet taught Sisley the Impressionist approach to color and brushstroke, which Sisley combined with his love of English landscape painting and somber palette. He never reached the success of his fellow artists and died in obscurity.

CAMILLE PISSARRO

***L'Abreuvoir, Éragny
(The Watering Place, Éragny)***
55 × 65 cm (21.7 × 25.6 in)

By 1884, Pissarro already had six children and his wife, Julie, was pregnant again. Looking for more space for his family, he moved to Éragny–a commune in the northwestern suburbs of Paris. With the help of a loan from Monet, he was able to buy his house in 1892. Pissarro painted several rural scenes of the area and died in the town on November 13, 1903. The main road through the town has been renamed rue Camille Pissarro and the local primary school is also named after the artist. This painting showcases the dappled brushstrokes and thick impasto that dominated the latter part of his career.

EDGAR DEGAS

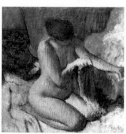

***La Sortie du bain
(After the Bath)***
**1883-1890, pastel on paper
89 × 116 cm (35 × 45.7 in)**

Degas was interested in the movement of the body and was attracted to the awkward poses that revealed its tension. He began a series of paintings of bathers around 1880. Although this image shows a woman viewed from the front, most women in the series were pictured at their toilet as seen from behind. In these images, as in much of his work, Degas turns the viewer into a voyeur and subverts the French academy's idea of what a young pretty girl should look like.

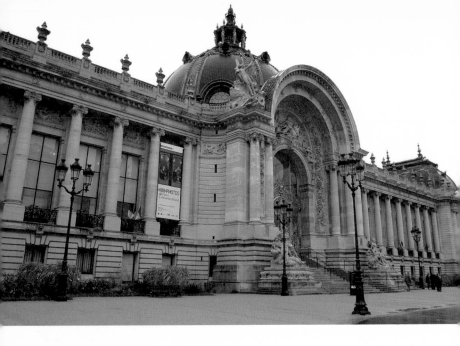

Petit Palais

Petit Palais
🏠 Avenue Winston
 Churchill
 8th arrondissement
☎ +33 (0) 1 53 43 40 00
🖥 petitpalais.paris.fr
🕐 Tue–Sun 10AM–6PM
€ Free

Access: Métro lines
1 and 13, stopping at
the Champs-Élysées
Clémenceau station
and bus lines 28, 42, 72,
73,83, 93.

Designed by architect Charles Girault and built for the World's Fair in 1900, the Petit Palais became a museum in 1902 and is now home to the Musée des Beaux-Arts de la Ville de Paris (The City of Paris Museum of Fine Arts). The collection of the museum is vast, featuring medieval, Renaissance, Baroque and 19th-century paintings, including work by the Impressionists such as Manet's *Portrait of Theodore Duret* — depicting one of the first advocates of Impressionism — and Monet's *Sunset over the Seine at Lavacourt*, 1880.

In addition to the art on display here, the museum also houses a collection of decorative murals and sculptures created between 1903 and 1925. Girault planned these works into the design of his building in order for them to create a palace-like atmosphere. The works together form a program that glorifies the city of Paris and the benefits of art. The murals took over 20 years to complete and were painted by the team of Fernand Cormon and Alfred Roll, as well as Ferdinand Humbert, Paul Baudoüin, Maurice Denis and Girault himself, who painted the mural in the entrance gate.

MARY CASSATT

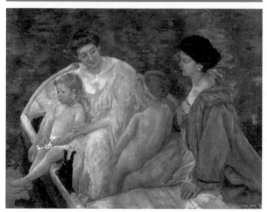

Le Bain (Two mothers and their children in a boat)
1910, oil on canvas
99 × 129 cm (39 × 50.8 in)

Cassatt's friends and relatives often served as models for her paintings and, on occasion, she would give them designer dresses as gifts. In this painting, the women's fashionable dresses, by designer Madame Paquin, are not typical boating attire but add to the painting's lush atmosphere. The scene could depict the pond at the Château de Beaufresne, where Cassatt spent the last years of her life. This painting was incorporated into the Petit Palais collection during the artist's lifetime, courtesy of the son of American banker James A. Stillman. When he retired to Paris in 1909, Stillman sought Cassatt's advice on what works to purchase to expand his collection. When he died in 1918, he owned 20 works by the artist.

PAUL CÉZANNE

Trois Baigneuses
(Three Bathers)
c. 1879 - 1882, oil on canvas
53 × 55 cm (20.9 × 21.7 in)

Cézanne started painting scenes of bathers in the late 1860s and continued to develop the theme through to 1906, revisiting the subject more than 200 times. Matisse was impressed by the painting and bought it from Ambroise Vollard in 1899; he donated it to the museum in 1936, stating the painting "has sustained me morally in the critical moments of my venture as an artist."

Les Saisons: Le Printemps, L'Été, L'Automne, L'Hiver
The Seasons: Spring, Summer, Autumn, Winter
c. 1860. Dated 1811 and signed Ingres
315 × 98 cm (124 × 38.6 in), 314 × 109.5 cm (123.6 × 43.1 in)
314 × 105 cm (123.6 × 41.3 in), 314 × 104 cm (123.6 × 41 in)

Vieil homme au baton
(Old man with a Stick)
1888, oil on canvas
70 × 45 cm (27.6 × 17.7 in)

Cézanne painted these four murals at his father's property, Jas de Bouffan, in Aix-en-Provence. The property was in disrepair, which might explain why his father, Louis-Auguste Cézanne (who was not encouraging of his son's interest in art) allowed him to paint the grand salon of the house. Still enrolled in law school at the time, Cézanne signed the panels "Ingres 1811," possibly to show his father his worth as a painter—the date corresponds to the inscription on *Jupiter and Thetis*, the painting by the famed Neoclassical painter Jean-Auguste-Dominique Ingres in the Musée Granet. By signing these works with Ingres's name, Cézanne may have wanted to advise his father, in a mocking way, that he was not inferior to even the most famous artist of the age. The older Cézanne allowed his son to go to Paris and study art in 1861. The estate was sold in 1899 following the death of Cézanne's mother; the panels joined the collection of dealer Ambroise Vollard.

After being invited to Arles by Vincent van Gogh, Gauguin and his friend worked side by side from October 23-December 26, 1888; the two-month period served to be a creative time in both artists' work. This piece is similar to a painting Van Gogh completed in August 1888, which depicts Patience Escalier, a herdsman from Camargue. In this piece, the chair that the model rests his arm upon is identical to one Van Gogh depicts in his painting *Gauguin's Chair*.

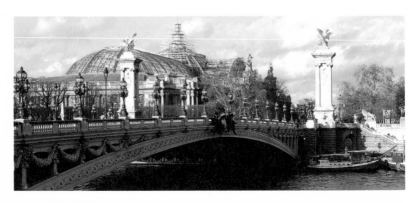

ÉDOUARD MANET

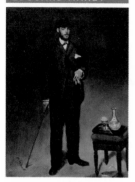

**Portrait de Théodore Duret
(Portrait of Théodore Duret)
1868, oil on canvas
46.5 × 35.5 cm (18.3 × 14 in)**

Manet met critic Théodore Duret after a trip to Spain. Having been influenced by 17th-century portrait artist Velázquez, Manet painted his new friend with the Spanish master's style in mind. The two remained friends and Duret published a biography of the painter in 1926.

CLAUDE MONET

**Soleil couchant sur la Seine à Lavacourt, effet d'hiver
(Sunset on the Seine, at Lavacourt, Winter Effect)
1880, oil on canvas
100 × 150 cm (39.4 × 59.1 in)**

During the unusually harsh winter of 1879-80 Monet made several paintings of the gradual thawing of the Seine. Monet believed that another version of this painting, *The Seine at Lavacourt*, with its crisp lines and academic feel, would be more to the jury's liking and chose to submit it

over this more "impressionistic" work. Although *The Seine at Lavacourt* was accepted, it was hung so high that it received little attention.

ALFRED SISLEY

**L'église de Moret, le soir (The Church at Moret, Evening)
1894, oil on canvas
101 × 82 cm (39.8 × 32.3 in)**

Between 1893 and the summer of 1894, Sisley spent a year painting this church in Moret-sur-Loing, a small town on the edge the Fontainebleau forest. Like Monet, Sisley also produced numerous versions of the painting, capturing the building at different times throughout the day and year.

HENRI DE TOULOUSE-LAUTREC

**Nice, souvenir de la promenade des Anglais (Nice, Memories of the English Promenade)
1880, oil on canvas
38.5 × 50 cm (15.2 × 19.7 in)**

Toulouse-Lautrec painted this work when he was about 17

years old—around the time he decided to study art in Paris. The painting depicts the English Promenade at Nice; the driver could possibly be his father, Count Alphonse de Toulouse-Lautrec, one of the last aristocrats to hunt with falcons on horseback. Prior to drawing his popular motifs of Parisian nightlife, the young Toulouse-Lautrec mainly painted horses; his first apprenticeship was with animal painter René Princeteau, a friend of the Lautrec family who specialized in equestrian and military subjects.

AUGUSTE RENOIR

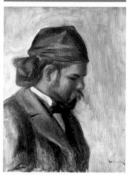

**Ambroise Vollard au foulard rouge (Ambroise Vollard in a Red Scarf)
c. 1899, oil on canvas
30 × 25 cm (11.8 × 9.8 in)**

Ambroise Vollard had his portrait painted by several artists besides Renoir, including Cézanne, Sisley and Picasso. Sitting for these paintings allowed the art dealer to develop a rapport with the artists. He went on to write biographies on several, including Renoir. The scarf around Vollard's head is a reference to his origins on Réunion, a French island in the Indian Ocean.

Musée Picasso

**Musée National
Picasso Paris**
🏠 Hôtel Salé
 5, rue Thorigny
 3rd arrondissement
☎ +33 (0) 1 42 71 25 21
▣ musee-picasso.fr
◉ Check for opening
 hours.

Access: Métro line 1 to
St. Paul stop or line 8 to
St-Sébastien–Froissart or
Chemin Vert.

The Hôtel Salé was built in the middle of the 17th century in the Marais district of Paris. It underwent several incarnations, including as the Embassy of the Republic of Venice and a school, where Balzac studied, before being chosen as the location for the Musée National Picasso in 1974.

Some 3,000 different works by Picasso as well as his own personal collection of works by other artists including Matisse, Cézanne, Degas and Seurat, are kept here. The collection was amassed from multiple donations, including from Picasso's daughter Jacqueline and a selection from Picasso himself upon the artist's death.

Picasso kept paintings from each of his periods for his own personal collection, allowing the museum to display a wide range of his *oeuvre*.

The museum also holds a selection of important Impressionist works collected by Picasso. Despite not being an Impressionist himself, he kept

close ties with the group. He called Cézanne "The father of us all," and said that "Cézanne was my one and only master." Cézanne's work can be seen as a link between Impressionism with Cubism, which began in the early 1900s.

Picasso himself did not visit Paris until 1900, when Impressionism was already waning. His art collection was amassed both by purchase and by exchange: He bought Cézanne's *La mer à l'Estaque (The Sea at l'Estaque)* from his banker and he gave Matisse the Cézanne painting *Cruche, bol et citron (Pitcher, bowl and lemon)* in exchange for Matisse's *Marguerite*, 1906.

AUGUSTE RENOIR

Baigneuse assise dans un paysage or Eurydice (Seated Bather in a Landscape or Eurydice)
c. 1895–1900, oil on canvas
116 × 89 cm (45.7 × 35 in)

Renoir's discoveries in Italy left him in an intellectual crisis over his own work. Gone was the revelry of his Impressionist style, replaced with themes included mythology and the female form. This new direction was met with ambivalence and even animosity. Mary Cassatt wrote that Renoir was painting grotesque pictures of "enormously fat red women."

EDGAR DEGAS

Des prostituees attendent les clients dans une maison close (Prostitutes Awaiting Clients at a Brothel)
1879, monotype
21 × 16 cm (8.3 × 6.3 in)

By the time Picasso moved to Paris from Barcelona in 1904, Degas was already an established, well-known artist. Picasso set up his studio in Montmartre (close to Degas) and would often see the artist pass by in the street, although the two never met. Degas completed a series of monotypes in the 1870s depicting prostitutes and their customers in brothels. Picasso bought nine of these monotypes between 1958 and 1960.

*La fête de la patronne Maison close lors d'une fête en l'honneur de proxenete
The feast of the brothel patron during a celebration in honor of the procuress*
1879, monotype
26 × 29 cm (10.2 × 11.4 in)

This monotype depicts a brothel scene, a topic Degas worked with throughout his career. In this scene, naked prostitutes celebrate the madame of the house., presenting her with flowers. Picasso was in awe of Degas and his work, and the younger artist owned and copied several of Degas's monoprints, all depicting brothel scenes. Near his 90th birthday, Picasso created a series of etchings based on these monotypes, including Degas as the wary client, sometimes seen on the periphery of the frames.

PAUL CÉZANNE

Cinq baigneuses (Five Bathers)
c. 1877 – 1878, oil on canvas
45.8 × 55.7 cm (18 × 21.9 in)

Cézanne's approach to the subject of bathers in works such as this most likely influenced Picasso when he produced several paintings depicting bathers. Picasso bought this oil painting (similar to the *Baigneurs* that Matisse acquired in 1899) in 1957 from the Marlborough Gallery in London.

La mer à L'Estaque (The sea at L'estaque)
c. 1878 – 1879, oil on canvas
73 × 92 cm (28.7 × 36.2 in)

Picasso acquired this painting from banker Max Pellequer in the 1950s. The painting's geometric shapes and careful construction foreshadowed the Cubist artistic philopophy so much that Picasso would sometimes joke that he was Cézanne's grandson. Cézanne painted the fishing village of L'Estaque, where his family had a home, more than 20 times.

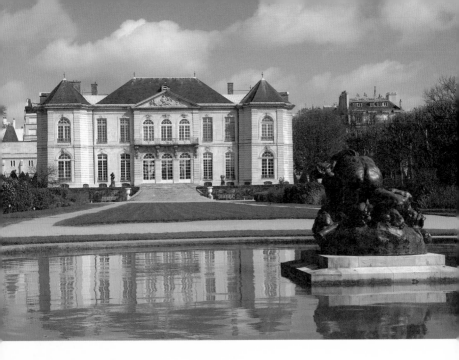

Musée Rodin

Musée Rodin

🏠 79, rue Varenne
 7th arrondissement

☎ +33 (0) 1 44 18 61 10

🖥 musee-rodin.fr

⏰ Tue–Sun 10AM- 5:45PM

€ 7

Access: The museum is accessed from the Métro line 13, stops Invalides or Varenne, where you can see Rodin sculptures on display.

The elegant Hôtel Biron is where Auguste Rodin, one of the greatest sculptors of all time, spent his days working, having turned the French château into a workshop. Rodin donated the building and his entire collection of his own sculptures—as well as works he had acquired by Van Gogh (*Le Père Tanguy*) and Renoir (*Femme nue*)—to France on the condition that the building be turned into a museum dedicated, modestly, to him.

The museum opened in 1919 and it holds amongst its many works, the significant pieces such as *The Kiss*, *The Thinker* and *Gates of Hell*. Visitors can also take advantage of the house's expansive garden, which holds examples of Rodin sculptures. In addition, the museum has a room dedicated to works of Camille Claudel, a French sculptor who was influenced by Rodin, worked in his workshop and eventually became his lover for eight years until an unwanted abortion ended their romantic affair. An art critic of the time once called Claudel "A revolt against nature: a woman genius."

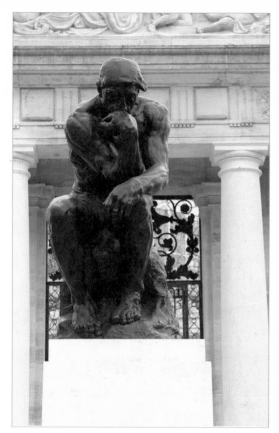

Femme nue (Female Nude)
c. 1880, oil on canvas
80.5 × 65 cm (31.7 × 25.6 in)

Renoir's later work was influenced by mythology and the paintings of Renaissance masters, including Titian.

Le Père Tanguy
late 1887, oil on canvas
92 × 73 cm (36.22 × 28.74 in)

Rodin's sculptures are not impressionistic, but in 1889 Rodin and Monet held a joint exhibition at the Georges Petit Gallery. The show was a success; Rodin showed 36 works, and it opened his art to collectors and museums around the world.

Musée Rodin also holds contemporary art exhibitions to compliment its permanent collection, like the 2010 installation of video-art performances by artists Vito Acconci, Sanja Iveković, Marina Abramović and Mona Hatoum.

Color merchant Julien Tanguy was a Breton peasant who had settled in Paris and ran a small paint shop on 14, rue Clauzel. Known as Père, or Papa, Tanguy would accept paintings from artists as credit for the painting materials he supplied. This exchange turned his shop into a gallery of sorts. In the painting, Tanguy is shown surrounded by his collection of Japanese prints, which influenced Van Gogh and other artists of the time.

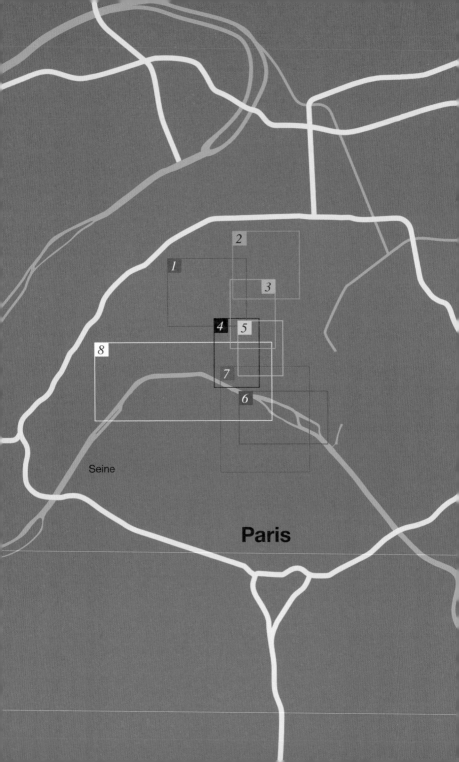

Paris Walking Tours

Walk in the footsteps of the Impressionists through the streets of Paris, to the places where they lived, laughed, fell in love and received some of their greatest inspirations. Discover the 17th-century palace turned brothel that Toulouse-Lautrec called home, the majestic boulevards captured by Caillebotte and the cafés where the artists and their compatriots would gather to plan the next great exhibition.

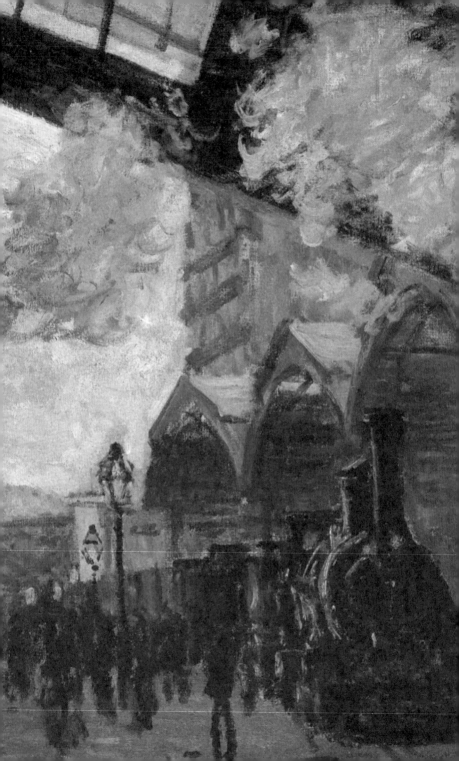

Les Batignolles and Gare Saint-Lazare

Tour starts from the historic Place de Clichy (Métro lines 2 and 13 to Place de Clichy).

Boulevard and Place de Clichy

Cabaret du Père Lathuille

Café Guerbois

Bazille's Studio,
rue La Condamine

Zola's Home, rue La Condamine

Villa des Arts

Montmartre Cemetery

Monet's Studio, rue de Vintimille

Monet's Studio, rue Moncey

Manet's Last Home,
rue Saint-Petersbourg

Place de Dublin

Manet's Last Studio,
rue Saint-Petersbourg

Place de l'Europe

Gare Saint-Lazare

Monet's Home, rue d'Edimbourg

Caillebotte's Home,
rue de Miromesnil

Parc Monceau

TRAVEL TIPS:

If you are short on time, start from La Fourche Métro station (line 13).

Be aware: The huge Cimètiere de Montmartre only has one entrance.

Claude Monet, *Gare St-Lazare* (detail), 1877
National Gallery, London

Wepler, a historic bras-serie that celebrated its 100th anniversary on the place de Clichy in 1992.

Boulevard and Place de Clichy

🔒 Border between the 8th, 9th, 17th and 18th arrondissements

Clockwise from top left:
Édouard Manet
Vue prise près de la Place Clichy (Rue), 1878
Private Collection

Auguste Renoir
Place Clichy, c. 1880
Fitzwilliam Museum, Cambridge, England

Vincent van Gogh
Boulevard de Clichy, 1887
Van Gogh Museum, Amsterdam

Paul Signac
The Boulevard de Clichy under Snow, 1886
The Minneapolis Institute of Arts

Boulevard and Place de Clichy

The place de Clichy marked the Paris city limit until 1860. It is one of the very few places in the city where four arrondissements (8th, 9th, 17th and 18th) meet at a single point. The bronze statue honors the Marshal de Moncey, who fought against France's foes in 1814 to defend the nearby city gate. The place de Clichy can be seen in many works by the Impressionist painters who worked here.

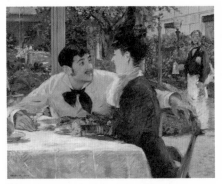

2 Cabaret du Père Lathuille

Opened in 1765 (closed in 1906), this cabaret only became well known after the Battle of Paris (1814) when Marshal de Moncey set up his headquarters here. As the story goes, the owner famously said, "*Mangez, buvez mes enfants, il ne faut rien laisser à l'ennemi*" ("Eat, drink my children, nothing should be left to the enemy"). The French defeat in the battle led directly to Napoleon's abdication. The Cabaret is immortalized in Manet's *Chez le Père Lathuille* (painted in 1879).

Cabaret du Père Lathuille
🏠 7, avenue de Clichy
 17th arrondissement

3 Café Guerbois

Café Guerbois was one of the meeting places of the Impressionists. Manet was the first to start frequenting the café in 1866. Soon Degas, Monet, Renoir, Bazille, Sisley as well as Zola (who often mentioned the café in his texts)—and occasionally Cézanne and Pissarro—would meet on Thursdays and Sundays to debate painting and art. In 1870 Manet, insulted by a review from Louis Edmond Duranty (a friend of Degas who painted his portrait), challenged the critic to a duel. Duranty received a slight wound and honor was satisfied; the two remained friends. Zola was one of Manet's seconds for the duel.

Café Guerbois
🏠 9, avenue de Clichy
 17th arrondissement

Left: Édouard Manet
Au Café Guerbois, 1869
National Gallery of Art,
Washington, D.C.

Right: Édouard Manet
Le Bon Bock, 1873
Philadelphia Art Museum

Rue La Condamine

Frédéric Bazille
L'atelier de Bazille, 1870
Musée d'Orsay

Frédéric Bazille Studio
⌂ 9, rue La Condamine
(access from No. 7)
17th arrondissement

Émile Zola Residence
⌂ 14, rue La Condamine
17th arrondissement

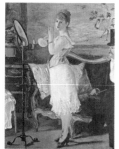

Above: Édouard Manet
Nana, 1877
Hamburger Kunsthalle

Right: Paul Cézanne
*Paul Alexis Reading to
Émile Zola*, 1869-70
São Paulo Museum of Art

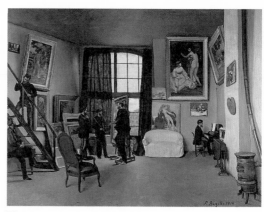

�४ **Frédéric Bazille Studio**

One of Bazille's masterpieces, *L'atelier de Bazille*,
depicts the studio the artist shared with Renoir for
two years. It was painted just months before Bazille
joined a Zouave regiment that August 1870. He was
killed in battle on November 28.

◵ **Émile Zola Residence**

Zola was a writer and close friend with many of the
Impressionists. Manet painted Zola's heroine *Nana*
(1877) and a portrait of the writer (1868), now at
the Musée d'Orsay; Cézanne was Zola's childhood
friend and painted *Paul Alexis reading a manuscript
to Émile Zola* (1869-70); while Zola is also included
in the painting *L'atelier de Bazille*.

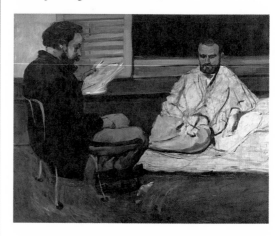

6 Villa des Arts

A number of painters rented studios at the Villa des Arts. Renoir was here from 1892 to 1896, while Cézanne rented a studio to work on his *Bathers*, a series completed between 1898 and 1905. Later, Signac also had a studio here.

Villa des Arts
🏠 15, rue Hégésippe-Moreau
18th arrondissement

7 Cimetière Montmartre

The final resting place for many artists, the Montmartre Cemetery is beautiful and hilly, and is often visited by tourists. Degas is buried here, in Division 4. Despite its large size, the only entrance is on rue Rachel, which can be accessed by boulevard de Clichy.

Cimetière Montmartre
🏠 20, avenue Rachel
18th arrondissement
☎ +33 (0) 1 53 42 36 30
🕐 Sun-Fri 8AM-6PM
Sat 8:30AM-6 PM

The graves of Edgar Degas (left) and Émile Zola (right).

8 Claude Monet Studio

Monet used this studio until 1882, while he was decorating the large drawing room in Durand-Ruel's apartment at 35, rue de Rome.

Claude Monet Studio
🏠 20, rue de Vintimill
9th arrondissement

9 Claude Monet Studio

Monet moved to this studio in 1877, when he painted several views of the Saint-Lazare railway station. Because of its proximity to the station, the studio was easy to reach from Monet's home in suburban Argenteuil. Caillebotte paid the rent of 175 francs until July 1878. This ground-floor pied-à-terre was used for receiving clients who found difficult to travel to Monet's house in Argenteuil. He may have also used it for Parisian trysts with Alice Hoschedé.

Claude Monet Studio
🏠 17, rue Moncey
9th arrondissement

Manet's last residence
⌂ 39, rue Saint-
Petersbourg
8th arrondissement

⑩ Édouard Manet's Final Residence

Manet and his family moved here from 49, rue Saint-Petersbourg in 1878. He died here at 7 p.m. on April 30, 1883 at age 51. The combination of an amputation (left leg, below the knee) and advanced-stage of syphilis proved fatal for the painter.

Place de Dublin
⌂ 8th arrondissement

⑪ Place de Dublin

The eight-street intersection of the place de Dublin depicted in Caillebotte's most famous painting, *Paris Street, Rainy Day* still exists. The painting captures the new, uniform "Haussmannian" city as seen from rue de Saint-Petersbourg northwards. Caillebotte gave a study for *Paris Street, Rainy Day* (Marmottan Museum) to Monet, who loved and displayed it for years in his bedroom at Giverny.

Gustave Caillebotte
Paris Street, Rainy Day
1876-77
Art Institute of Chicago

⑫ Édouard Manet's Final Studio

Manet's studio from 1872-78 was spacious enough to invite critics and the public. Jounalists wrote, "it is the cleanest and best kept studio ever seen." Artists, writers, society women and courtesans frequented the studio and posed for paintings such as *Lady with Fans: Portrait of Nina de Callias, Portrait of Stéphan Mallarmé* and *Nana*.

Manet's Studio
⌂ 4, rue St-Petersbourg
8th arrondissement

Straight ahead from Manet's studio was the new rue Mosnier (today, the rue de Berne), which he painted several times from his windows. *Rue Mosnier with Flags* depicts a vivid patriotic celebration in the 1870s. The crippled man on the left is a sad omen, as Manet's own left leg would be amputated just five years later.

Édouard Manet
The Rue Mosnier with Flags, 1878
The J. Paul Getty Museum, Los Angeles

🅱 Place de l'Europe

After Manet moved to his studio at at 4, rue Saint-Petersbourg in 1872, he began painting *The Railway*, which he showed at the 1874 Salon. Model Victorine Meurent posed for the painting in a friend's back-yard, overlooking the railway at 58, rue de Rome. Manet's studio can be seen in the upper left corner. The neighborhood surrounding the Gare Saint-Lazare was known as the Europe district; most of its streets were named for European cities. In the 1860s, a massive star-shaped bridge, the Pont de l'Europe, was built to connect six avenues over the railway. Caillebotte painted the bridge in 1876, focusing on the massive iron superstructure, which was remodeled in 1930.

Place de l'Europe
📍 8th arrondissement

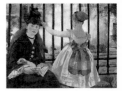

Édouard Manet
The Railway, 1872
National Gallery of Art, Washington, D.C.

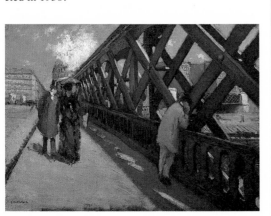

Gustave Caillebotte
Le Pont de l'Europe, 1876
Private Collection

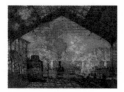

Claude Monet
Gare Saint-Lazare, 1877
Musée d'Orsay

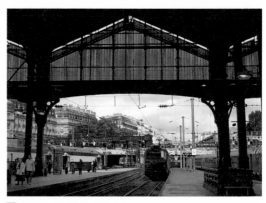

🖼 Gare Saint-Lazare

The Gare Saint-Lazare was a favorite subject for several Impressionists as a symbol of modern urbanization. Monet's depictions of the station, however, are the most iconic. Monet obtained permission to paint inside the station and completed a series of 11 paintings. These paintings reflected Monet's sensitivity to changing light and atmospheric conditions. His Saint-Lazare paintings also mark the first time the painter delved into series—he would continue to pursue singular themes (poplars, haystacks, the Rouen Cathedral and water lilies).

Gare St-Lazare
 8th arrondissement

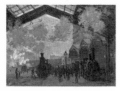

Claude Monet
Gare Saint-Lazare, 1877
The National Gallery,
London

🖼 Claude Monet Residence

Monet and his family lived in this third-floor apartment (which faced a courtyard) in 1878, after returning from Argenteuil. Caillebotte once again paid for

Claude Monet Residence
🏠 26, rue d'Edimbourg
 8th arrondissement

the rent, an annual fee of 1,360 francs. Camille gave birth to the couple's second child, Michel, while living here—Manet signed the birth certificate. In August, the family moved to Vétheuil, their final home together.

16 Gustave Caillebotte Home

Caillebotte's father, Martial Sr., built this four-story house at the corner of Miromesnil and Lisbonne in November 1866, when Caillebotte was 18-years-old. Signs of the family's wealth were prevalent through-out the house: hot water ran on every floor and the house featured a billiard room and an internal garden. Caillebotte lived here until 1879. Two floors have since been added.

Gustav Caillebotte Home
🏠 77, rue de Miromesnil
8th arrondissement

Gustave Caillebotte, *Young Man at His Window*, 1875 Private Collection

17 Parc Monceau

In total, Monet painted the Parc Monceau five times. Monet was introduced to this lovely urban garden by his friend and early patron Ernest Hoschedé.

Hoschedé's daughter, Marthe, later recalled meeting Monet for the first time while at the park.

Parc Monceau
🏠 8th arrondissement

Claude Monet, *The Parc Monceau* (detail), 1878 Metropolitan Museum, New York

Morisot's Studio and Home Near the Arc De Triomphe

Eugène Manet built a home for his wife, the art-ist Berthe Morisot, at 40, rue Paul Valéry (formerly rue Villejust) on the edge of the Bois de Boulonge in 1883. Within a few years, Morisot was hosting her own soirées in her famous white salon, entertaining writers and artists with talks about art and literature and serving exotic dishes like Moroccan chicken. When Morisot died, her daughter Julie married Ernest Rouart and continued living in the house for many years.

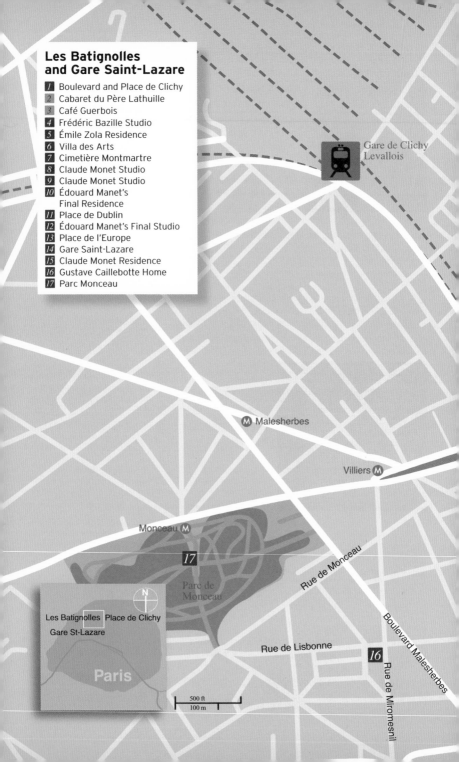

Les Batignolles
and Gare Saint-Lazare

Gare de Clichy
Levallois

Ⓜ Malesherbes

Villiers Ⓜ

Monceau Ⓜ

17

Rue de Monceau

Parc de
Monceau

Les Batignolles | Place de Clichy

Gare St-Lazare

N

Paris

Rue de Lisbonne

16

Rue de Miromesnil

Boulevard Malesherbes

500 ft
100 m

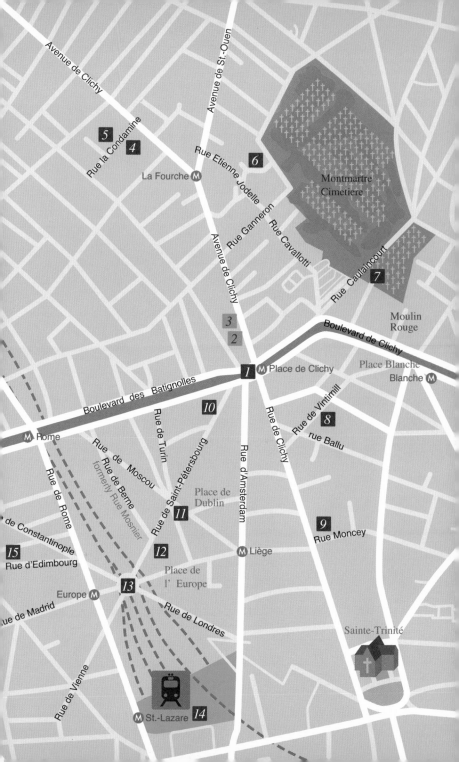

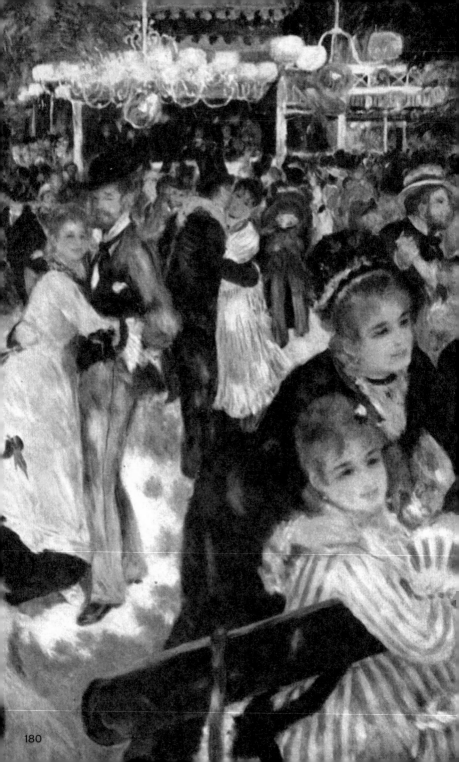

Pigalle and Montmartre

Tour starts from the Blanche Métro station (Métro line 2), located in front of the Moulin Rouge.

Moulin Rouge

Gérôme Studio, boulevard de Clichy

Le Chat Noir

Café du Tambourin

Café de la Nouvelle Athènes

Degas's Last Home, boulevard de Clichy

Brasserie des Martyrs

Le Divan Japonais

Brasserie de Reischoffen

Cirque Fernando

Elysée Montmartre

Jardin de Montmartre

Saint-Jean-l'Evangéliste

Van Gogh Apartment, rue Lepic

Le Moulin de la Galette

Bateau-Lavoire

Picasso Studio, rue Gabrielle

Rue des Saules

Renoir Studio / Musée de Montmartre

Lapin Agile

Renoir Home, rue des Brouillards

Rue Caulaincourt

TRAVEL TIPS:

If you do not wish to walk up large the slope and staircase to Montmartre, try the tram from the Jardin de Montmartre.

If exploring Montmartre separate from Pigalle, start from the Abbesses Métro station (Métro line 12).

Auguste Renoir, *Bal du moulin de la Galette* (detail), 1876
Musée d'Orsay

M

Henri Toulouse-Lautrec
At The Moulin Rouge
(Detail), 1892-95
National Gallery of Art,
Washington, D.C.

Moulin Rouge
🏠 82, boulevard de
 Clichy
 18th arrondissement
☎ +33 (0) 1 53 09 82 82
🖥 moulinrouge.fr

**Jean-Léon Gérôme
Studio**
🏠 65, boulevard de
 Clichy
 9th arrondissement

Le Chat Noir
🏠 68, boulevard de Cli-
 chy, 18th arrondissement

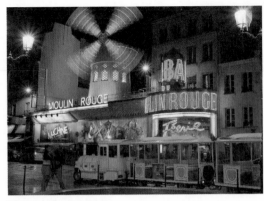

1 Moulin Rouge
The Moulin Rouge (the Red Mill) is one of the most popular Parisian cabarets and is the spiritual birthplace of the modern form of the *can-can* dance. Built in 1889, it can still be found at its original address, with shows still performed nightly. Toulouse-Lautrec painted a number of canvases depicting scenes from the nightlife at the Moulin Rouge.

2 Jean-Léon Gérôme Studio
Gerome died here, in front of his easel, on January 10, 1904. A vehement opponent of the Impressionist movement, he caused a scandal over his opposition to Caillebotte's bequest of Impressionist art to the state.

3 Le Chat Noir
The Black Cat first opened in 1881 (at 84, boulevard Rochechouart) with an interior decorated by images of black cats. It quickly became popular and a number of artists—including Louis Rodolphe Salis, Rene Gilbert, Antonio de la Gandara and Henri Rivière—exhibited their work there. Théophile Steinlen's poster *Tournée du Chat Noir* from 1896, still popular even today, is actually an advertisement for a tour of the Chat Noir cabaret artists.

4 Café du Tambourin

Van Gogh and his friends frequented this café, and the painter would often pay for his meals with flower still life paintings. In fact, it was at this café that Van Gogh's paintings were exhibited for the first time. The owner of the Tambourin, Agostina Segatori, allowed Van Gogh to display his Japanese prints in the café in 1887; she often posed for Van Gogh (as seen in *Agostina Segatori in the Café du Tambourin* and *L'Italienne*) and it is likely the two had an affair.

Café du Tambourin
🏠 62, boulevard de Clichy
18th arrondissement

Vincent van Gogh
L'Italienne, 1887
Musée d'Orsay

5 Café de la Nouvelle Athènes

La Nouvelle Athènes was a popular café and the setting of a number of Impressionist paintings. With an open terrace (which was heated during the winter) and billiard tables, La Nouvelle Athènes managed to "steal away" the Impressionists from their former hangout, the Café Guerbois, which they had denounced in 1874. Jean-Louis Forain's *Au Cafe de la Nouvelle Athènes* (1877, now at the Louvre); Manet's *La prune* (1878, The National Gallery of Art); and Degas's *L'absinte* (1876, Musée d'Orsay) were all painted here.

La Nouvelle Athènes
🏠 9, place Pigalle, border of 9th arrondissement

Edgar Degas, *L'absinthe*, 1876, Musée d'Orsay

6 Edgar Degas's Last Residence

After he had to leave his studio at 37, rue Victor Masse in 1912, Degas—78-years-old and nearly blind—moved to this address, where he passed away in 1917, aged 83.

Edgar Degas's Last Residence
🏠 6, boulevard de Clichy
18th arrondissement

Brasserie des Martyrs
⌂ 75, rue des Martyrs
18th arrondissement

Le Divan Japonais
⌂ 75bis, rue des Martyrs
18th arrondissement

Left: Édouard Manet
Au Café, 1878
The Walters Art Gallery,
Baltimore

Right: Édouard Manet
Coin de Café-Concert,
1879
National Gallery, London

Brasserie de Reischoffen
⌂ Corner of boulevard
Rochechouart and
boulevard de Clichy
border of 9th and 18th
arrondissements

Ellen Andrée (1857-1925)

7 Brasserie des Martyrs

Brasserie des Martyrs was a small café where Courbet, Proudhon, Théophile Gautier and Baudelaire often met. Upon arriving in Paris, Pissarro and Monet also started going to the Brasserie. Listening to the famous painters, the two young artists found out about alternatives to "academic" forms of art.

8 Le Divan Japonais

Often visited by Toulouse-Lautrec, the Divan changed its name to Madame Arthur (taking its name from a popular risqué song) in 1945. It is the venue for Paris's perennially most famous transvestite show.

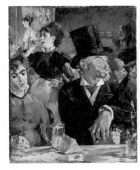
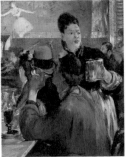

9 Brasserie de Reischoffen

Also known as the Café or Cabaret de Reischoffen, Brasserie de Reischoffen was one of the cafés favoured by Manet, who painted several paintings here: *La Serveuse de Bocks* 1878-79; *Au Café*, 1879, now part of the Oskar Reinhart collection; and *Coin de cafe-concert*, 1879, now at the National Gallery in London. *Au Café* and *Coin de café-concert* were actually once the same canvas that Manet cut in two. The man wearing the top hat is the engraver Henri Guerard, the husband of Eva Gonzalès, Manet's model and pupil; the woman with the hat is the actress Ellen Andrée, the same woman that appears in Degas's painting *L'Absinthe (The Absinthe Drinker)*, 1876.

⑩ Cirque Fernando

Now known as Cirque Medrano, the circus was loved by Manet, Degas and Renoir. There are a number

of paintings that depict its shows and attractions at the circus: Degas, *Mademoiselle La La au cirque Fernando*, 1879; Georges Seurat, *Cirque*, 1891; Renoir, *Acrobates au cirque Fernando*, 1879; Toulouse-Lautrec, *Au cirque Fernando: l'écuyère*, 1888.

Cirque Fernando
🏠 63, boulevard Rochechouart on the corner with the rue des Martyrs
9th arrondissement

Edgar Degas
Mademoiselle La La at the Cirque Fernando (Detail), 1879
National Gallery, London

⑪ Elysée Montmartre

This concert venue first opened in 1807 and since then has changed locations several times. In 1840, it was at boulevard de Clichy, and later at 10, boulevard de Rochechouart. Henri de Toulouse-Lautrec often visited, and painted a number of canvases including *A l'Elysée-Montmartre* from 1888 and *Au bal masque de l-Elysée Montmartre*, 1889.

Elysée Montmartre
🏠 72, boulevard de Rochechouart
18th arrondissement
🖥 elyseemontmartre.com

⑫ Jardins de Montmartre

The Jardins de Montmartre were created in 1880. At the time of the Impressionists, the Church of Sacré-Coeur was still under construction, as seen in Renoir's 1896 painting *Les jardines de Montmartre avec une vue sur le basilique du Sacré-Coeur en cours de construction*, at the Munich Neue Pinakothek. Renoir painted several views of the gardens.

Jardins de Montmartre
🏠 Square Willette
18th arrondissement

Saint-Jean l'Evangéliste
🏠 21, rue des Abbesses
18th arrondissement

The Métro entrance of
Abbesses station, de-
signed by Hector Guimard
(1867-1942).

**Vincent and Theo van
Gogh Apartment**
🏠 54, rue Lepic
18th arrondissement

Vincent Van Gogh
*View of Paris from
Vincent's Room in the Rue
Lepic*, 1878
Van Gogh Museum,
Amsterdam

Le Moulin de la Galette
🏠 83, rue Lepic
18th arrondissement
☎ +33 (0) 1 46 06 84 77
🖳 lemoulindelagalette.fr

13 Saint-Jean-l'Evangéliste

Architect Anatole de
Baudot (1834-1915),
used innovative Belle
Époque ironwork
and concrete for
a "modern-style"
design. The church
was inaugurated in
1904; Degas's funeral
was held here, a block
north of his home, in
1917. His only request
was for his friend, Bartholomé, to say: "He loved
drawing very much and so do I." Monet and Cassatt
attended his burial.

14 Vincent & Theo van Gogh Apartment

When Vincent joined Theo van Gogh in Paris in
March of 1886, they initially stayed in Theo's apart-
ment on rue Laval, but later moved to a third-floor

apartment here (at one
point, Guillaumin lived
on the first floor). They
lived here for two years
until, in February of
1888, Vincent left for
Arles, leaving behind
close to 200 paintings
he made in Paris. The
Van Gogh Museum in
Amsterdam has a paint-
ing (*View of Paris from
Vincent's Room in the
Rue Lepic*; 1887) showing a view of the city as seen
from Vincent's window.

15 Le Moulin de la Galette

Around 1870 the owner of this mill added to it a
small *guinguette* (a drinking establishment named for
a local type of sour white wine) with a dancing room
and rechristened it the Moulin de la Galette (*galette*
being a type of bread). It was a place where respect-
able working-class families could gather on Sundays.

Renoir rented the studio on rue Cortot specifically to be close to the Moulin, where he painted one of his most celebrated paintings—*Bal du moulin de la Galette*; 1876 (right). Every day he carried his canvas—nearly 6-feet long—up the hill to the Moulin. In addition to Renoir, Van Gogh, Toulouse-Lautrec, Signac, Utrillo and Picasso also painted the Moulin. It is now a restaurant.

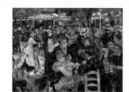

Vincent Van Gogh
Le Moulin de la Galette,
1886
Kröller-Müller Museum,
Otterlo

16 Bateau-Lavoire

Bateau-Lavoire is the name coined by painter and writer Max Jacob for the place at the top of the steps leading up to 13, place Émile-Goudeau. At the begin-

ning of the 20th century, a number of artists lived and worked here, including Picasso, Juan Gris, Braque, and the poet Pierre Reverdy.

Bateau-Lavoire
13, place Émile-Goudeau
18th arrondissement

17 Pablo Picasso Studio

Upon arriving in Paris in 1900, Picasso had a studio here, which he shared with Carlos Casagemas, a close friend he had met in Barcelona.

Pablo Picasso Studio
49, rue Gabrielle
18th arrondissement

18 Rue des Saules

A charming street in the heart of the Montmartre neighborhood; a number of famous restaurants and cafés once (and still) lined the street, including Café aux Billiards en Bois and La Bonne Franquette, pictured in Van Gogh's painting *Terrasse du café à la Guinguette*, from 1886. In 1867 Cezanne painted a view of the street (*Rue des Saules*, 1867).

19 Auguste Renoir Studio / Musée de Montmartre

In 1875, Renoir started renting the house in the heart of Montmartre, close to a number of locations he would paint over the years. Today, his studio is the home of the Musée de Montmartre, which is dedicated to the cultural history of the neighborhood. Renoir's painting of the house gardens is now at the Carnegie Museum of Art in Pittsburgh.

Vincent van Gogh, *Terrasse du café à la guinguette*, 1886 Musée d'Orsay

Paul Cézanne, *Rue des Saules Montmartre*, 1867 Private Collection

Auguste Renoir Studio / Musée de Montmartre
- 12, rue Cortot
 18th arrondissement
- museedemontmartre.fr
- Tue-Sun 11AM-6PM

A Place du Tertre

The Place du Tertre, is the very heart of Montmartre, and is the place to find tourist information. Located at the top of the hill near the Sacre-Coeur basilica, this square was home to Impressionists, and to the Cubists, Fauvists and Surrealists that followed. Artists from Manet, Renoir, Cézanne and Toulouse-Lautrec to Picasso, Utrillo and Braque all lived and worked nearby, many in absolute poverty. Today, a number of artists keep Montmartre's artistic tradition alive by painting souvenirs for tourists in the square.

Lapin Agile
⌂ 22, rue des Saules
18th arrondissement

Auguste Renoir Home
⌂ 6, allee des Brouillards
18th arrondissement

Toulouse-Lautrec Home
⌂ 21, rue Caulaincourt
Final Renoir Studio
⌂ 43, rue Caulaincourt
Auguste Renoir Home
⌂ 73, rue Caulaincourt

20 Lapin Agile

This cabaret was called Cabaret des Assassins until 1875, when the artist André Gill painted the sign of a rabbit leaping out of a sauce pan. At the end of the 19th century and the beginning of the 20th, it was a favorite hangout for struggling artists and writers, including Picasso, Modigliani, Apollinaire and Utrillo.

21 Auguste Renoir Home

Renoir lived here with his family from 1890 to 1897; during this time his sons Jean and Pierre were born.

22 Rue Caulaincourt

Named after a French general, rue Caulaincourt was home to both Toulouse-Lautrec and Renoir. Toulouse-Lautrec kept an apartment at number 21, while Renoir lived in number 73 from 1910 until he

passed away in 1919. Renoir's final studio was located nearby in building number 43.

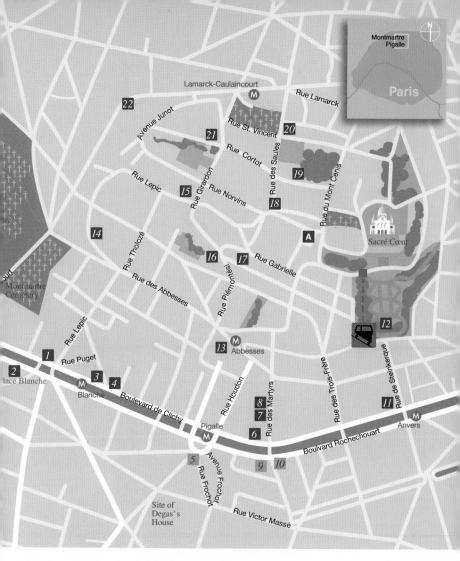

Pigalle and Montmartre

1. Moulin Rouge
2. Jean-Léon Gérôme Studio
3. Le Chat Noir
4. Café du Tambourin
5. Café de la Nouvelle Athènes
6. Edgar Degas's Last Residence
7. Brasserie des Martyrs
8. Le Divan Japonais
9. Brasserie de Reischoffen
10. Cirque Fernando
11. Elysée Montmartre
12. Jardins de Montmartre
13. Saint-Jean-l'Evangéliste
14. Vincent & Theo van Gogh Apartment
15. Le Moulin de la Galette
16. Bateau-Lavoire
17. Pablo Picasso Studio
18. Rue des Saules
19. Auguste Renoir Studio / Musée de Montmartre
20. Lapin Agile
21. Auguste Renoir Home
22. Rue Caulaincourt

A Place du Tertre

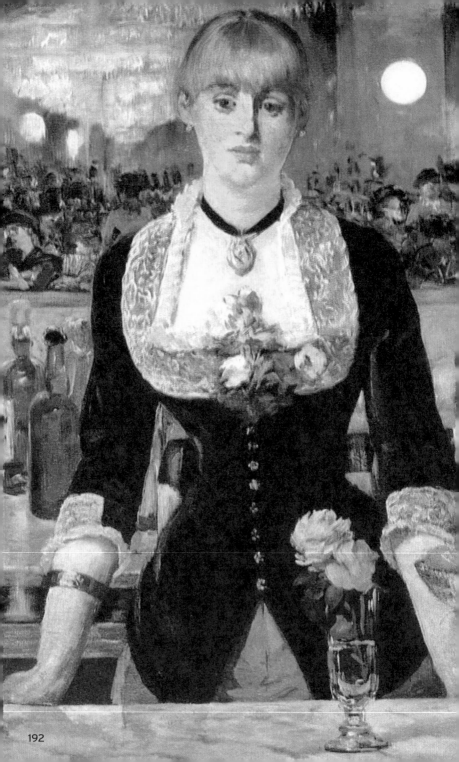

Pigalle and Notre-Dame de Lorette

Tour starts at the Pigalle Métro station (lines 2 and 12).

Toulouse-Lautrec's Last Studio, avenue Frochot

Degas's Last Studio, rue Victor Masse

Theo & Johanna van Gogh Apartment, cite Pigalle

Musée Gustave-Moreau

Gauguin Birthplace, rue Notre-Dame-de-Lorette

Père Tanguy Gallery

Gauguin Home, place St-Georges

Renoir Studio, rue St-Georges

Notre-Dame de Lorette

Monet Birthplace

Ambroise Vollard Gallery

Degas Birthplace

Folies Bergère

TRAVEL TIP:

After the tour, continue on to the Grands Boulevards area, built between 1668 and 1705.

Édouard Manet, *A Bar at the Folies-Bergère* (detail) 1882
Courtauld Institute of Art, London

Last Studio of Henri de Toulouse-Lautrec
🏠 15, avenue Frochot
9th arrondissement

Last Studio of Edgar Degas
🏠 37, rue Victor Masse
9th arrondissement

Theo &Johanna Apts
🏠 6 & 8, cite Pigalle,
9th arrondissement

Musée Gustave-Moreau
🏠 14, rue de La
Rochefoucauld
9th arrondissement
◎ Wed-Mon 10AM–
12:45PM, 2PM–5:15PM

🏛 Last Studio of Toulouse-Lautrec

The final studio of Toulouse-Lautrec, who died from complications due to alcoholism and syphilis at the family estate in Malrome on September 9, 1901, at only 36.

② Last Studio of Edgar Degas

In the later period of his career, Degas worked mainly in pastel. His final studio was on the fourth floor of this building. When it was to be demolished in 1912, Degas moved to another apartment, on the boulevard de Clichy, but never worked there. He died in 1917 nearly blind.

③ Theo & Johanna van Gogh Apartments

Before his marriage in April 1889, Theo van Gogh rented a third-floor apartment at No. 6. Nine months later, the couple had a son that they named after Theo's brother Vincent, who was being treated in an asylum at St-Rémy and who visited his family on his way to Auvers-sur-Oise. After the baby was born, the family moved to a first-floor apartment at No. 8. Three months after Vincent's suicide, Theo also suffered from a mental breakdown. He was taken to a hospital in Passy and died on January 25, 1891 in Utrecht. He was 33.

④ Musée Gustave-Moreau

This museum is dedicated to the Symbolist painter Gustave Moureau, located in his old studio. Between

1857 and 1859, Moreau and Degas worked in Florence and Rome, which inspired of Degas's later style.

5 Paul Gauguin Birthplace

On June 7, 1848, Paul Gauguin was born, the second child of Clovis Gauguin, a journalist, and Aline, daughter of the feminist activist, Flora Tristan. Delacroix lived and worked next door at No. 54 from 1844 to 1857, before moving to his last studio (which is now the site of the Musée Delacroix). It is likely that the two crossed paths on one of Delacroix's frequent outings, with the elder artist unaware that this child would join him as one of France's great artists.

Paul Gauguin Birthplace
56, rue Notre-Dame-de-Lorette
9th arrondissement

6 Père Tanguy Gallery

Julien Tanguy, affectionately called "Père" (or father) Tanguy, was a paint dealer who often supported young artists. Van Gogh's portraits of Tanguy show him as a benevolent old man. A Socialist who participated in the Paris Commune, Tanguy also had at a small showroom where he displayed works by Van Gogh, Seurat, Gauguin and Cézanne — between 1880 and 1885 it was the only place in Paris where one could see a canvas by Cézanne. His gallery also introduced many of the Impressionists to Japanese prints, which ended up as a major influence on their work. Tanguy's shop and gallery still exist, now as Père Tanguy Gallery of Japanese Prints.

Père Tanguy Gallery
14, rue Clauzel
9th arrondissement
+33 (0) 1 48 78 77 41
www. artmedia-paris. com/home.html

Vincent Van Gogh, *Portrait of Père Tanguy*, 1887
Private Collection

Père Tanguy Gallery
In 19th and 20th centuries, artists such as Monet and Van Gogh were strongly influenced by Japanese prints (*ukiyo-e*). Today, a Japanese gallery has opened in the exact same space as Père Tanguy's old shop and gallery, reviving his memory by exhibiting Japanese prints there once again. The gallery owner, Mr. Aoyagi, has provided advice to *ukiyo-e* collectors for more than 30 years.

7 Mette and Paul Gauguin's First Home

Paul Gauguin and Mette Gad married one year to the day of their first meeting. Here they settled into what Gauguin liked to call their "petit appartement." At the time, he was working as a stock broker and earning a substantial salary of 200 francs a month; in 1874 received a bonus of 3,000 francs. The first of their five children, Emil, was born here on August 31, 1874.

Mette and Paul Gauguin's First Home

🏠 28, place St Georges
9th arrondissement

8 Auguste Renoir Studio

Renoir used a studio here in 1880; it is on the top floor with an unusual (for 19th-century Paris) bank of windows for light. The building was damaged during World War II but rebuilt using the original plans.

Auguste Renoir Studio

🏠 35, rue Saint Georges
9th arrondissement

9 Notre-Dame de Lorette

The church was designed by architect Hippolyte Lebas and built in 1836, a time when the neighborhood was becoming popular with a new class of affluent artists and the bourgeoise. The Hungarian composer Franz Liszt lived in in the Hôtel de France (23, rue Laffitte) where he introduced the composer Frédéric Chopin to the writer George Sand; the two went on to have a torid love affair. Delacroix lived at 54, rue Notre-Dame-de-Lorette until he moved to be closer to the church of Saint-Sulpice, where he was working on the Chapelle des Anges. Notre-Dame de Lorette was also the site of important milestones in the of the

Notre-Dame de Lorette

🏠 18, bis rue de Chateaudun
9th Arrondisement

A Artecosa

🏠 32, rue Drouot
9th arrondissement
🖥 artecosa.com

Artecosa is a shop that specializes in the purchase and sales of original documents, letters, signatures and photographs, such as photographs of Monet and letters by Gauguin.

Impressionists: the marriage of Degas's parents in 1832, Monet's 1840 christening, and Caillebotte's funeral service in 1894.

Claude Monet Birthplace
⌂ 45, rue Laffitte
9th arrondissement

Ambroise Vollard Gallery
⌂ 39-41, rue Laffitte
9th arrondissement

Edgar Degas Birthplace
⌂ 8, rue Saint Georges
9th arrondissement

Folies Bergère
⌂ 32, rue Richer
9th arrondissement
▦ foliesbergere.com

⑩ Claude Monet Birthplace

Monet was born on the fifth floor here on November 14, 1840. The family lived at this address until 1845 when they moved to Le Havre.

⑪ Ambroise Vollard Gallery

Regarded as one of the most important dealers at the beginning of the 20th century, Vollard helped and promoted a number of artists, including Cézanne, Renoir, Picasso, Gauguin and Van Gogh. In 1893, he established his gallery where he would later stage exhibitions of Manet, Gauguin and Van Gogh. In addition to being an art dealer he was an avid collector and wrote the first biographies of Cézanne, Degas and Renoir.

⑫ Edgar Degas Birthplace

Hilaire-Germain-Edgar De Gas was born on July 19, 1834. His father, Auguste, was a French banker, his mother, Célestine, was an American from New Orleans. The building has since been demolished.

⑬ Folies Bergère

Established in 1869, the Folies Bergère was modeled on the Alhambra Music Hall in London, though it has been renovated a number of times. Built as an opera house, it was first called the Folies Trévise; it was renamed the Folies Bergère in 1872, taking its name from a nearby street. Always following the

popular taste of time, the cabaret remained highly popular from the 1890s all the way through the 1920s featuring famous performers such as Josephine Baker. Manet depicted the music hall in the *Bar at the Folies Bergères* (left), 1882, one of his last major works.

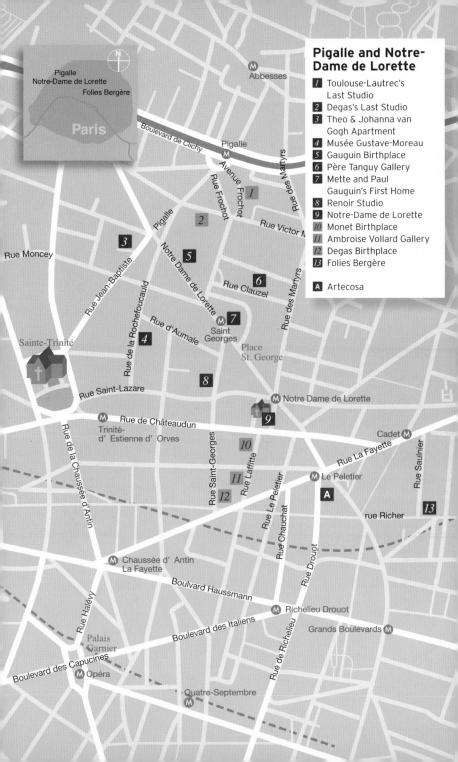

Pigalle and Notre-Dame de Lorette

1 Toulouse-Lautrec's Last Studio
2 Degas's Last Studio
3 Theo & Johanna van Gogh Apartment
4 Musée Gustave-Moreau
5 Gauguin Birthplace
6 Père Tanguy Gallery
7 Mette and Paul Gauguin's First Home
8 Renoir Studio
9 Notre-Dame de Lorette
10 Monet Birthplace
11 Ambroise Vollard Gallery
12 Degas Birthplace
13 Folies Bergère

A Artecosa

Pigalle
Notre-Dame de Lorette
Folies Bergère

Paris

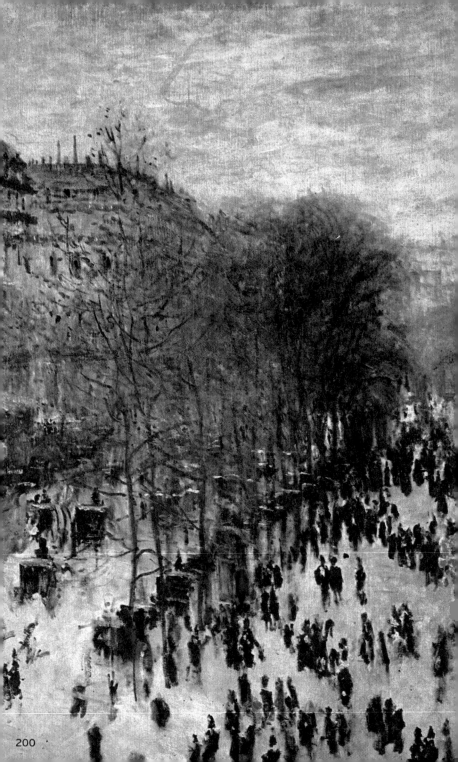

Opéra

Tour starts at the Palais Royal–Musée du Louvre Métro station (Métro lines 1 and 7).

Avenue de l'Opéra

Place Colette/
Place André Malraux

5th Impressionist Exhibition

7th Impressionist Exhibition

Renoir Family Home, rue d'Argenteuil

4th Impressionist Exhibition

Bernheim, Jeune & Cie Art Gallery

Café de la Paix

Gallery Georges Petit

Nadar Photography Studio, boulevard des Capucines

Palais Garnier

Caillebotte Studio, boulevard Haussmann

Place Diaghilev

Rue Halévy

TRAVEL TIPS:

See and feel Caillebotte's modern Parisian life from the Terrasse des Galeries Lafayette.

After touring the Opera area, you may continue touring the Grands Boulevards to see Paris as the Impressionists saw it.

Claude Monet, *Boulevard des Capucines* (detail), 1873
Nelson-Atkins Museum of Art, Kansas City

Camille Pissarro
Avenue de l'Opera: Rain Effect, 1898
Private collection

Avenue de l'Opéra
🏠 1st and 2nd
 arrondissements

View of the avenue de l'Opéra from the Pissarro suite at the Hôtel du Louvre

Place Colette/Place André Malraux
🏠 1st arrondissement

1 Avenue de l'Opéra

Avenue de l'Opéra is a Haussmanian avenue running from Place André Malraux to Place de l'Opéra. It is one of the most unusual avenues in Paris—its appearance was a compromise between Haussmann and Charles Garnier (architect of the Opéra). Garnier persuaded Haussmann not to plant any trees on the avenue, as they would obstruct the view of the Opéra's main façade. Pissarro painted a number of views of the avenue from his room at the Hôtel du Louvre.

2 Place Colette/Place André Malraux

The two squares in front of the Comédie-Française are named after the famous French novelist Sidonie-Gabrielle Colette (the author of the novel *Gigi*) and author and statesman André Malraux. In 1897, while staying at the Hôtel du Louvre, Pissarro painted a number of views of the squares. His rooms at the hotel are today known as the Pissarro Suite.

Camille Pissarro
Place du Théâtre Français, 1898
Los Angeles County Museum of Art

A Pissarro Suite at Hôtel du Louvre
In early 1897, Camille Pissarro took up residence at the Hôtel du Louvre. Inspired by the uninterrupted views of the sprawling Avenue de l'Opéra and the Opéra Garnier, he painted a number of views from his floor-to-ceiling windows. Even in Pissarro's time, the hotel was considered luxurious; today, the Pissarro Suite and fetches around 2,000 EUR per night. For more information visit hoteldulouvre.com.

3 5th Impressionist Exhibition

For the month of April in 1880, the 5th Impressionist Exhibition featured 232 paintings by 19 different artists including, for the first time, Gauguin. Monet refused to join the exhibition and opened his one-man show—25 canvases and a few lithographs—from April 1-30 at the offices of the journal *La vie Moderne*.

5th Impressionist Exhibition
🏠 10, rue de Pyramides (corner of rue Saint-Honoré)
1st arrondissement

4 7th Impressionist Exhibition

From March 1-31, 1882, this exhibition featured 213 works by 9 artists. Caillebotte had 27 paintings, Gauguin had 13, Guillaumin 26, Monet 35, Morisot 9, Pissarro 36, Renoir 25, Sisley 27 and Vignon 15.

7th Impressionist Exhibition
🏠 251, rue Saint-Honoré
1st arrondissement

5 Renoir Family Apartment

After moving from Limoges to Paris, a young Renoir lived here when his family's home in the nearby courtyard of the Louvre was demolished by Baron Haussmann's extension of the rue de Rivoli. In 1872, Sisley painted a view of the street.

Renoir Family Apartment
🏠 23, rue d'Argenteuil
1st arrondissement

Alfred Sisley
*La Grande-Rue
Argenteuil*, 1872
Norwich Castle Museum

6 4th Impressionist Exhibition

The 4th Impressionist Exhibition opened on April 10 and closed on May 11, 1879. It featured 260 works by 16 artists. In a review of the exhibition critic Henry Havard called Monet and Pissarro "the high priests of Impressionism;" absent from the exhibition were Renoir (who chose the official Salon that year) and Morisot (she had recently given birth).

**4th Impressionist
Exhibition**
🏠 28, avenue de l'Opéra
1st arrondissement

7 Bernheim, Jeune & Cie Art Gallery

In May and June 1912, Monet had a one-man exhibition here entitled "Venise," where he presented 29 canvases of the Italian city (arranged in groups by the topic/view of Venice such as Grand Canal, San Giorgio Maggiore).

**Bernheim, Jeune & Cie
Art Gallery**
🏠 36, avenue de l'Opéra
1st arrondissement

8 Café de la Paix

Designed by Charles Garnier, the same architect who designed the Opéra, the café quickly became very popular after its opening in 1862, attracting famous patrons such as Zola and Guy de Maupassant.

Café de la Paix
🏠 5, place de l'Opéra
9th arrondissement
☎ +33 (0) 1 40 07 36 36
🖥 cafedelapaix.fr

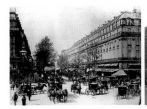

9 Gallery Georges Petit

The site of a joint exhibition of Monet and Rodin in 1889, which featured 145 canvases by Monet and 36 sculptures by Rodin, including the debut of one of his masterpieces, *The Burghers of Calais*. For Monet, it was a retrospective exhibition as he was represented by paintings from a 25-year period, 1864 to 1889. In January of 1897 the gallery held a huge exhibition of Sisley's work: 146 paintings and 5 pastels, covering the whole of his career.

Gallery Georges Petit
🏠 8, rue Seze
9th arrondissement

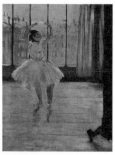

Edgar Degas
Danseuse posant chez un photographe, 1875
Pushkin Museum, Moscow

Felix Nadar's Studio
🏠 35, boulevard des
Capucines
border of the 9th and
2nd arrondissements

Claude Monet, *Boulevard des Capucines*, 1873
Nelson-Atkins Museum of Art, Kansas City

🔟 Felix Nadar's Photography Studio

Born as Gaspard-Félix Tournachon in 1820, Nadar was not only a photographer but also a caricaturist, journalist, novelist, balloonist and friend to the Impressionists. Some of his photographs can be seen at the Musée d'Orsay. Degas's *Danseuse posant chez un photographe* from 1875 was probably painted in Nadar's studio. Additionally, Monet's two canvases entitled *Boulevard des Capucines* are both presumed to have been views of the street painted from Nadar's studio window.

After Nadar moved out, the studio was home to the first Impressionist Exhibition, which opened exactly 15 before the opening of the official Salon and ran from April 15 to May 15, 1874. Entry fee for the exhibition was one franc, while the catalogue (made by Renoir's brother Edmond and printed at Alcan-Levy) was 50 centimes. The 6th Impressionist Exhibition was held in the same building, but not in Nadar's studio. Organized by gallerist Paul Durand-Ruel, this exhibition ran from April 2 to May 1, 1881, in poorly lit, rented rooms facing the building's inner courtyard.

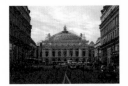

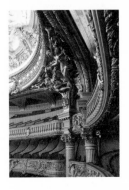

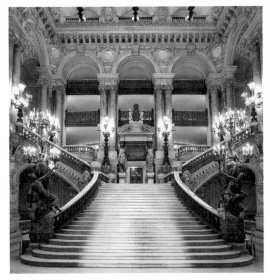

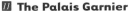

11 The Palais Garnier

Palais Garnier, one of the theaters of the Paris national Opéra and the Bastille Opéra, was designed by the architect Charles Garnier. It was the primary home of the Paris Opéra from the moment it opened in 1875 (then under the name of Théâtre National de l'Opéra de Paris) until 1989 when the Bastille Opéra was inaugurated. Its revolutionary design inspired numerous other theaters and buildings in the world, including the Thomas Jefferson Building of the Library of Congress in Washington, D.C. As the high point of the social life of Paris, scenes from the Palais Garnier appear in works of numerous Impressionist artists such as Mary Cassatt (*At the Opera*, 1878-1879) and Edgar Degas (*Fin d'arabesque*, 1877).

The Palais Garnier
- Corner of rue Scribe and rue Auber 9th arrondissement
- + 33 (0) 1 71 25 24 23
- operadeparis.fr

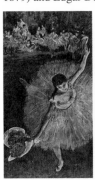

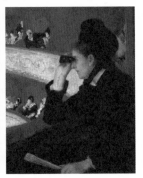

left: Edgar Degas
Fin d'arabesque, 1877
Musée d'Orsay

right: Mary Cassatt
At the Opera, 1878-79
Museum of Fine Arts, Boston

Gustave Caillebotte Studio & Home

⌂ 31, boulevard
 Haussmann
 9th arrondissement
 (Caillebotte's
 apartment was 2nd
 floor from top with
 balconies.)

Gustav Caillebotte
*Boulevard Haussmann,
Snow*, 1880
Private collection

Place Diaghilev

⌂ Behind the Palais
 Garnier
 9th arrondissement

🔢 Gustave Caillebotte Studio & Home

After his mother's death, Caillebotte moved to boulevard Haussmann with his brother, Martial, in 1879. Caillebotte's studio here was well placed for the types of themes which appear in his paintings from the late 1870s and early 1880s: He could observe the traffic on the streets below and painted numerous scenes as seen from the windows of his studio, including *Rooftops under snow* and *Boulevard Haussmann, Snow*.

🔢 Place Diaghilev

The circular traffic island was painted by Caillebotte in 1880. The painting (*A Traffic Island, Boulevard Haussmann*) is now in a private collection.

🔢 Rue Halévy

Caillebotte's many paintings of this street, completed around 1880, show it in different light conditions and from slightly different angles; as witnessed by the difference between *La Rue Halévy, vue du sixième étage* (left) and his *La Rue Halévy, vue d'un balcon*.

B Terrasse des Galeries Lafayette

The Galeries Lafayette is a world-famous, seven-story department store. The roof features a terrace with great views of Paris. From here, you can see many of the scenes Caillebotte painted of the boulevard Haussmann. The terrace also has a restaurant and bar, offering a much needed respite from your walking tour.

40, boulevard Haussmann
www.galerieslafayette.com

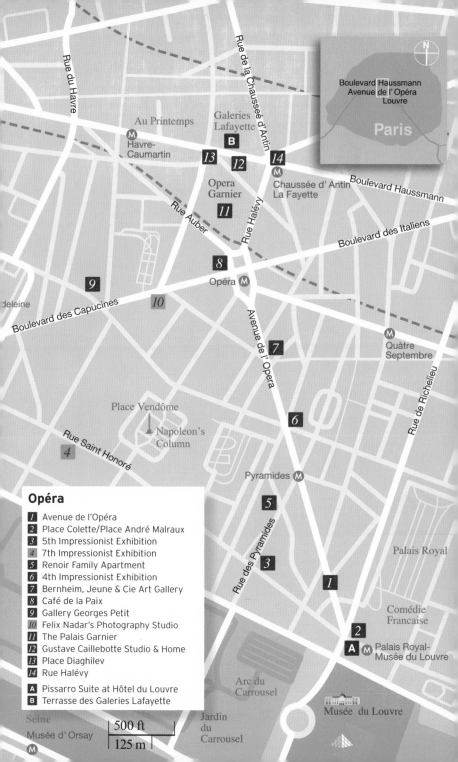

Rue du Havre

Rue de la Chausseé d'Antin

Boulevard Haussmann
Avenue de l' Opéra
Louvre

Paris

Au Printemps

Galeries
Lafayette

B

M Havre-
Caumartin

13　**12**

14

M

Chaussée d' Antin
La Fayette

Opéra
Garnier

11

Rue Halévy

Boulevard Haussmann

Rue Auber

Boulevard des Italiens

8

Opéra **M**

9

deleine

10

Boulevard des Capucines

M

Quàtre
Septembre

Avenue de l' Opéra

7

Rue de Richelieu

Place Vendôme

Napoleon's
Column

6

Rue Saint Honoré

4

Pyramides **M**

5

Palais Royal

Rue des Pyramides

3

1

Comédie
Francaise

2

A **M** Palais Royal-
Musée du Louvre

Opéra

1 Avenue de l'Opéra
2 Place Colette/Place André Malraux
3 5th Impressionist Exhibition
4 7th Impressionist Exhibition
5 Renoir Family Apartment
6 4th Impressionist Exhibition
7 Bernheim, Jeune & Cie Art Gallery
8 Café de la Paix
9 Gallery Georges Petit
10 Felix Nadar's Photography Studio
11 The Palais Garnier
12 Gustave Caillebotte Studio & Home
13 Place Diaghilev
14 Rue Halévy

A Pissarro Suite at Hôtel du Louvre
B Terrasse des Galeries Lafayette

Seine

Musée d' Orsay

M

500 ft

125 m

Arc du
Carrousel

Jardin
du
Carrousel

Musée du Louvre

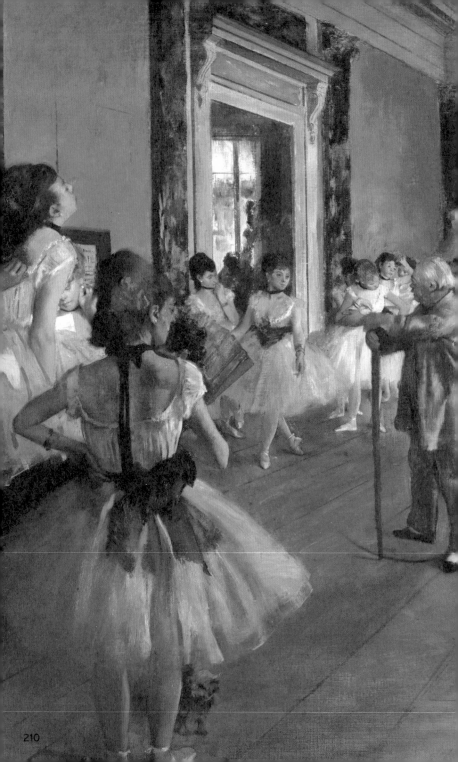

Grands Boulevards

Tour starts at the Opéra Métro station (lines 3, 7 and 8).

Café de Bade / Café de Tortoni

8th Impressionist Exhibition

Maison Dorée

Toulouse-Lautrec Apartment, rue d'Amboise

La Vei Moderne Gallery

Pissarro Apartment, boulevard Haussmann

Adolphe Goupil Art Gallery

Paul Durand-Ruel Gallery

3rd Impressionist Exhibition

2nd Impressionist Exhibition

L'Opéra Le Peletier

Restaurant Au Petit Riche

Hôtel Drouot

Rue Montorgueil

TRAVEL TIPS:

Take a walk down boulevard des Capucines to experience Haussmann's Paris.

To save time, start at the Richelieu–Drouot Métro station (lines 8 and 9). From here you can continue touring the Notre-Dame de Lorette and Pigalle areas.

Edgar Degas, *The Ballet Class* (detail), 1871-74
Musée d'Orsay

Café de Bade
⌂ 22, boulevard des
Italiens
9th arrondissement

Café de Tortoni
⌂ 26, boulevard des
Italiens
9th arrondissement

Édouard Manet
*The Café in the Place du
Théâtre*, 1880
Glasgow Museums

**8th Impressionist
Exhibition**
⌂ 1, rue Laffitte
9th arrondissement

Maison Dorée
⌂ 20, boulevard des
Italiens
9th arrondissement

ⅼ Café de Bade / Café de Tortoni
In the middle of the 19th century, the boulevard des
Italiens became the fashionable place to be, with
cafés and restaurants lining the street.

Café de Bade was one of many cafés that were popu-
lar at the end of the 19th century. Manet frequented
this popular café around 1865 before switching
allegiences to the Café Guerbois at 11, rue des Bati-
gnolles (now the avenue de Clichy). The café is no
longer there.

Tortoni was one of the most popular establishments
along boulevard des Italiens, and Manet—who, more
than the other Impressionists, was at ease with the
high life of Paris—often had lunch here.

② 8th Impressionist Exhibition
The final Impressionist exhibition opened on May
15 and closed on June 15, 1886. Seurat and Signac
introduced Pointillism at the show, which included
a total of 17 artists (Bracquemond, Cassatt, Degas,
Forain, Gauguin, Guillaumin, Morisot, Camille and
Lucien Pissarro, Redon, Rouart, Schuffenecker, Til-
lot, Vignon and Zandomeneghi) and 249 works.

③ Maison Dorée
Frequented by Manet, the famous Maison Dorée was
one of the most expensive restaurants in Paris. It was

initially called Restaurant
of the Cité ("Restaurant
of the Public"), but its
luxurious design and the
expensive furnishings
inspired Parisians to begin
calling it the Maison
Dorée ("Golden House").
The restaurant closed in
1902. The 8th Impression-
ist Exhibition was held
on the second floor of this
building.

4 Henri de Toulouse-Lautrec Apartment

Toulouse-Lautrec lived at this address (a 17th-century palace which was "converted" to a brothel) for a time in 1894. While staying here he completed some 16 works, including his poster for Jane Avril's show at the Jardin de Paris. Today this is the Hôtel Lautrec Opéra.

Henri de Toulouse-Lautrec Apartment
🏠 8, rue d'Amboise
 2nd arrondissement

Jane Avril (1868-1943)

5 Gallery of the Illustrated Journal *La Vie Moderne*

Theodore Duret was a journalist, author, art critic and one of the first advocates of the Impressionist movement. Manet, Monet and Renoir each had solo exhibitions at the offices of his weekly magazine, *La Vie Moderne*, between 1879 and 1880. Monet's first exhibition at the gallery, in June 1880, featured 18 works; Duret wrote the preface of the catalogue.

Gallery of the Illustrated Journal *La Vie Moderne*
🏠 7, boulevard des
 Italiens
 9th arrondissement

6 Camille Pissarro Apartment

In 1897, Pissarro rented a series of rooms to use as studios in different locations around Paris. From February to April he stayed at the Hôtel de Russie, which once stood here. The view from his room in the hotel is depicted on a series of canvases entitled *Boulevard Montmartre*. Examples of these can be found at the National Gallery London and at the Hermitage in Saint Petersburg.

Camille Pissarro Apt
🏠 2, boulevard
 Haussmann
 9th arrondissement

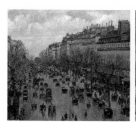

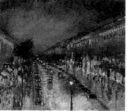

Left: Camille Pissarro
Boulevard Montmartre,
Afternoon Sun, 1897
The Hermitage,
St. Petersburg

Right: Camille Pissarro
Boulevard Montmartre at
Night, 1897
National Gallery, London

Adolphe Goupil Art Gallery
🏠 19, boulevard Montmartre
2nd arrondissement

⑦ Adolphe Goupil Art Gallery

The first address of Adolphe Goupil's art gallery Goupil & Cie (afterwards Boussod, Valadon & Cie, successeurs de Goupil & Cie). When the administration of the gallery moved to 9, rue Chaptal, this address became a simple saleroom, and from 1881 it was run by Theo van Gogh. In 1892, Monet had a small exhibition here, comprised mostly of canvases from the *Haystacks* series bought by Maurice Joyant who replaced Theo van Gogh. Later, the main showroom of the gallery was re-located to 2, place de l'Opéra (now the location of the Paribas bank).

Paul Durand-Ruel Gallery
🏠 16, rue Laffitte
9th arrondissement

⑧ Paul Durand-Ruel Gallery

During the Franco-Prussian war of 1870-71 Durand-Ruel escaped to London where he met Monet, Pissarro and Daubigny. Recognizing their talent, he organized an exhibition of their work in London. Later, he also exhibited their work in the United States. At the time his Paris gallery was located here.

3rd Impressionist Exhibition
🏠 6, rue Le Peletier
9th arrondissement

⑨ 3rd Impressionist Exhibition

The Impressionists' third exhibition was staged thanks to the efforts of Caillebotte, who rented a five-room, second-floor apartment here. There were 18 participants and the principal organizer was Alphonse Legrand, a former employee of Durand-Ruel (whose gallery was unavailable at the time).

⑩ 2nd Impressionist Exhibition

The second Impressionist exhibition was held at this location of Durand-Ruel Gallery from March 30 to April 30, 1876. To participate, each artist paid 25 francs. Art critic Louis-Edmond Duranty wrote an essay for the catalogue entitled: *La nouvelle peinture, A propos du grupe d'artistes qui expose a la galerie Durand-Ruel* (*The New Painting, Concerning the Group of Artists Exhibiting at the Durand-Ruel Gallery*). The exhibition included 252 works by 20 artists such as Monet, Degas, Pissarro, Renoir, Sisley, Morisot and Caillebotte.

2nd Impressionist Exhibition
⌂ 11, rue Le Peletier
9th arrondissement

⑪ L'Opéra Le Peletier

Constructed in 1821, this was the premier opera and ballet building in Paris until it burned down in 1873. As the focal point of the nightlife of the Parisian upper crust, it was depicted by a number of painters, most notably Degas's *The Orchestra of the Opéra*, 1870, Musée d'Orsay (below) and Manet's *The Masked Ball at the Opera*, 1873, National Gallery of Art, Washington, D.C. (right).

L'Opéra Le Peletier
⌂ 12, rue Le Peletier
9th arrondissement

Left: Paris Opéra c. 1865
Right: Opéra fire, 1873

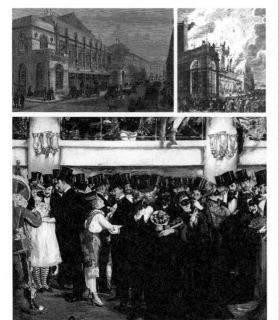

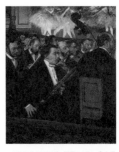

🔢 Restaurant Au Petit Riche

In the 1850s, the Au Petit Riche bistro was a popular with coachmen, stage hands and other employees from the nearby opera. The café was rebuilt in an updated bourgeois style in 1880, attracting a new clientele of politicians, actors, opera dancers, bankers and art collectors from the Drouot auction house.

Restaurant Au Petit Riche

🏠 25, rue Le Peletier
9th arrondissement

🖥 restaurant-aupetit-riche.com

🔢 Hôtel Drouot

This auction house was the site of the famous Impressionist auction of March 24, 1875, during which 163 works by Renoir, Morisot, Sisley and Monet were sold for very small prices—20 canvases by Monet went for under 200 francs each. The highest price was for a painting by Berthe Morisot—450 francs. Gallerist Durand-Ruel was the auctioneer. The present building, constructed between 1976 and 1980, still holds auctions of all types of art, collectibles and antiques. During its construction, sales were held in the Gare d'Orsay.

Hôtel Drouot

🏠 9, rue Drouot
9th arrondissement

🖥 drouot.com

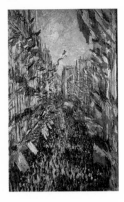

Beyond the Area

A Rue Montorgueil

Rue Montorgueil
2nd arrondissement

Monet painted this street on the occasion of the closing of the World Fair called *La rue Montorgueil, à Paris. Fête du 30 Juin 1878*, now at the Orsay (left). When working in the city, Monet experimented with painting crowd effects. The vibrant colors and the numerous waving flags capture the festive atmosphere of the day. The painting is similar to Manet's *La Rue Mosnier aux drapeaux*, which is a lot more melancholic, although it was painted on the same day for the same occasion. Monet painted a similar image of the nearby rue Saint-Denis (Musée des Beaux-Arts, Rouen).

Grands Boulevards

1. Café de Bade / Café de Tortoni
2. 8th Impressionist Exhibition
3. Maison Dorée
4. Henri de Toulouse-Lautrec Apartment
5. Gallery of the Illustrated Journal *La Vie Moderne*
6. Camille Pissaro Apartment
7. Adolphe Goupil Art Gallery
8. Paul Durand-Ruel Gallery
9. 3rd Impressionist exhibition
10. 2nd Impressionist Exhibition
11. L'Opéra Le Peletier
12. Restaurant Au Petit Riche
13. Hôtel Drouot

A. Rue Montorgueil

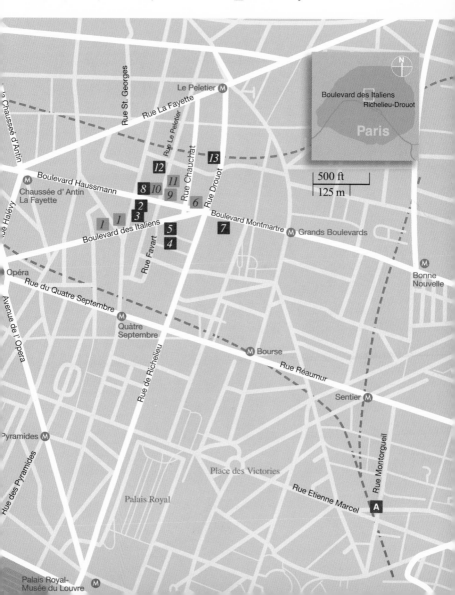

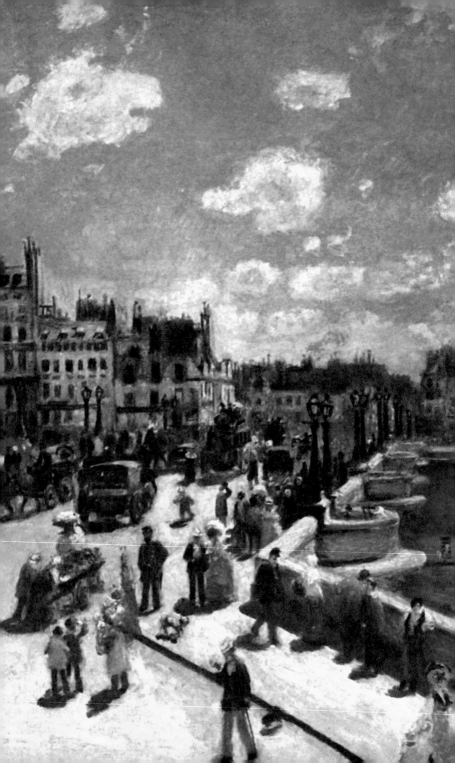

Islands

This tour starts at the Pont Marie Métro station (line 7). After arriving you will walk across Pont Marie to Île St-Louis.

Quai d'Anjou and Quai de Bourbon
Pont Louis-Philippe
Hôtel de Ville
Notre-Dame de Paris
Académie Suisse
Square du Vert-Galant
Pont Neuf
Canavalet Museum

TRAVEL TIPS:

Along the Quai d'Anjou and Quai de Bourbon you will find plaques indicating the homes where artists once lived.

After the tour, the Louvre—Opéra and Saint-Germain areas are both easily accessible.

Auguste Renoir, *Le Pont-Neuf, Paris,* 1872 (Detail)
National Gallery of Art, Washington, D.C

① Quai d'Anjou and Quai de Bourbon

Many artists lived on quai d'Anjou (including Daumier at number 9 and Daubigny at 27) and quai de Bourbon (Bernard at 15, Claudel at 19) on the Île Saint-Louis. Lantier, the protagonist of Zola's *L'Œvre* had his first studio at 13, quai de Bourbon, where Cézanne actually shared a studio with Guillaumin in 1875.

② Pont Louis-Philippe

Connecting the quai de Bourbon on the Île Saint-Louis and quai de l'Hôtel-de-Ville, the bridge was constructed in 1862 and painted several times by Armand Guillaumin around 1874.

③ Hôtel de Ville

The political center of the City of Light, the Hôtel de Ville is Paris's City Hall, housing local administrations, including the Mayor. The site has been the official seat of the city's government since 1357, and was once the place where people gathered for public executions. The communards, which had occupied the building in 1871, allegedly burned it down shortly before suffering defeat at the hands of Federal troops. A competition was held for ideas on its reconstruction; it was rebuilt in its original French Renaissance style, inspired by the châteaux of the Loire Valley. Manet submitted an unsolicited proposal for the decoration, but was "treated like a dog"—his proposal wasn't approved.

Quai d'Anjou and Quai de Bourbon
⌂ Île Saint-Louis
 4th arrondissement

Pont Louis-Philippe
⌂ 4th arrondissement

Hôtel de Ville
⌂ 29, rue de Rivoli

◢ Notre-Dame de Paris

Notre-Dame de Paris, in the heart of the city, was begun in the middle of the 12th century and is one of the first churches to use a flying buttress. Its sculptures and stained glass windows—heavily influenced by naturalism—are unlike those of earlier Romanesque architecture. One of the more recognizable monuments in Paris, it has been painted numerous times. Jongkind's painting *La Seine et Notre-Dame de Paris* (1864) was painted from quai Saint-Michel, close to Pont Saint-Michel; Guillaumin's *Paris: la Seine et Notre Dame* shows the iconic structure from the other end (painted from Port de la Tournelle, between Pont de l'Archevêché and Pont de la Tournelle).

Notre-Dame de Paris
🏠 Île de la Cité

◢ Académie Suisse

Founded by Charles "le Père" Suisse, a model who posed for Neoclassical painter Jacques-Louis David, the Académie Suisse was an unofficial art academy on the second floor of a building on Île de la Cité. Frequented by a number of artists including Delacroix, Courbet, Monet, Pissarro, Manet, Guillaumin and Cézanne, it was a place where the "students" paid 40 francs per month to work uninterrupted and

Académie Suisse
🏠 Corner of quai des Orfèvres and boulevard du Palais Île de la Cité

without reprimand for six hours a day—with no examinations, no professors and no corrections. The last week of every month was reserved for a live model. One of the more famous models was Scipio, depicted in Cézanne's canvas *The Negro Scipio*.

Paul Cézanne
The Negro Scipio, 1867
Museu de Arte Moderna, São Paulo

Square du Vert-Galant
🏠 Île de la Cité

Pont Neuf
🏠 Connects the 1st and
6th arrondissements
Île de la Cité

Right:
Claude Monet
Le Pont-Neuf, 1871
Dallas Museum of Art

Bottom Right:
Auguste Renoir
Le Pont-Neuf, Paris, 1872
National Gallery of Art,
Washington, D.C.

Camille Pissarro
Le Pont-Neuf, series
1901-1902

⑥ Square du Vert-Galant

Named for a nickname of King Henry IV, square du Vert-Galant is located on the very tip of the Île de la Cité. It was painted by Pissarro in 1902 and 1903.

⑦ Pont Neuf

Despite its name, which means New Bridge, Pont Neuf is the oldest standing bridge across the Seine. Started at the end of the 16th century, it was finished during the reign of Henry IV, whose equestrian statue is displayed on the southern part of the bridge. It was the first bridge in Paris that did not have residential houses. Painted by several artists including Renoir, Monet and Signac, it was the subject of a series of paintings by Pissarro in the last years of his life. Renoir and Monet's paintings were done from the second floor of a corner café.

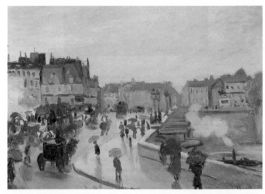

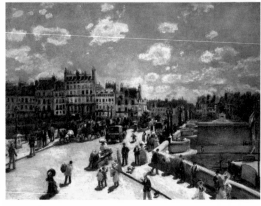

Beyond the Area

A The Carnavalet Museum

This museum, dedicated to the history of the city of Paris, features a permanent collection with close to 3,000 paintings, 20,000 drawings, 300,000 engravings and about 150,000 photographs. In addition, the museum also has pieces of furniture, ceramics, archaeological fragments and other *objects d'art*.

The museum has a number of paintings by the Impressionists (including Raffaelli's *Les Invalides*, 1895 and Beraud's *Les Boulevards*, 1880).

The Carnavalet Museum
- 23, rue de Sevigne
 3rd arrondissement
- Tues–Sun 10AM–6PM
- carnavalet.paris.fr

Islands

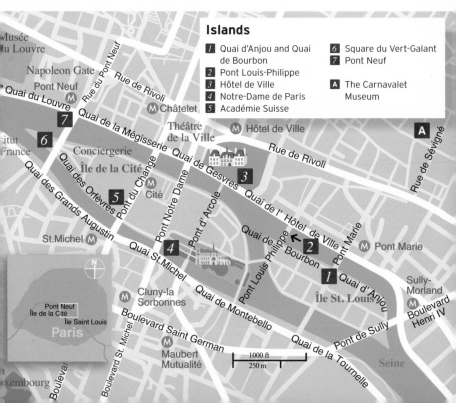

1. Quai d'Anjou and Quai de Bourbon
2. Pont Louis-Philippe
3. Hôtel de Ville
4. Notre-Dame de Paris
5. Académie Suisse
6. Square du Vert-Galant
7. Pont Neuf

A. The Carnavalet Museum

Saint-Germain and Montparnasse

Tour starts from the Saint-Germain-des-Prés Métro station (line 4).

Église de Saint-Germain-des-Prés

Musée national Eugène Delacroix

Bazille Studio, rue de la Visconti

École nationale supérieure des Beaux-Arts

Manet Birthplace

Pont des Arts

Institut de France

La Palette

Baudelaire Birthplace

The Church of Saint-Sulpice

Jardin du Luxembourg

Closerie des Lilas

Rue Nortre-Dame-des-Champs

Gauguin Studio and Apartment, rue de la Grande-Chaumière

TRAVEL TIPS:

Take a stroll through the Jardin du Luxembourg, which is one of largest parks in Paris.

If you still have time, visit Musée Rodin, located in the area (see Museum section).

Auguste Renoir, *Paris Le Quai Malaquais*, c.1874 (Detail)
Private Collection

Saint-Germain-des-Prés
⌂ 3, place St-Germain-
des-Prés
6th arrondissement

Musée national Eugène Delacroix
⌂ 6, rue de Furstenberg
6th arrondissement
◎ Wed-Mon 9:30AM-
5PM
▣ musee-delacroix.fr

Frédéric Bazille Studio
⌂ 20, rue de la Visconti
6th arrondissement

▮ Église de Saint-Germain-des-Prés

This is the oldest church in Paris, dating originally to the 6th century. Manet was baptized here as a baby on February 2, 1832; his family lived about three blocks away from the chruch.

▮ Musée national Eugène Delacroix

This museum is dedicated to the painter Delacroix,

the hero of the young Impressionists (1798-1863). The museum was his last apartment and studio. Delacroix moved here in 1857 so he could be close to the church of Saint-Sulpice, where he was working in the Chapelle des Anges. The museum has on exhibit a number of his works and drawings, as well as memorabilia. This building was also the location of Frédéric Bazille's studio, which he rented in 1865 and later shared with Monet. Bazille's painting of this studio is now at the Musée Fabre in Montpellier.

▮ Frédéric Bazille Studio

Bazille moved to this narrow street in 1867 from the studio in rue de Furstenberg and invited his friends Renoir and Monet to join him. Renoir, short on money, lived here for the first few months of 1867. The inside of the studio can be seen in Bazille's

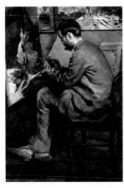 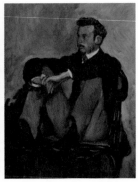

Left:
Auguste Renoir
Portrait of Frédéric Bazille Painting The Heron with Wings Unfurled, 1867
Musée d'Orsay

Right:
Frédéric Bazille
Portrait de Pierre-Auguste Renoir, 1867
Musée d'Orsay

painting *Studio of the rue Visconti*. While working here Bazille and Renoir made portraits of each other.

5 École nationale supérieure des Beaux-Arts

The École is the prestigious French national school of Fine Arts, which has a history spanning more than 350 years. In the 19th century, the dominant teaching philosophy at the school was based on the idea that the classical "antiquities," and the preservation of the idealized antique form, was the ultimate expression in art, and one which must be passed onto the next generations. Raffaelli, Caillebotte and Forain were students here; Cassatt took lessons from Jean-Léon Gérôme, a professor at the École des Beaux-Arts, as women were not accepted as students. A retrospective of Manet's works was held at the École des Beaux-Arts in the Salle Melpomène on January 5-28, 1884, after his death.

École nationale supérieure des Beaux-Arts

⌂ 14, rue Bonaparte
6th arrondissement

▣ www.ensba.fr

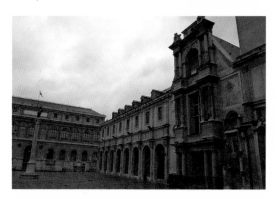

4 Birthplace of Édouard Manet

Manet was born on January 23, 1832, and lived on 5, rue Bonaparte, when the street was still called rue des Petit-Augustins (the name was changed in 1852).

There is a memorial plaque on the wall next to the entrance to the inner courtyard of the building, which looks on to the École des Beaux-Arts across the street.

Birthplace of Édouard Manet

⌂ 5, rue Bonaparte
6th arrondissement

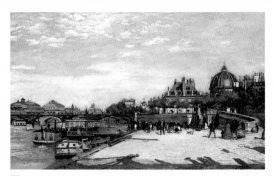

Pont des Arts
⌂ Border of 1st and 6th arrondissements

Auguste Renoir, *Paris Le Quai Malaquais*, c.1874
Private Collection

Institut de France
⌂ 23, quai de Conti
6th arrondissement

La Palette
⌂ 43, rue de Seine
6th arrondissements
☎ +33 (0) 1 43 26 68 15
🖥 cafelapaletteparis.com
🕐 8AM-2AM

⑥ Pont des Arts

This pedestrian bridge, linking the Institute de France and the Louvre Palace, was constructed between 1802 and 1804, when the Palace was called Palais des Arts. The original bridge had nine metallic arches and collapsed when a barge rammed into it in 1979. The present Pont des Arts was built between 1981 and 1984, using the same design as the original; the number of arches was reduced to seven. Renoir's painting *Pont des Arts* (1867), painted from quai Malaquais, shows the southern end of the bridge.

⑦ Institut de France

Comprising (and governing) five French academies—among them the academies of sciences, humanities and fine arts—the Institut de France was founded in 1795. The powerful institution sanctioned the regulations for the École des Beaux-Arts that the Impressionists rebelled against.

⑧ La Palette

In his first novel Zola described the area Saint-Germain-des-Prés as a terrible slum. This café survived the area's transition from slum to chic, and has served art students for more than a century.

9 Birthplace of Charles Baudelaire

Charles Baudelaire, one of the major innovators and the most influential poet (together with Rimbaud) of 19th-century France, was born here in 1821. Today he is best remembered for his revolutionary collection of poems *Les Fleurs du Mal*, published in 1857. Manet, a good friend, included his portrait in his painting *Music in the Tuileries* (1862).

Birthplace of Charles Baudelaire
13, rue Hautefeuille
6th arrondissement

10 The Church of Saint-Sulpice

Now famous for its role in Dan Brown's novel *The Da Vinci Code*, Saint-Sulpice is the second-largest church in Paris. During the 19th century, the interior was redecorated after the church was badly damaged during the Revolution. Between 1855 and 1861, Eugène Delacroix painted frescoes in one of the chapels—the Chapelle des Anges, the first one to your right when entering the building. The broken brushstrokes and plains of pure color foreshadow the experiments with light and pigment that would be undertaken by the Impressionists some 30 years later.

The Church of Saint-Sulpice
place de Saint-Sulpice
6th arrondissement

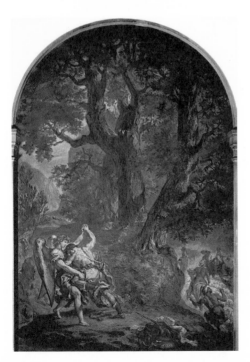

Eugène Delacroix
Jacob Wrestling with the Angel, 1861

Vincent van Gogh
Lane at the Jardin du Luxembourg, 1886
Sterling and Francine Clark Art Institute, Williamstown, Mass

ⅠⅠ Jardin du Luxembourg

Jardin du Luxembourg is one of the biggest parks in Paris. In 1611, Marie de Medici bought Hôtel de Luxembourg (now Petit Luxembourg Palace – the Luxembourg Museum) and later built the Luxembourg Palace (today the French Senate; there are a number of Delacroix paintings inside which can be viewed only on a guided tour). It was at the Luxembourg Museum where the Caillebotte collection was contested, then admitted in 1896. Van Gogh's painting *Lane at the Jardin du Luxembourg* (1886) shows the lanes and open area around the central basin of the gardens, while Degas's painting *A Nanny in the Luxembourg Gardens* (1875) shows a completely different approach to the same place.

Dalou's superb monumental sculptural fountain *Homage to Delacroix* (1890), is close to the Luxembourg museum and worthy of a visit.

Jardin du Luxembourg
🏠 6th arrondissement

Edgar Degas
A Nanny in the Luxembourg Gardens, c. 1875
Musée Fabre, Montpellier

Ⅰ2 Closerie des Lilas

Opened in 1847, La Closerie des Lilas is a restaurant once visited by Renoir, Bazille, Monet and Sisley. Other notable patrons included Hemingway, Man Ray and André Breton.

La Closerie des Lilas
🏠 171, boulevard du Montparnasse
border of 6th and 14th arrondissements
☎ +33 (0) 1 40 51 34 50
🖥 closerie.cluster002.ovh.net

13 Rue Nortre-Dame-des-Champs

Gleyre's studio, where many young Impressionists met for the first time, was located at 70bis, rue Nortre-Dames-des-Champs, nearby were Cézanne's studio (No. 53) and Courbet's (No. 61).

14 Paul Gauguin Apartment and Studio

Gauguin lived at 13, rue de la Grande-Chaumière, when he came back to Paris from Tahiti in 1893. At the time, he was finishing a number of paintings for the art dealer Durand-Ruel at No. 8, the studio of Art Nouveau artist Alphonse Mucha.

Paul Gauguin Apartment and Studio

13 & 8, rue de la Grande-Chaumière
6th arrondissement

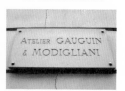

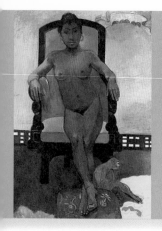

Gauguin and Annah the Javanese

When Gauguin went to Brittany in April 1894, he brought his teenage mistress with him—a half-Indian, half-Malay girl known as Annah the Javanese. She was nothing but trouble for the painter, keeping him from working and stirring up trouble in the town. One particularly bad incident involved 15 fishermen beating Gauguin unconscious. Annah used this as an opportunity to ransack his apartment (leaving behind only his paintings). She fled to Paris, where she later posed for Alphonse Mucha.

Paul Gauguin
Annah the Javanese, 1893
Private collection

Saint-Germain and Montparnasse

1 Église de Saint-Germain-des-Prés
2 Musée national Eugène Delacroix
3 Frédéric Bazille Studio
4 Birthplace of Édouard Manet
5 École des Beaux-Arts
6 Pont des Arts
7 Institut de France
8 La Palette
9 Birthplace of Charles Baudelaire
10 The Church of Saint-Sulpice
11 Jardin du Luxembourg
12 la Closerie des Lilas
13 Rue Nortre-Dame-des-Champs
14 Paul Gauguin Apartment and Studio

Carrousel

Musée d' Orsay

Seine

Pont Royal

Pont du Carrousel

Quai du Louvre

Louvre-Rivoli

Quai Malaquais

Pont des Arts

Pont Neuf

Quai de la Mégisserie

Quai de Gesvres

6

7

Île de la Cité

5

4

3

Rue Visconti

The Mint

8

Rue Bonaparte

Quai des Grands Augustins

Quai des Orfèvres

Pont Neuf

Pont St. Michel

Pont Notre Dame

2

Rue de l' Echaudé

Rue de Seine

1

Saint-Germain-des-Prés

Mabillon

Saint-Michel

Quai St.Michel

Matisse & Marquet's Studio

Le Chat Qui Peche

Odéon

Boulevard Saint-Germain

9

Blvd St-Michel

Cluny-la Sorbonne

Saint-Sulpice

10

Place Saint-Sulpice

Place de l' Odéon
Theatre

Site of Café Voltaire

Maubert Mutualité

Rue Racine

Rue des Ecoles

Rennes

Delacroix Fountain

Musée du Luxembourg

Rue de Vaugirard

Sorbonne

11

Jardin du Luxembourg

Boulevard Saint-Michel

Rue Saint-Jacques

Notre Dame des Champs

Rue Auguste Comte

Rue Notre Dame des Champs

Vavin

La Rotonde
La Dôme

13

14

Rue de la Grande Chaumière

Rue de Chevreuse

Boulevard du Montparnasse

Jardin de l' Observatoire

Rue Henri Barbusse

N

Saint-Germain-des-Prés
Jardin du Luxembourg
Montparnasse

Paris

1000 ft
250 m

12

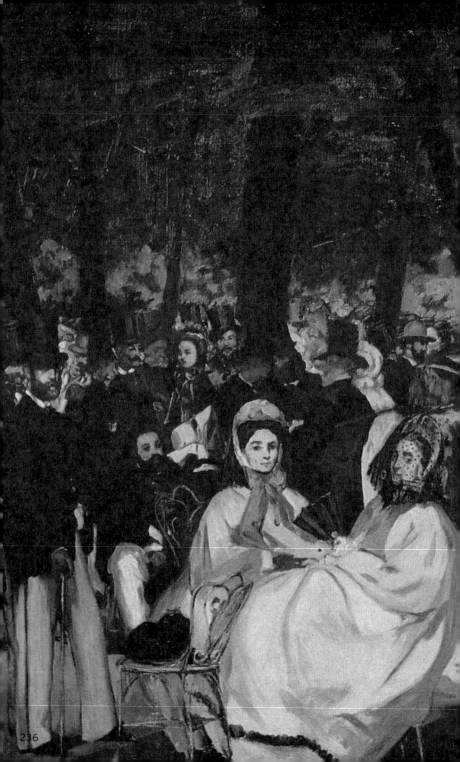

Tuileries and Champs-Élysées

**Tour starts from the Musée du Louvre
(Métro Palais Royal–Musée du Louvre, lines 1 and 7)**

Place du Carrousel / Jardin du Carrousel
Jardin des Tuileries
Apartment of Victor Chocquet
Place de la Concorde
Les Ambassadeurs
Palais de l'Industrie
Pont d'Iéna
Trocadéro / Palais de Chaillot
Passy Cemetary

TRAVEL TIP:

After the tour, enjoy a long walk along the Seine or use
the Métro or bus to end your day at the Trocadéro.

Édouard Manet, *Concert in the Tuilleries Gardens*, 1862 (Detail)
National Gallery, London

left: Camille Pissarro
Place du Carrousel, 1900
National Gallery of Art,
Washington, D.C.

right: Camille Pissarro
*Tuileries Gardens Winter
Afternoon*, 1899
Metropolitan Museum,
New York

**Place du Carrousel
Jardin du Carrousel**

⬛ Open end of the court-
yard of the Louvre
1st arrondissement

1 Place du Carrousel/Jardin du Carrousel

The Place du Carrousel was used as parade grounds
for cavalry in the 18th century (carrousel referring
to a type of military dressage). The Triumphant Arch
(Arc de Triomphe du Carrousel) was built between
1806 and 1808 to serve as the entrance of honor for
the Tuileries gardens. Pissarro's paintings of the
Place du Carrousel and the Jardin des Tuileries (28
canvases in total) were painted from 204, rue de
Rivoli, which he rented for 6 months in the last years
of his life.

2 Jardin des Tuileries

Created by Catherine de Medici in the middle of the
16th century, the Tuileries became a public garden
only after the French Revolution. By the end of the
19th century, it was one of the more popular places
for Parisians to promenade and relax. As such, it
was painted numerous times by the Impressionists in
works like Manet's painting *Music in the Tuileries*
(1862) and Monet's *Jardin des Tuileries* (1875).
At the western end of the gardens, around the Or-
angerie Museum, there are four Rodin sculptures.
One is opposite the main entrance of the museum,
while three more can be found just around the bend,
in the yard north of the entrance, offering a unique

Jardin des Tuileries

⬛ Between the Louvre
Museum and the Place
de la Concorde
1st arrondissement

Édouard Manet
Music in the Tuileries
1862
National Gallery, London

opportu-
nity to see
Rodin's
sculptures
outside of
a museum
setting.

Claude Monet
Jardin des Tuileries, 1875
Musée Marmottan Monet

left: Auguste Renoir
Portrait of Victor Chocquet, 1875
Fogg Art Museum, Cambridge

right: Paul Cézanne
Portrait of Victor Chocquet, 1876-77
Collection de Lord Rothschild, Cambridge

❸ Apartment of Victor Chocquet

Born in Lille, Chocquet was a minor customs official and an important patron of the Impressionists. He first encountered their art at Père Tanguy's paint shop, and later met most of them at the famous Drouot sale in 1875. When Chocquet died in 1891, his collection included 32 Cézannes, 11 Monets, 11 Renoirs and five paintings by Manet. Both Cézanne and Renoir painted his portrait. In 1876, Monet painted at least four versions of the Jardin des Tuileries as seen from Chocquet's apartment.

Apartment of Victor Chocquet
📍 198, rue de Rivoli
4th floor
1st arrondissement

❹ Place de la Concorde

Designed in 1755, this is the largest square in Paris. One of its more prominent features is a giant Egyptian obelisk, imported in 1833 and installed three years later on the place where the guillotine stood during the Revolution. A view of the square—just the northern part and the walls of the Tuileries gardens— is depicted in Degas's *Place de la Concorde* or *Ludovic Lepic and his Daughter* (1875), now at the Hermitage Museum in St. Petersburg, Russia.

Place de la Concorde
📍 Border between 1st and 8th arrondissements

Edgar Degas
Place de la Concorde or *Viscount Lepic and his Daughters*, 1875
Hermitage, St. Petersburg

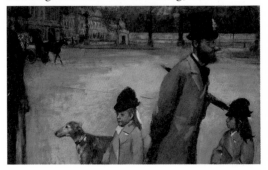

Les Ambassadeurs
🏠 1-3, avenue Gabriel
(now Espace Cardin)
8th arrondissement

Left: Edgar Degas, *La Chanson du chien*, 1875-77
Private collection

Right: *Le Café-Concert des Ambassadeurs*, 1876-77
Lyon Musée de Beaux-Arts

Édouard Manet
Chânteur du café-concert
1879
Private collection

The Palais de l'Industrie, now distroyed.

Palais de l'Industrie
🏠 2, rue Commandant-Schloesing
8th arrondissement

⑤ Les Ambassadeurs

Les Ambassadeurs was one of the most famous of the *café-concerts* that flourished in the years before the war in 1870. A number of painters visited the café daily and there are a quite a few paintings which depict scenes there: Manet's *Chânteur du café-concert*; Degas's *La Chanson du chien* (both in private collections); and Degas's *Le Cafe-Concert des Ambassadeurs* (1876-77) at the Lyon Musée des Beaux-Arts.

⑥ Palais de l'Industrie

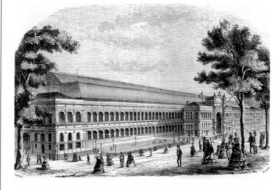

The Palais de l'Industrie was an exhibition hall erected for the Paris World Fair in 1855. It was ultimately destroyed in 1897 to make way for the Grand Palais of the 1900 World Fair. The Palais de l'Industrie was the place where the annual Salon des Beaux-Arts was held between 1856 and 1890.

7 Pont d'Iéna

The bridge was named after the battle of Jena in 1806, a significant victory for Napoleon, after which Prussia was occupied by French troops. Gauguin's painting of the bridge, *La Seine près du pont d'Iena* (right), 1875, now at the Orsay, was painted from Port Debilly looking southwards, just after the Passerelle Debilly.

Pont d'Iéna
🏠 Connecting the 7th and 16th arrondissements

8 Trocadéro / Palais de Chaillot

The Trocadéro is an area across the Seine from the Eiffel Tower. Morisot's painting *View of Paris from the Trocadéro* captures the Arc de Triomphe, the Dôme des Invalides and the dome of the Pantheon. Completed in 1872, the painting also shows how much of the center of Paris was yet to be built. Manet's *View of the Universal Exhibition*, 1867, was also painted here.

Trocadéro
Palais de Chaillot
🏠 place du Trocadéro and place du 11 Novembre 16th arrondissement

Berthe Morisot
View of Paris from the Trocadéro, 1872
The Santa Barbara Museum of Art

9 Passy Cemetery

Opened in 1820, this cemetery was considered the premier resting place for French aristocracy. Manet died and was buried here at the age of 51 in 1883. In 1895, Morisot was buried in the same grave as her husband Eugène Manet.

Camille Pissarro
Garden at the Tuileries
Spring Afternoon, 1900
Private Collection

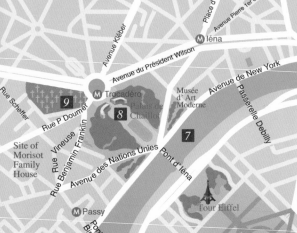

Tuileries and Champs-Élysées

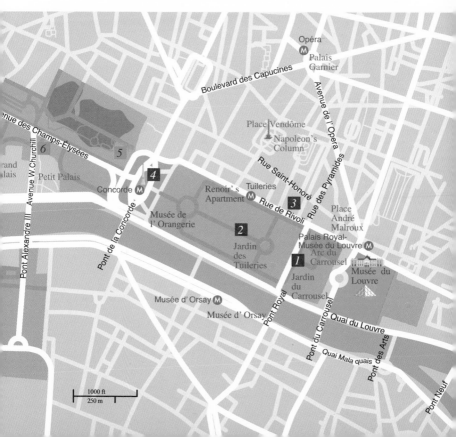

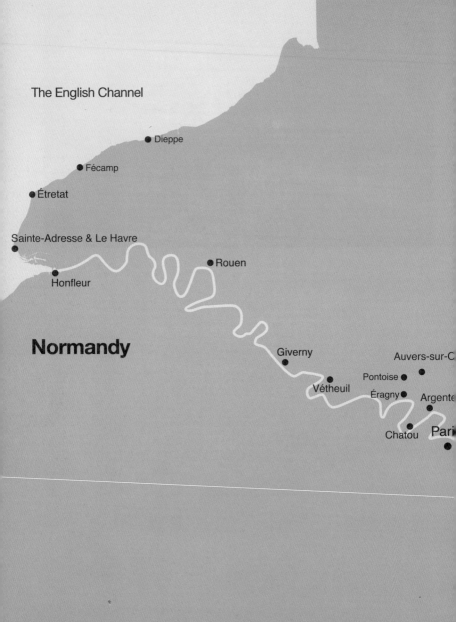

The English Channel

● Dieppe

● Fécamp

● Étretat

Sainte-Adresse & Le Havre
●

● Rouen

● Honfleur

Normandy

● Giverny

Auvers-sur-C

Pontoise ● ●

● Vétheuil

Éragny ●

Argente

● Chatou

Pari

●

North of Paris and Normandy

Throughout the 19th century, Parisians began looking outside the city for respite from their increasingly modern city. Beaches and the banks of the Seine became popular places for weekend getaways, aided by the arrival of rail service from Paris. The Impressionists, too, looked beyond the city's borders for fresh air and inspiration. These artists were united in their appreciation of landscape and depictions of modern life, as well as a commitment to outdoor, plein air painting. Outside of the Paris, these artists reveled in nature, embracing the region's shifting light and bountiful flora.

This tour heads north from Paris, through the suburbs where Monet and Renoir once worked, to Normandy, a scenic seaside retreat captured in many Impressionist masterpieces.

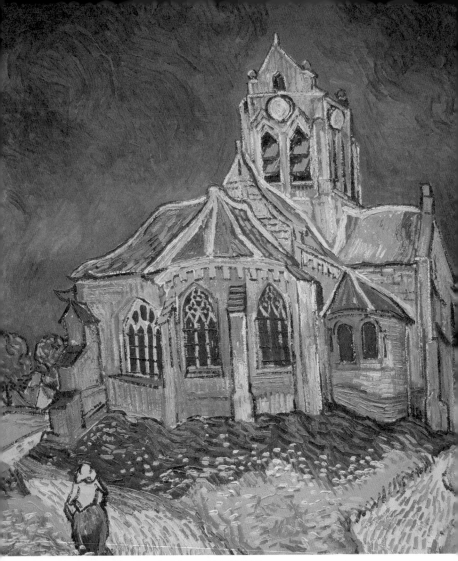

Vincent van Gogh, *The Church at Auvers* (detail) 1890
Musée d'Orsay

Auvers-sur-Oise

"Auvers is really beautiful—among other things many old thatched roofs, which are becoming rare."

—Vincent van Gogh

Set in the Oise Valley, just 30 km (16.9 mi) north of Paris, the town of Auvers-sur-Oise brims with quaint charm. One hundred and fifty years after the first Impressionist artists arrived here to paint its picturesque landscape, Auvers still retains its natural beauty, as well as many of its original 19th-century buildings. The town remains virtually unchanged from the days of Vincent van Gogh and Paul Cézanne, allowing visitors to see nearly the same exact scenes the artists painted.

Upon arriving in Auvers-sur-Oise on May 20, 1880, Van Gogh wrote to his brother and sister-in-law Jo his first impressions of the town:

"I'd hope, then, that in doing a few canvases of that really seriously, there would be a chance of recouping some of the costs of my stay—for really it's gravely beautiful, it's the heart of the countryside, distinctive and picturesque."

This arrival marked the beginning of Van Gogh's last 70 days; he shot himself on July 27. While staying in Auvers, Van Gogh was inspired to paint over 70 works including *The Church at Auvers*, *Daubigny's Garden* and, most famously, *Wheatfield with Crows*. Van Gogh came to Auvers to be treated by Dr. Paul Gachet, who was a collector and close friend of many Impressionists. Gachet lived here with his family three days a week and practiced medicine in Paris the rest of the time. While in Auvers, Cézanne also took full advantage of Dr. Gachet's hospitality.

In 1872, Cézanne joined Camille Pissarro in Pontoise with Marie-Hortense Fiquet and their newborn son.

ACCESS:
There is direct service to Auvers-sur-Oise from Paris, Gare du Nord on the Transilien suburban rail line. The trip takes about 30 minutes.

1854
Daubingny (1818-1878) comes to Auvers where he meets Cézanne. Daumier and Corot often join him, being influenced by Daubingny's style of painting *en plein air*.

April 9th, 1872
Dr. Paul-Ferdinand Gachet moves to Auvers-sur-Oise, purchasing his now-famous *maison*.

1872–1874
Cézanne moves to Auvers for 18 months. With the influence of Pissarro and Impressionist collector Dr. Gachet, Cézanne painted his first Impressionist work here, *The Hanged Man's House*.

1877
Pissarro, Cézanne and Gauguin spend the summer painting together in and around Auvers.

May 20th, 1890
Vincent van Gogh moves to Auvers where he befriends Dr. Gachet. He spends the final 70 days of his life here, dying by a self-inflicted gunshot wound on July 29th, 1890.

1900s
After the Impressionists leave, many other artists live or spend time in Auvers, including Rajon, Goeneutte, Vignon, Beauverie, Maximilien Luce, Giran Max, Spraque Pearce, Boggio, Otto Freundlich and Henri Rousseau.

Paul Cézanne, *The Hanged Man's House*, 1873, Musée d'Orsay; Auvers Town Hall as painted by Van Gogh

Early in 1873, Cézanne moved to Auvers, a few miles up from Pontoise, and worked in Dr. Gachet's house for 18 months. It is in Auvers where Cézanne painted two of his most celebrated works, *A Modern Olympia* (which Dr. Gachet acquired) and *The Hanged Man's House*. It is said that the Barbizon painter Charles-François Daubigny once watched Cézanne work here and could not restrain his enthusiasm. "I've just seen on the bank of the Oise an extraordinary piece of work," he told a friend. "It is by a young and unknown man: a certain Cézanne!"

Scenes from Auvers-sur-Oise, including a sculpture of Vincent van Gogh (top).

However, Auvers did not always harbor the peace that drew artists from all over the world. The Oise valley was the location of several wars, ranging from the 9th-century Norman invasion to the Hundred Years' War of the 16th century. It was not until the 17th century that Auvers saw true peace, when the building of the Colombières manor, and then later in the 18th century, the elegant Léry chateau, were made possible.

Auvers is easily explored on foot, and the tourist office is the best starting point. Here the friendly staff provides free maps that indicate 24 sites where Impressionist artists set up their easels. These sites are indicated by plaques, on a "works of art" tour of the town.

Impressions of Auvers

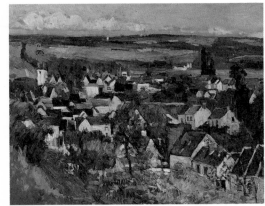

Paul Cézanne, *View of Auvers-Sur-Oise*, c. 1873
Art Institute of Chicago

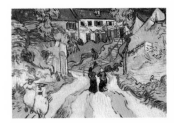

left: Vincent van Gogh, *Stairway at Auvers*, 1890. St. Louis Art Museum; right: Paul Cézanne, *Dr. Gachet's House at Auvers*, c. 1873. Musée d'Orsay

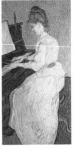

left: Vincent van Gogh, *Landscape with Carriage and Train in the Background*, 1890, Pushkin Museum, Moscow
right: Vincent van Gogh, *Mademoiselle Gachet at Piano*, 1890, Kunstmuseum Basel

Scenes of Auvers-sur-Oise

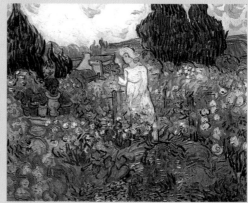

Two works from the collection of Dr. Paul Gachet (left) Vincent van Gogh, *Dr. Paul Gachet*, 1890. (right) Paul Cézanne, *Marguerite Gachet in the Garden*, 1890. Musée d'Orsay

Paul-Ferdinand Gachet

Physician, patron and friend to some of the greatest Impressionist artists, Dr. Paul-Ferdinand Gachet was born to an upper-middle-class family in Lille in 1828. As a teenager, Gachet learned to draw from artists Eugène Cuvelier and Ambroise Detrez. In his 20s, he spent evenings roaming Paris exhibition openings, with his wild hair dyed a shocking shade of yellow, buying work from up-and-comers like Manet and Courbet; the days he spent struggling through his university classes.

In 1872, Gachet traded Paris for the quieter countryside, relocating with his young wife to Auvers-sur-Oise, because of both its pastoral beauty and its popularity with artists. Here, Gachet operated his medical practice part-time while entertaining painters such as Pissarro, who introduced him to his protégé Cézanne. It was Cézanne who helped Gachet turn his attic loft into a studio. Of Gachet's life in Auvers, contemporary journalist Paul Alexis wrote, "Up hill and down dale, with an extraordinary energy, he does everything at once: his consultations in his surgery and his painting, homeopathy and allopathy, literature and fishing, not to mention teaching his children..."

On May 20, 1890, Vincent van Gogh appeared at Gachet's door with a letter of introduction from his brother Theo. Pissarro had advised Theo to get in touch with Gachet regarding his older brother's mental health and Gachet agreed to keep watch over him. Upon his arrival, Van Gogh was struck by the doctor's appearance: "I've seen Dr. Gachet, who gave me the impression of being rather eccentric, but his doctor's experience must keep him balanced himself while combating the nervous ailment from which it seems to me he's certainly suffering at least as seriously as I am." Doctor and patient became close friends, but the friendship could not save the painter. As Van Gogh lay dying, Gachet stood at his bedside, sketching the artist in his final hours.

Gachet died in 1909 and is buried in Père Lachaise Cemetery in Paris. In 1949, his son donated the incredible collection his father had amassed—including nine Van Goghs, eight Cézannes, three Pissarros, a Monet and a Renoir—to France. They are now on exhibit at the Musée d'Orsay.

Daubigny Museum

🏠 Manoir des
Colombières
rue de la Sansonne

☎ +33 (0) 1 30 36 80 20

🖥 musee-daubigny.com

🔘 Wed-Fri 2PM-5:30PM
Sat-Sun 10:30AM-
12:30PM, 2PM-5:30PM

€ 4

Tourist Office

☎ +33 (0) 1 30 36 10 06

🔘 Apr-Oct Tue-Sun
9:30AM-12:30PM
2PM-6PM
Closed: Nov-Mar
Tue-Sun 9:30AM-
12:30PM, 2PM-5PM

Vincent van Gogh, *Portrait
of Adeline Ravoux*, 1890
Private Collection

Auberge Ravoux

🏠 place de la Mairie

☎ +33 (0) 1 30 36 60 60

🖥 maisondevangogh.fr

🔘 Wed-Sun 10AM-6PM

€ 6

�１ Daubigny Museum / Tourist Office

The painter Daubigny was a forerunner of the
Impressionist movement and, in 1854, came to

Auvers to join
friends and fellow
artists Corot and
Daumier. A museum
featuring his works
along with memo-
rabilia is on the
second floor of the
Colombières Manor.

The first floor is the tourist office, from which 1-hour
guided tours of the town leave from April through
October for €6.

�２ Auberge Ravoux

On May 20, 1890, Van Gogh arrived in Auvers-sur-
Oise and moved into a small room at the Auberge
Ravoux that cost him 3.50 francs per night. The
inn was a favorite amongst painters and here Van
Gogh found himself in the company of other Dutch,
American and French artists. It is at the inn where
Van Gogh died on July 29, 1890 at 1:30 a.m., with
his brother Theo at his side. The inn no longer keeps
overnight guests but does offer the same traditional
fare that Van Gogh would have eaten while living
here. His room has been kept the same as it was when
the painter occupied it and is open to the public.

3 Notre-Dame d'Auvers (The Church at Auvers)

Dating back to the 11th century, this Gothic church has a Romanesque chapel, which was once the private chapel of Queen Adélaide de Maurienne, widow of Louis VI (Louis the Fat). But what has made the church most famous is Van Gogh's painting *The Church at Auvers*. With a bell tower that looms over the town, the church is difficult to miss and has remained unchanged since it was imortalized by Van Gogh.

4 Wheatfield with Crows

Wheatfield with Crows is often wrongly assumed to be Van Gogh's final painting. In fact, Van Gogh painted several wheatfield landscapes during his time in Auvers, telling his brother Theo, "They depict vast, distended wheatfields under angry skies, and I deliberately tried to express sadness and extreme loneliness in them." But these pictures also had a positive side: "I am almost certain that these canvases illustrate what I cannot express in words, that is, how healthy and reassuring I find the countryside." Van Gogh's fields are right outside Auvers and a short walk up the plateau from Notre-Dame d'Auvers.

Notre-Dame d'Auvers
🏠 rue Daubigny
☎ +33 (0) 1 30 36 71 79
🕙 Daily 9AM–6PM
€ Free

Van Gogh's Last Works
On July 23, 1890, four days before he shot himself, Van Gogh wrote to his brother Theo describing a painting he is working on depicting Daubigny's garden and a *croquis* (quick drawing) of thatched roof cottages. These, rather than *Wheatfield with Crows*, are much more likely to be his final works.

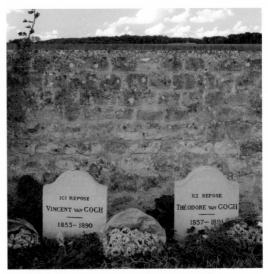

Cimetière d'Auvers

🏠 place de l'Eglise

Theo's death

Van Gogh's younger brother Theo had a complicated series of ailments, ranging from a kidney infection to what was most likely syphilis. Camille Pissarro wrote to his son regarding Theo, "It appears that Theo van Gogh was ill before his madness; he had uremia. For a week he was unable to urinate..." In January of 1891, his sickness caught up with him and Theo had a physical breakdown and suffered a stroke, which paralyzed him. A few days later, he fell into a coma and passed away.

5 Cimetière d'Auvers (Cemetery)

Theo Van Gogh reported this his brother's last words were, "*La tristesse durera toujours*" ("The sadness will last forever"). Vincent was buried at the cemetery of Auvers-sur-Oise. Theo, unable to come to terms with his brother's death, died six months later and was buried next to him. Both graves are at the back wall of the cemetery, covered in ivy. The artists Norbert Gœneutte and Léonide Bourges are also buried here.

6 Parc Van Gogh (Van Gogh Park)

Parc Van Gogh

🏠 rue du Gén De Gaulle

Home to a 10 ½ foot, 880-pound bronze sculpture of Van Gogh—a contemporary piece by the Russian-born sculptor Ossip Zadkine, who studied Van Gogh's self portraits and found inspiration for the piece in two works, one in which Van Gogh looked like his father and the other, his mother. Van Gogh is portrayed with deep-set eyes and a paint box and easel slung over his shoulder, staring ahead towards the field from *Wheatfield with Crows*.

7 Dr. Gachet's House

A great friend and supporter of artists, Dr. Gachet entertained a plethora of painters at his home, from Pissarro to Sisley and Cézanne. In 1890, Van Gogh painted two portraits of the doctor, as well as his daughter, his gardens and his house, which today still looks very much the same and has been turned into a museum.

8 Pendu House

In 1872, Cézanne moved to Auvers to follow his mentor Pissarro, who found inspiration for his Impressionist works in the countryside. In 1873, Cézanne painted his first Impressionist work here, *The Hanged Man's House* (*La maison du Pendu*), considered to be the greatest work from his Impressionist period. The painting depicts a cottage near the rue de Four at which a suicide or hanging has never been recorded to take place. The title comes from the then-owner of the house, whose surname was Penn'du (a name that closely resembles the French word *pendu*, meaning hanged man). The house is privately owned, but a plaque outside indicates where Cézanne placed his easel when painting *la maison*.

Dr. Gachet's House
🏠 78, rue du Dr. Gachet
☎ +33 (0) 1 30 36 81 27
🕐 Apr-Oct Wed-Sun 10AM-6PM
€ 4

Pendu House
🏠 rue de Four
🕐 Not open to the public

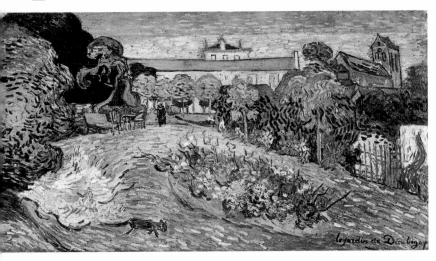

Vincent van Gogh, *Daubigny's Garden*, 1890
Kunstmuseum , Basel

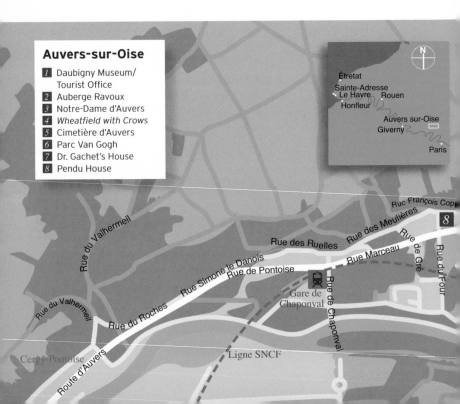

Auvers-sur-Oise

1 Daubigny Museum/
 Tourist Office
2 Auberge Ravoux
3 Notre-Dame d'Auvers
4 *Wheatfield with Crows*
5 Cimetière d'Auvers
6 Parc Van Gogh
7 Dr. Gachet's House
8 Pendu House

Étretat
Sainte-Adresse
Le Havre Rouen
Honfleur
 Auvers sur-Oise
Giverny
 Paris

Rue François Cop
Rue des Meulières
Rue des Ruelles
Rue du Valhermeil
Rue de Gré
Rue du Four
8
Rue Marceau
Rue Simone le Danois
Rue de Pontoise
Rue du Roches
Gare de
Chaponval
Rue de Chaponval
Rue du Valhermeil
Cergy-Pontoise
Route d'Auvers
Ligne SNCF

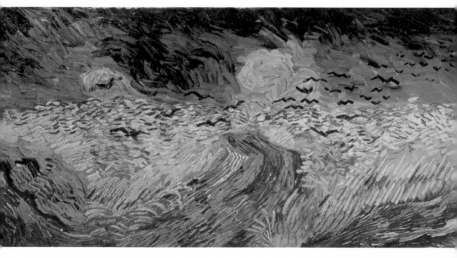

Vincent van Gogh, *Wheatfield with Crows* 1890
Van Gogh Museum, Amsterdam

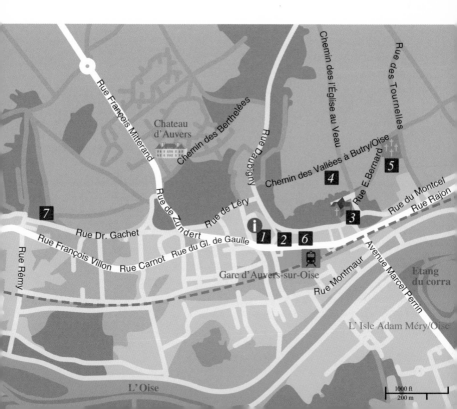

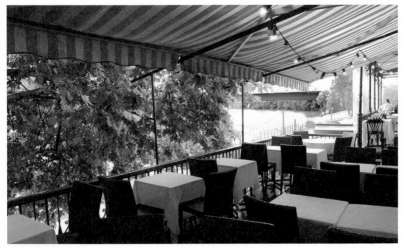

Restaurant Fournaise

Other Suburbs of Paris

Chatou

In 1868, Auguste Renoir first visited Chatou, a suburb of Paris 14.4 km (8.9 mi) from the city center. Just a 20-minute train ride from the city, Chatou and the small island there became a fashionable getaway for Parisians of all classes. Renoir visited the town until 1884, studying the play of light on water on the shores of the Seine. He also liked that Chatou was near his mother in Louveciennes and would often stay for months at a time. Along with his fellow artists, Renoir frequented the Maison Fournaise, a restaurant, hotel and boat rental business. The struggling artist became a close friend of the proprietors, who often accepted paintings in exchange for his bill. It is here that Renoir painted one of his most famous works, *Luncheon of the Boating Party* in 1881, which features other regulars of the restaurant including Gustave Caillebotte, Renoir's future wife Aline Charigot and the Fournaise children. The Maison Fournaise has since been transformed into the Musée Fournaise, housing paintings from a variety of artists who passed through the restaurant (most notably the Fauvist Andre Derain) as well as objects that belonged to author Guy de Maupassant. The restaurant was restored and reopened in 1990, complete with the orange and white canopy from Renoir's painting. Just a few miles away from Chatou was the popular meeting place La Grenouillère. The so-called "frog pond" took its name not from any four-legged creatures, but from the available women who frequented it, many of whom Renoir used as models. Renoir painted many scenes here along with his close friend Monet in hopes of selling the paintings to tourists.

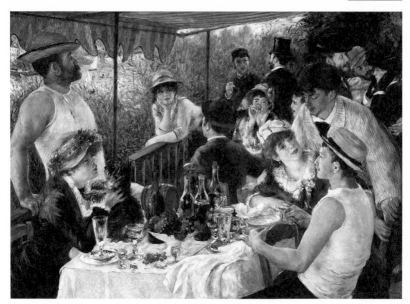

Auguste Renoir, *Luncheon of the Boating Party*, 1880-81, The Phillips Collection, Washington, D.C. Renoir's scene of the Restaurant Fournaise features a youthful portrait of his fellow artist, close friend and wealthy patron, Gustave Caillebotte, sitting backwards in his chair near the actress Angèle and the Italian journalist Maggiolo. Caillebotte, an avid boatman and sailor, wears a white boater's shirt and flat-topped boater hat. The young woman holding a dog was Aline Charigot, a seamstress Renoir had recently met and would later marry.

clockwise from left: Édouard Manet, *Argenteuil*, 1874, Musée des Beaux-Arts de Tournai; Claude Monet, *Promenade near Argenteuil*, 1873, Musée Marmottan; Auguste Renoir, *Claude Monet Painting in his Garden at Argenteuil*, 1873, Wadsworth Atheneum Museum of Art, Hartford
opposite: Claude Monet, *The Road to Vétheuil in Winter*, 1879, Göteborgs Konstmuseum

Argenteuil

Located just to the northwest of Paris, this suburb is 19 km (12 mi) from the capital or a 15-minute train ride from Gare Saint-Lazare. When a rail line was built between Argenteuil and Paris in 1851, the town underwent an industrial expansion while also attracting day-trippers from Paris. During the 1870s and 1880s, Impressionist artists who came to the town to paint its gardens, streets and modern bridges. Monet lived here from 1871 to 1878, where he created many works on his floating studio, a flat-bottomed boat he purchased and converted to a workspace (he also had a makeshift, lean-to studio near his home). From the boat, Monet could capture sprawling views of the Seine and its banks, as seen in works such as *Argenteuil*, 1875, now at the Musée de l'Orangerie. Suburban life marked a particularly happy and domestic time for Monet, who discovered his love of gardening in the town. His wife and their young son, Jean, often served as models for works like *Coquelicots (Poppy Field)*, 1873, which was shown at the first Impressionist exhibition, and *Woman with a Parasol*, 1875. Friends Renoir, Manet and Sisley would often visit the artist, turning the small village into an enclave of artistic activity. Paintings such as Manet's *Argenteuil*, 1874, of a couple near

the port, document the fashionable leisure of the day, which included rowing and sailing. Caillebotte, an accomplished sailor as well as artist, first visited Argenteuil following Monet's departure, and frequently painted the boats, bridges and factories of the increasingly industrialized city.

Pontoise

Camille Pissarro lived in this suburb of Paris, 28.4 km (17.6 mi) from the city center, for 17 years. Here he painted over 100 works, including *Hillside of the Hermitage, Pontoise*, 1873. Pontoise has a museum and garden dedicated to its most famous resident, the Musée Pissarro, which holds a collection mainly of prints and drawings by the Impressionist. The Roman road runs through Pontoise and is still used today as part of the N14 from Paris to Rouen.

Vétheuil

In 1878 Monet moved his family up the Seine to the small and rural village of Vétheuil, located near a scenic bend in the Seine 66 km (41 mi) from Paris. He had become disillusioned by the modern industry that seeped into Argenteuil, and also faced financial ruin. His former patron, Ernest Hoschedé, had gone bankrupt, and Monet was having a more difficult time than ever selling his work. He spent much of 1878 in Paris, in search of new patrons and new subjects, while trying to elude his creditors (and entertaining his mistress). He lived in the quiet village of about 600 from 1878 to 1881, entertaining fewer guests, though he invited Hoschedé and his family to move in. In Vétheuil, he became less interested in painting modern life and even more committed to *plein air* painting, creating some 150 landscapes. The Seine provided particular inspiration, and the artist painted the icy river in throughout the difficult winter in such works as *Ice Breaking up near Vétheuil*, 1880, now at the Louvre. At the same time, Monet exhibited at the Salon for the first time in a decade, showing one work, *La Seine à Lavacourt*, a detailed view of the town across the river. Monet was also captivated by the play of light on the façade of the Romanesque church in the village center, and painted it many times, in works such as *Église de Vétheuil (Church at Vétheuil)*, 1879. A year after moving here, Monet's wife Camille died and was buried in the old cemetery at Saint Nicholas Church. Her tombstone identifies her as "Camille Doncieux: The wife of Claude Monet." Following Camille's death, Monet and his sons moved to a large rented house in Poissy in 1881, along with Alice Hoschedé (her husband remained in Paris) and the six Hoschedé children.

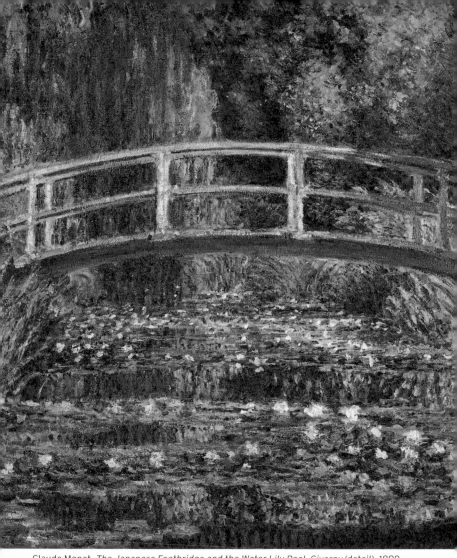

Claude Monet, *The Japanese Footbridge and the Water Lily Pool, Giverny* (detail), 1899
Philadelphia Museum of Art

Giverny

"I am good for nothing except painting and gardening. My greatest masterpiece is my garden."

—Claude Monet

Giverny is a small village on the border between Normandy and Île-de-France, about 80 km (50 mi) northwest of Paris and 5 km (3 mi) from the town Vernon. The village rests against the hills on the east bank of the Seine, where the river meets Epte. In the 19th century, the town's natural beauty attracted a number of artists, most notably Monet. "Once settled, I hope to produce masterpieces," he wrote to Paul Durand-Ruel, his dealer, in 1883. The spirit that inspired Monet can still be felt while strolling through this cozy village.

After the death of his first wife, Camille, Monet moved to the suburban town of Poissy in 1881, but continuous poverty, family illness and flood forced him to find a new home. In April 1883, Monet and his extended family—Alice Hoschedé, his two sons by Camille and Alice's six children by her first husband, Ernest—moved to Giverny, an unassuming farming village with 279 inhabitants. There they rented one of the largest houses in the village, a pink stucco house known as Le Pressoir (the cider press), which sat on two acres of land. It remained Monet's home for 43 years, until his death.

Monet's fortunes began to change for the better as Durand-Ruel had increasing success selling his paintings. By November 1890, he was prosperous enough to buy Le Pressoir.

During the same period, Émile Zola called Monet a "leading Impressionist," and American artists began visiting the painter. From 1886 to the start of World War I in 1914, an American artist colony existed in Giverny. But Americans weren't the only artists to visit Monet, friends such as Paul Cézanne, Auguste Rodin, Auguste Renoir, Edgar Degas and Alfred Sisley visited as well.

ACCESS: Trains leave from Paris Gare Saint-Lazare to Vernon, journey time is 45 minutes. From there, Giverny is 3 miles away via taxi, bus or bicycle. The bus service is timed to link with the train and a combined ticket can be obtained at Gare Saint-Lazare. By car, Giverny is 90 minutes from Paris, along the A13 highway. Exit after the first toll from Paris and follow the signs to Vernon, then follow signs across the bridge to Giverny on the other side of the Seine.

1883 Monet sees Giverny from a train window and decides to move to the rural town of only 279 people with Alice Hoschedé and children.

1886 American painters Theodore Robinson and Willard Metcalf come to Giverny in search of Monet.

1887 The Hôtel Baudy opens. It caters especially to the influx of painters eager to meet Monet and experience Giverny.

1892 Monet marries Alice Hoschedé, widow of Ernest Hoschedé; Monet's stepdaughter Suzanne marries Theodore Butler, an American painter.

1894 Cézanne visits and paints with Monet in Giverny, staying at the Hotel Baudy. He meets Auguste Rodin, Gustave Geffroy and Georges Clemenceau.

1911 Alice Hoschedé Monet dies.

1900s In 1914, Monet begins painting a group of large panels of his water lily pond.

1926 Monet dies at 86 years old. Clemenceau is at his side.

By 1888, Monet was painting *en plein air*, setting up his easel and observing the local farmers clearing fields and harvesting hay, studying the way light colored the haystacks throughout the day. By the end of 1890, he had completed *Haystacks*, his first great series. Throughout his career, Monet continued to study the effects of light in series such as *Poplars* (1891), *Rouen Cathedral* (1892), *Morning On the Seine* (1896) and the *Thames* series (1899).

Monet actively traveled through Europe—to the French Riviera, Bordighera in Italy, Holland, London, Venice, Norway—looking for new themes. But soon, Monet's health began to fail. He suffered from bouts of depression and would disappear for days, wandering through fields and winding up in the nearby town of Vernon. At home, even Alice and the children wondered if "Monet"—as they distantly referred to him— would ever return. His depression deepened following the deaths of Alice (1911) and his beloved son Jean three years later. Around the same time, Monet was diagnosed with cataracts in both eyes, a condition which had changed the way he perceived color and blurred his vision for nearly a decade. Surgery did little to help. Despite these setbacks, Monet painted the large and brilliant *Water Lilies* series as a present to France upon the encouragement of his friend, Prime Minister Georges Clemenceau.

On Sunday, December 5, 1926, a telegram was sent to the newspapers from the post office in Vernon: "The painter Claude Monet died at noon at his property in Giverny. M. Georges Clemenceau was with him during his last moments. Claude Monet was 86 years old."

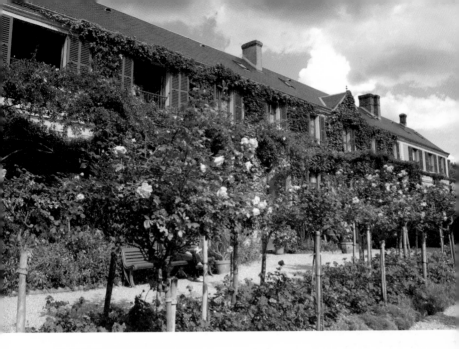

▮ Monet's House and Garden

Monet moved to this house, Le Pressior, in 1883 with his second wife and their collective eight children. He lived here for 43 years, until his death in 1926. Monet designed the gardens himself— the wide, tulip-filled Clos Normand garden and the Oriental water garden, with its famous Japanese bridge and water lilies—and at one point had a staff of seven gardeners. The gardens are the subject of some of Monet's most famous paintings, including *Water Lilies* and *The Artist's Garden at Giverny*. In 1966, Monet's heir, his son Michel, bequeathed the house and gardens to the French Academy of Fine Arts and the gardens have been restored to the original splendor painted by Monet. The house also contains Monet's extensive collection of Japanese woodcut prints.

Monet's House and Garden

- ⌂ 84, rue Claude Monet
- ☎ +33 (0) 2 32 51 28 21
- ▯ fondation-monet.com
- ◉ Open daily Apr 1-Nov 1 9:30AM-6PM, last entrance at 5:30PM
- € 8

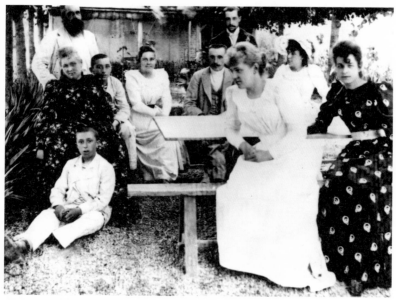

The Monet and Hoschedé families, c. 1880 Musée Marmottan Monet
(left to right): Claude Monet, Alice Monet, Jean-Pierre Hoschedé, Jacques Hoschedé, Blanche
Hoschedé, Jean Monet, Michel Monet, Marthe Hoschedé, Germaine Hoschede; Suzanne
Hoschede

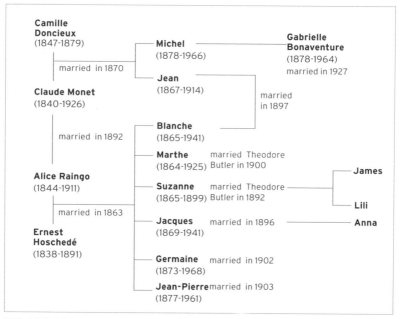

History of Monet's House

April 30, 1883 Monet and his family move to a leased house, Le Pressoir. He buys the property in 1890.

1892-1993 Builds a greenhouse and purchases a tract of land containing a stream and a pond where he builds the Japanese footbridge.

1901 Purchases more land near the water-lily pond and begins to enlarge it, growing more exotic plants. Granted permission in November to divert a branch of the Epte River through his property.

1916 Builds a third studio, large enough to contain the oversized *Water Lilies* cycle.

1926 Upon Monet's death, his son, Michel, inherits the property but leaves it abandoned. The gardens become a jungle, inhabited by river rats.

1966 Michel dies and leaves the home to the Académie des Beaux-Arts.

1977 Gerald Van der Kemp, who restored Versailles, is appointed to restore Le Pressoir.

1980 Fondation Claude Monet is created; the property opens to the public on June 1.

One Day with Monet

Monet's House and Garden

1 Entrance
2 House and First Studio
3 Second Studio
4 Third Studio
5 Clos Normand
6 Japanese Bridge
7 Water Lily Pond

When journalist Maurice Guillemont visited Monet for an interview in August 1897, he reported an intimate glimpse of the artist at work. He described a well-appointed home, brightly painted in violets and pale yellows, and filled with artwork by Monet and others. Outside, the lush gardens burst with wildflowers and willows, while exotic water lilies crowded a quiet pond.

Guillemont recalled the artist appearing on the steps of the pink house in the early morning, before sunrise: "On his head a brown felt hat, picturesquely battered, the tip of his cigarette a glowing point in his bushy beard."

That morning Guillemont followed Monet and an assistant through the empty gardens and neighboring fields

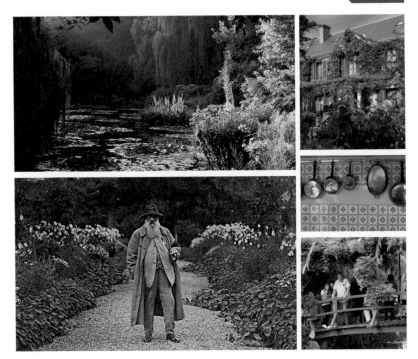

to the banks of the Epte in the eerie dawn. There they boarded a small boat that carried them to the artist's floating studio, another boat anchored to the small wooded island of Île aux Orties.

Monet set to work immediately with the help of his assistant. "There were 14 canvases that he had begun at the same time, a range of studies of the same motif, each one modified by the hour, the sun and clouds," recalled Guillemont. Monet painted his way through the morning, and as the day grew hot, the group returned to the house, its salon filled with rows and rows of the artist's canvases, spanning his career and arranged like a personal museum. After lunch, Monet proudly ascended the stairs and showcased his collection of work by his artist friends: Édouard Manet, Berthe Morisot, Auguste Renoir, Camille Pissarro, Edgar Degas and Paul Cézanne.

Then, Monet took his place under an umbrella near the pond, in the same place he often studied and sketched the rosy petals and green leaves that spread across the water's surface—always in the afternoon, before 5 p.m., when the flowers closed.

Monet's Garden Paintings

The Garden at Giverny, 1890
Private Collection

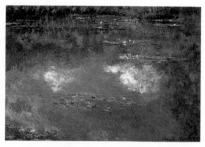

The Cloud, 1903
Private Collection

The Flowering Arches, 1913
Phoenix Art Museum

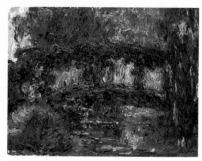

The Japanese Bridge
c. 1918-24, Minneapolis Institute of Arts

John Singer Sargent
Claude Monet Painting
c. 1885
Tate Gallery, London

The American painter John Singer Sargent, who was introduced to Monet by his teacher, Carolus-Duran, painted this idyllic scene, showing Monet at work on what is likely his *Meadow with Haystacks near Giverny*. Sprawled in the grass near Monet may very well be Alice Hoschedé.

Chronology of Monet's Series Paintings

1888 Begins *Haystacks*.

1895 Begins painting Japanese footbridge.

1902 Begins *Water Lilies*.

1891 Begins *Poplars* in nearby Lemetz.

1896 Begins the *Morning on the Seine* series.

Monet's Japanese Influence

"My true discovery of Japan, the purchase of my first prints, dates from 1856. I was 16. I spotted them at Le Havre, in a shop that dealt in curiosities brought back by foreign travelers." So recounted Monet of his first encounter with Japanese prints, an obsession that would make his way into not only his art, but also into his home.

In the 1870s, Japan was just opening up to the West, and a Japanese mania, dubbed *Japonisme*, spread throughout Europe. Many artists, including Vincet Van Gogh, Édouard Manet and Camille Pissarro, found inspiration from the vibrant prints that were soon hanging on shop walls around Paris. Throughout his life, Monet collected 231 Japanese prints, including many of historical importance on the advice from his curator and art dealer friends. The most significant works in his collection include prints by Utagawa Hiroshige, Katsushika Hokusai and Kitagawa Utamaro, as well as a rare battle scene from the Sino-Japanese war of 1894-95.

The prints' influence in Monet's art was subtle, a reflection of their tone and composition rather than direct mimicking. In his domestic life, however, Monet reveled in the Japanese style. In 1876, he painted *La Japonaise*, portraying his first wife Camille in a kimono against a background decorated with *uchiwa* (Japanese paper fans). Then, in Giverny in 1883, Monet built his famous Japanese gardens complete with a Japanese-style bridge—a style he must have seen in a print. He covered the walls of the house with woodblock prints, with 56 in the dining room alone.



4 Sainte-Radegonde Church and Monet's Grave

The Catholic church of Sainte-Radegonde traces its origins back to the Middle Ages and in the 15th century, was built partially in the Romanesque style. Claude Monet and his family celebrated their religious events here and the artist is buried in the nearby cemetery, his grave marked by a large white cross.

Sainte-Radegonde Church
🏠 rue Claude Monet
◉ Open daily

Monet's Funeral
When Claude Monet died, Georges Clemenceau was there to pay a final farewell to his long-time friend. It is said that upon finding Monet's coffin draped with the customary black pall Clemenceau snatched away the cloth and replaced it with a multi-coloured shawl, saying *"Pas de noir pour Monet."* (Not black for Monet.)

5 Rue des Chandeliers/Rue aux Juifs

The Ancient Rue des Chandeliers is lined with outstanding examples of partially restored, late-medieval stone houses. Even more ancient, the Rue aux Juifs (Street of Jews) features several fully preserved half-timbered houses and a walled medieval monastery.

Impressions of Giverny

Willard Metcalf, *Poppy Field*, 1886
Private Collection
American artist Willard Metcalf became friends with the Monet family in Giverny; during a visit from May-June of 1886, he painted this version of one of Monet's favorite subjects—a field of bold red poppies.

Claude Monet, *Church at Vernon*, 1883
Private Collection

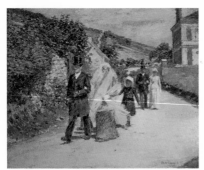

Claude Monet, *The Boat at Giverny*, c. 1887
Musée d'Orsay

Theodore Robinson, *A Bird's-Eye View*, 1889
Metropolitan Museum of Art, New York
Theodore Robinson first visited Giverny in 1887, when he became friends with Monet and adopted much of his Impressionistic style.

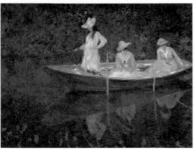

Theodore Robinson, *The Wedding March*, 1892
Terra Foundation for American Art, Chicago
Much to Monet's chagrin, his stepdaughter Suzanne Hoschedé married the American painter Theodore Earl Butler in Giverny on July 20 1892. This painting shows the wedding procession from the town hall to Sainte-Radegonde.

Paul Cézanne, *Winter Landscape, Giverny*, 1894, Philadelphia Museum of Art

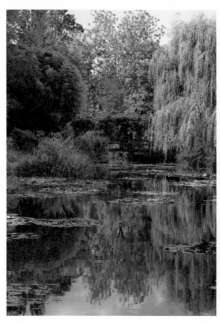

Giverny

1 Monet's House and Garden
2 Giverny Impressionism Museum
3 Hôtel Baudy

4 Sainte-Radegonde Church
and Monet's Grave
5 Rue des Chandeliers/Rue aux Juifs

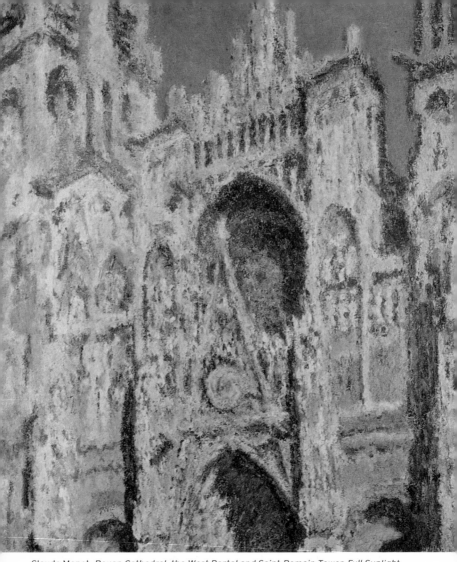

Claude Monet, *Rouen Cathedral, the West Portal and Saint-Romain Tower, Full Sunlight, Harmony in Blue and Gold* (detail), 1893, Musée d'Orsay

Rouen

"I am exhausted, I can't bear it any more and I had nightmares last night: the cathedral was falling down on me, it seemed to be blue, or pink or yellow."

—Claude Monet

With a long history dating back to the Gauls, Rouen is the historic capital of the region of Normandy in northern France, and was once one of the largest and most prosperous cities in all of Medieval Europe. Its 13th-century Gothic cathedral is an important monument of art history, in part due to its famous stained glass windows, and in part as the subject of a series of paintings by Claude Monet.

From 1892 to 1893, Monet painted the 31 works that comprise his *Rouen Cathedral* series. The series features the famous cathedral at different times of the day, a study of light meant to capture the intricate elements of the architectural masterpiece as the sun traversed the sky. For Monet, it became an obsession. He was solitary and oblivious to the other artists working around him. "I am a prisoner here and must go until the end," he wrote in 1893, describing the subject as his "cliff." All in all, Monet's study took four years, during which he intermittently lived and worked in the city. In 1892, Monet took up a room across from the cathedral at 25, place de la Cathédrale and then, in 1893, lived in a second-story room at 18, rue Grand-Pont, again within sight of the cathedral. Once the preliminary paintings were created he then finished the work in his studio in Giverny in 1894.

In 1895, the public had their first glimpse of the work that had consumed the artist; Monet chose 20 of his pieces for display in a Paris gallery, where he was received with great acclaim. Camille Pissarro and Paul Cézanne visited the exhibition, praising the series highly. Eight of these paintings were sold

ACCESS: From Paris, Rouen is approximately an hour and a half's drive northwest from the center of the French capital on the A13 motorway. Trains depart Paris several times a day from the Saint-Lazare Station. Travel time is about 1 hour 15 minutes.

immediately and they continue to be popular even today; in 2000 one of the works sold at auction for more than $24 million.

In the summer time, Rouen pays tribute to its most famous painter with a light show projecting Monet's works onto the façade of the cathedral after dark.

But Monet wasn't the only artist inspired by Rouen. Pissarro came to Rouen in 1883, looking for a home outside of Paris. He rented rooms across from the Seine and stayed for more than three months, returning again in the autumn for another three-month stint. Between 1883 and a second stay that lasted from 1896 to 1898, Pissarro painted 28 cityscapes including *The Roofs of Old Rouen*, *Gray Weather* and *The Boldlieu Bridge, Rouen*.

Paul Gauguin followed in his mentor Pissarro's footsteps and came to Rouen in January of 1884. He settled outside the city center, in the more suburban Jouvenet quarter. Gauguin stayed in the house he rented there for eight months, painting some of his most Impressionistic works, which he sent back to Paris for exhibition.

The love affair between artists and Rouen extended beyond the Impressionists. J. M. W. Turner painted watercolors depicting the cathedral and, in the 20th century, Roy Lichtenstein created a series of pictures depicting the cathedral's front façade.

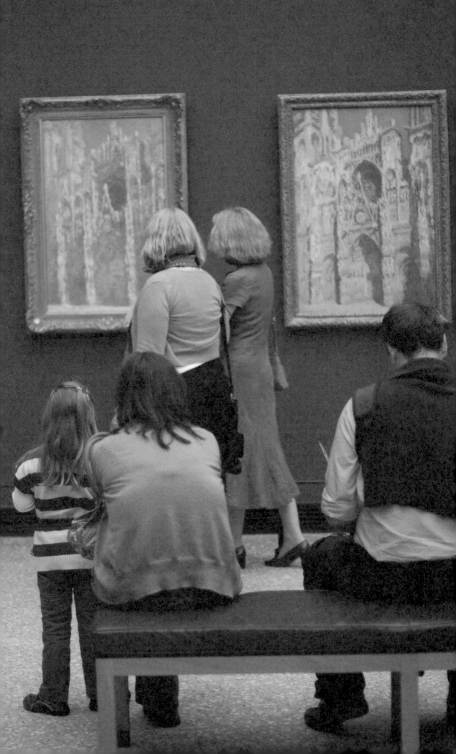

Camille Pissarro
Roofs of Old Rouen, Notre-Dame Cathedral, Overcast Weather, 1896
Toledo Museum of Art, Ohio

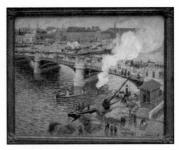

Paul Gauguin
Rue Jouvenet, Rouen, 1884
Thyssen-Bornemisza Museum, Madrid

Camille Pissarro
Afternoon, Sun, Rue de l'Épicerie in Rouen, 1898
Private collection

Camille Pissarro
Boieldieu Bridge in Rouen, Wet Weather, 1896
Art Gallery of Ontario, Toronto

Early History of Rouen

1st Century B.C.
Founded by the Gaulish tribe Veliocasses, who called the city Ratumacos; the Romans called it Rotomagus.

841 Vikings overrun Rouen until finally settling here and founding a colony led by Rollo (Hrolfr), who was nominated as count of Rouen by the king of the Franks in 911. In the 10th century Rouen became the capital of the Duchy of Normandy and residence of the dukes, until William the Conqueror established his castle at Caen.

June 24, 1204 Philip II Augustus of France enters Rouen and annexes all of Normandy to the French Kingdom.

January 19, 1419 Rouen surrenders to Henry V of England during the Hundred Years' War, becoming the capital city of the English power in occupied France.

Christmas, 1430 Joan of Arc is brought to the jail in Rouen, tried as a heretic and burnt at the stake on May 30, 1431.

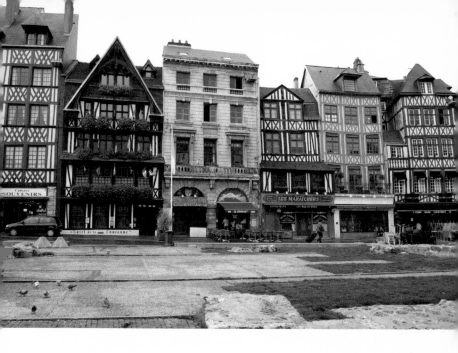

Joan of Arc and Rouen

Born around 1412 in eastern France, Joan of Arc had her first glimpse of greatness at age 12, when she claimed she was visited by visions of Saint Michael, Saint Catherine and Saint Margaret. After a series of visions, she went on to lead the French army—dressed as a man—in several victories, which paved the way for the coronation of Charles VII. Eventually she was captured, sold to the British and brought to Rouen to be tried for heresy in an ecclesiastical court.

Pucelle's Tower, where she was kept during the trial, still stands in the city. It is all that remains of a larger, 13th-century castle built by Philippe Auguste. After Joan was found guilty, she was kept at a castle keep on rue du Donjon (also known as the Tour Jeanne-d'Arc or Joan of Arc Tower).

On May 30, 1431, at age 19, she burned at the stake in the Old Market Place. Her body was burned twice to prevent any taking of relics, then tossed into the Seine. The Boieldieu Bridge marks the spot where her ashes were scattered. A flower garden commemorates the place where she was killed, in front of the modern church of Saint Joan of Arc, built to represent her pyre. The square is also home to the Joan of Arc Wax Museum, which chronicles the life of this unlikely saint through 50 wax models. Each year on the last Sunday of May, Rouen hosts the Joan of Arc Festival, complete with a medieval market and tavern.

Impressions of Rouen's Port

Although Monet had visited Rouen many times before, he made his first painting trip to the city in 1872 and painted 13 views between 1872 and 1873. He may have traveled to Rouen to see his older brother, Léon who moved there to become a chemist.

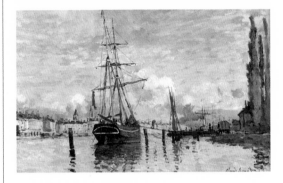

Claude Monet, *The Seine at Rouen,* 1872
Shizuoka Prefectural Museum of Art

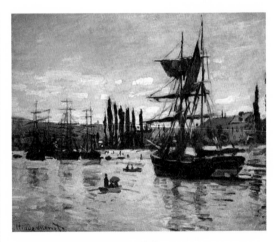

Claude Monet, Ships at Rouen, 1872
Private Collection

Monet's Rouen Cathedral Series

Monet painted more than 30 views of Rouen Cathedral in 1892 and 93. Twenty of them, ranging in effect from dawn to sunset, were exhibited at Durand-Ruel's gallery in 1895 with great success.

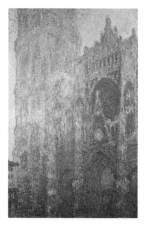

Rouen Cathedral, the Portal and the tour d'Albane, Morning Effect, 1893
Musée d'Orsay

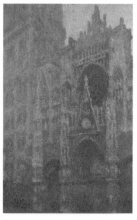

Rouen Cathedral, the Portal and the tour d'Albane, Grey Weather, 1893
Musée des Beaux-Arts, Rouen

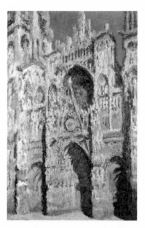

Rouen Cathedral, Full Sunlight
1894
Musée d'Orsay

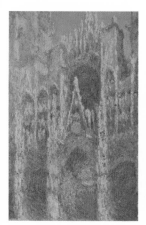

The Rouen Cathedral Façade at Sunset, 1894
Museum of Fine Arts, Boston

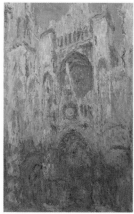

Rouen Cathedral Façade (Sunset), 1894
Musée Marmottan Monet

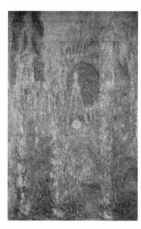

The Rouen Cathedral Façade
1894
Pola Museum of Art, Hakone

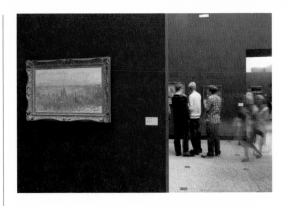

Musée des Beaux-Arts de Rouen
🏠 Esplanade
 Marcel-Duchamp
☎ +33 (0) 2 35 71 28 40
🖥 rouen-musees.com
🕐 Daily 10AM-6PM
€ 5

1 Musée des Beaux-Arts de Rouen

Created by Napoleon in 1801 in the wake of the French Revolution, this museum is home to the largest collection of Impressionist art outside of Paris. The collection is now housed in a building designed by Louis Sauvageot in 1877 and completed in 1888. Its holdings range from the 15th century (masters such as Peter Paul Rubens, Caravaggio and Diego Velázquez) to modern day abstract painters like Maria Helene Vieira da Silva, Jean Dubuffet and Aurélie Nemours. The museum is also well known for its rare collection of Russian icons from the 15th to the beginning of the 19th century and their vast Depeaux collection, consisting of paintings donated in 1909. Among the Impressionist works in the collection are canvases by Sisley, Renoir and Monet's painting *Rouen Cathedral, Façade and the Tour d'Albane. Grey Weather*.

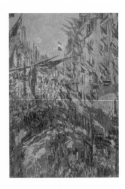

Claude Monet
*Rue Saint-Denis,
30th June 1878,* 1878
Musée des Beaux-Arts,
Rouen

2 Gros-Horloge (The Great Clock)

An iconic symbol of Rouen, the 14th-century Great Clock is part of a larger architectural structure that encompasses a Gothic belfry, Renaissance archway and 18th-century fountain. This is one of the oldest clock mechanisms in Europe and, thanks to a 2006 restoration, the clock is again fully functional, with a new museum inside revealing the clock's inner workings. Local Impressionist artist Léon-Jules

Gros-Horloge
🏠 rue de Gros-Horloge
☎ +33 (0) 2 32 08 01 90
🕐 Apr 1-Oct 31
 10AM-1PM, 2PM-7PM
 Nov 1-Mar 31 2PM-6PM
 Closed Mondays
💶 6

Léon-Jules Lemaître
Rue du Gros-Horloge
1890
Musée des Beaux-Arts, Rouen

Lemaître, who was a part of the School of Rouen, depicted the clock as it was in 1890; the work now hangs in the Musée des Beaux-Arts.

3 Tourist Office

Information for tourists can be found in the tourist office, located in the building from which Monet painted his *Cathedral* series in his second floor studio.

Tourist Office
🏠 25, place de la
 Cathédrale
☎ +33 (0) 2 32 08 32 40
🖥 rouentourisme.com
🕐 May-Sept
 Mon-Sat 9AM-7PM
 Sundays and
 holidays 9:30AM-
 12:30PM, 2PM-6PM

 Oct-April Mon-Sat
 9:30AM-12:30PM,
 1:30PM-6PM
 Closed Sundays
 and holidays

Camille Pissarro
*Afternoon, Sun, rue de
l'Épicerie in Rouen*, 1898
Private collection

Cathédrale de Rouen
🏠 Place de la Cathédrale
🕐 Apr 1–Oct 31
 Sun 8AM–6PM
 Mon 2PM–7PM
 Tue–Sat 7:30AM–7PM

 Nov 1–Mar 31
 Sun 8AM–6PM
 Mon 2PM–6PM
 Tue–Sat 7:30AM–noon,
 2PM–6PM

🄴 La Cathédrale de Rouen (Rouen Cathedral)

Built on the foundation of a 4th-century basilica—destroyed by Vikings in the 9th century and once visited by Charlemagne—this Gothic cathedral began its construction in the 12th century. The cathedral again faced raids in 1944 by German bombings, destroying the oldest tower, the North Tower, and two rose windows. Today, the cathedral remains the seat of the Archbishop of Rouen and Normandy.

🄵 Rue de l´Épicerie

Though the scene painted by both Pissarro and Monet of the bustling street and its half-timbered houses are now gone (destroyed by fire during World War II) the rebuilt street offers picturesque views of the cathedral.

⑥ Pont Boïeldieu

Inspired by the industry of Rouen's port, Pissarro painted *Pont Boïeldieu in Rouen, Rainy Weather* while he was staying at the Hôtel de Paris from January to April 1896. Pissarro's room at the hotel overlooked the Seine and it is from this vantage point that this work was painted. The subject, the Pont Boieldieu, was an iron bridge completed a few years before, in 1885. Unfortunately, that bridge no longer stands; the current one is from 1955.

Camille Pissarro
Le Pont Boïeldieu à Rouen, soleil couchant, temps brumeux, 1896
Musée des Beaux-Arts, Rouen

⑦ Port de Rouen, Saint-Sever

There has been a port in Rouen since at least 50 B.C., when the Greek geographer Strabo commented on its importance to trade on the Seine. The port is still a vital part of the local economy. Pissarro painted the port in several of his paintings, fascinated by the steamboats and industry.

⑧ Côte Sainte-Catherine

Listed as an Historic Monument and Site of Natural Beauty, Monet painted his panorama of the city, *View of Rouen*, 1892, from this hilltop—a 15-minute drive from the center of the city—before beginning work on his *Cathedral* series. The hills surround the city, creating what Flaubert once compared to an amphitheatre.

Claude Monet
La Vue générale de Rouen, 1892
Musée des Beaux-Arts, Rouen

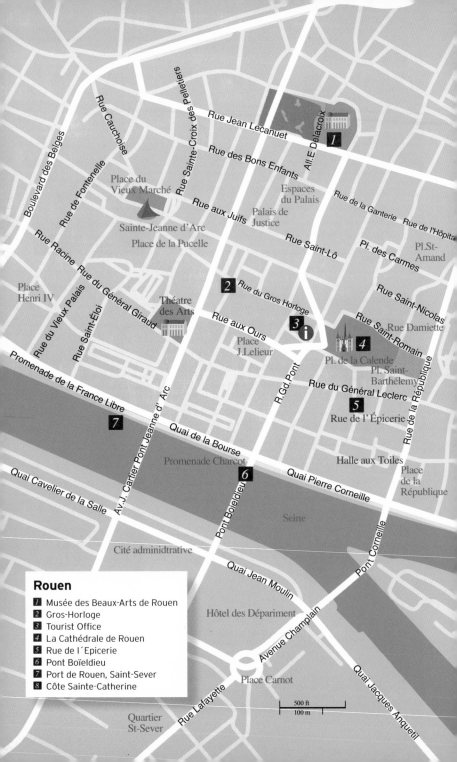

Rouen

1. Musée des Beaux-Arts de Rouen
2. Gros-Horloge
3. Tourist Office
4. La Cathédrale de Rouen
5. Rue de l´Epicerie
6. Pont Boïeldieu
7. Port de Rouen, Saint-Sever
8. Côte Sainte-Catherine

Boulevard des Belges

Rue Cauchoise

Rue de Fontenelle

Rue Sainte-Croix des Pelletiers

Rue Jean Lecanuet

Rue des Bons Enfants

All.E Delacroix

Place du Vieux Marché

Espaces du Palais

Rue de la Ganterie

Rue de l'Hôpital

Rue aux Juifs

Palais de Justice

Sainte-Jeanne d'Arc

Place de la Pucelle

Rue Saint-Lô

Pl. des Carmes

Pl.St-Amand

Place Henri IV

Rue Racine

Rue du Général Giraud

Rue du Gros Horloge

Rue Saint-Nicolas

Théatre des Arts

Rue aux Ours

Rue Damiette

Rue Saint-Romain

Rue du Vieux Palais

Rue Saint-Éloi

Place J.Lelieur

Pl. de la Calende

Pl. Saint-Barthélemy

Rue de la République

Promenade de la France Libre

R.Gd Pont

Rue du Général Leclerc

Rue de l´Épicerie

Av.J. Cartier Pont Jeanne d´ Arc

Quai de la Bourse

Promenade Charcot

Quai Pierre Corneille

Halle aux Toiles

Place de la République

Pont Corneille

Quai Caveler de la Salle

Pont Boïeldieu

Seine

Cité admindtrative

Quai Jean Moulin

Hôtel des Dépariment

Avenue Champlain

Quai Jacques Anquetil

Rue Lafayette

Place Carnot

500 ft
100 m

Quartier St-Sever

Jouvenet quarter

Place de la
Rougemare

Rue de Bourg l'Abbé

Rue de l' Orbe

Avenue de la Porte des Champs

Rue des Capucins

Étretat
Sainte-Adresse
Le Havre
Honfleur
Rouen
Auvers sur-Oise
Giverny
Paris

Boulevard de Verdun

Place du
Général
de Gaulle

Town Hall
Jourdins
de l' Hôtel de Ville

Saint-Ouen

Rue des Faux

Rue Saint-Vivien

Rue Eau de Robec

Rue Saint-Hilaire

Place
Saint-Hilaire

Rue Damiette

Rue Eau de Robec

Rue d'Amiens

Rue Armand Carrel

Place du
39'me R.I.

Centre Hospitalier Régional
Charles Nicolle

Aitre
Saint-Maclou

Rue Martainville

Saint-
Maclou

Place Saint-Marc

Rue Alsace-Lorraine

Rue des Augustins

Hôtel de
Région

Boulevard Gambetta

Rue du Faubourg Martainville

Route de Lyon-la-Forêt

A28 Boulogne,
N31 Beauvais

Rue du Mont-Gargan

Esplanada du
Champ-de-Mars

Quai de Paris

Avenue Aristide Briand

Jardins
Saint Paul

Cimetiére du
Mont Gorgan

Ile Lacroix

Avenue Jacques Chastellain

Pont Mathilde

8

Rue Annie de Péne

N15 Vernon, Paris

N14 Bonsecours
Pongoise , Paris

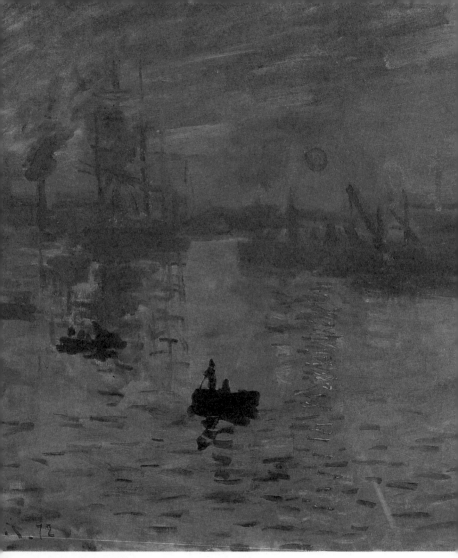

Claude Monet, *Impression, soleil levant* (detail), 1872
Musée Marmottan Monet

Le Havre & Sainte-Adresse

"One day Boudin said to me, 'Learn to draw well and appreciate the sea, the light, the blue sky.' I took his advice."

—Claude Monet

Le Havre translates simply to "The Port" or "The Harbor" and it is this port that has dictated much of the city's fate, helping to create its busy industry, which in turn made it a target for German bombers during World War II.

During the 19th century, Le Havre reached its industrial peak, becoming a center for shipping and manufacturing. Seeking more opportunities, Monet's parents moved here from Paris in 1845, when the painter was only five. Bucking his father's wish to join the family business, the headstrong Monet spent his days at the boardwalk in Le Havre, creating caricatures for tourists. His drawings soon became so popular that, by age 15, he was charging commercial rates for the works and selling them in local shops along the beach towns of Normandy. It is in one of these shops, Gravier's (on the Rue de Paris), where Monet met Eugène Boudin, who also exhibited often in the store. Boudin was impressed by Monet's work and soon became the young artist's mentor, encouraging him to paint the world around him, like the harbor and the tranquil hillsides outside the city.

With the aid of his well-to-do aunt and with encouragement from Boudin, Monet traveled to Paris to study and paint. Throughout his life, Monet would return to Le Havre, most often in the summer and usually penniless, seeking money from the family coffers. During these sojourns home, Monet would meet with fellow artists (his old friend Boudin and new acquaintance, the Dutch painter Johan Jongkind) to venture off into the countryside and paint *en plein air*.

In 1903, the final year of his life, Camille Pissarro, perhaps influenced by Monet's stories of his youth, traveled to Le Havre. Ever influenced by scenes of

ACCESS: Trains to Le Havre leave from Paris regularly; the trip takes about 2 hours. There is also service once a day from Marseille. Le Havre is a port and ferries arrive here from Portsmouth and Newhaven in southern England daily on LD Lines. There is also a small airport with services running to Lyon, Amsterdam and Brighton. If arriving by car, take the A29 or A13; Paris is 195 km, or 121 miles, away.

Claude Monet
Petit Pantheon Theatral, 1860
Musée Marmottan

industry, and unable to paint out of doors in the cold due to illness, Pissarro took up a hotel room overlooking the busy city port and painted his well-known series of the harbor, its bridges, boats and visitors.

Today, Le Havre is still a busy port town, with ships arriving regularly from England and beyond.

Its sister town of Sainte-Adresse—only a 10-minute car ride away—has long been a refuge for residents of Le Havre to escape for the day; to walk its peaceful beaches or sketch and paint its quiet shores. Today, visitors to Sainte-Adresse will find plaques marking the places where Monet once set up his easels.

Impressions of Le Havre

Claude Monet, *Fishing Boats Leaving the Port Le Havre*, 1874
Los Angeles County Museum of Art
This painting appeared at the Impressionist Exhibition in Paris in May 1874.

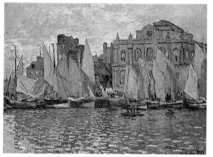

Claude Monet, *The Museum at Le Harvre*, 1873
The National Gallery London

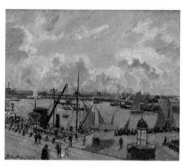

Camille Pissarro, *Le Havre Harbour on a sunny morning at high tide, 1903*
Musée Malraux

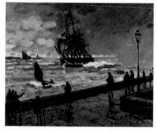

Claude Monet,
The Jetty at le Havre Bad Weather,
1870, Private Collection

Le Havre Harbor, c. 1920

UNESCO World Heritage Site

During World War II, Le Havre was in ruins. Heavy bombing killed 5,000 of its people and destroyed 12,000 buildings. The city, which had attracted so many Impressionist artists, was gone. It was decided after the war that Le Havre would rebuild and architect Auguste Perret was hired to design the new city center in the modernist style. His plan called for combining the original plan of the city and its still-standing

historic structures with contemporary urban planning, modular grids and concrete construction.

The rebuilding took nearly 20 years to complete and now forms the commercial and cultural center of Le Havre. In 2005, UNESCO listed the city as a World Heritage Site—one of the few contemporary sites with the designation in Europe—noting the city's "innovative utilization of concrete's potential" and calling it "an exceptional example of architecture and town planning of the postwar era."

Claude Monet,
Portrait of Madame Louis Joachim Gaudibert, 1868
Musée d'Orsay

The portrait of Madame Gaudibert, Monet's family friend, was painted in a large villa just outside of Le Havre. The Gaudiberts' commission for portraits and their purchase of other pictures by Monet saved him from the worst of his difficulties for a time and enabled him to resume the painting he had almost abandoned in despair. `Thanks to this gentleman of Le Havre who's been helping me out', he wrote to Bazille.

Office de Tourisme
The city's official tourist center offers maps, information on the city's history, and travel tips for accomodations, restaurants and tours of the city.

🏠 186, boulevard
Clemenceau
☎ +33 (0) 2 32 74 04 04
🖥 le-havre-tourism.com

Musée des Beaux-Arts Andre Malraux
🏠 2, boulevard
Clemenceau
☎ +33 (0) 2 35 19 62 62
🖥 lehavre.fr/rubrique/
musee-malraux
🕐 Sat-Sun 11AM-7PM
Mon, Wed-Fri 11AM-6PM
💶 5

🗾 Musée des Beaux-Arts André Malraux

This museum houses a collection of art spanning the past five centuries, and the Impressionist painting collection is the second most extensive in France after those of the Musée d'Orsay in Paris.

There are paintings by Monet and other artists who lived and worked in Normandy. Highlights include work by Boudin, Delacroix, Courbet, Degas, Manet, Renoir, Seurat, Dufy and Sisley. One of the museum's latest purchases is the seascape *Vague, par temps d'orage* by Courbet.

The museum is named in honor of the French writer André Malraux. Malraux was Minister of Culture from 1959 to 1969 and made the museum one of his top priorities, opening it in 1961. The original Musée des Beaux-Arts du Havre was founded in 1845 but was destroyed in World War II.

2 Cathédrale Notre-Dame du Havre

Walk around this landmark and you'll get a striking contrast between the 15th-century cathedral and the buildings constructed in the '50s and '60s around it. The foundations of the cathedral are lower than the other buildings because the new city was built on the ruins of the old town.

Cathédrale Notre-Dame du Havre
🏠 69, rue de Paris
☎ +33 (0) 2 32 74 04 05

3 Church of St. Joseph

Built between 1951 and 1958, this church has become one of the icons of Le Havre. The building was designed by Auguste Perret when the architect was in charge of rebuilding the city. The immense bell tower is one of the tallest in France and works as a lighthouse to ships at sea—as well as serving as a symbol of the city. The tower is lined with multi-colored glass and its interior is an austere, Neo-Gothic design.

Church Of St. Joseph
🏠 rue Louis de Caligny
☎ +33 (0) 2 32 74 04 04

The Entrance of Le Havre in Stormy Weather, 1895
🏠 boulevard Clemenceau and rue des Moulins

Impression, Sunrise, 1872
🏠 place Guynemer Semaphore

4 The Entrance of Le Havre in Stormy Weather, 1895

This work by Boudin from 1895 depicts a stormy English Channel with ships riding the waves. The spot from which Boudin painted this, however, is normally a peaceful scene—a quiet harbor that today is lined with docked yachts.

5 Impression, Sunrise, 1872

Impression, Sunrise (*Impression, soleil levant*) is an important work not only in Monet's career but also for Impressionism as a whole, as its title gave name to the entire movement of art created by the artist and his peers. The painting was made using loose brushstrokes giving the viewer the feeling of the harbor at Le Havre instead of the details. When asked about the title of the work, Monet said, "I had sent a thing done in Le Havre, from my window, sun in the mist and a few masts of boats sticking up in the foreground ... They asked me for a title for the catalogue, it couldn't really be taken for a view of Le Havre, and I said: 'Put Impression.'" Monet's vantage point of the harbor is now located in a parking lot with a view of industrial factory chimneys.

6 *Outer Harbor of Le Havre, 1885-1890*

Throughout his career, Pissarro had an interest in manufacturing and industry. He painted this work at the busy port in Le Havre, whose dock was bustling with cranes, workers and townspeople out for a stroll. Today, the plaque where this was painted is situated along a canal, which was built after Pissarro's time.

Outer Harbor of Le Havre, 1885-1890
🏠 quai de Southampton

7 *Twilight over the Basin of Le Havre, 1872*

The spot where Boudin painted this work offers a view out over the basin of Le Havre, a man-made commercial harbor. In Boudin's day, the water was filled with tall ships, as seen lightly sketched in the painting, but today the spot from which he painted this work offers a view of the modern city and a newly built bridge.

Twilight over the Basin of Le Havre, 1872
🏠 rue de Paris between quai George V and quai Lamblardie

8 Ocean Walk in Sainte-Adresse

The resort town of Sainte-Adresse has long attracted tourists and artists alike, each searching out its quiet waters and seaside attractions. Along the beach walk here, you'll find plaques marking where various Impressionists painted some of their most famous works, including Monet's *The Beach of Sainte-Adresse*, 1867.

Sainte-Adresse
Access: Sainte-Adresse is accessible by a 10-minute car ride north from Le Havre.

Sainte-Adresse

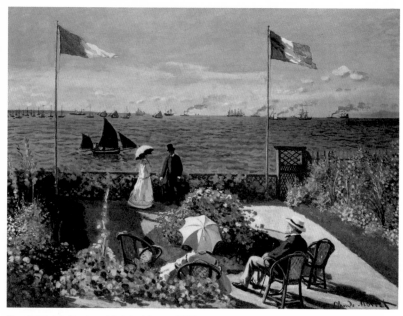

Claude Monet, *Garden at Sainte-Adresse*, 1867
Metropolitan Museum of Art, New York

Monet's *Garden at Sainte-Adresse*, 1867, is his most important seascape from the first decade of his career. The work was painted in Monet's aunt's garden in her seaside villa in the town. The seated figures are most likely his father and aunt, while in the background, Monet's cousin

Jeanne-Marguerite speaks with an unidentified man. The painting takes in not only the industry of modern life (the smoke stacks and ships in the background), but also the luxuries and pleasures those industries make possible. The colors used in the painting are purposely bold. Monet used pure pigment to better portray the blinding brightness of a clear day by the sea. When exhibited, Monet's contemporaries were shocked by the bright hues, thinking them crude. The composition of the work is influenced by a Japanese print of Hokusai's *Turban-shell Hall of the Five Hundred Rakan Temple*, a well-worn copy of which Monet owned. The print shows a group of figures relaxing on a very modern pavilion, overlooking the pastoral landscape of marshland and a mountain in the distance. The figures in the print contemplate the perfection of the mountain while Monet's figures watch the ships, importing goods to France. Monet called this work his "Chinese painting."

Claude Monet, *The Pointe de la Hève at Low Tide*, 1865
Kimbell Art Museum, Forth Worth
Monet's public career began at age 24 when this painting was exhibited at the 1865 Salon. It was one of two seascapes accepted for his first appearance at the official exhibition.

The Beach at Sainte-Adresse

Claude Monet, *Regatta at Sainte-Adresse*, 1867
Metropolitan Museum of Art, New York

Claude Monet, *The Beach at Sainte-Adresse*, 1867
Art Institute of Chicago

Le Havre & Sainte-Adresse

1 Musee des Beaux-Arts
 André Malraux
2 Cathédrale Notre-Dame du Havre
3 Church of St. Joseph
4 *The Entrance of Le Havre in Stormy Weather*, 1895
5 *Impression, Sunrise*, 1872
6 *Outer Harbor of Le Havre*, 1885-1890
7 *Twilight over the Basin of Le Havre*, 1872
8 Ocean Walk in Sainte-Adresse

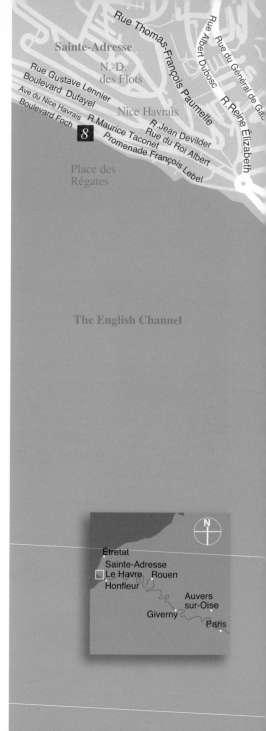

Sainte-Adresse

N.-D.
des Flots

Rue Gustave Lennier
Boulevard Dufayel
Ave du Nice Havrais
Boulevard Foch

Rue Thomas-François Paumelle

Rue Albert Dubosc

Rue du Général de Ga..

R. Reine Élizabeth

Nice Havrais

R.Jean Devilder
R.Maurice Taconet
Rue du Roi Albert
Promenade François Lebel

8

Place des
Régates

The English Channel

N

Étretat
Sainte-Adresse
Le Havre Rouen
Honfleur
 Auvers
 sur-Oise
 Giverny
 Paris

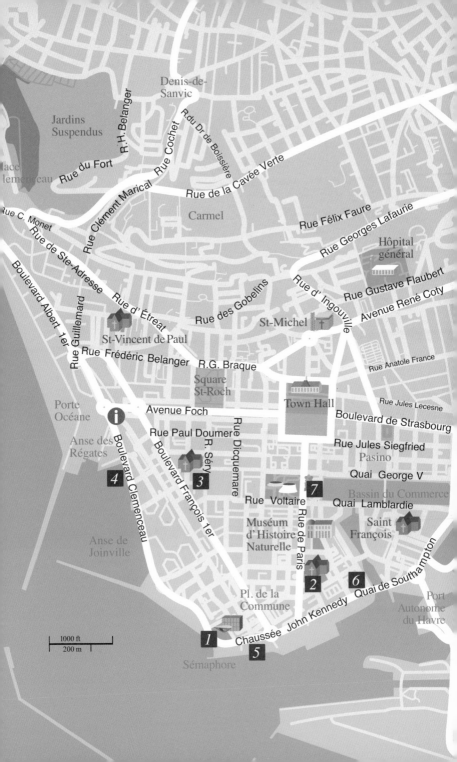

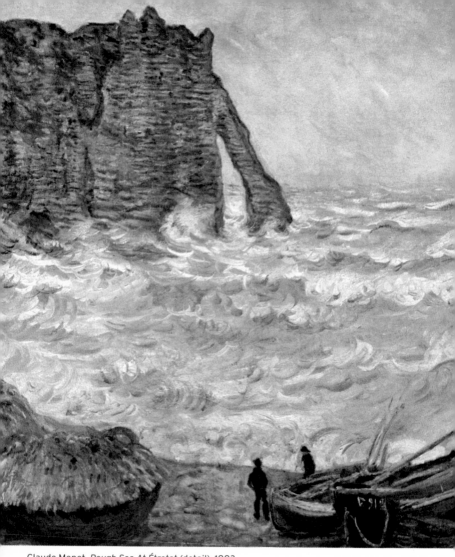

Claude Monet, *Rough Sea At Étretat* (detail), 1883
Musée des Beaux-Arts, Lyons

Étretat

"I didn't see a huge wave coming. It threw me againt the cliff...the worst thing was that I lost my painting which was very soon broken up."

—Claude Monet

The small, seaside town of Étretat has a long history of attracting artists with its natural beauty, most notably the drastic cliffs that line the coast. The famous natural arch—known as Port d'Avel but lovingly referred to as the "elephant" arch—is a subject that Claude Monet, Eugène Boudin, Gustave Courbet, Jean-Baptiste-Camille Corot and Eugène Delacroix all put to canvas several times.

From January 31 until February 21, 1883, Monet stayed at the Hôtel Blanquet in Étretat, painting the barren, wintery seaside devoid of tourists in 11 different works, such as *Rock Arch West of Étretat (The Manneport)*. He returned to Étretat several times over the next few years: in the summer of 1884, the fall of 1885 and lastly in early 1886, when he painted *Étretat in the Rain*.

In 1885, Monet first met the French writer Guy de Maupassant, who spent most of his childhood in Étretat. Eventually, Maupassant permanently settled in the town in 1883, building his home "La Guillette," which sits on a street renamed after the author, rue Guy-de-Maupassant.

In 1890, Monet's mentor Boudin traveled to Étretat; the beach there soon became a favorite location for him to paint, creating the works *The Laundresses of Étretat* and *The Cliffs at Étretat*.

But Étretat called to artists even before these titans of Impressionism came to the town. Courbet journeyed here in 1869, painting his *The Sea-Arch at Étretat*—a work with light brushstrokes and restraint of detail that predicted the treatment the arch would receive by both Monet and Boudin. This work, in fact, is what inspired Monet to come to the town and paint.

Today, visitors to Étretat can see plaques marking the places where these artists once worked.

1883 Monet takes up residence in l'Hôtel Blanquet in Étretat from January 31 until February 21, where he writes lover Alice Hoschédé numerous romantic letters.

1884 Monet returns to Étretat in August, painting, among other works, *The Cliffs at Etretat* and *The Rocks Etretat*.

1885 Monet settles in Étretat with Alice and her children in a house lent by the singer Jean-Baptiste Faure in mid-September. Left alone in the town on October 10, he again takes a room at the Hôtel Blanquet until mid-December, during which time he often meets with Maupassant.

1886 In February, Monet returns to Étretat and sends 10 works to the Exposition des XX in Brussels.

1886 Monet and Maupassant met in Etretat.

1890 Boudin paints the cliffs of Étretat.

Hôtel Blanquet

Eugène Delacroix, *Cliff at Étretat*, c. 1859
Museum Boymans van Beuninge, Otterlo

Claude Monet, *Rough Sea at Étretat*, 1868-69
Musée d'Orsay

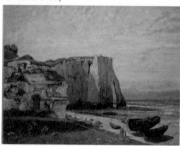

Gustave Courbet, *The Étretat Cliffs after the Storm*, 1870
Musée d'Orsay

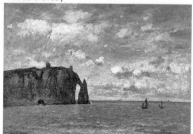

Eugène Boudin, *The Cliffs at Étretat*, 1890
Private Collection

Tourist Office
⌂ place Maurice
 Guillard
☎ +33 (0) 2 35 27 05 21
▤ etretat.net
◎ Summer Hours:
 Jun 15-Sep 16
 Daily, 9AM-7PM

Winter Hours:
Sep 17-Nov 11
Mar 15-Jun 14 and
during school
holidays
Daily 10AM-noon;
2PM-6PM.

◼ Port d'Aval

The most famous of Étretat's three arches, nick-named the "elephant arch." Along with arches Porte d'Amont and the Manneporte, it is reachable via sea-side hiking trails from the beach, which is composed of smooth stones. A few of the works created at these cliffs include *Cliff at Étretat,* C1859 by Delacroix, *Rough Sea at Étretat,* 1868-69 by Monet, *The Cliffs at Étretat After the Storm*, 1870, by Courbet, and *Fishermen on the Beach*, 1890, by Boudin.

Étretat's seaside
architecture.

◼ Bateaux de Pêche

Monet depicted the moored fishing boats, or the *bateaux de pêche*, along the beaches of Half-moon Bay in Étretat in his work *Boats on the Beach,* 1885. This fishing industry is long gone from the town, now replaced by tourism, but visitors can still visit the bay and feel thankful to have missed the smell of gutted fish in the air.

Monet's Impressions of Étretat

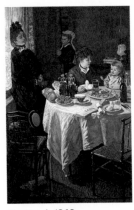

The Magpie, 1869
Musée d'Orsay

Monet painted this work in the
countryside around Étretat,
during a time when he was in a
friendly competition with Courbet
to portray snowscapes.

The Lunch, 1868
Städelsches Kunstinstitut,
Frankfurt

The Manneport, 1883
The Metropolitan
Museum of Art
New York

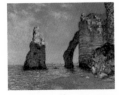

The Cliffs of Étretat, 1885
Sterling and Francine
Clark Art Institute,
Williamstown

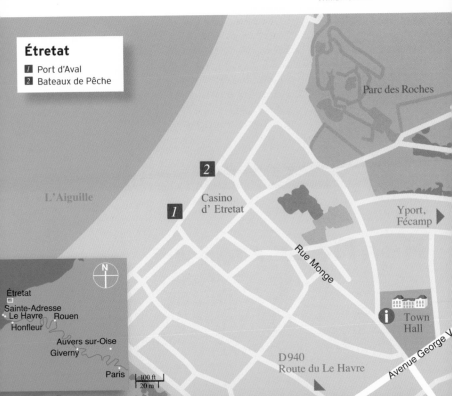

Étretat

1 Port d'Aval
2 Bateaux de Pêche

Parc des Roches

2

L'Aiguille

1 Casino
d' Etretat

Yport,
Fécamp

Rue Monge

Étretat
Sainte-Adresse
Le Havre Rouen
Honfleur

Auvers sur-Oise
Giverny

Paris

100 ft
20 m

Town
Hall

D 940
Route du Le Havre

Avenue George V

Claude Monet, *Seascape, Night Effect* (detail), 1866
National Galleries of Scotland, Edinburgh

Honfleur & Trouville

"To steep oneself in the sky. To capture the tenderness of the clouds. To let the cloud masses float in the background, far off in the gray mist, and then make the blue blaze forth."

—Eugène Boudin

Honfleur is well known in France for being the caldron of pioneers, from famous explorers (Samuel de Champlain, who founded Quebec in 1608 to artists (Impressionist painter Eugène Boudin), born in Honfleur in 1824). But the well-preserved town, with its superb quality of light and its surrounding rolling hills have long attracted artists beyond its native sons.

In the early 19th century, Romantic landscape painters such as Richard Parkes Bonington, J. M.W. Turner, Paul Huet, Xavier Leprince, Camille Corot and Eugène Isabey (to name a few), were drawn to Honfleur. These artists then paved the way for the Barbizon painters Troyon, François and Daubigny, who flocked to the Saint-Siméon Inn.

In 1864, Claude Monet brought his friend and fellow artist Frédéric Bazille to Honfleur for two weeks, searching the countryside for subjects to paint and renting rooms from a local baker. Monet returned alone in the summer of 1866, setting up his easel at Hôtel Cheval Blanc to paint the busy 17th-century harbor. Today, Honfleur's harbor is still an active fishing port and many of its historic, medieval buildings remain, leaving it much the same way these artists first encountered the town.

ACCESS: Honfleur is 190 km (118 mi) west of Paris via the A13 roadway and is serviced by the Deauville-Saint-Gatien airport. There is no direct train line from Paris to Honfleur; switch trains at the towns of Deauville, Lisieux and Pont-l'Evêque.

![M]

Impressions of Honfleur

1608
Samuel de Champlain's leaves Honfleur on his expedition to found Québec.

1820s
Romantic painters—including Turner, Bonington, Isabey and Corot— come to Honfleur to paint the local landscapes .

1824
Boudin is born in Honfleur.

1856
Boudin meets Monet, who visits his studio in Honfleur.

1859
Boudin meets Baudelaire; the poet spends his last years escaping from Paris to the fashionable fishing village, residing with his mother.

1864
Monet and Bazille come to Honfleur together to paint. Jongkind and Monet work side-by-side to paint *La Chapelle de Nortre-Dame de Grâce* in September.

1866
Monet returns to Honfleur to paint the harbor.

1882
Caillebotte stays in Trouville and paints several works during the summer.

Claude Monet, *La Chapelle de Notre-Dame de Grace, Honfleur*, 1864
Private Collection

Johan Barthold Jongkind *La Chapelle de Notre-Dame de Grace, Honfleur*, 1864

Claude Monet, *The Cart; Snow Covered Road at Honfleur, with Saint Simeon Farm*, c. 1867
Musée d'Orsay

Claude Monet, *Rue De La Bavolle, Honfleur*, 1864, Museum of Fine Arts, Boston

Claude Monet, *Mouth of the Seine at Honfleur*, 1865
Norton Simon Museum, Pasadena
This painting was accepted for the 1865 Salon with *The Pointe de la Heve at Low Tide*.

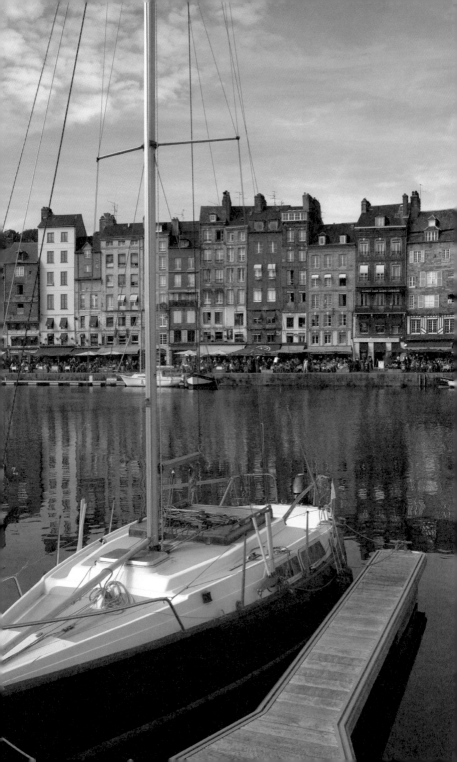

Claude Monet, 1917
Johan Jongkind, 1863
Musée Eugène Boudin

1 Sainte-Catherine Church
Clocher Sainte-Catherine (Bell Tower)

The oddly shaped, mismatched 15th-century church of Sainte-Catherine is France's largest wooden church with a separate bell tower. The church was built by local boatmakers and is shaped like an upside-down boat, a common architectural model in Scandinavia but rare in France. Surrounding the church are narrow, medieval streets, with the best restaurants and art galleries the town has to offer.

2 The Musée Eugène Boudin

Honfleur's favorite son is honored here with his own museum, which contains 92 of the painter's works. The museum is housed in a 19th-century chapel overlooking the town and the Seine. Other artists who were born in Honfleur or worked there are also represented, including Dubourg, Monet, Jongkind, Dufy, Friesz and Gernez, among others.

🖪 Ferme Saint-Siméon

Located in the hills surrounding the town, about one mile from the old port, is this artist haven and 17th-century, half-timbered hotel. Boudin wrote of his love for the hotel in his notebooks; Monet, Jongkind and Courbet visited here to paint the farmlands. In 1854, Boudin and Courbet met with poet Baudelaire at the hotel. Today, Saint-Siméon is a hotel and spa, and has a well-regarded restaurant called La Table Toutain, which offers traditional cuisine. Reservations recommended.

Ferme Saint-Simeon
🏠 rue Adolphe-Marais
☎ +33 (0) 2 31 81 78 00
✉ www.fermestsimon.fr

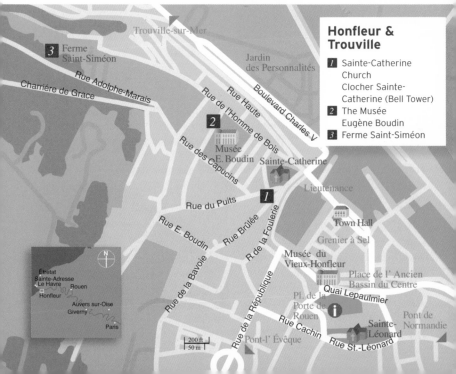

Honfleur & Trouville

🖪 Sainte-Catherine Church Clocher Sainte-Catherine (Bell Tower)
🖪 The Musée Eugène Boudin
🖪 Ferme Saint-Siméon

Trouville

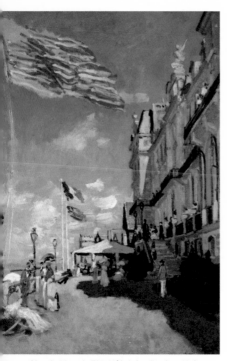

Claude Monet, *The Hôtel des Roches Noires*, 1870, Musée d'Orsay

On June 28, 1870, Monet married his lover Camille at her parents' home in Bougival in Normandy. For their honeymoon, they traveled to the fishing village Trouville, near Honfleur, staying at the Hôtel Tivoli. Here Monet painted *Hôtel des Roches Noirs, Trouville*, as well as a portrait of his new bride sitting on the beach with her parasol in *The Beach at Trouville*, which famously has grains of sand embedded within the paint. The hotel no longer exists here (it is now a block of apartments), but the beach is still expansive, reaching miles in each direction, uninterrupted.

The couple and their young son Jean were still honeymooning in Trouville in July when the war between France and Prussia broke out. Those men eligible for service in Paris were drafted, including Degas, Renoir and Bazille, so Monet bided his time at the seashore waiting for the conflict to subside. Eventually, in August, Boudin and his wife joined the Monets in Trouville.

The following month, Monet abandoned his wife, son and friends, returning home to his father when he was unable to face his landlord at the Hôtel Tivoli over the back rent. His whereabouts are uncertain through the end of 1870, but eventually, Camille and Jean also left Trouville and met up with Monet in London.

Trouville has other claims to fame than Monet's renegade stay; it is where Gustave Flaubert fell in love in 1836—walking behind a beautiful married woman, Elisa Schlesinger, he gallantly picked up her cape when it fell on the sand. Marcel Proust stayed in one of the villas overlooking the beach, making it the model for La Raspelière in *Remembrance Of Things Past*, he also stayed at the Hôtel Des Roches Noires, the hotel pictured in Monet's work.

The Beach in Trouville

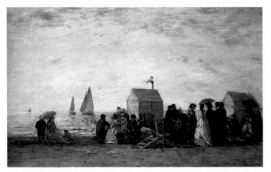

Eugène Boudin, *The Beach at Trouville*, 1864
Private Collection

ACCESS: Trouville is 21 km (13 mi) from Honfleur, about a 20-minute car ride.

Eugène Boudin, *Princess Pauline Meternich*, 1865, Metropolitan Museum of Art, New York

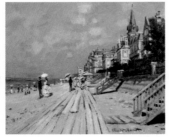

Claude Monet, *The Beach at Trouville*, 1870, Wadsworth Atheneum Museum of Art, Hartford

Scenes of Trouville

Claude Monet, *Camille on the Beach at Trouville,* 1870
Yale University Art Gallery, New Haven

Other Impressionists North of Paris

top: Édouard Manet, *On the Beach, Boulogne-sur-Mer*, 1869, Virginia Museum of Fine Arts, Richmond; (left) Edgar Degas, *Marine*, c. 1873, Musée d'Orsay (right) Edgar Degas, *Cliffs at the Edge of the Sea*, 1869, Musée du Louvre

Édouard Manet

Manet spent the summer of 1874 at his cousin's home in Gennevilliers (just across the Seine from Monet and Renoir in Argenteuil) where he painted nautical scenes. Though Manet did not spent much time in Normandy, the work he produced on other excursions, including trips to Boulogne in the mid- and late-1860s, were reminiscent of the Boudin's Norman work, down to Boudin's frequent subject, bathers on the beach.

Edgar Degas

In 1869, Degas made many of his most important series of large landscapes while staying on the coast in Étretat, a town known for its dramatic landscapes. He returned to Normandy throughout the 1860s and '70s, painting works like *Cliffs at the Edge of the Sea* and *Marine*.

Berthe Morisot

Morisot and her family spent the summer of 1874 in the Norman fishing village of Fécamp with her husband Eugène Manet and his family, though without the company of brother Édouard. Throughout her career, Morisot was known to work *en plein air*. The greatest work Morisot created while in Fécamp was *In a Villa at the Seaside*, which shows the terrace of their rented home, overlooking the sea, but she also painted scenes of the tranquil harbor and port.

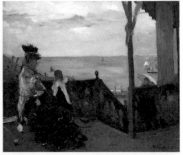

clockwise from left: Auguste Renoir, *Mussel Fishers at Berneval*, 1879, The Barnes Foundation, Philadelphia; Berthe Morisot, *In a Villa at the Seaside, 1874*, Norton Simon Museum; Camille Pissarro, *View through the Window, Éragny*, 1888, Ashforth Museum, Oxford

Pierre-Auguste Renoir

Renoir often visited Monet in the Norman countryside but, in 1879, Paul Bérard, a wealthy retired diplomat and banker, invited the painter to his inland estate near Dieppe. This would be the first of many visits for Renoir; he painted over 40 works for the family, including a series of paintings for their library, drawing room and dining room. Renoir would sojurn to the coastal town of Dieppe, where he painted his famous *Mussel Fishers at Berneval* in 1879. Renoir sent this work to the Salon in 1880, where it was accepted along with three others. Unlike his contemporaries, Renoir chose to depict the everyday people of Normandy rather than the seaside tourists.

Camille Pissarro

In 1884, Pissarro moved to a village in the countryside called Éragny, where he lived until his death and where his family remained until his wife died in 1928. Though Pissarro kept a series of rented apartments in Paris, he painted hundreds of landscapes outside of Paris, often working with friends such as Cézanne, Guillaumin and Gaugin in places like Rouen, Louveciennes and Pontoise. By the time he rented the house in Éragny, he was experimenting with a more "scientific" form of painting closer aligned with Pointillism of the Neo-Impressionists, a move that alienated him from his peers. Pissarro's home in Éragny is privately owned, well preserved and not often visited.

INDEX

PHOTO CREDITS

P4 *Moulin Rouge: La Goulue*, 1891, (lithography) by Toulouse-Lautrec, Henri de (1864-1901) Paris, France, National Library. © AISA/Everett Collection

P10-11 courtesy of the Library of Congress

P22 *Self Portrait with a Beret*, 1886 (oil on canvas) by Claude Monet (1840-1926), Private Collection/ Photo © Lefevre Fine Art Ltd., London/ The Bridgeman Art Library

P32 Bazille, Jean-Frédéric (1841-1870). *Portrait of Renoir*. 1867. Impressionism. Oil on canvas. Paris, France, Musée d'Orsay © AISA/Everett Collection

P 42 Self Portrait, 1890-94 (oil on canvas) by Paul Cezanne (1839-1906) Bridgestone Museum of Art, Tokyo, Japan/ Giraudon/ The Bridgeman Art Library

P 50 *Self-portrait*, 1863. (oil on canvas) by Edgar Degas (1834-1917), Portugal, Lisbon. Museu Calouste Gulbenkian (Lisbon Calouste Gulbenkian Museum). © AISA/Everett Collection

P64 photo: *Eugene Manet (1833-92) his wife Berthe Morisot (1841-95) and their daughter, Julie (1878-1966) at Bougival*, 1880 (b/w photo) by French School

(19th century) Musee Marmottan, Paris, France/ The Bridgeman Art Library

P66 *Self Portrait*, c.1889 (oil on canvas) by Gustave Caillebotte (1848-94) Musee d'Orsay, Paris, France/ The Bridgeman Art Library

P99 Courtesy of Normandy Regional Tourism Board

P103 *Édouard Manet, French Impressionist painter getting the better of the art establishment*, 14 May 1876 (cartoon) by Gill in L'Eclipse, Mary Evans Picture Library/Everett Collection

P144 courtesy of Musée Marmottan Monet

P160 © tomjmac

P161 © Guillaume Bavière

P207 (Interior photos) ©Christian Leiber/ONP

P266 The Monet and Hoschede families, c.1880 (b/w photo) by French School (19th century) Musee Marmottan, Paris, France/ Giraudon/ The Bridgeman Art Library

269 (top left) Courtesy of Normandy Regional Tourism Board

Original photography © Museyon Inc

CONTRIBUTORS

Michael B. Dougherty is a New York City-based lifestyle writer and editor whose work has appeared in *New York*, *Travel + Leisure* and AOL.com.

Charlie Fish is a New York City-based writer and editor. The former editor in chief of online photography magazine WINk, his interviews with legendary photographers are regularly featured in *Resource* magazine. His arts and lifestyle musings have also appeared in *Time Out New York*, *PLANET°* and *Out*.

April Isaacs is a travel and web writer. She recently fled New York and now spends her time traveling around the U.S. and Europe. She's currently working on an audio project based in New Orleans.

Cindy Kang is a doctoral candidate at the Institute of Fine Arts, New York University specializing in

19th-century French art. She has taught at NYU and worked on exhibitions at the Metropolitan Museum of Art, the Frick Collection and the Bard Graduate Center for the Decorative Arts.

Lelia Packer is working on her doctorate in art history at New York University. She has studied and worked in France and is currently based in New York City.

A Macedonian art historian with tempestuous hair, Kiril Penušliski wasted years of his life visiting shady cafés in the Montmartre district of Paris. He is an expert in Italian Renaissance art and is supposedly writing his doctorate but can on most nights be found playing chess online.

ACKNOWLEDGMENTS

Museyon would like to thank the many people and institutions that helped with the creation of this book, including:

Normandy Regional Tourism Board
Musées de la Ville de Rouen
Office de Tourisme du Havre
Fondation Claude Monet
Musée des Impressionnismes Giverny
Musée d'Orsay
Musée de l'Orangerie
Musée Marmottan
Musée du Louvre
Opéra National de Paris
Hôtel du Louvre
Auvers-sur-Oise Tourist Office

Maison de Van Gogh
Maison du Docteur Gachet
Restaurant Fournaise
Moulin des Chennevieres, Giverny
Rouen Tourist Office
Musée des Beaux-Arts André Malraux
Ferme Saint-Siméon
Honfleur Tourist Office
Lapin Agile
Galerie Pére Tanguy
Café de la Paix

WORKS CONSULTED

Auvers Tourist Office. *Auvers-sur-Oise*. Auvers-sur-Oise: Auvers Tourist Office, 2010. Print.

Covington, Richard. "Renoir's Controversial Second Act." Smithsonian.com. *Smithsonian* Magazine, 1 Feb. 2010. Web. 21 Jan. 2011. Smithsonian.com

Distel, Anne, and Susan Alyson. Stein. *Cézanne to Van Gogh: the Collection of Doctor Gachet*. New York: Metropolitan Museum of Art, 1999. Print.

Eisenman, Stephen, and Thomas E. Crow. *Nineteenth Century Art: a Critical History. New York*, NY: Thames & Hudson, 2002. Print.

Engelmann, Ines. *Impressionism: 50 Paintings You Should Know*. Munich: Prestel, 2007. Print.

Fowle, Frances. "Monet's Blue Period." The Scotsman [Edinburgh] 23 July 2003. Print.

Lacambre, Geneviève. *Impressionist and Post-impressionist Masterpieces at the Musée d'Orsay*. New York, NY: Thames and Hudson in Collaboration with Éditions De La Réunion Des Musées Nationaux, 1987. Print.

Lemonedes, Heather, David Steel, Lynn Federle Orr, and Richard Robson Brettell. *Monet in Normandy*. New York: Rizzoli, 2006. Print.

Monet's Year's at Giverny. New York: Metropolitan Museum of Art, 1978. Print.

Pissarro, Joachim. *Monet and the Mediterranean*. New York: Rizzoli in Association with the Kimbell Art Museum, Fort Worth, Texas, 1997. Print.

Renoir, Jean. *Renoir, My Father*. Boston: Little, Brown, 1962. Print.

Rewald, John. *The History of Impressionism*. New York, NY: Museum of Modern Art, 1987. Print.

Roe, Sue. *The Private Lives of the Impressionists*. New York: Harper Perennial, 2007. Print.

Rubin, James Henry. *Impressionism*. London: Phaidon, 2008. Print.

Seine-Maritime Tourisme. *Impressions of Seine-Maritime*. Bihorel: Seine-Maritime Tourisme, 2010. Print.

Trachtman, Paul. "Degas and His Dancers." Smithsonian.com. *Smithsonian Magazine*, 1 Apr. 2003. Web. 10 Jan. 2011. <Smithsonian.com>.

Wildenstein, Daniel. *Monet: Or the Triumph of Impressionism*. Los Angeles: Taschen, 2010. Print.

Williams, Ellen. *The Impressionists' Paris: Walking Tours of the Painters' Studios, Homes, and the Sites They Painted*. New York: Little Bookroom, 1997. Print.

MUSEYON INC.

Publisher: Akira Chiba
Editor-in-Chief: Heather Corcoran
Media Editor: Jennifer Kellas
Art Director: Ray Yuen
Cover Design: José Antonio Contreras

Maps & Illustration Design: EPI Design Network, Inc.
Contributing Writers: Mackenzie Allison, Michael B. Dougherty, Charlie Fish, April Isaacs, Cindy Kang, Lelia Packer, Kiril Penušliski, Catherine Ventura
Proofreader: Janice Battiste, Charlie Fish

ABOUT MUSEYON

Named after the Museion, the ancient Egyptian institute dedicated to the muses, Museyon Guides is an independent publisher that explores the world through the lens of cultural obsessions. Intended for frequent fliers and armchair travelers alike, our books are expert-curated and carefully researched, offering rich visuals, practical tips, and quality information.

Pick one up and follow your interests... wherever they might go.